GAME CHANGERS

THE UNSUNG HEROINES OF SPORTS HISTORY

MOLLY SCHIOT

SIMON AND SCHUSTER

New York London Toronto Sydney New Delhi

Simon & Schuster
1230 Avenue of the Americas
New York, NY 10020

First Simon & Schuster hardcover edition October 2016

SIMON & SCHUSTER and colophon are registered trademarks
of Simon & Schuster, Inc.

For information about special discounts for bulk purchases,
please contact Simon & Schuster Special Sales at 1-866-506-1949
or business@simonandschuster.com.

The Simon & Schuster Speakers Bureau can bring authors to your
live event. For more information or to book an event contact the
Simon & Schuster Speakers Bureau at 1-866-248-3049
or visit our website at www.simonspeakers.com.

Interior design by Joy O'Meara

Manufactured in the United States of America

1 3 5 7 9 10 8 6 4 2

Library of Congress Cataloging-in-Publication Data

Names: Schiot, Molly, author.
Title: Game changers : the unsung heroines of sports history / Molly Schiot.
Description: New York : Simon & Schuster, 2016. | Includes bibliographical references.
Identifiers: LCCN 2016017922 | ISBN 9781501137099 (hardback) |
ISBN 9781501137105 (trade paperback)
Subjects: LCSH: Women athletes—Biography. | Women athletes—History—20th century. | BISAC:
PHOTOGRAPHY / Subjects & Themes / Sports. | SPORTS & RECREATION / History.
Classification: LCC GV697.A1 S416 2016 | DDC 796.0922 [B]—dc23
LC record available at https://lccn.loc.gov/2016017922

ISBN 978-1-5011-3709-9
ISBN 978-1-5011-3711-2 (ebook)

This book is dedicated to all the women who were forever told "no."

Judi Oyama

"It is not our differences that divide us. It is our inability to recognize, accept, and celebrate those differences."

—*Audre Lorde*

AUTHOR'S NOTE

This book is about women's stories.

When I was a kid, I thought only men could be champions. *Slap Shot. Raging Bull. Rocky. Youngblood. The Karate Kid. Breaking Away. Hoop Dreams. Point Break. Chariots of Fire.* These were the fast-paced, adrenaline rich, sweaty-as-heck films that shaped me. In 1985, there were no films that featured strong female boxers running up the steps of the Philadelphia Museum of Art, no training sequences with a girl version of Ralph Macchio, no images of girl gangs shredding down Los Angeles streets under floodlights on their worn-in skateboards. Growing up in New England, my screen flashed to the Boston Bruins, the Boston Celtics, the New England Patriots and, of course, always PBS. The only option I—and millions of other young girls—had for my role models, my heroes, were people I couldn't really relate to. Outside of the Olympics, I rarely saw a woman in a uniform or holding a trophy. When you're a kid without cable in a small town, names like Billie Jean King and Althea Gibson might be overheard once or twice, but no photos or stories seemed to exist to make them anything more than just a few syllables strung together.

Thankfully things are gradually improving. We're seeing women running for public office, rising through the corporate ranks, and fighting on the front lines for equality. Yet there is still a colossal lack of attention paid to female athletes, journalists, coaches, and their achievements. I wanted to change that.

I am neither a historian nor am I an expert. I am a director in Hollywood who wanted to tell stories that mattered, who tried to pitch documentaries about female athletes to a major sports network. To me, groups like the Wake-Robin Golf Club, founded by Helen Webb Harris in the 1930s, were the stuff of legend. Harris and her friends had come together to find a place to play a game they loved, but there was just one problem: they were African-American, and the sport wouldn't have them. They drafted letters and petitioned public courses to desegregate, but to no avail. The compromise was the option to build a nine-hole course on the site of an abandoned trash dump, the furthest thing from the ideal, manicured green sprawl. They retrieved balls from under the old tires or rusty tin cans covering the property, which was described as having a raw sewage ditch running through it. This tale had everything an audience would be looking for: great characters and a slice of history that showcased good old American triumph, resilience, and perseverance. Development executives saw it differently. When I presented my idea, they said, "Sorry, but keep looking."

So I did.

My research began at the Los Angeles Public Library, where I would comb through pages of old books in the sports section for days on end, alone except on the days when I was visited by Rodney, a homeless man who could recite—on command—all the records of every man and woman who competed in the 1984

Summer Olympics. When I had exhausted the library's image archives, I bid farewell to my new friend and headed to the LA84 Foundation's library, a true hidden gem in the city of Los Angeles that houses the largest sports research library in North America. It sits in the West Adams district, surrounded by the largest grouping of historic homes west of the Mississippi, and burns an Olympic-like flame in the courtyard. As I dove deeper into the materials I found there, I learned about Rena "Rusty" Kanokogi, Margaret Dunkle, Laura Thornhill-Caswell, Dr. Bernice "Bunny" Sandler, Junko Tabei, and hundreds of other women. When I shared these stories at dinner tables and coffee shops, both men and women would reply, shocked, "How on earth do we not know these women's names?" I would also respond with a "Well, how *would* you?!"

One day, I discovered the LA84's entire collection of *womenSports* magazine, which was launched in partnership with the Women's Sports Foundation (started by Billie Jean King) and assisted by *Ms.* magazine co-founders Pat Carbine and Gloria Steinem. This treasure trove of images inspired me to pull these stories out of the dark. I now had the pictures to match the text, and knew I had to share them with the world.

In 2013 I started an Instagram account called @theunsungheroines, posting a photo and story every day about the women I'd found: women disqualified from tennis tournaments because of the color of their skin; women who changed their physical appearances to pass as men so they could step up to the plate and hit balls into the outfield; the first black woman to win a gold medal, who returned home and was congratulated publicly by a white mayor who still would not shake her hand because "That's just the way it was at the time."

All were strong, smart, and sacrificed to do what they loved.

And now they are here.

I don't think I quite understood the absence of women in sports history when I was a kid. It's not until I started this project that I, a proud feminist, came to the uncomfortable realization that these names have always been there, but we haven't recognized them; it baffles me that the real Wake-Robin Club is less known than the fictional Bad News Bears. With this book, I hope to change that, even if just a little. It is our job to remember these women and tell their stories. Of course, there are many more game changers, known and unknown, than are included here. Think of this as a primer. Since this began as a personal project, many of the women featured are ones that I did not know about and wanted to investigate further. Others, in my opinion, truly changed the direction and face of the sport they played, and I wanted to reinforce their influence. I tried my best to hit all ends of the spectrum, from sport to nationality and time period, and use lesser-known, more candid images than we're used to seeing flashed across a front page. I welcome and challenge you, reader, to learn as much as you can about them, and to find those who have yet to be discovered. Every field we step on, every finish line we cross, is for them. I wish I could put hundreds more women between these covers, because they deserve to be celebrated.

To each of the women on the pages of this book, I thank you. I am honored to have—finally—found my heroes.

Molly Schiot

GAME CHANGERS

ALICE MARBLE

Championship tennis player Alice Marble's approach was called "the killer instinct." As a child, she was an avid baseball fan. She and her brother would frequent San Francisco Seals games, arriving before the crowds to play catch while the stadium was still empty. One day, a player mistook her for a young boy and asked her if she wanted to play catch with him. She obliged and from that day on, she regularly participated in the Seals' pregame warm-up. Before long, she was catching flies from her hero, Lefty O'Doul, while Joe DiMaggio cheered her on from the sidelines. Marble experienced her first bit of fame when the press started writing about the Seals' unofficial mascot, dubbing her "the Queen of Swat." Unfortunately, her reign was short-lived. When she turned thirteen, Marble's brother gave her a tennis racket and told her she had to stop acting like a boy. Just like that, her baseball days were over.

Though she was devastated, Marble quickly developed a passion for tennis. She was the first woman to adapt the "serve and volley" style of play used by male players, and she eschewed the traditional tennis uniform of skirts, opting for shorts instead. The wardrobe choice garnered criticism that both she and her technique were too masculine, but none of it affected her game. In fact, the subversive style brought Marble eighteen Grand Slam championship titles and a four-year reign as the number one American tennis player, from 1936 to 1940.

While her playing record alone warranted Marble a significant place in history, it was her fascinating post-tennis life that elevated her story to a level of grandeur normally reserved for the big screen. During World War II, Marble's husband, Joe Crowley, was killed in action only days after she suffered a tragic miscarriage. Inconsolable, she attempted to take her own life. She was unsuccessful, and after she had time to regain her mental and physical strength, American intelligence recruited her to work as a spy. Her mission involved rekindling correspondence with a former lover (a Swiss banker) to secure Nazi financial documents for the Allies. While undercover, she was shot in the back by a Nazi agent—and survived.

After the war, Marble returned to the United States and played an essential role in the desegregation of American tennis. When African-American player Althea Gibson's standing was called into question, Marble submitted a letter to *American Lawn Tennis* magazine, writing, "If tennis is a game for ladies and gentlemen, it's also time we acted a little more like gentlepeople and less like sanctimonious hypocrites. . . . If Althea Gibson represents a challenge to the present crop of women players, it's only fair that they should meet that challenge on the courts." Marble believed that if Gibson was not given the opportunity to compete, "then there is an uneradicable mark against a game to which I have devoted most of my life, and I would be bitterly ashamed." Her words made an impact. Althea Gibson was included in the 1950 U.S. Open, making her the first African-American to play in a Grand Slam event.

In her later years, Marble continued to play in exhibition games and promote equality on and off the tennis court. In 1964, she was inducted into the International Tennis Hall of Fame. She passed away in California in 1990. There are courts named after her on Russian Hill in her native city of San Francisco.

ALICE COACHMAN

Alice Coachman clears the five-foot bar to win the high jump on July 8, 1948, at the Women's National Track Meet, her tenth consecutive national championship win. One month later, at the 1948 Summer Olympics in London, she would become the first black woman to win an Olympic gold medal. During the Games, she set an American and Olympic record for her jump and was the only American woman to win gold.

1964 JAPANESE VOLLEYBALL TEAM

The 1964 Olympic Games marked a slew of monumental firsts. It was the first internationally televised Olympics, the first time the Games were hosted by a country in Asia (Japan), and the first year that women's team sports were included.

The final game for women's volleyball was held on October 23 and remains the second-most watched television event in Japan's history. The home team unseated the sport's reigning queen, Russia, despite their opponents' physical advantages, with fierce determination. The performance catapulted each team member to a skill level so surprising it seemed almost magic, earning them the nickname "the Witches of the Orient."

But there was absolutely nothing magical or supernatural behind Japan's success. The team's coach, Hirofumi Daimatsu, laid everything out on the table, and the team's brutal, hyperdisciplined training was legendary in the athletic world. Nicknamed the "ogre" or "demon," Daimatsu had been working with the team since its birth as the Nichibo Corporation's in-house volleyball team. All but two of the players began as Nichibo employees, working their days on the office floor and then devoting their after-work hours completely to volleyball. Once he became the company team coach in 1954, Daimatsu required that all players begin practice promptly at 4:30 p.m., continuing on until midnight, with only a fifteen-minute break. They practiced every single day of the year—with the exception of a few days off around New Year's.

Daimatsu's tenure as a platoon commander in Japan's Imperial Army inspired the team's signature practice drill, *kaiten reeshiibu* (rotate and receive), a seemingly ad infinitum repetition of the team's secret weapon move to defend against the spike. It had the girls running and diving to the floor, landing roughly and painfully on their shoulders and chests, as they recovered with a judo-like somersault to bring them back to their feet. The desire to win above all else was so heavily ingrained in the players that they defended their coach and his methods against any criticism.

However controversial the program was, it worked. The Olympic win was a great boon for a nation that had found its national pride foundering since the end of World War II. Enthusiasm for the team united and inspired the entire country. Their athleticism became a symbol of the Japanese economy's determination to stand up and rise again, despite being knocked down. It sent a message that the country's lack of resources, just like the team's, could be made up for with a fighting spirit and hunger to be the best.

The winning spirit of the women's team endured for two more decades, despite rotating rosters of players and the team's infamous coach. The team went on to medal in the next four consecutive Olympics in which it participated (the team did not compete in 1980), going on to nab one more gold in addition to two silver medals and a bronze.

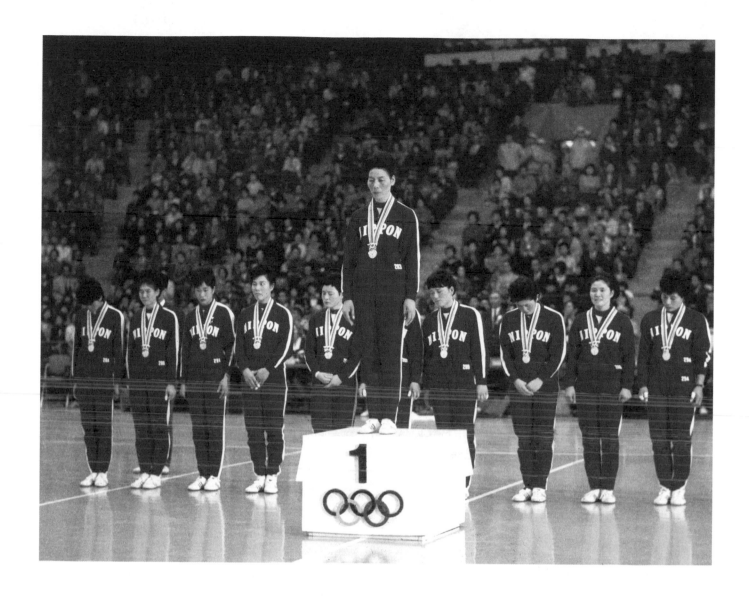

 7

ANITA DEFRANTZ

Growing up in Indianapolis, there were zero athletic opportunities for an African-American girl like Anita DeFrantz. The city was so overtly segregated that her father, a community activist and social worker, referred to it as "the northernmost southern town in the country." In such a place, there was no indication that DeFrantz would one day be called "the most powerful woman in sports." But she would.

An academic scholarship brought her to Connecticut College, where one day during her sophomore year, fate stepped in. DeFrantz was walking past a central campus building when she saw a boat in slings. The strange sight piqued her interest, and she walked right over to rowing coach Bart Gulong. "What's that?" she asked. "It's for rowing," he replied, "and you would be perfect for it." He then asked her if she'd be interested in joining the newly formed rowing team. DeFrantz was, and soon enough, her natural athletic ability, discipline, and determination made her one of the top rowers on the team. Recognizing her talent, Gulong suggested she set her sights on the Olympics; this came as a surprise to DeFrantz, who wasn't even aware that rowing was going to be a sanctioned event.

After graduating from college in 1974, she went on to study law at the University of Pennsylvania, to appease her parents and continue rowing. One year later, she had made the national women's team, and by 1976 she was in Montreal as captain of the U.S. rowing team in the first Olympic Games to feature the event. She came home with a bronze medal only six years after she first stepped into a boat.

Thrilled by her medal, DeFrantz now set her sights on the 1980 Olympics, and this time she wanted gold. Between 1976 and 1980, she was a member of every national rowing team, earning six national championship titles, in addition to completing law school in 1977 and joining a practice. Yet, almost as quickly as DeFrantz's prowess on water improved, American relations with the Soviet Union imploded when the latter invaded Afghanistan. President Jimmy Carter ordered a U.S. boycott of the Summer Games in Russia, at which point DeFrantz's academic and athletic lives converged: she filed a lawsuit against the U.S. Olympic Committee (USOC), citing the Amateur Sports Act of 1978, which specifically barred anyone from denying an athlete's right to compete in the Olympics. With this precedent in hand, she argued that the USOC could send American athletes to the Olympics and override the Carter administration's order.

The move was an extremely divisive one. Hundreds of athletes came to her side, hoping they still had a chance to compete, which many Americans saw as unpatriotic. DeFrantz found herself on the receiving end of hate mail, phone taps, and visits from people she suspected to be thinly disguised FBI agents. Ultimately, the USOC brought overriding the boycott to a vote and the president's Moscow ban was upheld. Though DeFrantz lost her chance at another Olympic medal, the International Olympic Committee (IOC) rewarded her fight with the Bronze Medal of the Olympic Order. Despite their past differences, her involvement with the Olympics improved, and endured. In 1986, the IOC granted her lifetime membership. In 1997 she became the first female vice president of the IOC's executive committee, where she served until 2001. In September 2013, she was elected back onto the executive board, where she currently serves.

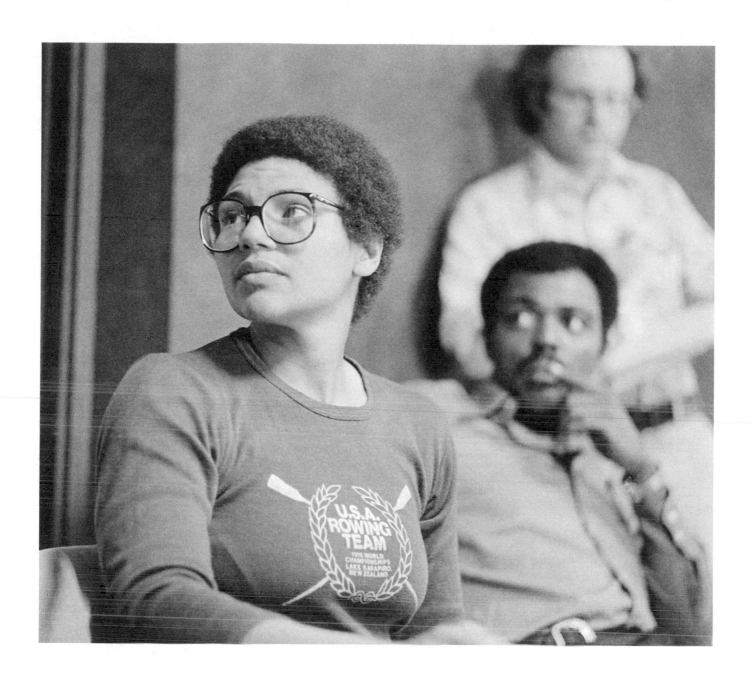

ALISON JANE HARGREAVES

Alison Jane Hargreaves was the first climber to solo all six of the great north faces of the Alps in a single summer season. She summited the most challenging, the Eiger, while six months pregnant. In 1995 she became the first woman and second climber ever to summit Mount Everest unaided by oxygen or porters. She died later that same season when she was swept off K2 by a hurricane while making a descent from its peak.

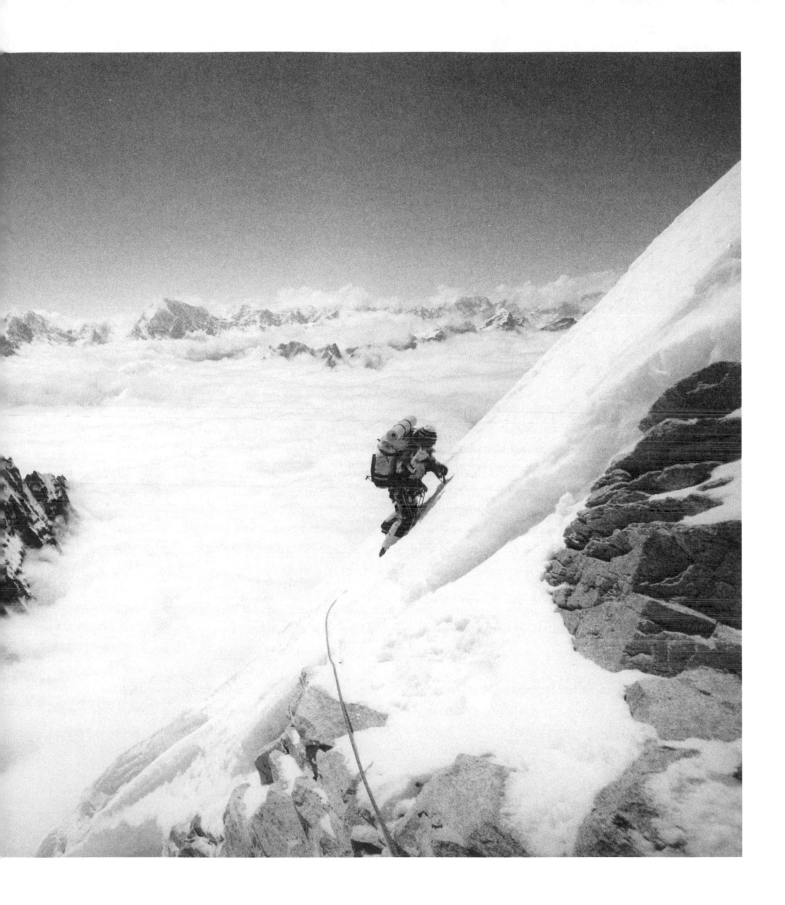

ALTHEA GIBSON

A whirlwind of ticker tape blanketed lower Manhattan as more than one hundred thousand cheering fans welcomed home America's first black Wimbledon champion, Althea Gibson. She had received her trophy in England from Queen Elizabeth II herself, saying later that "shaking hands with the Queen of England was a long way from being forced to sit in the colored section of the bus going into downtown Wilmington, North Carolina." Gibson was now seated in a convertible, waving to the crowd as she traveled the parade route known as the "Canyon of Heroes." The year was 1957, and the moment was bittersweet: though Althea had made history in her sport, segregation remained.

Only seven years earlier, Gibson had made headlines for breaking the color barrier at the U.S. Open as the first African-American player to ever set foot on the grass courts in Forest Hills. It was a universe away from her start as a young girl playing table tennis in Harlem, the beginning of an amateur tennis career that would lead her to become the first person of color to win a Grand Slam title, culminating in a total of 56 national and international singles and doubles titles, and 11 Grand Slam titles.

Despite being the top-ranked tennis player in the world, Gibson's athletic success did not translate to financial gain. When she retired from amateur tennis in 1958, it was still fifteen years before the dawn of professional tours for women; no prize money was awarded at tournaments and endorsement deals were prohibited. In her autobiography, *I Always Wanted to Be Somebody*, she wrote:

> *Being the Queen of Tennis is all well and good, but you can't eat a crown. Nor can you send the Internal Revenue Service a throne clipped to their tax forms. The landlord and grocer and tax collector are funny that way: they like cold cash. . . . I reign over an empty bank account, and I'm not going to fill it by playing amateur tennis.*

Instead, she gave back to her sport, and to her community. In 1972 she began running Pepsi's national mobile tennis project, bringing nets and racquets to underprivileged areas, where she coached a new generation of players like Leslie Allen and Zina Garrison.

After suffering two cerebral hemorrhages, Gibson suffered a stroke in 1992. The cost of medical expenses depleted her already-dwindling bank account, and when she reached out to formal tennis organizations for help, none responded. It was only after her former doubles partner Angela Buxton made Gibson's situation known to the tennis community that the money came. Almost $1 million in donations was raised from around the world.

Fifty years after Gibson won the U.S. championships, she was inducted into the U.S. Open Court of Champions in 2007. At the ceremony, USTA president Alan Schwartz honored her by saying:

> *It was the quiet dignity with which Althea carried herself during the turbulent days of the 1950s that was truly remarkable, [her] legacy . . . lives on not only in the stadiums of professional tournaments, but also in schools and parks throughout the nation. Every time a black child or a Hispanic child or an Islamic child picks up a tennis racket for the first time, Althea touches another life. When she began playing, less than five percent of tennis newcomers were minorities. Today, some thirty percent are minorities, two-thirds of whom are African-American. This is her legacy.*

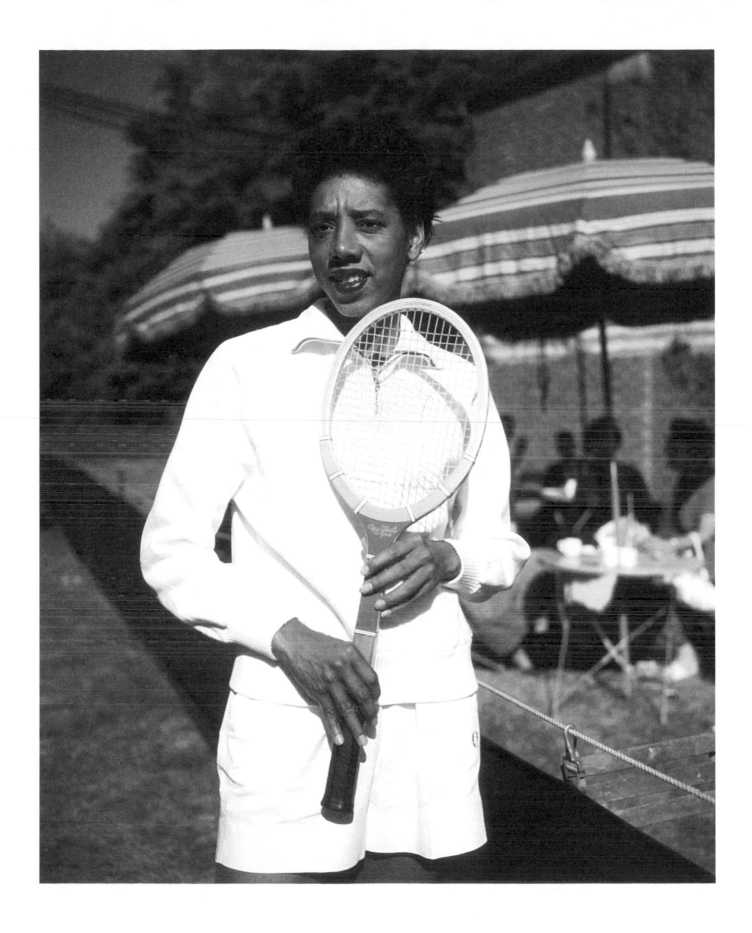

ALL AMERICAN RED HEADS

The "All American Red Heads" was a barnstorming team started by C. M. "Ole" Olson in 1936 to get crowds out of the house and into the stands. Inspiration for the team name came from Ole's wife, who owned a number of beauty salons in the South. Many of the players were natural redheads and those who weren't in the team's early years dyed their hair to keep in step with their team name. They traveled across the nation, playing exhibition games against local men's teams in mostly rural towns. The men played to win but were often defeated by their highly skilled, highly entertaining opponents. Crowds of spectators would flock to the games—audiences often numbered two to three thousand. The team existed for fifty years, making it the longest-running women's professional team in the history of the sport. Their popularity even brought them to the Philippines, where they became the first professional basketball team to ever play in the island nation. The crowd totaled ten thousand.

In a bizarre and ironic twist of fate, Title IX, the groundbreaking legislation that opened the doors of equal opportunity to female athletes across the nation, brought about the end of the All American Red Heads in 1986. Since women now had opportunities to earn athletic scholarships and gain equal time on the basketball court as their male counterparts, the team's mission was deemed irrelevant. After the team folded, its history fell into relative obscurity.

In 2011, the All American Red Heads were inducted into and honored by the Women's Basketball Hall of Fame under the banner "Trailblazers of the Game."

ABBY HOFFMAN

As a nine-year-old in Ontario, Canada, cutting her hair and shortening her on-ice name to "Ab" was everything Abigail "Abby" Hoffman could do to mask her gender as a phenomenal youth hockey player in the Toronto boy's Junior A hockey league. When her skills developed and set her apart from her peers, she was selected to the league's all-star game, but in order to participate, a birth certificate was required. When her gender was revealed, her player eligibility was revoked. Forced away from hockey, Hoffman focused on track and field, where she would become one of Canada's most accomplished middle-distance runners.

At seventeen, Hoffman took her speed and endurance to the global stage, representing Canada in four consecutive Summer Olympic Games from 1964 to 1976, carrying her home country's flag in her last opening ceremonies—and making it to the final heat at both the 1968 and 1972 Games. She earned gold at her first of four Pan American Games in 1963, and went on to claim five medals (two gold, one silver, and one bronze) over the course of her career. She captured gold at the Commonwealth Games in 1966, claimed the national 800m title eight times, and held the national records in the 800m from 1962 to 1975 and the 440 yards from 1963 to 1976.

Hoffman's hunger for equality in competition carried her throughout her career, and she soon added "activist" to her long list of achievements. In 1966, she fought to allow women to attend and train at the Hart House, the University of Toronto's all-male facility—and Ontario's only indoor track at the time. The Canadian government took this to heart and supported the cause. In 1981, Hoffman was elected the first female director general of Sport Canada. With the power to initiate top-down changes to the sports world, she helped assemble the first Canadian National Women's Hockey Championship in 1983, featuring representation from each province, with the eponymous Abby Hoffman Cup going to the tournament winners.

In 1982, Hoffman became the first woman elected to the executive board of the Canadian Olympic Committee, and was given the prestigious title of Office of the Order of Canada a year later. In 1995, Hoffman became a council member of the International Association of Athletics Federations, and she was recently inducted into Canada's Sports Hall of Fame.

ANKE-EVE GOLDMANN

Racing her motorcycle through snow, sleet, and ice in a leather catsuit of her own design was precisely how German-born Anke-Eve Goldmann liked to spend her time. Throughout the 1950s, women were barred from the highest levels of racing, but Goldmann still managed to compete in speed and endurance competitions. She raced at the German Nürburgring and Hockenheimring events, until women were removed from those as well. Men on the moto circuit were not eager to change the rules anytime soon, especially when they were faced with the six-foot-tall Goldmann towering over the BMW bikes that she rode regularly—and sometimes beating them.

Goldmann possessed a brilliant mind, and she regularly wrote for motorcycle journals around the world. Her work was published in many countries, including France, Spain, Sweden, Japan, and the United States. She also taught German to the children of American soldiers stationed at a U.S. Air Force base in Germany. Since female bikers were rare in the 1950s, no proper motorcycle gear existed for them. So, Goldmann collaborated with German designer Harro on a line of gear that featured an iconic one-piece leather suit with a diagonal zipper called "the catsuit."

In 1958, Goldmann helped found the Women's International Motorcycle Association in Europe. After the death of a very dear friend, she gave up cycling, shedding the catsuit for a backpack and traveling throughout Asia, often solo, navigating remote regions of Burma, Cambodia, and Vietnam. She was the inspiration for the lead character of Rebecca in the novel *The Motorcycle* by French Surrealist author André Pieyre de Mandiargues, which was then made into the 1968 movie *The Girl on a Motorcycle*, starring Marianne Faithfull.

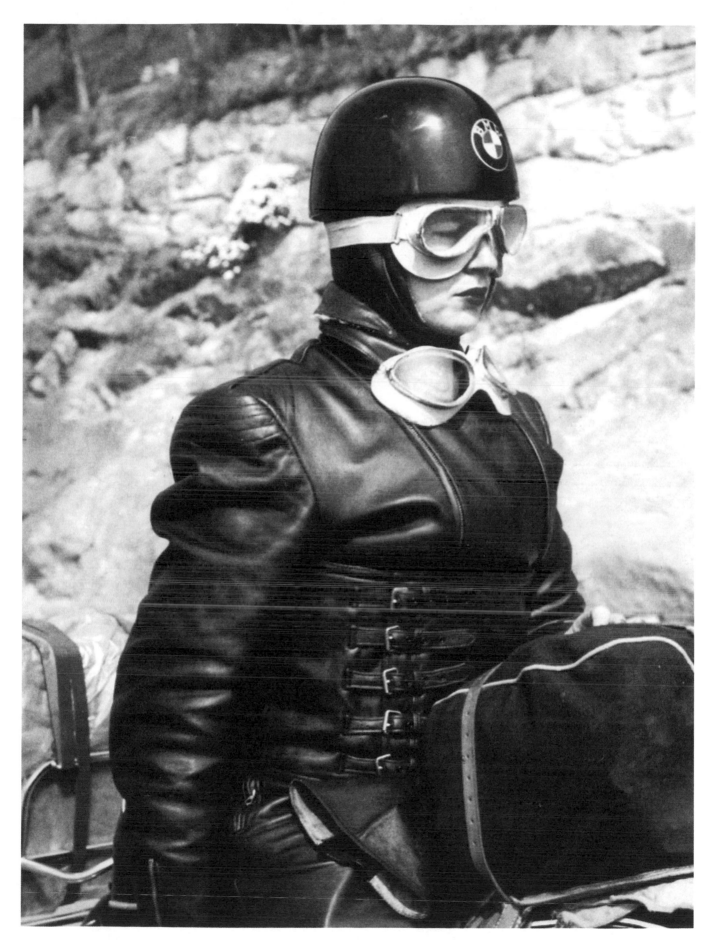

ANNIE SMITH PECK

As she traveled by train through the mountain passes of the Swiss Alps and saw the majestic Matterhorn for the first time, thirty-five-year-old American suffragette and educational activist Annie Smith Peck felt a sudden yearning, akin to a siren's song, for what would become one of her life's great callings: mountain climbing. She later wrote of the moment: "I felt that I should never be happy until I, too, should scale those frowning walls which have beckoned so many upwards, a few to their own destruction." In an instant, her life changed.

Soon enough, Peck had summited Cape Misenum in Italy and mountain passes in Switzerland measuring three to four thousand feet. She became a pioneering female figure in the sport, conscientiously correlating the physical heights she scaled with the sociopolitical advancements of her gender: when she climbed Coropuna, the highest volcano in Peru, she did so for the Joan of Arc Suffrage League, planting its "Votes For Women" flag at the summit. Breaking barriers was not a new passion for Annie. She had already made a name for herself as the first woman to attend the American School of Classical Studies in 1881, and from 1881 to 1892 she was one of the first and only female college professors in America, teaching Latin at Smith College and Purdue University. Through her athletic achievements, she was determined to further prove to the world that women could be equal to men.

Ten years after she first laid eyes on the Matterhorn, Peck became the second woman (after fellow American Lucy Walker) to reach its peak. She was forty-five. Unfortunately, her accomplishment was greatly overshadowed by the scandal caused by her decision to wear trousers while climbing instead of a skirt. The story made it to the pages of the New York Times and became a much-discussed topic of debate in public forum; wearing such an outfit was an offense for which Peck could have been arrested had she been in the United States.

Throughout her career, Peck successfully reached peaks all over North and South America. At sixty-five years old, after five attempts within four years, she became the first person to scale Mount Nevado Huascarán in Peru, setting a record for the highest ascent in the Americas. In 1928, the mountain's northern peak was named Cumbre Ana Peck. To this day, she is the only woman to ever make a first ascent on a major world peak.

In 1927, at the age of eighty-two, Peck climbed her last mountain, New Hampshire's Mount Madison. Two years later, she became ill while climbing the Acropolis in Athens; she died soon after while on a world tour.

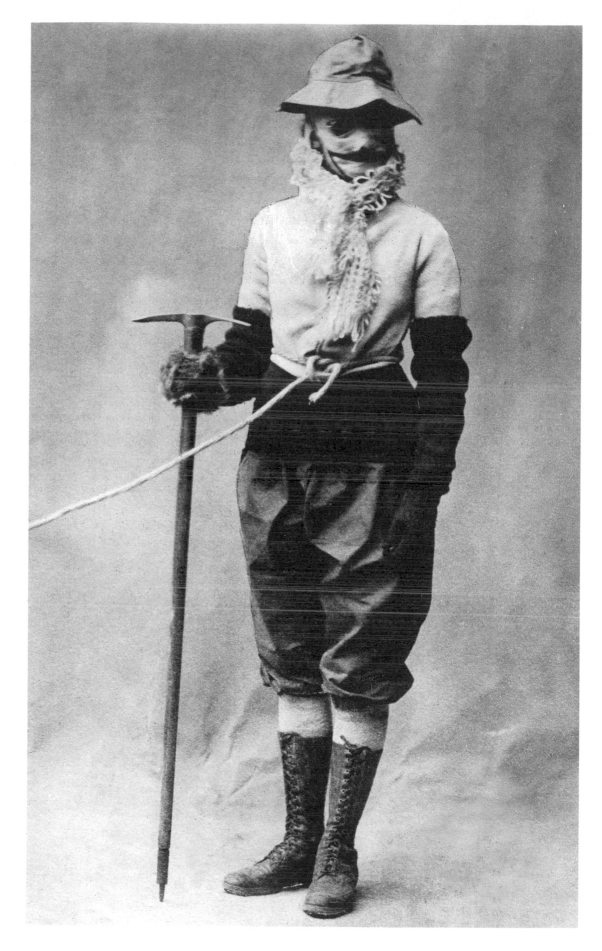

BETTY COOK

For much of her life, she was dismissed as a bored housewife, a grandma, and a rich socialite with too much time on her hands, but when fifty-five-year-old Betty Cook won her first world championship in offshore powerboat racing in Key West, Florida, no one could deny that she was a winner.

Cook's story is a surprising one. She certainly was not groomed for the grueling, competitive lifestyle that goes along with powerboat racing. Growing up in Glens Falls, New York, she wasn't even allowed to have a bicycle until she was sixteen because her mother feared they were too dangerous. Instead, she took ballet lessons and secretly played baseball, going to great lengths to hide the cuts and bruises. She went on to earn her bachelor's degree in political science at Boston University and then continued her education at the Massachusetts Institute of Technology, where she met her husband, Paul Cook. They moved to California, started a family, and had good luck in their investments. They became quite wealthy and while her husband began racing powerboats as a hobby, Cook took on the role of hostess on their yacht. One day in 1974, a friend of the couple, Don Pruit, convinced Cook to give racing a whirl. He gave her a brief lesson, took her out for a test drive, and three days later, she won her first rookie race. She went on to win 17 races in all, including three U.S. titles and another world championship in Venice, Italy in 1979.

Before long, she gained the respect of the men who initially had written her off in the extremely male-dominated sport, piloting her boat at speeds up to 100 mph with equal or better aplomb. In contrast to the stark and intimidating decor and titling of the men's boats with names like *Villain*, *Intimidator*, and *Bounty Hunter*, Cook named her boat *Kaama*, after the graceful African antelope, and painted its face on the foredeck.

In 1981, Cook was inducted into the American Power Boat Association Hall of Champions as the first woman of any class of boat to be included, and was named England's "Powerboat Personality of the Year" in 1973 after winning the famous Cowes–Torquay race. Still, she measured her success by more than just the accolades she garnered over her career: "I've paid my dues as a mower of lawns and sweeper of floors. Before this I'd never won anything in my life— always second best," she said. "Now I have an enormous amount of self-confidence. I feel worthwhile."

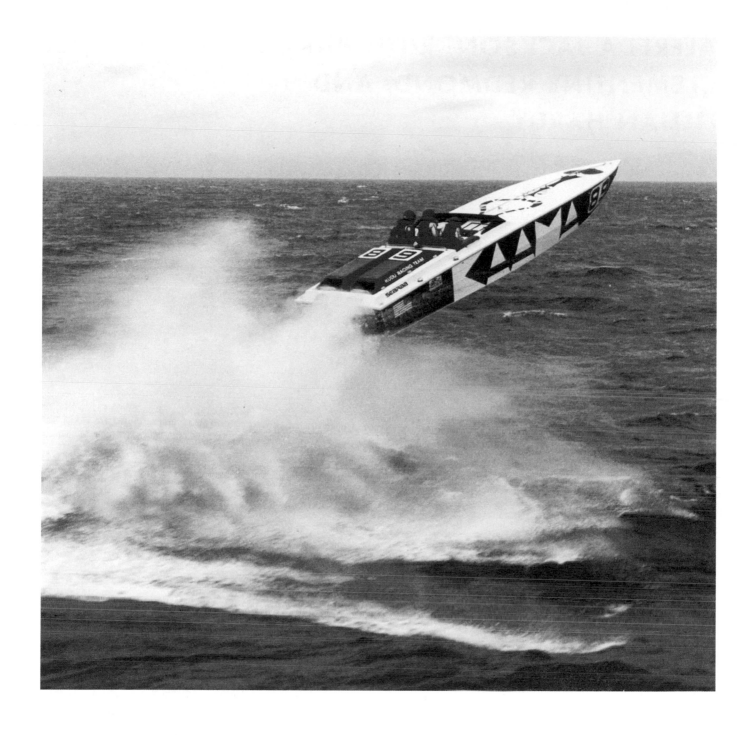

ALFREDA JACKSON, RUTH HARRIS, CLEMENTINE REDMOND, AND LILLIAN HARDY

Alfreda Jackson, Ruth Harris, Clementine Redmond, and Lillian Hardy at the segregated tennis courts of Druid Hill Park in Baltimore, Maryland, in 1928, where the first American Tennis Association National Championships were held in 1917. The ATA remained the primary governing body for African-American tennis until the desegregation of the United States Lawn Tennis Association, prompted by Althea Gibson's participation in the 1950 United States National Championships (now U.S. Open). Two years prior to Gibson's championship appearance, Druid Hill was the site of one of the first antisegregation protests in the country, staged by a group of black and white tennis players and resulting in twenty-four arrests. The courts and other park athletic facilities would not be integrated until the summer of 1956.

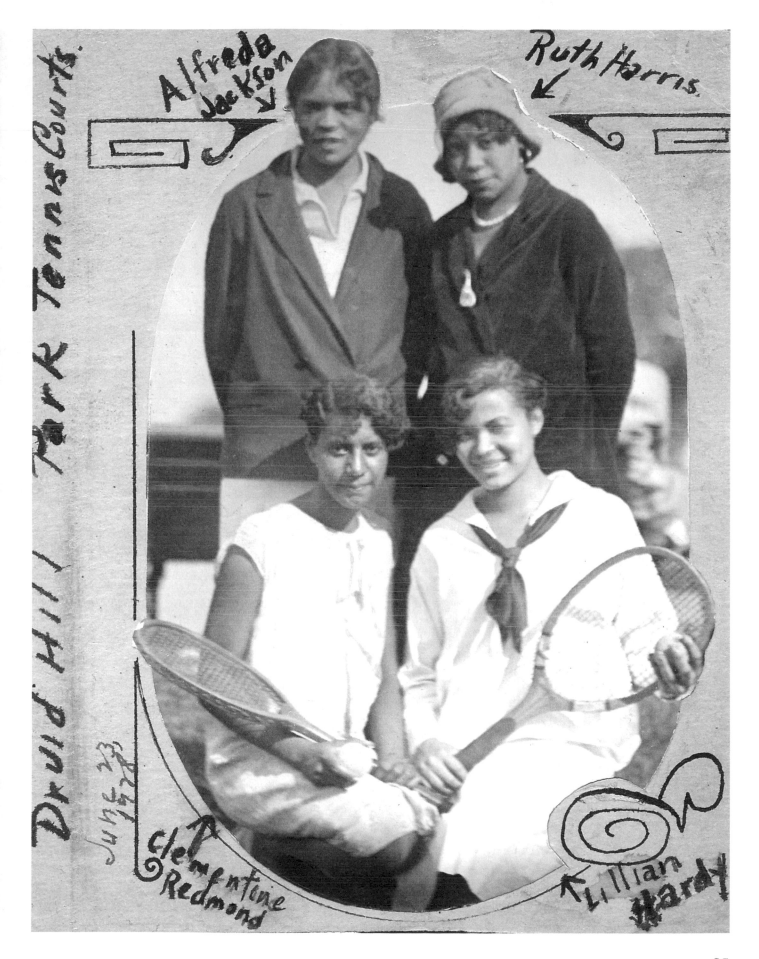

Alfreda Jackson

Ruth Harris.

Druid Hill Park Tennis Courts.

June 23 1922

Clementine Redmond

Lillian Hardy

THE BAKERSFIELD JUNIOR COLLEGE WOMEN'S SWIM TEAM

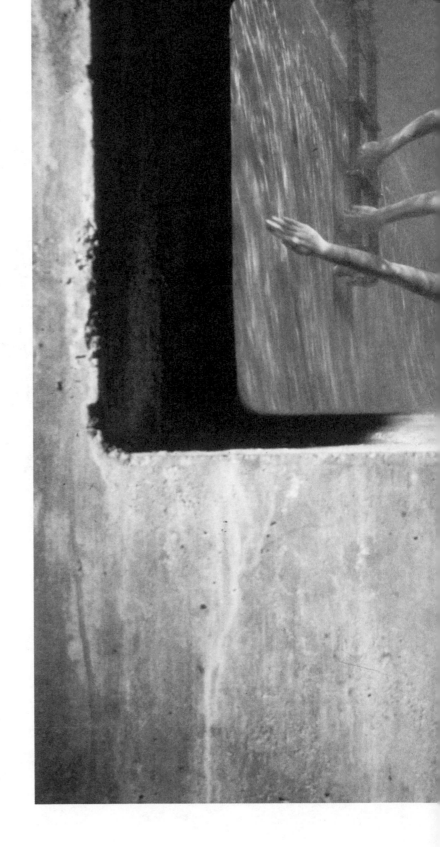

The Bakersfield Junior College Women's Swim Team is instructed by a coach through a poolside window in July 1958, fifteen years before Title IX went into effect and nearly forty years after female swimmers became the first American women to achieve Olympic status, at the 1920 Summer Games in Antwerp, Belgium.

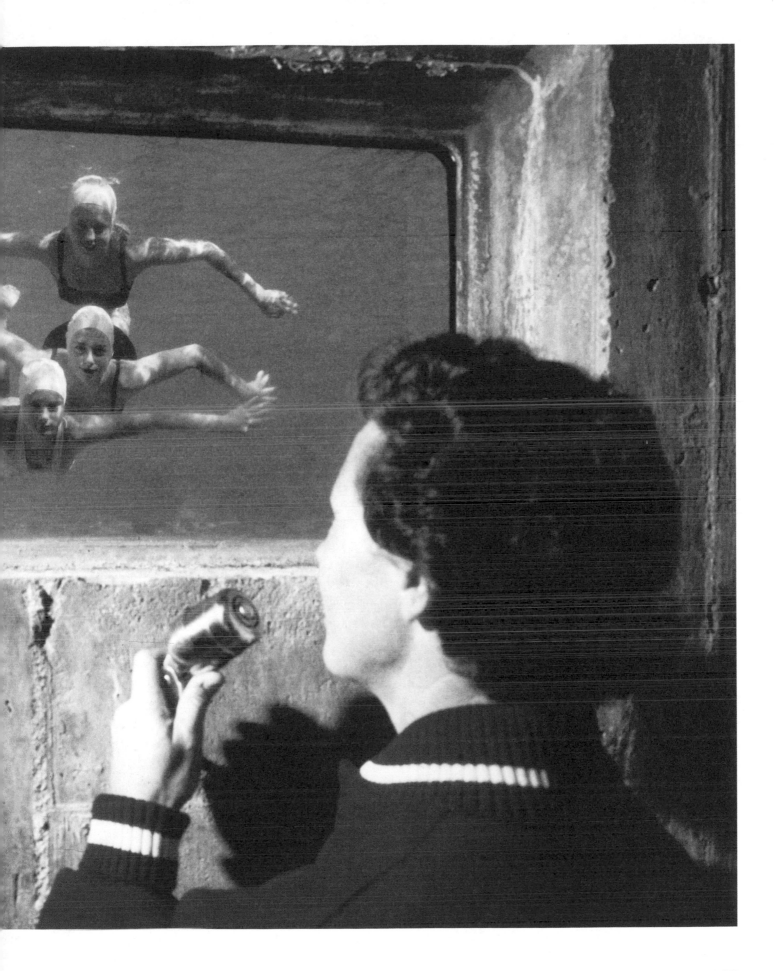

BABE DIDRIKSON ZAHARIAS

American superathlete Babe Didrikson was once asked if there was anything she didn't play. "Yeah. Dolls," she replied.

From an early age, Didrikson, the Texan-born daughter of Norwegian immigrants, decided that her life's ambition was to be the greatest athlete that ever lived. She was consumed by sports and anything she took up, she excelled at: baseball, softball, tennis, billiards, bowling, and diving all came naturally. She was an all-American basketball player, an Olympic track and field gold medalist, and a golf champion who came in first in an astonishing 82 tournaments.

After high school, she took a job as a secretary with the Employers' Casualty Insurance Company of Dallas so that she could play amateur basketball on the company's industrial team, the Golden Cyclones. In 1931, Didrikson led the team to the Amateur Athletic Union (AAU) championships, but it was her turn as an AAU track star that made history. As a one-woman team for Employers' Casualty, she competed in eight events within the span of two and half hours, taking first place in five of them. She won the championship title against the Illinois Women's AC, which had twenty members, by eight points.

In 1932, Didrikson competed in the Los Angeles Olympics, winning two gold medals and one silver. The press nicknamed her the "Iron Woman," the "Amazing Amazon," and "Whatta Gal Didrikson." After the Games, she retired from amateur sports and began playing golf professionally in 1935. She qualified to play among the men in the PGA, the first woman to do so—and the last for nearly six decades. She was an influential founding member of the Ladies Professional Golf Association (LPGA) and dominated the sport from 1935 until the 1950s, when her career was cut short by illness. During her tenure, she won 82 golf tournaments, and every golf title possible in the professional and amateur worlds.

In her lifetime, Didrikson inspired awe and devotion in fans the world over. The sportswriter Grantland Rice wrote, "She is beyond all belief until you see her perform. Then you finally understand that you are looking at the most flawless section of muscle harmony, of complete mental and physical coordination, the world of sport has ever seen." Didrikson was voted Female Athlete of the Year by the wire service six times (once for track, five times for golf), and the Associated Press voted her the Greatest Female Athlete of the first half of the twentieth century. With an outsize personality brimming with bravado and a wardrobe that bucked the more traditional feminine fashion standards of the day, she often received as much criticism for her demeanor as she did for her preference for pants. Though she was married to the wrestler George Zaharias during the last years of her life and took his name, she also lived with fellow golfer Betty Dodd. And while the word *lesbian* was never used, it is known that the two were romantic partners.

In 1953, Didrikson was diagnosed with colon cancer, which would lead to her untimely death at the age of forty-five in 1956. She remains one of the most successful athletes in American history, and was posthumously named the 10th Greatest North American Athlete of the 20th Century by ESPN.

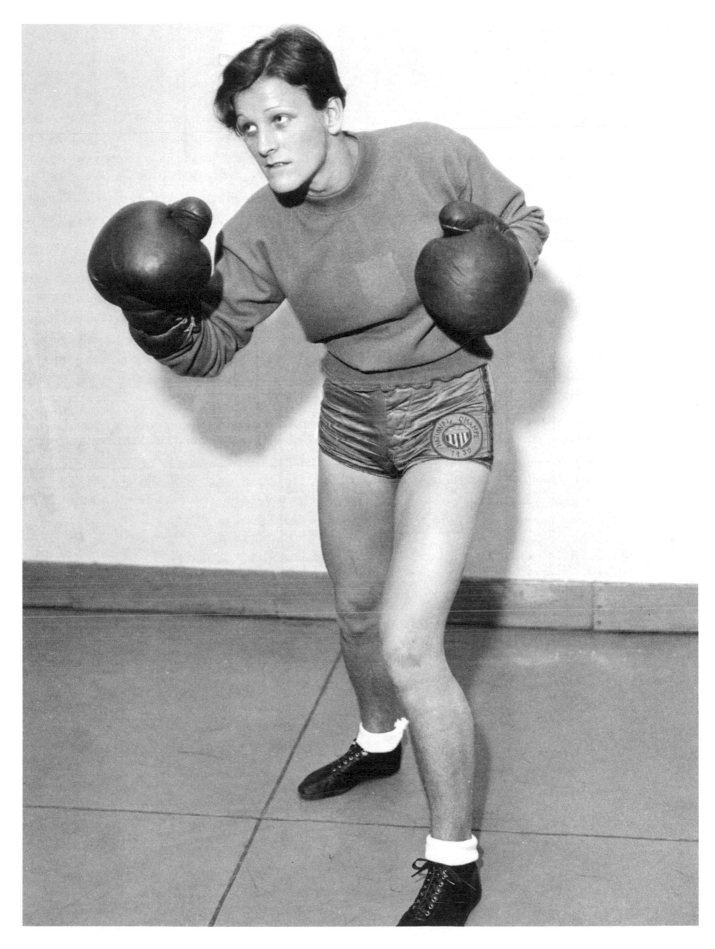

ARLENE BLUM

At the height of the second wave of the feminist movement, mountaineer Arlene Blum boldly declared "A Woman's Place Is On Top . . . Annapurna." More than fifteen thousand people agreed by purchasing T-shirts emblazoned with the cheeky double entendre, generating the bulk of the $80,000 needed to finance Blum's all-female climbing team, and creating a whirlwind of publicity for the American Women's Himalayan Expedition. Annapurna I, the tenth-highest mountain in the world, looms at a treacherous 26,545 feet above sea level in the Himalayas of Nepal. Its peak, considered one of the most dangerous in the world, had only been summited four times previous, and never by an American. Blum sought to change that.

On October 15, 1978, the shirt slogan became more than just hyperbole when four members of Blum's team, Vera Komarkova, Irene Miller, and two Sherpa guides joined her atop Annapurna I. It proved to the entire world that women possessed the physical and mental strength necessary to climb the highest mountains. The win was triumphant, but bittersweet; two days later, Alison Chadwick-Onyszkiewicz and Vera Watson attempted the summit and fell to their deaths. Blum later wrote an account of her experience, *Annapurna: A Woman's Place*, where she offered a detailed account of the women's expedition. "You never conquer a mountain," she wrote. "You stand on the summit a few moments, then the wind blows your footprints away."

After the climb, Blum's historical impact on the world reached beyond the Himalayas and into the world of environmental science. Research she spearheaded in the 1970s discovered two cancer-causing flame retardants that had been widely used in children's pajamas. These findings helped lead to a ban on use of Tris and Fyrol in sleepwear and the pesticide DBCP. Blum is the founder and executive director of the Green Science Policy Institute, whose mission is to facilitate responsible use of chemicals to protect human and ecological health.

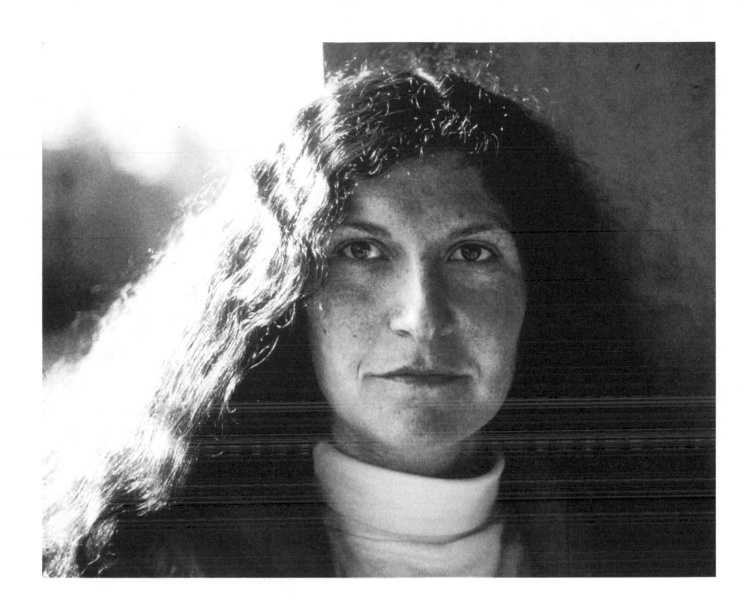

BERNICE GERA

Bernice Gera, the first female umpire in professional baseball, never set out to be a pioneer; she didn't even set out to be an umpire. But her passion for baseball led her to enroll in the Florida Baseball Umpires School, the only woman in a class full of men who welcomed her by spitting tobacco in her shoes and hurling beer bottles at her dorm room door all night. Though she glossed over the negatives when the press asked about her experience, she finally confessed, years after graduating magna cum laude in 1967, that "it was a horrible, lonely experience."

Though she completed her courses and became certified, Gera was rejected by the National Association of Baseball Leagues (NABL), which claimed she didn't meet the physical requirements of the job. Undeterred, Gera fought the decision in court for years, and finally, on June 23, 1972, she stepped on the field to umpire her first game. Sadly, it would also be her last. The match-up was a double-header between the Geneva Senators and the Auburn Twins in upstate New York. The other umpire, a fellow rookie named Doug Hartmayer, refused to share his signals with her (an essential exchange between umpires), let alone acknowledge her presence. Despite the crowd supporting her entertaining and enthusiastic style, Gera felt she'd never be able to succeed without the support of the other umpires and she quit before the second game.

Her husband, Steve Gera, said that his wife had told him, "I could beat them in the courts, but I can't beat them on the field." In an interview with Nora Ephron for the profile "Bernice Gera, First Lady Umpire," she discussed the improbable path that cemented her place in history, summing up how generations of women had felt:

> I have loved, eaten, and lived baseball since I was eight years old. Put yourself in my shoes. Say you loved baseball. If you love horses, you can be a jockey. If you love golf or swimming, look at Babe Didrikson and Gertrude Ederle. These are great people and they had an ability. I had it with baseball. What could I do? I couldn't play. So you write letters, begging for a job, any job, and you keep this up for years and years and years. There had to be a way. So I decided to take up a trade. I decided to take up umpiring.

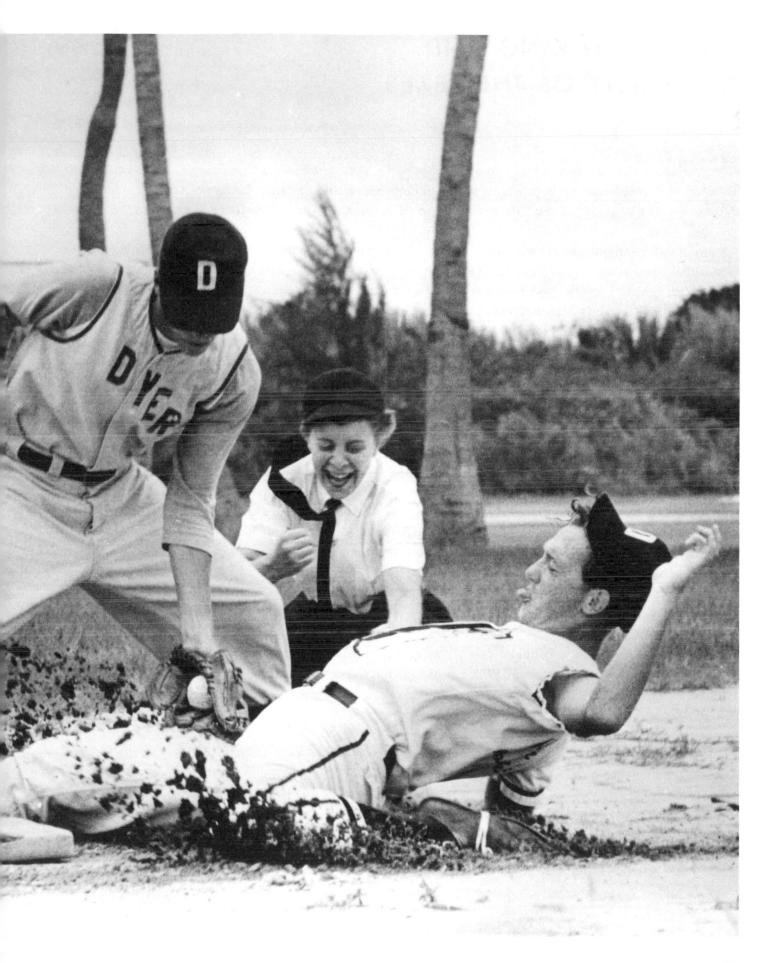

BILLIE JEAN KING AND THE BATTLE OF THE SEXES

With an upturned lip, he called her "the women's libber leader." Fed up with his misogynistic jabs, she curtly labeled him a "creep." This was just the beginning of the media battle that erupted between Bobby Riggs and Billie Jean King during the weeks leading up to the 1973 match that would forever be known as "The Battle of the Sexes."

A known hustler and provocateur who was itching to get back into the spotlight, fifty-five-year-old Riggs loved to taunt and provoke female tennis players, but especially King, and so he challenged her to a match. With ten championship titles already under her belt, King was at the height of her career; Riggs was so sure he'd emerge victorious (despite the fact that it had been thirty-four years since his Wimbledon victory) that he promised to jump off a bridge if he lost. High on his recent victory against top-ranked player (and King rival), Margaret Court, he shot off chauvinistic jabs to the press at lightning speed, claiming to be "the champion of women's tennis" and "a woman specialist." He challenged King to play on "clay, grass, wood, cement, marble, or roller skates," claiming that he would win because "women don't have the emotional stability" to play and that they belonged "in the bedroom and kitchen—in that order." The winner-take-all match was scheduled, with a $100,000 prize—and much more—at stake.

On September 20, 1973, the Houston Astrodome, according to the New York *Daily News*, was "as bizarre a setting as you will see in sports—equal parts of Texas big, Hollywood showbiz, Madison Avenue slick, and Barnum and Bailey madness." A reported 30,492 fans crowded into the stadium and more than 90 million viewers tuned in to watch at home as King entered in an over-the-top display befitting her regal surname. She was carried in like Cleopatra, sitting atop a gold sedan held high in the air by toga-clad members of the Rice University men's track team and outfitted in a specially designed lime-green outfit with sequins across the front, blue suede sneakers on her feet. Riggs entered promptly after her, pulled in on a rickshaw, dressed in a gaudy yellow jacket emblazoned with "Sugar Daddy" and surrounded by barely dressed models he had nicknamed "Bobby's Bosom Buddies." Before the match began, King presented him with a squealing baby pig; he presented her with an extra-large Sugar Daddy lollipop.

On the court, King switched up her usual style of play, opting for a men's tactical approach that was heavy with baseline hits. It exhausted Riggs completely. With a calm and collected demeanor, she defeated him 6–4, 6–3, 6–3. The audience, largely on her side, erupted in cheers. The next day's *Los Angeles Herald Examiner* headline read: "PIGS ARE DEAD . . . LONG LIVE THE KING." The London *Sunday Times* called it "the drop shot and volley heard around the world."

Almost overnight, King became the first superstar female athlete known the world over. In later interviews, she explained that losing was never an option: "I thought it would set us back fifty years if I didn't win that match; it would ruin the women's tour and affect all women's self-esteem." Though she retired with 39 Grand Slam title wins, she recognizes that her win in the Battle of the Sexes will most likely be the defining one of her career.

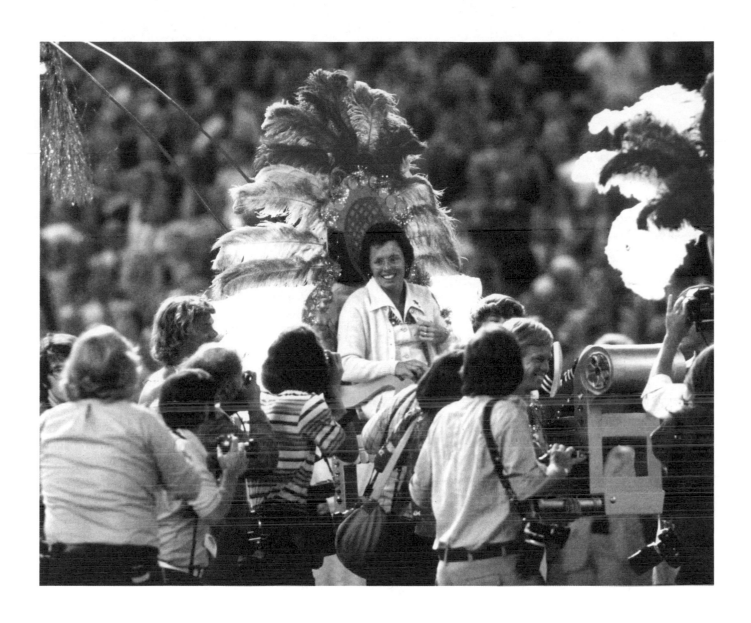

ANNMARIA DE MARS

AnnMaria De Mars was never one for being told what she could and couldn't do. "A lot of people told me a girl from the middle of the United States with only one leg that worked could never be world judo champion," she said. "They were wrong."

Indeed they were. De Mars began practicing judo at the age of twelve at her local YMCA in Alton, Illinois, and by the age of sixteen, she was a national competitor. She started college that same year at Washington University, where her intelligence matched her athletic prowess. She earned her degree in business at age twenty and got her MBA from the University of Minnesota in 1980 at age twenty-two. While studying business, she enrolled in a Japanese exchange program to practice judo under Sensei Osawa. After graduating from college, De Mars went on to win the U.S. Senior Nationals, U.S. Collegiate Nationals, and U.S. Open in the sport. She left competitive judo and went on to earn an MBA, but came out of retirement in 1984 to become the first American to win the World Judo Championships.

After retiring, De Mars went on to earn an MA and PhD in educational psychology, and balanced careers in teaching (from eighth-grade math to doctorate-level statistics) and IT consulting with motherhood. In 2001, she founded Spirit Lake Consulting, a company that improves life on Indian reservations and in disadvantaged communities. She is the founder and CEO of 7 Generation Games, a company that creates video games that combine math, Native American history, and adventure gaming, and continues to teach judo to middle school students in California. One student, in particular, has risen to—and possibly surpassed—De Mars's level of achievement: her daughter, Ronda Rousey.

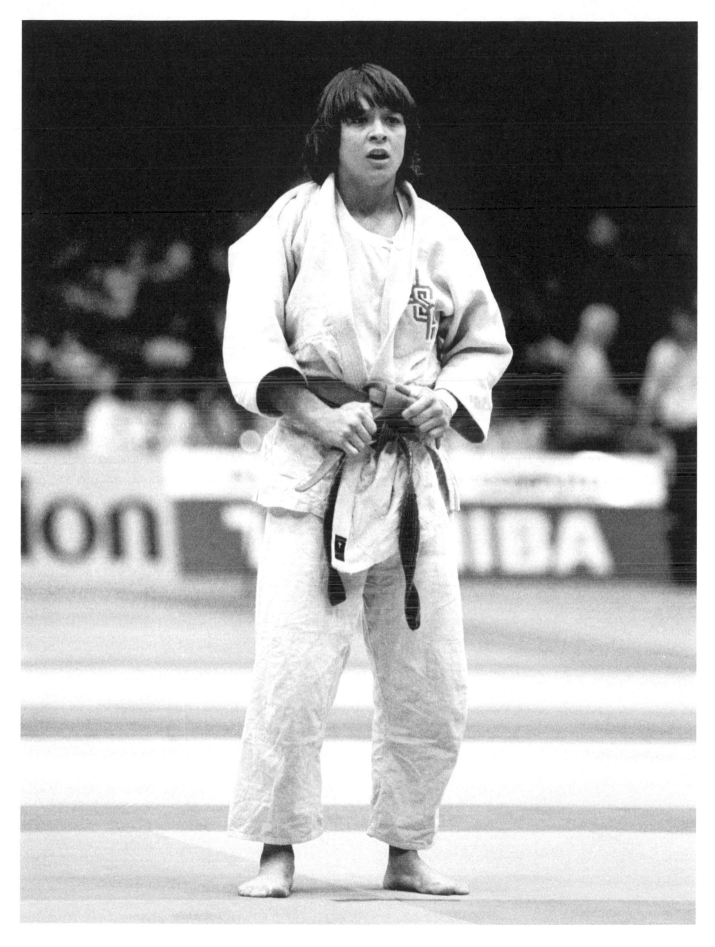

ANDREA JAEGER

Before she was old enough to drink, vote, or drive, Andrea Jaeger was seeded at Wimbledon. At fifteen years old, she was the youngest player ever to enter the tennis match. In 1980, she stunned the world again when she made it to the singles semifinals at the U.S. Open. A year later, she won the French Open in mixed doubles and went on to reach the singles semifinals of the Australian Open and the singles finals of the French Open in 1982. In 1983, she defeated six-time Wimbledon singles champion Billie Jean King, 6-1, 6-1, in a semifinal match that marked King's last career singles match at Wimbledon and her harshest defeat ever at the tournament. Jaeger lost the final to Martina Navratilova, but her defeat had a bright side: she was officially the second-best women's tennis player in the world.

It seemed nothing could stop her—until the 1985 French Open when, in a shocking moment, she dislocated her shoulder on the court. After two years and seven surgeries, she was forced to retire at the age of nineteen. To many, the decision was viewed as a classic case of burnout. Trained by a forceful father, a former boxer who she later said was more of a coach than a parent, Jaeger had spent most of her life on the court running drills and competing. Though the Women's Tennis Association used her as an example when arguing for eligibility restrictions to prevent overexposing teenagers to the professional tour circuit, Jaeger maintained that the end of her career was brought on only by physical circumstance. Her problems stemmed not from exhaustion, she said, but an unfortunate injury and a genetic disposition to foot pain.

In retrospect, it seems that Jaeger's injuries were a blessing in disguise; despite her statistical successes, her life was often painful and socially isolating. The second chapter of her life, however, led to a powerful and unpredictable higher calling. She went to college, earning a degree in theology, and upon graduation, used the upwards of $1 million she'd earned in prize money to start the Silver Lining Foundation, a charitable organization to serve children with serious and terminal illnesses. Her passion for the cause had developed while she was still on the professional circuit, when she would visit children's hospitals between games in order to relieve the loneliness she felt from being one of the youngest players within her sport.

In 2006, Jaeger was ordained as a Dominican nun in the Episcopal Church. She left the order in 2009 but continues to thrive as a philanthropist and activist. She has since established the Little Star Foundation in Hesperus, Colorado, which helps more than four thousand children annually.

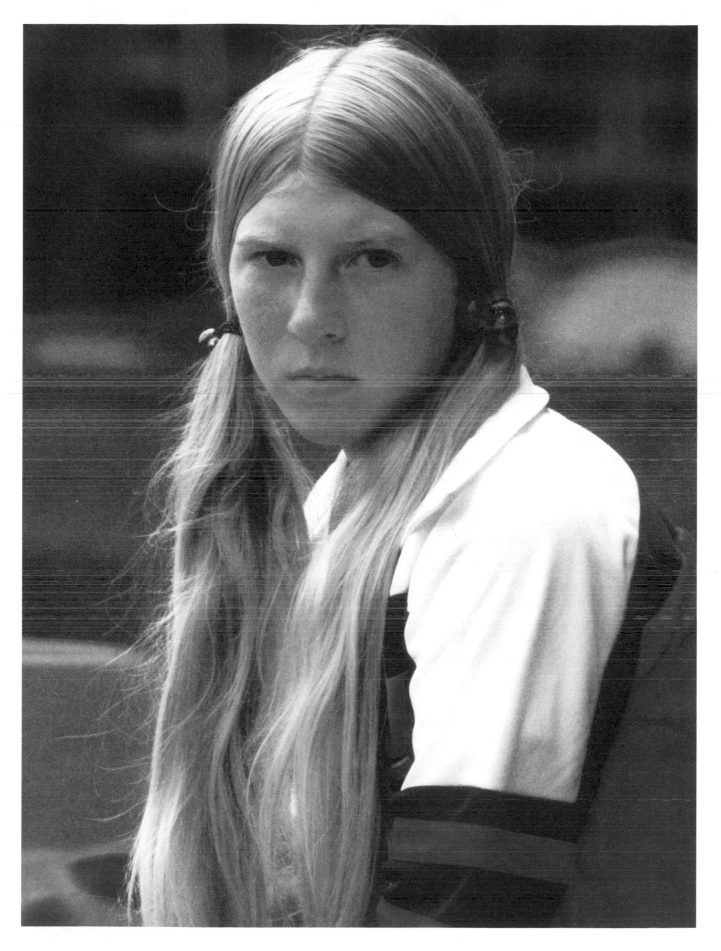

BARBARA POLK WASHBURN

The view all around was truly the way I imagined heaven to be when I was a little girl. . . . The wind was gusting to thirty miles an hour and the temperature was twenty degrees below zero. . . . Before me lay 100,000 square miles of Alaska. Snow-covered mountains and terrain stretched to the horizon in a view that left me breathless. . . . There were no windows, no buffers between my body and the cold. . . . I kept telling myself I must keep my head clear and be prepared for the difficulty of the descent. I had to get home to Massachusetts and our three young children.

—Barbara Polk Washburn, *The Accidental Adventurer: Memoirs of the First Woman to Climb Mount McKinley*

Barbara Polk Washburn's career as a pioneering mountaineer was, by her own admission, accidental. After a job interview with Bradford Washburn, the newly appointed head of the Boston Museum of Science, she found that she had zero interest working in a museum. She was also particularly put off by the fact that her potential boss was a "crazy" mountain climber, but after two weeks of persistent calling and convincing, she accepted a job as his personal secretary. One year later, they were engaged. In her 2001 memoir she recalled, "I sometimes wonder why I didn't question him then about what kind of life he expected me to lead. . . . But I didn't ask, and he didn't bring up the subject. He must have already gotten a glimpse into my sense of adventure."

A few months after their wedding, the Washburns climbed Mount Bertha, a 10,000-foot peak near the Alaskan coast. In the summer of 1941, just a few months after Barbara gave birth to the couple's first child, they were part of the first team ever recorded to ascend 13,832-foot Mount Hayes. In 1947, Bradford was asked to re-summit Mount McKinley (which he had first done in 1942), this time with a film crew from RKO Radio Pictures in tow. The purpose of the resulting movie would be to encourage the growth and interest in the sport of mountaineering. Both Bradford and the studio production team felt it would be an attention-grabbing novelty to have his wife come along. At this point she was a mother to three children, and extremely reluctant to go, but she ultimately decided to participate, making history as the first woman to ever climb Mount McKinley (also known as "Denali"), the highest peak in North America. Leaving her children for the three-month trip, she later said, was one of the hardest decisions of her life. She famously wrote that she trained to climb Denali by "push[ing] a baby carriage."

Over the next few decades, Washburn and her husband continued to spend their summers climbing and traversing the world's peaks. During the fall and winter, she worked at the Shady Hill School in Cambridge, Massachusetts, as a reading specialist and proponent of rights and programs for the learning disabled. The couple worked together to create topographical maps of the Grand Canyon, Mount McKinley, and the White Mountains of New Hampshire, and were part of a team that created what is still the most detailed and analytical map of Mount Everest. Washburn died in 2014, just a few weeks shy of her one hundredth birthday.

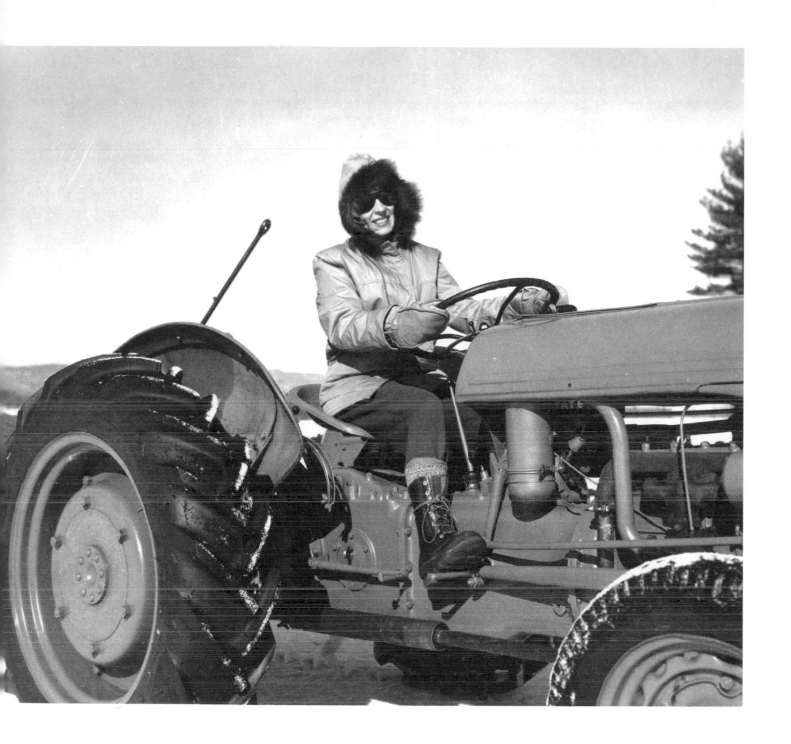

ANN KOGER

Tennis and the pursuit of equal rights seem to have been embedded in Ann Koger's DNA. She learned to play tennis on the segregated Colored Tennis Courts in Baltimore's Druid Hill Park, one of the country's oldest public parks. In 1948, twenty-four black, white, and Jewish tennis players were arrested for challenging the whites-only access policy, a protest in which Ann's mother, Myrtle Leary Thompson Koger, an active member of the Baltimore Tennis Club and cofounder of the Netmen Coed Tennis Club, played an integral part. It led to the courts' eventual integration. "As far as I remember, my mother and father never made an issue out of race to us kids," Koger later said. "They would just say something like, 'Oh, you'll find out later.'"

Koger attended Morgan State University, excelling in several sports, including volleyball, field hockey, basketball, and softball, though tennis remained her first love. She and her equally accomplished friend, Bonnie Logan, played for the university's men's team, advancing to the Central Intercollegiate Athletic Association finals one year. "It got to where no one wanted to play Morgan," she said. "After that, the league took a vote and did not allow us to play anymore. It sounds unbelievable, but it really happened."

After graduating, Koger became one of the first African-American women to compete on the Virginia Slims Circuit, a precursor to the Women's Tennis Association, founded by Billie Jean King in 1973. During a tournament in Boca Raton, Florida, she was shocked to see that where they were flying all the flags representing the participants' countries, a Confederate flag was flapping in the wind, instead of an American one. "I was like, 'What are we—chopped liver?'" she recalled. In protest, she scaled one of the poles that supported a Confederate flag and tore it down. When she returned to the venue the next day, the rest of them had been taken down. Koger wore American-flag knee socks the rest of that tournament.

Decades later, as head coach of the Haverford College women's tennis team, Koger's student-athletes got a taste of her passion when she refused to take the team to spring break matches in Hilton Head, South Carolina. "It's not just that the Confederate flag is a symbol of racial discrimination, but also a symbol of a divided country that needs to heal itself," she said. "You can't have the symbol of divisiveness floating around if this country wants to heal itself. That's why I was protesting." In 2010, Koger added "Presidential appointee to the USTA Executive Committee" to the long list of honors she has received. She continues to coach at Haverford, where she has led the team to an all-time record of 359–241.

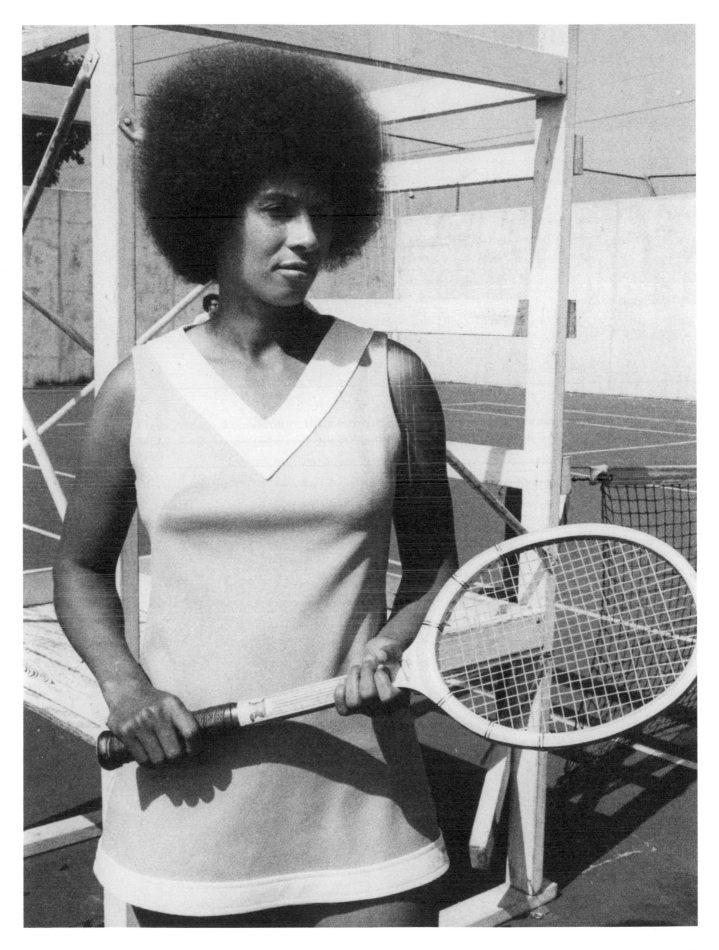

BETTY ROBINSON

When sixteen-year-old Betty Robinson competed in her sixth track and field competition, she clinched an Olympic gold medal, the first woman in history to do so in the sport. Astonishing and odds-defying events would continue to define the runner's life, seemingly stolen from the pages of a Hollywood script.

In 1925, Robinson, a suburban schoolgirl, ran to catch a train in her hometown of Harvey, Illinois, with such speed that legend says she actually *outran* it. Her biology teacher, a passenger on the train, was shocked by her speed and asked if he could time her running a 50-yard dash through the school's hallway. Three years later, at the Olympic Games in Amsterdam, Robinson became the first woman to win a gold medal in track and field. Wearing a skirt and a vest, she won the 100m race in 12.2 seconds, breaking the world record.

On June 28, 1931, Robinson and her cousin, a pilot, boarded a small biplane. At around 600 feet, the engine stalled and the plane crashed. A passerby pulled an unconscious Robinson from the debris. Believing her to be dead, he wrapped her in a blanket, placed her in the trunk of his car, and drove her to an undertaker, where it was discovered that she was still alive. She was immediately hospitalized, where she drifted in and out of consciousness for eleven weeks. One of the newspaper headlines read, "Girl Runner Will Never Race Again."

As she healed from her injuries, Robinson remained in a wheelchair. Though one of her legs was now a half inch shorter than the other, she was determined to get up and run again. Since she was no longer able to bend her knee to crouch on the starting blocks in races, she found another event to compete in—relay—and, unbelievably, made the 1936 Olympic team. When their German opponents were disqualified for fumbling their baton pass before the last handoff, the Americans took first place. In an astonishing and awe-inspiring comeback, Robinson took home her second gold medal.

Robinson retired after the Berlin Olympics, becoming a timer and judge at track meets, in addition to traveling the country speaking on behalf of the Women's Athletic Association and the Girl's Athletic Association. She passed away in 1999.

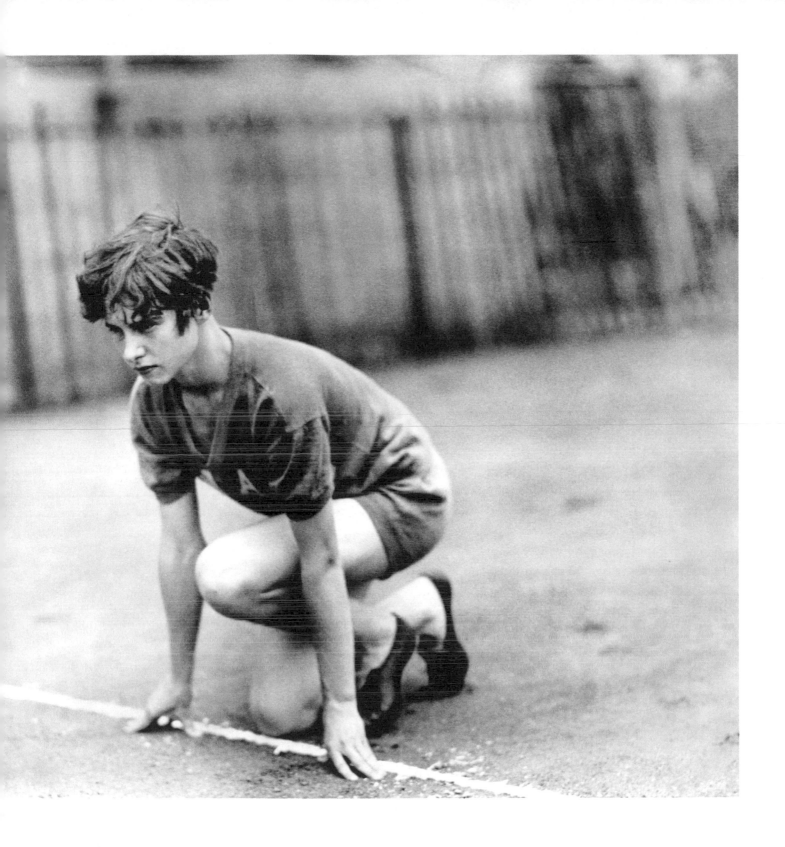

BRIANA SCURRY

Briana Scurry holds the record for the second-most international appearances for a female soccer goalkeeper, as a member of the U.S. women's national soccer team between 1994 and 2008. Her first appearance on the team resulted in a shutout, solidifying her role as the starting goalkeeper for two World Cups and three Olympics. She played every minute in the 1999 World Cup—the most-attended women's sporting event in history—where the United States took home the trophy, and every minute in the 1996 Summer Olympics in Atlanta, where her team won gold. Scurry conceded only three goals at either event. In 2001, as a player on the Atlanta Beat, she became a founding member of the Women's United Soccer Association, the first women's soccer league in the world to pay all its players as professionals.

BERNICE SANDLER

"You come on too strong for a woman." This single statement from a colleague sparked a fire within the heart of Bernice Sandler, and put her on the path toward becoming a trailblazer for equality. It was the reason given for why she had not been considered for one of the seven open teaching positions at the University of Maryland, where she had just received her doctorate. The thought that her personality and gender could stop her from having a career almost destroyed her, but when her then-husband pointed out that the decision was discriminatory, Sandler felt her feminist consciousness awaken.

It was 1969 and the term "sexism" barely existed. Sandler began to research laws and precedents to support her case, but could not find anything. Finally, in a footnote to a regulation on federal contracts, she found what she was looking for: a ban on discrimination based on sex in federal employment. Now she could fight for equality with the law on her side.

Sandler went on to serve as the chair of the Action Committee for Federal Contract Compliance of the Women's Equity Action League from 1969 to 1971, and using the footnote, was able to file sex discrimination charges against 250 educational institutions. She testified and played a major role in hearings headed by Representative Edith Green that focused on women's rights. The hearings produced significant evidence of gender discrimination in education and employment, and resulted in the historic Title IX ruling. Because of her determination, gender discrimination in federally funded programs was now illegal. Fortunately for countless future generations of athletes, this included sports.

Since the passage of Title IX in 1972, female participation in high school sports has risen 970 percent. Sandler was called the "Godmother of Title IX" by the *New York Times*, and has continued to tirelessly pursue equality for women. She has written extensively on sexual harassment, and with the help of her staff, coined the term "gang rape." According to Sandler, "Sex prejudice is so ingrained in our society that many who practice it are simply unaware that they are hurting women. It is the last socially acceptable prejudice."

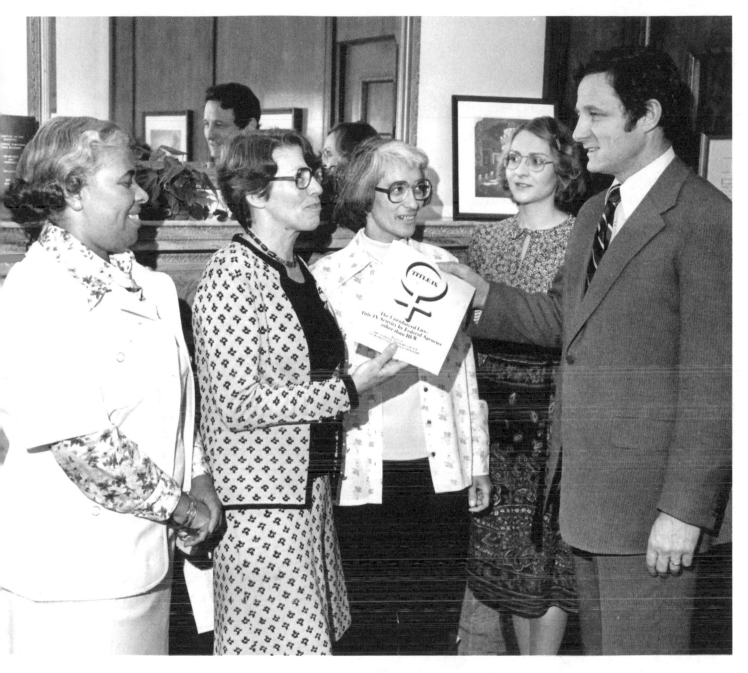

Left to right: Marguerite Seldon, Mary Beth Peters, Bernice "Bunny" Sandler, Nanny Bales, and Senator Birch Bayh

"Bunny turned around to me . . . and said, 'Margaret, athletics is going to become important. Figure it out.'"

Former captain of the U.S. Women's National Soccer Team, **ABBY WAMBACH**, speaks with **MARGARET DUNKLE**, the first Chair of the National Coalition for Women and Girls in Education, about Title IX and equal opportunity.

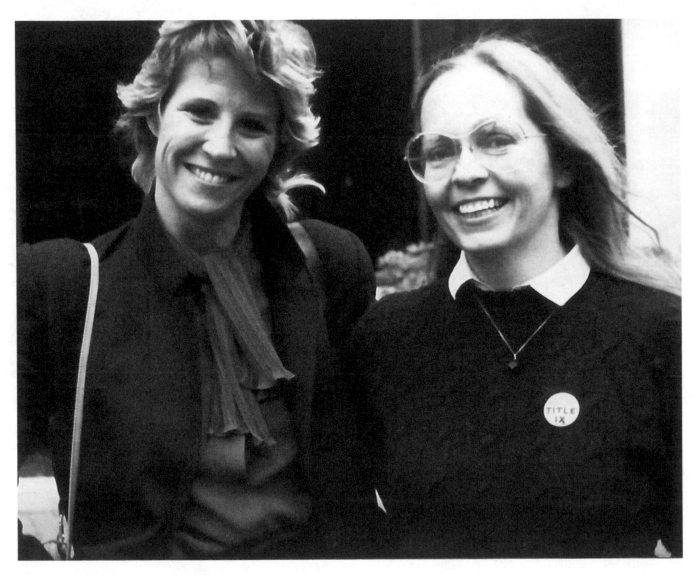

Donna de Verona (left) and Margaret Dunkle (right)

ABBY WAMBACH: So here we are. Margaret, this is such an amazing opportunity, obviously not just for me, but for everybody reading this because nobody really knows the true story. Truth be told, doing research on this for myself has been eye-opening. You're such a great woman. I feel so fortunate and pleased to be able to talk to you.

MARGARET DUNKLE: It goes both ways! When I see you and your accomplishments, I say, "This is one of the things we were working for." When you're on TV, when young girls look at you as the leader of tomorrow, that's what it is all about, so thank *you*.

AW: It's pretty amazing how you guys really did change the face of women's sports, by creating Title IX. What was life like before Title IX? What was it like for you to make you put something into policy that legislates rights for women?

MD: One of the things that is really amazing is that when Title IX passed, it was not passed solely for women in sports. It was passed because women were kept out of medical school, they were kept out of law school, they were even not admitted to undergraduate programs. Let me give you a little riddle. It's from the 1970s, and it goes like this: A father and his son are in a bad car accident. The father dies instantly. The ambulance takes the son to the hospital. The surgeon on call takes one look at the boy and says, "I can't operate on him. He's my son." The question was, *who's the surgeon*? Years ago, most people would be stumped by this riddle. Why? Because it simply did not occur to them that a woman, much less a mother, could be the surgeon.

We were figuring it out as we went along back then, and little did we dream of how far we would come. We knew how some of the challenges would be in the same areas, but not that they would be so different. In the 1960s, 1970s, maybe there was no girls' soccer team but there was also no playing field. And now there is. Women get the AstroTurf. It was only after Title IX was enacted that people said, "Oh my gosh, sports is going to be the tail that wags the Title IX dog."

AW: What a fascinating thought, because as I sit here thinking that when people hear the phrase "Title IX," they immediately think sports, athletics. It's so amazing that your whole reason for this venture before it became enacted is not, in my opinion, where we've had the most benefits. Forty years later, here I am. And as you look at the generational impact and the by-products of Title IX, sports might in fact be helping the most with executive-level positions and things that maybe you guys never even could consider being a possibility, like a women being a CEO of a massive Fortune 500 company.

MD: That's exactly right. The women who participate in athletics learn how to be competitive. They learn how to win and lose with energy and grace. When I was a teenager, we moved to a new high school. At about that same time, they stopped all intercollegiate athletics for women because they started football for the boys. There was no uproar. There was no, "Oh my gosh, this is awful." That was just the way it was. One of the things that's so important is that young women not take this for granted. Title IX is not in the Constitution, but it's in the hearts and minds of moms and dads all over the country. It is the law, but it can be enforced or not enforced, and it can be taken seriously or not taken seriously. There are a number of challenges that we still have today, in addition to outright exclusion.

AW: What you're saying is that we can't stop. We need to continue fighting for the rights of women, not just from an athletic perspective but across the board. In my opinion, it's no longer the feel-good thing to do to invest in women, and their rights; it's actually now being proven by research that it's the *smart* thing to do to give people straight-up equality and the same kind of love, respect, [and] kindness that any other human on the planet deserves. Can you tell me from Title IX, from idea to execution, how did that happen, the evolution of it all?

MD: What happened was Representative Edith Green, who was one of the few female members of Congress back then, chaired a subcommittee on the Education and Labor Committee on Higher Education and held

hearings on sex discrimination against women. Bunny Sandler staffed those hearings and put together a massive record documenting mostly sex discrimination in employment. Congress was at this point considering reauthorization of the higher education bill. Representative Green put in the bill—which then became Title IX, the law—that no person in the United States could on the basis of sex be excluded from participation and denied the benefits of programs and activities in any educational institution.

This was modeled on Title VI of the 1964 Civil Rights Act, which prohibited discrimination in programs and activities for African-Americans and other minorities. There was a model there for Title IX, but quite frankly, when Title IX passed, it did not gain a lot of attention. In fact, the lobbyist for the American Council on Education, the big conglomerate of education associations, said that he didn't even need to testify at the hearings being held in 1971, because there was no discrimination against women in higher education.

AW: What a joke. What a *joke*. Back then, people may not know now, but the terms "sexism," "sexual discrimination," and "sex discrimination" were virtually nonexistent. Everybody back then innately just believed that men were superior, and that was just the way it was. You guys were the strength and the brains, and had the heart and the minds to push this legislation through. I just think it's really courageous of you all.

Speaking of investigations into sex discrimination in collegiate athletics, I would like to hear more on that because for me, that obviously played a massive role not just in my career, but in who I am and who I have become as a human being. Could you talk about that part of it?

MD: Yes. It's hard to say you have a problem with something if you can't name it, if you can't describe it. What happened in the early 1970s right after Title IX became the law is that Bunny turned around to me as the new staff person of the Project on the Status and Education of Women and said, "Margaret, athletics is going to become important. Figure it out." Now, I had not been an athlete, and I'm still not the world's best athlete. In fact, I think the pinnacle of my athletic career was when I was in about

second grade playing badminton on our front yard. I tackled this like a civil rights problem. There was no study that looked at and identified all the different ways that athletic programs could discriminate against women.

I started looking every place I could. I called people up—this was 1972, we didn't have the Internet. We felt we were lucky because we had electric typewriters! We would get a news article from a college, or a blurb on page thirty-five of a two-hundred-page report, and we started to put together a taxonomy of what the issues might be.

AW: Who were all the women involved in terms of Title IX and getting it from the idea to the execution?

MD: Actually, it was a relatively small group that was involved both before and in the early years after Title IX. Then, after Title IX was signed into law by President Nixon, a couple of organizations started to take the lead. One of those was Bunny's Project on the Status and Education of Women at the Association of American Colleges. Another was a group working out of what's now the Legal Defense and Education Fund called PEER, the Project on Equal Education Rights. The Association for Intercollegiate Athletics for women became involved as they realized that sports was going to become an issue. There was a brilliant attorney that represented them, Margaret Polivy, who knew her way around Capitol Hill and was an incredible help there. Then we pulled in some of the less likely partners like the American Council on Education, which was the umbrella organization for all the education associations. When we started meeting and became a national coalition for women and girls in education to get the Title IX regulation through, we met in their conference rooms time and time and time again.

At the same time, the Women's Legal Defense Fund, which would become a national partnership for women and families, was just getting started with director Judy Lichtman. The National Women's Law Center was also just beginning with Marcia Greenberger. It was a critical moment, a combination of some new organizations that were pulling in women in education institutions and education associations across the whole spectrum, elementary, secondary, and postsecondary.

AW: It seems like a small group of women got the ball rolling, and then once it went into legislation, it's like all these other women's groups and affiliations thought, "Wow, this could be something big." Fast-forwarding thirty-five years, it's got to be an amazing thing to see the progress that has resulted from that small group of smart, educated, powerful, strong, courageous women putting this into motion. It must really feel like you did change the world, because you did.

MD: It feels amazing when you see how women today are in positions of influence and power. When Title IX was passed in 1972, 3 percent of the members of Congress were women. That was 17 out of 535. Today, it is 104 women. Now, that's still less than 20 percent, but it sure is a lot more than 3 percent, so incredible progress has been made. It is gratifying to see you and the next generation, metaphorically and literally, carry the ball.

AW: That's very cool. Keeping the ball rolling forward, that's what I like to think I've metaphorically and literally been doing for the last thirty years of my life. How is Title IX regulated today, and what can I do to keep it strong?

MD: Title IX the law went into effect in 1972. Then, responsibility for enforcing Title IX and developing the regulations—so people and institutions would know what was okay and what wasn't okay—went to the Office of Civil Rights. Initially, that was in the Department of Health, Education, and Welfare. Then, a few years later, the Department of Education was formed. It moved there, but it remained the job of the Office of Civil Rights to figure out how to enforce the law. They came up with the regulation, but then there was this quirky little provision in education law at that time that said if Congress didn't like a regulation, they could disapprove it.

This was the second battle we had to fight. There were hearings, and by that point, people had caught on that one of the issues Title IX would affect would be sports, so there were hearings around sports as well. The traditional women's organizations—the New York Association of University Women, Business Profes-

sional Women, the League of Women Voters—who had branches or chapters in many, many congressional districts, were enlisted to support Title IX against congressional disapproval. Those groups, and Senator [John] Tower of Texas, worked really closely together to beat the assault on the Title IX regulations. In fact, the AAUW, American Association of University Women, lobby corps was initially formed to lobby on behalf of a strong Title IX regulation back in the early 1970s. They still exist today, lobbying a whole bunch of different issues.

AW: That's very cool. See, I want to do that, to fix where I see problems like you guys did in the seventies. I want to figure out how we can change the patterns of women in powerful roles. Where I see the biggest problem is women in executive positions and decision-making positions. How can we impact and get more equality across the board between not just men and women, but people of all different races, backgrounds, orientations, and whatnot?

MD: One thing is you need information and you need data to find what the problem is. Then, you need to name it. The problem is that still in Congress fewer than 20 percent of the members of Congress are female. We have yet to have a female president. Many states have never had a female governor. The superintendency of many school systems is still regarded as being a male rather than an equal-opportunity position, going to whomever is the most qualified. You need to get the data, identify it, and label it, so people know what they're talking about, and it's not some fuzzy idea. Then, use it to make the story. Very few people are really convinced by data, but if you have the data to know which areas to focus on, then you can find the stories that make the issues and perhaps the solutions more apparent and more engaging. You start to engage fathers as well as mothers, boys as well as girls.

AW: There have been times throughout my career that I've gotten an endorsement deal or an appearance for a company, and the person who signs off on it says they have a daughter. For a long time I thought, "Wow, this is pretty cool." Then, one of my teammates, Megan Rapinoe, said, "You know what? That really irks me." I

looked at her and said, "Why?" She said, "We're one of the best teams in the world. We are like a solid, unified front, people love us, people know who we are. Why should we be getting these appearances to do things because these CEOs are male and they have daughters?" I thought, *That's a really great answer.* I said, "Because those CEOs' daughters are going to grow up to be CEOs, and they want their girls to have us as role models." How do we keep moving forward? You've got to name it, you've got to have the research behind it, so it's not too fluffy.

MD: You need the story to make it really touch people's heart[s].

AW: The story is so important. Everybody can relate to good stories on some level in one way or another.

MD: That's right. You're a good story, Abby.

AW: You think so?

MD: You're a great story, Abby. You've earned your success. And, let's face it, you are truly exceptional. But we'll have real equality when a female schlemiel can go just as far and just as fast as a male schlemiel.

AW: I'm going to use that. Can I quote you on that in my future talks?

MD: Absolutely.

AW: What a heck of a statement. What were the emotions of it when you were going through the creation of Title IX? Were you scared? Were you excited? Did you enjoy it all? Did you feel empowered at the time or was that a process? I feel empowered because this legislation developed me, and I'm a by-product of it, but that's because of the hard work you guys went through.

MD: All of the feelings you said and more. One of the things that was truly extraordinary was that there was a handful of women in Washington who were figuring this out together and using whatever avenues we had available to try to go toward the common goal of getting a

Title IX regulation that was really worth all the trouble. There was *incredible* camaraderie. There was sheer exhaustion. There was a lot of laughter, and eventually there was a real sense of success having gotten a strong result. Then, moving to the next arena of, how do you make sure that the law gets enforced and that colleges and schools know what they can and can't do, so they will do it voluntarily? There was a sense of plowing a field that had never been plowed before, and identifying a goal of getting equal educational opportunities for women and girls that we were really labeling for the first time. We were flying the plane as we were building it, and it turned out to be a pretty sturdy plane. It's really stood the test of time. It'll be forty years now since the regulation.

AW: The president of our country just called our World Cup championship team "badasses." We're redefining what it means to play like a girl. For our president to say that means so much, but I bet there's so many people out there that have similar feelings but they don't even know where to start. What advice could you give those people?

MD: You start with your local school. You take a look at what doesn't seem right or what doesn't seem fair, and then you become the squeaky wheel. You become educated about what your rights really are. Look at STEM: science, technology, engineering, and math. Where I live, in many of the courses and programs in the schools that lead to the best jobs, they're very underrepresented in terms of the number of women or the number of African-Americans. You might want to take a look at STEM and say, "Hey, wait a minute, these young girls were doing just dandy in terms of math and science in first, second, third, fourth, fifth grade. Why are they all doing something else when they reach junior high school? What can we do to empower them and their parents to make these courses really welcoming to them?"

AW: I have one final question, and I hope you have enough time for me. In the thirty-five-plus years since the institution of Title IX, there has been a marked difference in participation, but do you think that there has been a difference in the attitude and perception of women in sports and even beyond not just sports?

MD: I think there's been a huge change, and you really need to look at how much progress has been made. For example, in 1972 people would say, "Abby who? Do you mean Abner?" Now they know it's a woman, that it's Abby Wambach. It's a totally different world. Back when Title IX became law, the president of Harvard in 1972, Nathan Pusey, had just been on the cover of *Time* magazine, and the draft was being enacted because of the war in Vietnam. When he was asked what the effect of the draft meant for Harvard's graduate programs, his reply was—and this is a direct quote— "We shall be left with the blind, the lame, and women."

AW: Woah.

MD: Today the president of Harvard is a woman, and that's a very dramatic example of how much progress we have made.

AW: That's so amazing. There are few people on this planet that I get giddy and excited to talk to. Margaret, you are exceptional, and there're so few people in the world that do things nowadays without wanting any recognition in return. I just think that the value in that is beyond amazing, and I want to keep telling your story. I'm so inspired talking to you and hearing you speak and I love how smart you are and how passionate you still are about this topic. For you to have taken that leap of faith for something that wasn't really in existence, do it for people that you will never meet. . . . I think it's so important that people know that while the fight's been happening for years, in some ways, in some industries, it's just begun. I just hope you know that you are passing on the baton to strong, powerful women that also value the same things that you do and that your work was not in vain and it will continue to move forward.

I'm starstruck talking to you. We are so grateful for everything. I mean, I'm sitting on the beach in California right now talking to you because you guys gave me an opportunity to have the chance to be on a beach in California. I just want to thank you so much. I love you. •

CAROL ROSE
AND
THERESA SAMS

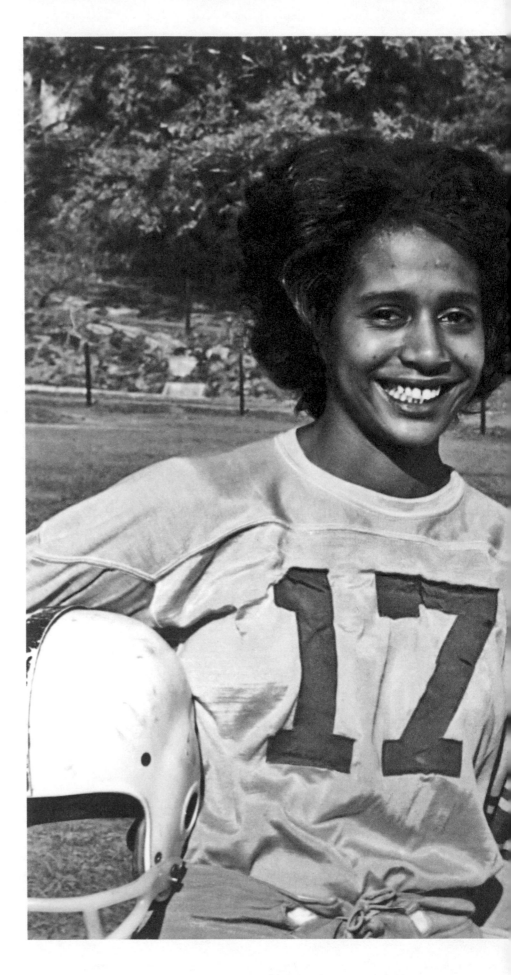

Carol Rose and Theresa Sams, students at the Tuskegee Institute, participate in their school's 1960 Powder Bowl Classic, an annual benefit of the United Negro College Fund, with male student cheerleaders and majorettes performing at halftime.

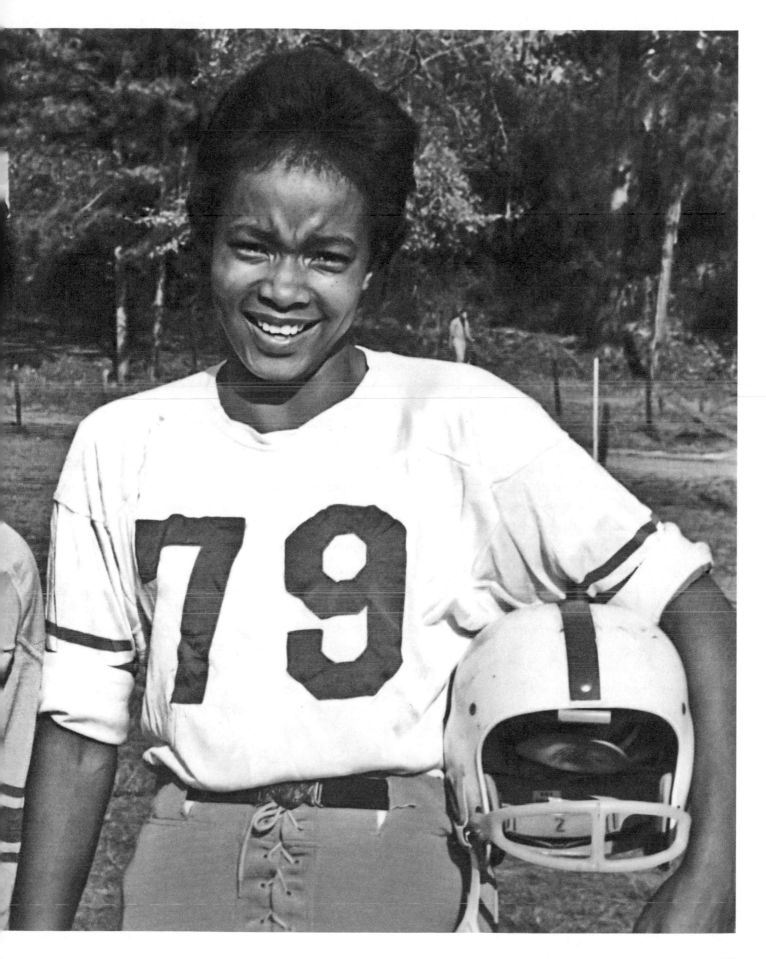

CHRISTY MARTIN

Christy Martin's (née Salter) career as one of the most successful and prominent female boxers in the United States began on a dare. In 1987, while she was still a freshman at Concord College in her native West Virginia, some teammates from her basketball team challenged her to enter a local Toughwoman competition. Though she had never laced up a pair of gloves in her life, she agreed. She faced off against three women who could not have been more different from her; Martin was decidedly feminine, physically fit, while the opponents were "the manly type, smoking and drinking right up to their bouts," according to Richard Hoffer at *Sports Illustrated.* Leaning on her athletic skills and instincts, Martin defeated all three contenders, collecting the night's thousand-dollar purse. For the next two years, she entered that same contest, winning each time. Word spread, and soon after she received a call from Larry Carrier, a promoter in nearby Bristol who needed a woman to go against one of his female fighters. The match ended in a draw. Martin agreed to a rematch, and won. After, that her taste for victory became insatiable.

In 1990, Martin was sent to gym owner and trainer Jim Martin. In an interview with *Sports Illustrated,* Jim admitted that though he agreed to take her on, he had no real intention of training a female boxer. His plan was to teach her a lesson by having one of his guys break a couple of her ribs in the ring. She unexpectedly won him over with her abilities, and not only did Jim enthusiastically sign on to train her, but also married her two years later.

Three years later, she caught the interest of world-famous boxing promoter Don King, who made her the first woman on his roster. She fought under the nickname "Coal Miner's Daughter," a reference to her West Virginia roots and her father's actual occupation. Despite King's initial hesitation, Martin's performance in the ring and bravado during press conferences garnered fans. She seemed built for stardom, especially when she stole the spotlight by wearing head-to-toe pink in the ring. She later told the *New York Times* that the color choice was inspired by the fact that she was a Gemini, an astrological twin, and that the pink delineated the contrast between "the soft Christy" and the "evil twin who is in the ring, trying to portray herself as a good twin."

In March 1996, Martin fought in the undercard for the Mike Tyson–Frank Bruno fight, her second nationally televised match. More than one million pay-per-view subscribers tuned in to watch. She defeated Irish fighter Deirdre Gogarty in six rounds, delivering her hits with an eye-catching precision. Similar to headliner Tyson, Martin wasted no time in the ring. When the opening bell rang, she began forcefully stalking her opponent, looking to decimate her as quickly as she could. The fight was packed with drama, blood, and excitement. Many said she stole the show and America's curiosity was officially piqued. A photo taken during the fight appeared on the cover of *Sports Illustrated,* making Martin the first female boxer to be featured there. That year, she was named the best female boxer by the World Boxing Council. Her winning streak spanned seven years, ending in 1998. After an eight-month hiatus, she regained her title again in 2000 after knocking out Sabrina Hall.

In November 2010, Martin survived a gunshot wound during an attack at the hands of her husband after he discovered that she planned on leaving him for Sherry Jo Lusk. He was sentenced to twenty-five years in prison. Martin remained unbowed and began training with the bullet still lodged in her body. She's since used the experience to publicize resources for victims of domestic abuse.

CHRIS VON SALTZA

Chris Von Saltza at the 1960 National Amateur Athletic Union Swimming and Diving Championships. Over the course of her career as a student-athlete, she took home nineteen individual titles. *Sports Illustrated* declared her "The No. 1 U.S. Swimmer, At the Age of 14" on its cover. She went on to the 1960 Pan-American Games, where she took home five gold medals, and not only broke a world record for the 400m freestyle during the qualifying trials for the Olympic Games but also became the first American woman to break the five-minute barrier. She later went on to Rome, where she won three gold medals and one silver.

CONCHITA CINTRÓN

Conchita Cintrón was a naturalized Peruvian, born in Chile to a Puerto Rican father and an American mother. She began her bullfighting career at the age of thirteen, and created a signature fighting style—an awe-inspiring combination of grace and bravado—that earned her the nickname "Diosa Rubia" or "the Blonde Goddess." She killed as many as 750 bulls in her career as a *matadora*, becoming one of the most famous bullfighters on the male-dominated sport's international circuit, and mastered the integration of two styles of bullfighting: Spanish (on foot) and Portuguese (on horseback). She would begin on foot, then provoke the bull further on horseback, and finally finish the kill on foot again.

After a decade of fighting, Cintrón stepped into the arena for the last time in 1950 in Jaen, Spain. The country's laws made it illegal for a woman to fight a bull on foot or dismount to make a kill, but that did not stop her from riding over to the *presidente*'s box to ask permission to do so. Her request was denied. The ruling was a not-so-subtle sign for Cintrón to leave the arena and have the young male *novillero* assigned to her complete the task. But she dismounted anyway, grabbing the sword and muleta out of his hands. She began to fight on foot, beckoning the bull closer and closer to her with each pass.

When it was time to make the kill, she lined up her sword in position, then, with dramatic flair, threw it to the ground. The bull charged forward. As it passed her, Cintrón poked the bull with her fingers right in the spot where she would have killed him. The crowd erupted into cheers, throwing flowers and hats into the ring. She was immediately arrested ringside for breaking the law, but was quickly pardoned and released when officials began to fear audience riots in her support. In the introduction to her memoir, *Memoirs of a Bullfighter*, Orson Welles called the moment a "burst of glorious criminality," and it remains a seminal moment of glory for women.

MEMBERS OF THE 1984 CUBAN NATIONAL WOMEN'S BASKETBALL TEAM

Members of the 1984 Cuban national women's basketball team pose with Cuban president Fidel Castro in the run-up to that year's Summer Olympics in Los Angeles. Cuba later became the eleventh of fourteen Eastern Bloc countries and allies to boycott the Games in response to the American-led boycott of the 1980 Summer Olympics, held in Moscow.

DIANE CRUMP

The moments leading up to Diane Crump's history-making ride at the Hialeah Park Race Track on February 7, 1969, included a swarm of angry men who raised their fists in the air and heckled, "Go back to the kitchen and cook dinner." The mob grew, requiring a full police escort to guard the diminutive five-foot-tall jockey as she walked into the stadium. That day's race made twenty-year-old Crump the first woman to ever compete in a pari-mutuel (professional gambling) race. Two female riders had attempted to compete professionally the year before, but their efforts were sidelined when the other jockeys threw rocks at their changing room trailers and threatened to boycott the race if the women were allowed to compete. The supposed "fear" was that it would be too dangerous for women to ride alongside men because they would crumble under pressure and endanger both themselves and others.

Crump proved the naysayers wrong by finishing in ninth place out of a field of twelve. Two weeks later, she returned to the same track and won her first professional race. In 1970, Crump became the first woman to ever participate in the sport's most prominent race, the Kentucky Derby.

On the twentieth anniversary of her first Derby ride, Crump was thrown from her horse, resulting in devastating injuries that left her bedridden for four months. Doctors told her she would never ride again, but she defied the odds and began training again. She finally retired in 1999, telling CNN reporter Sheena McKenzie in 2012, "The mentality in the 1960s was that women weren't smart or strong enough to be jockeys. But I proved that a woman could do the job. . . . I like to think I was a little footprint on the path to equality."

GABRIELA ANDERSEN-SCHIESS

The 1984 Summer Olympics in Los Angeles had already made history as the inaugural year of the women's marathon event. But things went a step further when seventy thousand people looked on with bated breath as Swiss long-distance runner Gabriela Andersen-Schiess collapsed over the finish line in what may be one of the most climactic achievements in Olympic history. To some, it was a heartening triumph representing the pinnacle of emotional and physical determination; to others it was an unnerving dance of death, a foolish gamble that toyed with the life of an athlete in distress.

As she raced for 26.2 miles, Andersen-Schiess was already feeling the debilitating effects of the 76-degree heat (greatly exacerbated by the 95 percent humidity), but making matters worse was the fact that she had, in a moment of intense concentration, missed the last water station before winding into the final 400 meters. Dehydration took over as her muscles began to cramp up and shut down. Her slow jog devolved into a disjointed walk with her entire body leaning left, her head and shoulders bent forward, one knee locked and one arm totally limp.

Though her physical control was quickly deteriorating, Andersen-Schiess's mental capabilities were sharp and unaffected. At thirty-nine years old, she knew the chances were high that this would be her last Olympics. She later told interviewers: "I knew that if I stopped or sat down, that would be the end of it. I was just determined to make it through that finish line."

The crowd offered support with thunderous cheering as track stewards followed her closely to make sure she was still sweating and well enough to keep going. She staggered away from them, knowing that physical contact would mean immediate disqualification. It took her an excruciating 5 minutes and 44 seconds to get to and cross the finish line. When she did, she immediately collapsed into the arms of three track stewards who rushed to get her medical attention. Miraculously, she was not suffering from heatstroke—which could have killed her. She finished 37th out of 44 runners.

Andersen-Schiess's fight to finish was an exhibition of courage, determination, and perseverance that inspired the world. In a recent interview she said:

> What really surprised me, in a very nice way, is all the compassion and the reaction of just average people that were watching the Games, and also of the athletes. I was kind of embarrassed that I didn't do well. I thought I didn't deserve all this attention and I really kind of felt guilty. . . . Now, looking back, with time, I can see that people kind of identify with you because they see the struggle and they see that if you really set your mind you can overcome a lot of obstacles.

CHICAGO DAILY DEFENDER 17TH ANNUAL INDIVIDUAL HANDICAP BOWLING TOURNAMENT OF 1965

Players pose at *The Chicago Daily Defender*'s 17th Annual Individual Handicap Bowling Tournament in 1965. The newspaper hosted the event, and at the time was the largest black-owned daily paper in the world.

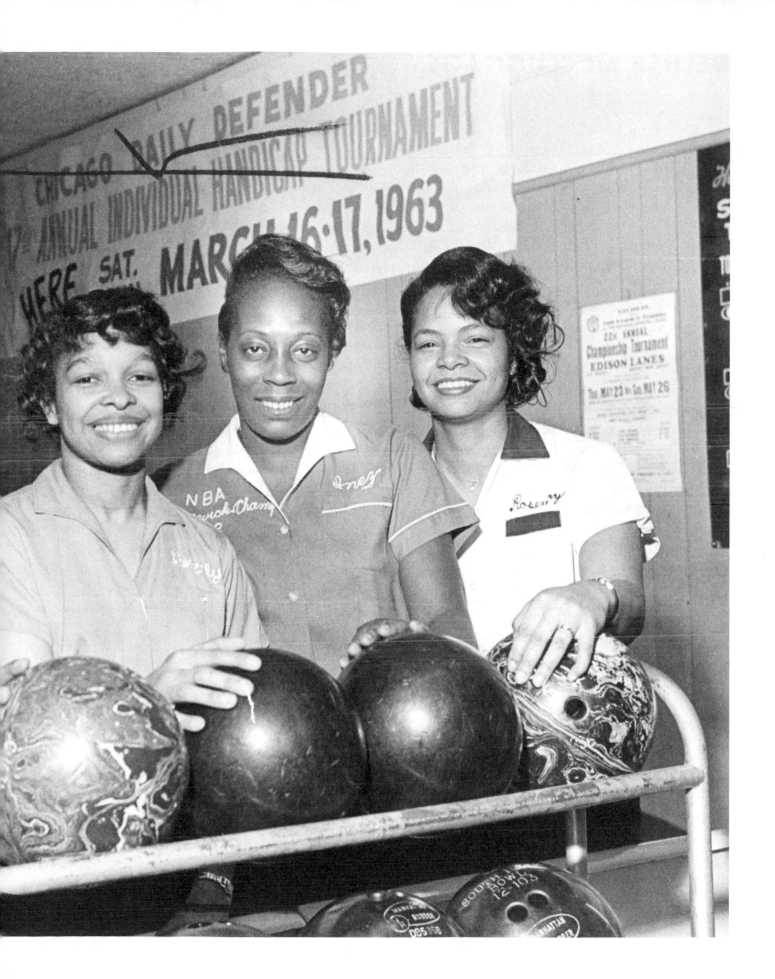

DENISE MCCLUGGAGE

At Christmastime in 1933, while most little girls asked Santa for a teddy bear, or toy typewriter, six-year-old Denise McCluggage requested a British four-cylinder car known as the "Baby Austin." Seeing that car on the street outside her house was the beginning of what would become a lifelong passion for all things automotive. By age fourteen, she had her license, and after graduating from Mills College, and working as reporter for the *San Francisco Chronicle*, she purchased an MG-TC Midget that she used for amateur sports racing. A year later, in 1954, she began working at the *Herald Tribune*, where she started on women's features, but quickly shifted to skiing, parachuting, racing, and other "extreme" sports coverage. Her athletic experience brought a unique advantage and perspective to her writing, and her passion for racing became a necessity as most racetracks prohibited female reporters from interviewing the male drivers. Placing herself in the races, against the drivers she was reporting on, proved to be a thrilling back door to a world that otherwise denied her access.

Alongside journalism, McCluggage continued to pursue life as a race car driver. By 1955, she was racing a Jaguar XK140MC in local events on the East Coast. She then moved on to a Porsche 550 RS Spyder, which she used in races against women and men. During the 1957 Nassau, Bahamas, Speed Week, she finished ninth in the TT, fourth in the Governor's Trophy, and eighth in the Memorial Trophy. She raced at all the great sports car venues of the day: Sebring, Nassau, Daytona, the Nürburgring in Germany and the Rallye Monte-Carlo. She also sat behind the wheel in a wild variety of race cars: the Italian OSCAs, De Tomasos and Maseratis, Volvos, MINI Coopers, Fiats, and Renaults.

In the 1960s, life as a reporter began to slowly overtake her life as a competitive driver. After authoring books on auto racing, she became involved in the early stages of a publication called *Competition Press*, which eventually evolved into *AutoWeek* magazine, the largest weekly automotive magazine worldwide. She remained a senior contributing editor there until her death in 2015. To this day, McCluggage remains the only journalist to ever be inducted into the Automotive Hall of Fame.

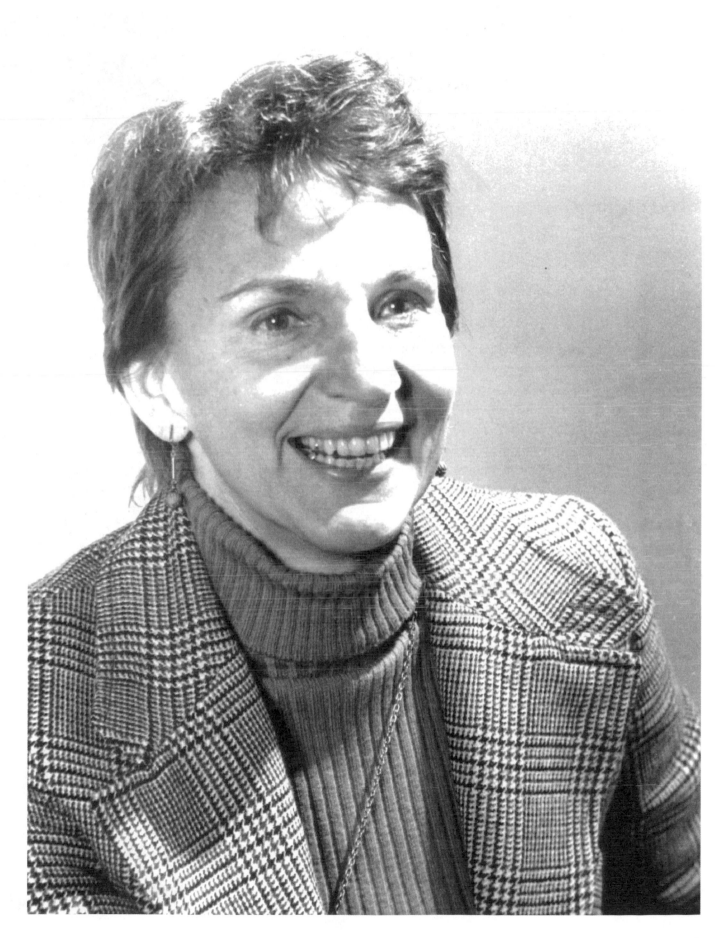

KATHRINE SWITZER

No one realized they'd let a woman into the race. To run the Boston Marathon, twenty-year-old Kathrine Switzer had registered with the gender-neutral initials "K.V."—not to hide anything, though. She had always signed her name that way. Race officials didn't catch it, but even if they had, it wouldn't have mattered. Switzer and her cross-country running coach at Syracuse University, Arnie Briggs, had combed over the rules and fine print on the sign-up sheet; nowhere did it specifically say that women were barred from competition.

April 19, 1967, was marathon day. There were 741 runners in the race, 740 of them men. The calendar said spring, but it felt more like winter, with brisk air and a headwind peppered with sleet and freezing rain. Switzer had intended to flaunt her femininity by wearing lipstick and a freshly ironed burgundy top and shorts, but the cold weather changed her wardrobe plans. Only the lipstick remained. Outfitted in a baggy sweatsuit, she took off from the starting line alongside Briggs and her all-American football player boyfriend, Tom Miller. As fellow racers took notice of her, the initial response was surprisingly positive. Double takes were punctuated with thumbs-ups and words of encouragement. As a press truck drove by, runners were instructed to get over to the right. Switzer and her team did so, expecting the truck to pass, but when the reporters saw that there was a girl running with an official number, the truck positioned itself in front of her. A frenzy of flashbulbs went off. She continued on.

Everyone was mildly amused by the attention, until suddenly Switzer heard the the noise of fast-approaching feet, turned, and saw a man lunging at her. He grabbed her and tried to rip off her bib numbers—261—screaming "Get the hell out of my race and give me those numbers! What are you trying to prove? When are you gonna quit?" In a later interview, she recalled thinking: "I'm gonna finish this race on my hands and my knees if I have to. . . . Because nobody thinks I can do this . . . If I don't finish this race, then everybody's going to believe women can't do it, and that they don't deserve to be here, and that they're incapable. . . . I've got to finish this race." She finished the race in 4 hours and 20 minutes. On the drive back to Syracuse, at a rest stop, she saw her name and photo on the cover of the evening newspapers. Only then did she realize that she'd made history. Her life was forever changed.

Five years later, in 1972, the same year Title IX was passed, women were finally welcome to run in the Boston Marathon. Two years after that, Switzer won the New York City Marathon, ran a personal best of 2:51 at the Boston Marathon, and went on to lead the drive to include the women's marathon in the 1984 Olympic Games. She is still running. The old bib number 261 has come to mean fearlessness in the face of adversity and spawned a global empowerment movement for women.

CONSTANCE APPLEBEE

Field hockey is one of the most popular sports in the world, third only to soccer and cricket. Its beginnings can be traced back to 510 BCE in Ancient Greece, and though many people can be credited with developing the sport, only one in particular was responsible for its modern migration across the Atlantic. Her name was Constance Applebee.

A native of Chigwell, England, Applebee came to the United States to take a summer course at Harvard in 1901. On campus, in a small courtyard near the university's gymnasium, she introduced field hockey to her American class-mates. Interest in the game that day inspired her to bring the sport to the other women's colleges. She provided the necessary equipment as she traveled from school to school, and by November she had cofounded the Women's American Hockey Association with PE directors from Smith and Wellesley colleges. An interest for the sport caught on at a rapid rate: the *New York Times* reported on Applebee and her athletic proselytization, calling her "a hockey player of note and an all-around athlete." The same article also noted that by the time of publication, all Seven Sisters schools had joined the Women's American Hockey Association, with more than five hundred students agreeing to participate. By 1907, the sport had spread across the entire country, and in 1904, Applebee took over as athletic director at Bryn Mawr College, a position she would hold for the next twenty-five years.

The NCAA accepted field hockey as an official sport in 1981, after the passage of Title IX. Applebee passed away that same year, at the age of 107, in her home in England. She just barely missed the first-ever field hockey NCAA championship. Three years later, the American women's field hockey team took home the bronze medal at the Los Angeles Olympics.

KATHRYN "KATHY" KUSNER

From the moment she first saw horses, Kathy Kusner was captivated. To be near them, she took low paying—and sometimes unpaid—jobs as a stable worker and before long, was trading her labor for lessons, cleaning stalls, feeding, grooming, and exercising horses in order to earn riding time. As time passed, her skills developed, and at age twenty-one, she officially became a member of the United States equestrian team. In 1960, she was named Horsewoman of the Year by the United States Equestrian Federation. She rode in the Olympic Games in 1964, 1968, and 1972, where her team won the silver medal.

Kusner also always wanted to ride in races. She rode all the ragtag, off-track races she could find, which didn't require a jockey's license. She won a number of these events, but dreamed of competing at a higher level on the track. When she applied for a jockey's license, the racing commission denied her on three separate occasions. Though they never cited her gender as the reason, Kusner knew that it was. Still determined, she took her case to the Maryland Superior Court. After hearing the arguments, the judge deliberated for about three minutes before deciding in her favor. Thanks to that and the 1964 Civil Rights Act, Kusner became the first licensed female jockey in the United States. She was also the first woman to ride in the Maryland Hunt Cup, considered the most difficult timber race in the world. Her license enabled her to compete internationally, making her the first female jockey to ride in Mexico, Germany, Colombia, Chile, Peru, Panama, South Africa, and what was then Rhodesia.

In 1999, Kusner started a nonprofit organization called Horses in the Hood, which provides children from areas of South Central Los Angeles—including Watts and Compton—the opportunity to work with horses and learn correct riding basics, and build self-esteem, confidence, and a relationship with nature.

GERTRUDE EDERLE

In France on August 26, 1926, twenty-year-old American Olympic swimmer Gertrude Ederle covered herself in sheep grease and waded into the frigid waters of the English Channel. In the distance, she spotted a red balloon signifying a small craft warning and thought to herself, "Please, God, help me," before plunging into the choppy sea. She swam through storms and turbulent squalls, guided by a boat containing her father and sister, who cheered her on by flashing signs that listed the parts of the red roadster promised to her if she was successful. Fourteen hours and thirty-four minutes later, she emerged, "bleary-eyed and waterlogged," on the shore of Dover, England, solidifying her place in history as the first woman to swim across the Channel. She had made it in record-breaking time—shaving two hours off the previous best.

Despite achieving this remarkable feat, nothing prepared Ederle for the fame and fanfare she received upon her return to the United States. When her steamship docked in New York City, she was greeted on the top deck by a shower of fresh flower bouquets falling from the sky, dropped by circling, swooping planes that danced overhead. A ticker-tape parade attended by more than two million people shouting "Trudy! Trudy!" welcomed her home to Manhattan. Fans wanting a closer look at their new hero stormed the doors of City Hall upon her arrival, forcing her to seek safety in the mayor's office. In the following weeks, a dance step was named after her, along with a song called "Tell Me, Trudy, Who's Going to Be the Lucky One?" Men proposed to her by mail week after week. She met President Calvin Coolidge, who dubbed her "America's Best Girl," while others deemed her "Queen of the Waves." She was flown to Hollywood to star in a short film about herself and joined a touring vaudeville act.

Ederle never got used to the attention, which brought a sense of mounting anxiety. "I finally got the shakes," she told an interviewer years later. "I was just a bundle of nerves. I had to quit the tour and I was stone deaf." As a child, a case of the measles left her with hearing problems made much worse by her Channel swim. Once she was out of the public eye, her notoriety died down and eventually drifted away, only to be dug up by journalists on the significant anniversaries of her famous crossing. In 1933 she suffered a terrible fall that left her in a full body cast for four years. Doctors said she would never walk or swim again, but she shocked them all by making a full recovery, even appearing in Billy Rose's Aquacade at the 1939 New York World's Fair.

For much of the rest of her adult life, Ederle's poor hearing pushed her toward relative reclusiveness. She taught swimming to children at the Lexington School for the Deaf in New York, later telling an interviewer, "I have no complaints. I am comfortable and satisfied. I am not a person who reaches for the moon as long as I have the stars."

GLADYS HELDMAN

In 1970, three of the top women's tennis players—Rosie Casals, Nancy Richey, and Billie Jean King—decided to take a stand against their sport's long-standing tradition of pay inequality after learning that yet another tournament had a men's purse nearly ten times higher than the women's. Looking for support to level the playing field, they collectively turned to Gladys Heldman, a former tennis player turned magazine publisher.

In 1953, despite ongoing success as a player (ranked number one in Texas, she also participated in early rounds of Wimbledon and the U.S. Open), Heldman struck out on her own and founded *World Tennis*, "a magazine written by and for the players." It began as a mimeographed newsletter, with Heldman herself serving as editor in chief, layout editor, art director, and advertising director. It quickly became a forum for the sport's views and problems, and turned her into one of the most influential figures in the game.

Frustrated by the sport's refusal to equally reward its players, Heldman joined the trio's fight. A boycott was thrown on the table, but was then pushed aside for a more declarative action: the women would create their own tournament on their own terms, with prize money matching what was offered to the men. Using her connections and expansive resources, Heldman convinced Philip Morris CEO Joe Cullman to sponsor the tournament, raising the necessary prize money and giving birth to the Virginia Slims Tour. Despite threats from tennis's ruling body, nine of the sport's best players, now known as the "Original 9," signed one-dollar contracts agreeing to participate in the tour. The participants consisted of the original players—King, Richey, and Casals—along with Julie Heldman (Gladys's daughter), Valerie Ziegenfuss, Kristy Pigeon, Peaches Bartkowicz, Judy Dalton, and Kerry Melville Reid. The USTA issued brief suspensions to all nine players for competing in a nonsanctioned event, but each player remained loyal to the new venture, and after a successful tour in 1970, Virginia Slims underwrote another tour for 1971. The sport's revolutionary first all-women professional tour was officially on its way.

That same year, the U.S. Open became the first Grand Slam contest to award equal prize money to men and women. Years later Billie Jean King perfectly summarized Heldman's contribution to the sport: "Without Gladys Heldman, there wouldn't be women's professional tennis. She was a passionate advocate for women tennis players and, as the driving force behind the start of the Virginia Slims Tour in 1970, she helped change the face of women's sports."

She also changed its worth. By 1980, there was a total of 47 women's tennis events throughout the world, which offered a collective total of $7.2 million in prize money. By 2003, the year of Heldman's death, the season-ending WTA Championships at the Staples Center in Los Angeles offered the winner $1 million.

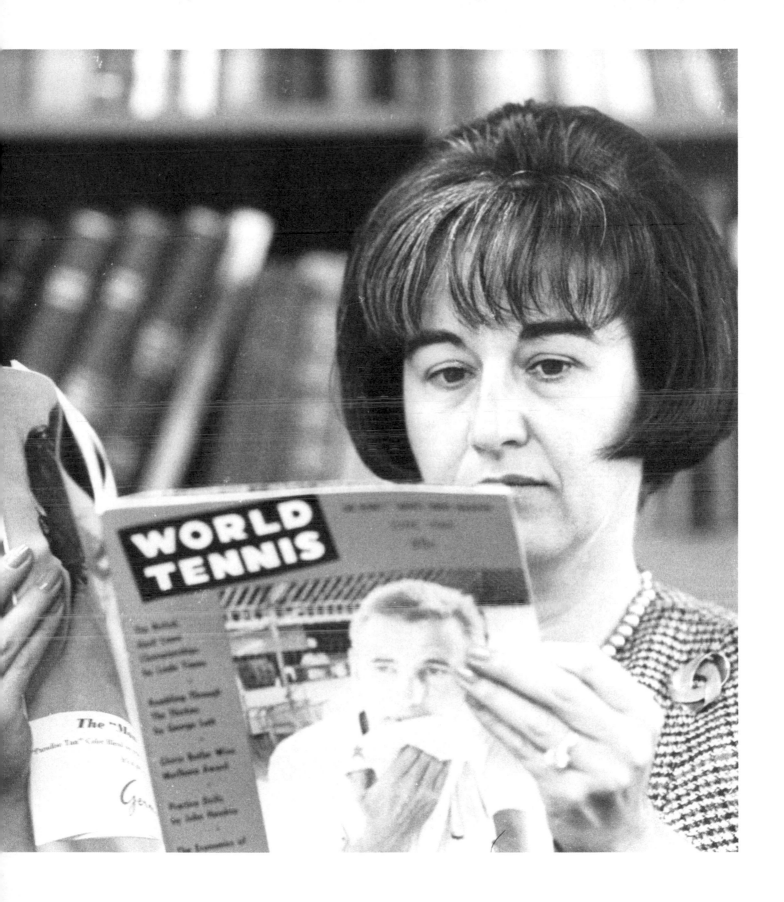

DEBI THOMAS

In addition to being a full-time college student (pre-med at Stanford), Debi Thomas made time to skate at the Redwood City Ice Lodge in Northern California. Thomas was the first female athlete since Tenley Albright (in 1953) to win the U.S. Figure Skating Championships and the World Figure Skating Championships while enrolled in school, and the first African-American woman to claim those titles. She made history again in 1988 as the first black athlete to win a medal at the Winter Olympic Games.

DIANA NYAD

Diana Nyad may not be faster than a speeding bullet or able to leap tall buildings in a single bound, but she did cement her role as a superhero when she broke a speed record swimming around the island of Manhattan, and set a distance record by swimming 102.5 miles from the Bahamas to Florida. Though a particular 110-mile expanse, from Havana, Cuba, to the Florida Keys, proved difficult, her perseverance became more famous—and more important—than the attempt itself.

Like a great Russian nesting doll, the challenge of the Cuba to Florida swim seemed to house innumerable smaller problems, with equal capacity to prevent Nyad from finishing. In addition to the obvious necessity of physical strength and stamina, there were tropical storms that raged at sixty miles per hour, winds with no warning, ominous swirling currents, hungry sharks, dehydration, blistering sun, and the vexing, continually perplexing problem of what to do with the deadly box jellyfish. In 1978, at the age of twenty-eight, Nyad made the first of what would be five attempts to swim this particular course. The first time, stormy seas pushed her far off course, toward the Gulf of Mexico. After nearly forty-two hours of swimming, she and her team accepted that reaching land would be impossible, and so she was forced to exit the water. She trained another two years to achieve her dream, but the governments of both countries denied her team entry to Cuba. It would be thirty years before she took another swimming stroke. During her middle age, Nyad's outsize personality led to a career as a sportscaster. She remained active and fit, but all her activities took place on land.

At the age of sixty, Nyad experienced some of the tough stages of midlife (the breakup of a ten-year relationship, the death of her mother, a pressing malaise that she was no longer a doer, only a talker) and found herself wanting to take on something that would require everything she had. Her mind automatically went back to that grand 110-mile, perhaps impossible dream.

And so she began swimming again, with the Cuba-to-Florida route back in her sights. The more she trained, the more she realized that her older age could serve as an advantage; endurance swimming was just as mental as it was physical. Her body was in some ways stronger than it had been at thirty, but the years had vastly expanded her emotional maturity. In 2011 and 2012, she made three attempts at the swim. One effort was cut short at fifty-one hours, after Nyad suffered a twelve-hour asthma attack in the water. The stings of box jellyfish halted the next two attempts, with one sting paralyzing her spinal cord and taking her desperately close to death. She may not have survived without her medical team, who were out on the boats. They sprang into action, giving her oxygen, epinephrine, prednisone, and painkillers. Without finding a way to fend off the venomous stings of the box jellyfish, Nyad knew she would never be successful. Her team began a year of intense research to find a solution.

On August 31, 2013, Nyad began her fifth attempt at the swim. Once again, she left from the coast of Cuba, accompanied by a thirty-five-person support team. This time, throughout the two nights, she wore a legal stinger body suit, gloves, booties, and a special silicone face mask, designed for patients who have suffered facial injuries, and with a special topical cream called "sting stopper." With all these innovations, and the indefinable power of the human spirit, Nyad finally triumphed. On September 2, 2013, at 2 p.m., approximately fifty-three hours after she left Havana, the sixty-four-year-old reached the beach in Key West, greeted by throngs of fans standing waist-high in the water, cheering wildly. When she spoke to the crowd on the shore she said, "I have three messages. One is, we should never, ever give up. Two is, you're never too old to chase your dream. Three is, it looks like a solitary sport, but it is a team."

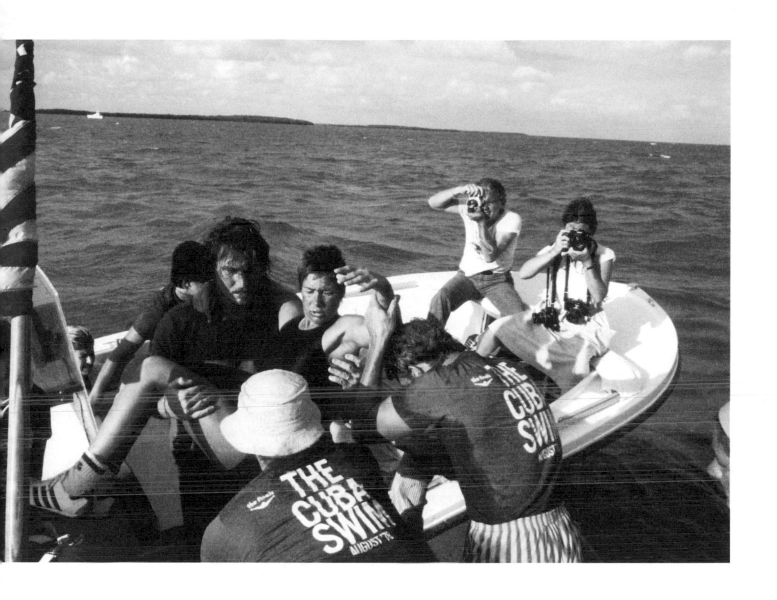

DICK, KERR'S LADIES FC

When Britain joined the Allied forces and went to war in 1914, men went to fight abroad and women went to work in munitions factories all over the country. With families split up and the world on the edge of violent uncertainty, the mood was understandably grim. In hopes of bolstering morale and productivity, the wartime factories, including Dick, Kerr & Company, encouraged women to participate for the first time in organized football (soccer) games.

In October 1917, the female workers at the Dick, Kerr & Company factory played against the remaining male employees during afternoon tea and lunch breaks. The women formed an official team, calling it the Dick, Kerr's Ladies FC. Shortly after that, they beat the all-male Arundel Coulthard Factory team at Deepdale Stadium in front of ten thousand spectators on Christmas Day.

Excited by their success, the team continued to play in charity leagues, donating all of their earned profits to injured servicemen during and after the war. Even when the male footballers came back, fan support and enthusiasm for the women continued to grow. On Boxing Day in 1920, they played to 53,000 fans in a packed Liverpool Stadium. Deeply intimidated by the increasing popularity of the women's teams and concerned that their generosity and good looks would outshine them, the male Football Association (FA) decided to ban women from playing on the Football League grounds.

With a lack of physical space to play on, the Dick, Kerr's went international, playing in France and the United States. In the States they played against men's teams in a series of games, leaving with three wins, three losses, and three ties. In 1926, the team changed their name to Preston Ladies FC, and they continued playing until the team disbanded in 1965.

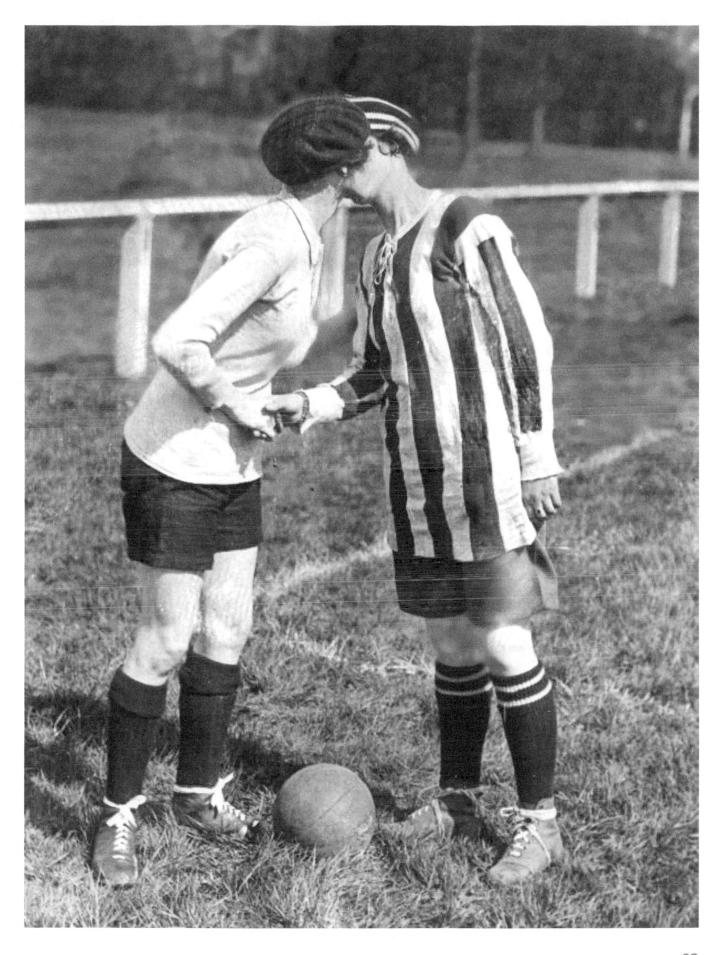

KAY YOW

Basketball coach Kay Yow's list of accomplishments includes an astounding career record of 737-344 (placing her at number six on the women's career list in 1999), two U.S. women's team Olympic gold medals, and a place in the Naismith Memorial Basketball Hall of Fame. In addition to her historical achievements as coach, the story of her courage and perseverance in the face of personal struggle has become an equally indelible part of her legacy.

Sandra Kay Yow grew up in Gibsonville, North Carolina, playing backyard basketball with her sisters as her mother, Cora Elizabeth Yow, a player on a local mill team, coached from the sidelines. After college, she went on to coach high school basketball for five years before making the jump to college-level play. She started as a coach at Elon College of North Carolina, and moved in 1975 to North Carolina State, where she would coach the Wolfpack for the rest of her career. Yow believed in the importance and potential of women's college basketball before most even considered it. Present for its beginnings on the national stage, she raised the bar for her team, which in turn forced other teams to rise to her level of play, changing the sport as a whole.

In 1987, Yow underwent treatment for breast cancer. The disease returned in 2004, requiring a second round of surgery. Two years later, the cancer came back again, this time spreading to her liver. Yow took a sixteen-game leave of absence, but when she returned, she defied expectations by taking NC State to round 16 of the 2007 NCAA Tournament. Despite exhaustion from chemotherapy, blood transfusions, a hoarse voice, and a loss of feeling in her toes that often prevented her from being able to stand up on her own, Yow endured. Her determination so inspired her players that it roused an electrifying and unpredicted winning streak for the Wolfpack. Outfitted in pink breast-cancer awareness shoelaces (which even opposing teams occasionally donned), Yow's players brought her her 700th career win against Florida State. Gaining even more momentum, the unranked Wolfpack went on to a surprise victory against number-two North Carolina. Soon after, they defeated the top seed, previously undefeated Duke University, in the ACC tournament.

Despite the growing intensity of her disease, Yow stuck with her team. Accompanied on the road by her oncologist and a nurse, she coached NC State in their semifinal game, where they lost to Connecticut. In February 2007, an adverse reaction to her medication nearly caused her to faint during practice. She was carried out on a stretcher.

In January 2009, Yow turned over coaching to her head assistant, taking time off for further surgery. That same month, at the age of sixty-six, she passed away. In a postgame statement to the *New York Times* in 2007 (which was then reprinted in her obituary), forward Khadijah Whittington welled up with tears as she stated: "The season was up and down, but we still had our leader believing and inspiring us, it teaches you to never give up. When you want something, pursue it."

MARGARET DEGIDIO "DIGIT" MURPHY

Margaret Degidio "Digit" Murphy was Brown University's first female head coach, as well as the most victorious Division I women's ice hockey coach in history at the time of her retirement. As a student-athlete at Cornell University—where the women's hockey team's Most Valuable Player award is now named for her—she was a four-year-letter winner, captaining the women's ice hockey team her junior and senior years, distinguishing herself as an all-time top scorer, and earning all-Ivy honors all four years. In 1981, she was named the Ivy League Player of the Year, and in 2004, she was inducted into the International Scholar Athlete Hall of Fame for her accomplishments as both coach and student athlete.

CATHY RUSH/IMMACULATA COLLEGE

In 1970, twenty-two-year-old Cathy Rush sought out a basketball coaching position at Immaculata College mainly as a way to occupy herself when her husband, Ed, a referee for the NBA, was away. Her only previous coaching experience was at the junior high school level, but Immaculata, a women's only institution in Pennsylvania with a student body of four hundred, wasn't worried about qualifications, or much about successes. According to former player Judy Martelli (née Marra), "There was never any talk about 'Our goals are to get a national championship,' because we didn't even know there was one." This ambivalence permeated every element of the basketball program. The school owned one basketball. A fire had destroyed the gym two years earlier, necessitating that all games be played away, and players had to arrange transportation for themselves to every game (which for some meant hitchhiking). Each woman was provided with one antiquated uniform, a blue wool tunic with box pleats and bloomers that they had to wash themselves. Any additional white blouses, warm-up outfits or Chuck Taylor Converse sneakers were paid for out of pocket.

Despite all the institutional hurdles placed before her, luck granted Rush a roster of players that surprised her with their skill level. That, combined with her coaching and passion for the game, set the team on a quick path to great improvement. By 1972, Immaculata had a reconstructed gym and a winning record that qualified them for the inaugural AIAW National Championship Tournament against Cathy's alma mater, West Chester State. Without a travel budget, the team organized raffles to raise money for the journey to the tournament site, Illinois State University. Fund-raising yielded only enough for eight of their eleven players (plus Rush) to fly standby. Once there, they slept four to a room, two to a bed, and spent only seven dollars a day on food. Against all odds, in front of a crowd of four thousand spectators, Immaculata defeated West Chester, and became the first AIAW national champions.

Winning the championship changed everything for the team. Though they had been previously referred to as "the Macs," their win in Illinois turned them into "the Mighty Macs." Their plane ride home included an upgrade to first class, and though only five fans had been at the tournament, a welcome wagon of five hundred greeted them at the airport upon their return. Rush remembered, "I was twenty-four years old when we won the national championship. I don't think any of us saw the impact of what we were doing. Every place we went, we attracted the largest crowd they had ever had. I don't think we saw the big picture because we were in the middle of it—going to the next practice or game. I don't think anyone anticipated [it would] have the effect that it did."

The Mighty Macs won the AIAW national championship for the next two years. For the rest of Rush's tenure the team had a 149-15 record, and became the first women's team to play abroad, traveling to Australia in 1975. They also participated in the first nationally televised women's game. Rush retired in 1977, after the positive effects of Title IX encouraged female athletes to seek out athletic scholarships, something Immaculata's already faltering budget could never provide. She was inducted into the Women's Basketball Hall of Fame in 2001 and the Naismith Memorial Basketball Hall of Fame in 2008.

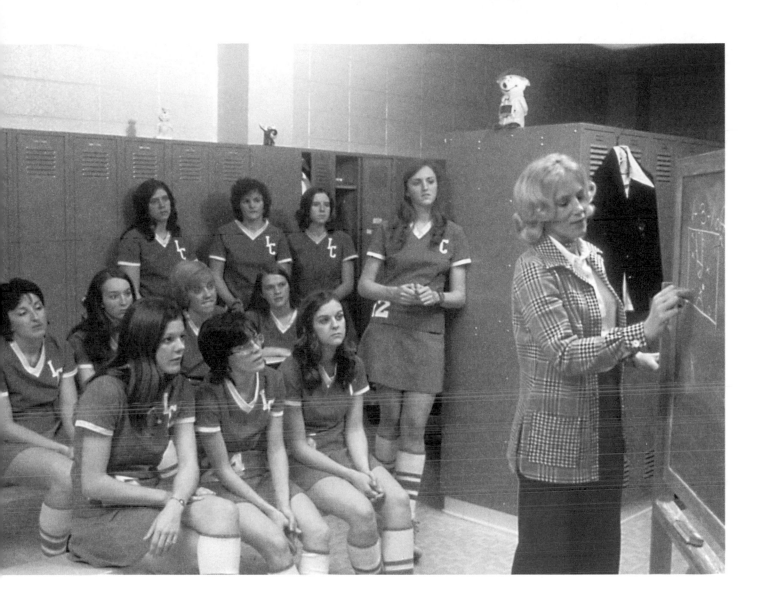

EDITH HOUGHTON

When Edith Houghton began playing professional baseball for the Philadelphia Bobbies in 1922, she was so small that her uniform had to be cinched with pins and string. Her team, part of an unofficial collection of barnstorming teams known as "the Bloomer Girls," was made up of young women in their early twenties and teens. Houghton, the Bobbies' starting shortstop, was only ten. She became a favorite of local sports writers who dubbed her a "phenom" and "the Kid." After touring Japan with the Bobbies, she played for the New York Bloomer Girls, the top women's team, for six years before finishing off with the Boston "Hollywood Girls," who played against semiprofessional men's teams.

After World War II, Houghton assumed a position even rarer than that of a ten-year-old playing professional baseball when she became a Major League Baseball scout for the Philadelphia Phillies. Only one other woman had held such a position; Bessie Largent had scouted for the Chicago White Sox alongside her husband, Ray, but Houghton would be working on her own, and so she liked to say that she was the first woman to ever scout solo in the major leagues. There are two accounts of the story of how she landed the job, and her *New York Times* obituary stated them both. One described Phillies president Robert Carter giving her the position because he was so astonished by the youngster's remarkable grasp and knowledge of baseball. Another claimed that her status as a former baseball prodigy won her the position; she supposedly walked into the office with an overflowing scrapbook filled with clippings from her days playing for the Bloomer Girls.

Houghton served as the Phillies' official scout from 1946 to 1952, and left an enduring legacy. At the time of her death, at the age of one hundred, in 2013, Frank Marcos, senior director of the MLB Scouting Bureau, told the *New York Times* that there was no record of a female scout since her tenure.

ISABEL LETHAM

When Australians on Sydney's Dee Why Beach watched fifteen-year-old Isabel Letham surf a wave in tandem with the infamous Duke "the Big Kahuna" Kahanamoku, it turned her into a legend. He picked her from a crowd of curious spectators, brought her into the water with him, and according to Letham "it was like looking over a cliff. . . . But after I'd screamed a couple of times he took me by the scruff of the neck and yanked me to my feet. Then off we went down that wave." In some versions of the story, Letham was at Freshwater Beach in front of a crowd of four hundred. In others she was at Dee Why Beach days later, with a far smaller number of onlookers. Some iterations of the story featured her riding elegantly atop Duke's shoulders. Others attempted to dispute that by citing that shoulder riding didn't become popular until the 1940s, but it was later discovered that surfing had been introduced to Sydney four years before Letham's tandem ride. For decades, she had been heralded as the country's first surfer. It was 1915 and surfing, an obscure novelty to the world outside Hawaii, was quickly gaining traction thanks to native Hawaiian and Olympic gold medal–winning Kahanamoku's well-attended wave-riding exhibitions. Letham went down in history as the first Australian to ride a surfboard, but that fact was later disputed by others, including Letham herself, who preferred to consider herself the first Australian to ride local waves in the Hawaiian fashion.

Bankrolled by her father, Letham journeyed to the United States in 1918 after it was suggested that she could make it in the movies. She quickly became disenchanted with Hollywood, however, and moved to San Francisco to focus on her first love: the water. She began teaching swimming lessons in 1923 and was soon appointed director of swimming for the city of San Francisco. Three years later, she started the city's first women's swimming competition. At the time, surf lifesaving methods were incredibly inefficient in California, so much so that police actively discouraged people from swimming in the ocean. Letham tried to introduce Australian surf lifesaving methods to the California beaches, but was rebuked by the Manly Life Saving Club, who also denied her membership because of her gender. Ironically, their reasoning was that "she would not be able to handle the conditions in rough seas."

Letham returned to Australia in 1929 and spent the rest of her career teaching swimming. She also started to teach water ballet, opening a school in the 1940s. She was inducted into the Australian Surfing Hall of Fame in 1993. When she died at age ninety-five, her ashes were scattered off Freshwater Beach, where she first surfed in 1915.

EARLENE BROWN

Earlene Brown (née Dennis) was born in Latexo, Texas, on July 11, 1935, an only child upon whom her parents focused and bestowed all their athletic abilities and ambitions (her father played semipro baseball). Brown started in track and field, and soon found herself to be a natural in shot put and discus throw. In shot put, the eight-pound ball is not thrown, but rather must be carefully balanced on the base of the fingers and pushed from the shoulder, utilizing the full weight of the competitor for momentum. Brown, it seemed, was perfectly suited and genetically destined for the sport. She once said, "My mother told me that the first thing she noticed about me when I was born were my hands."

At the age of twenty-one, Brown joined the Amateur Athletic Union (AAU) and quickly began collecting championships and new records in shot put and discus, including eight and three national championships, respectively. At the 1956 Olympics in Melbourne, Australia, she set the American record in both events. Two years later, she became the first American woman to break the 50-foot barrier in shot put, and rose to number one in the world rankings by *Track & Field News.* She won gold in shot put and discus at the 1959 Pan-American Games, and at the 1960 Olympic Games in Rome, took home the bronze medal in shot put, the first and only American woman to ever win an Olympic medal in the event. For the first time, her stature and size was admired. "When I was young I was ashamed of my size. I never thought something of which I was ashamed—my size and strength—could make me feel proud," she later said. "But I feel proud now."

In the second phase of her career, Brown traded one track for another as a Roller Derby star, terrifying the league as a dominant defender for teams like the New York Bombers. Though she died in 1983, she was posthumously inducted into the National Track and Field Hall of Fame in 2005, solidifying her status as one of the most dominant female athletes in American sports history.

ENRIQUETA BASILIO

In 1968, during the opening ceremonies of the Summer Games in Mexico City, a chorus of 100,000 cheering spectators greeted twenty-year-old runner Enriqueta Basilio as she entered the Olympic stadium. One of the host country's most promising female athletes, Basilio, Olympic torch in hand, made the journey up the long, grand staircase to the Olympic cauldron. Once she completed the climb, she stood atop the platform at the staircase's end, pointed the torch north, south, east, and west, and placed it into the cauldron, igniting the Olympic flame, the first woman in Olympic history to carry out the honored tradition. Though she went on to compete for Mexico in the 400m, the 4x100m relay, and the 80m hurdles, it was her barrier-breaking role as the final torch bearer that catapulted her to international fame and made her a part of history.

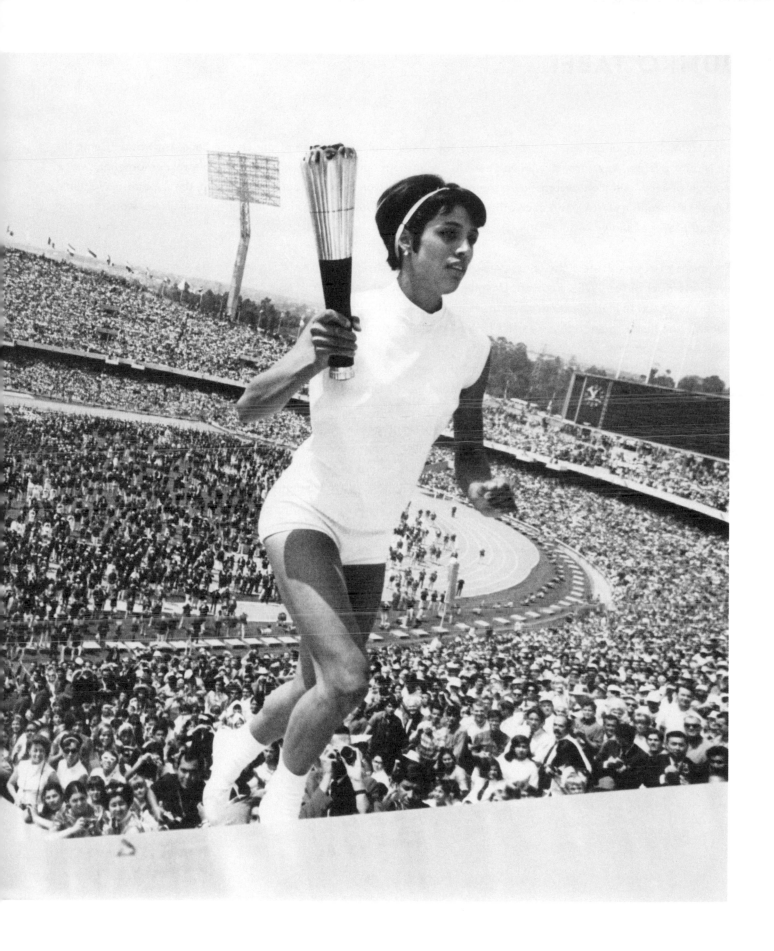

JUNKO TABEI

On May 4, 1975, thunder rumbled 21,326 feet above sea level, at the base of the Lhotse Face, known as "Camp II" on Mount Everest. In a tent, thirty-five-year-old Japanese mountaineer Junko Tabei jolted awake, moments before a surge of snow and ice erupted down the mountain. The swell tossed Tabei and her team, the Japanese Women's Everest Expedition (JWEE), into each other, destroying tents, totaling equipment and burying all fifteen women under a deadly layer of snow.

For more than six minutes, she lay unconscious. Miraculously, the team's six Sherpas made a stunning rescue, and every member of the JWEE survived. Despite injuries that rendered her unable to walk for nearly forty-eight hours, Tabei continued to lead her team's ascent, at times crawling on her hands and feet. Twelve days later, on May 16, she became the first woman to reach earth's highest peak: the summit of Mount Everest.

Even before her historic trek, Tabei had faced a series of challenges that proved her determination to succeed. "Newspaper articles liked mocking us," she remembered. "They would use the picture of us applying a lip balm and say 'even in the mountain, they don't skip wearing the makeup.' For a lot of people, it was a joke. They didn't think we would make it." Despite being the founder of the Joshi Tohan Kurabu (Ladies' Climbing Club: LCC) in 1969 and summiting Annapurna III a year later, it was nearly impossible for her to secure funding for her team's Everest expedition. "I was told, 'We can't be a sponsor to something that is bound to fail. We were told we should be raising children instead." To cut costs, the team sewed their own sleeping bags, stuffed with goose down feathers from China. Waterproof pouches and overgloves were made out of recycled car sheets. Students collected unused pouches of jam and donated them to their teachers. Last-minute finances were supplied by the *Yomiuri Shimbun* newspaper and Nippon Television, though the amount ended up being merely supplementary: in the end, the women paid the equivalent of an average annual salary out of their own pockets.

In 1992, Tabei became the first woman in the world to reach the highest points on all seven continents. In addition to a life spent climbing, she has also dedicated herself to the preservation of Everest's environment through the Himalayan Adventure Trust.

DONNA DE VARONA

Before Donna de Varona was old enough to vote, she had a list of accomplishments long enough to fill two lifetimes. In 1960, at the age of thirteen, she was the youngest swimmer to compete in the Summer Olympics in Rome, Italy. Before that, she held a world record in the 400m individual medley. In 1964, after gracing the covers of *Life*, *Sports Illustrated*, and *Look* magazines, she won two gold medals at the Tokyo Summer Games in the 400m individual medley and 400m relay. That same year, the Associated Press and United Press International voted her the most outstanding female athlete in the world.

De Varona was in college before Title IX granted equal opportunities in sports. Scholarships for women were so lacking that despite her Olympic medals and stature, she decided to retire from swimming at the age of seventeen.

Though her time in the water came to an end, De Varona's relevance in the media held strong. Her popularity in pop culture enabled her to make a smooth transition from star athlete to star sportscaster. Just as she made an impact in the water, she became a pioneer in the broadcasting world. At the age of seventeen, she became the youngest sportscaster ever contracted to a major television network (ABC), and was the first woman to cover the Olympics, (the first of seventeen). She's won an Emmy, two Gracies, and in 2006 was inducted into the Museum of Television and Radio's first class of fifty "She Made It" pioneers in media.

Activism has also always been at the forefront of De Varona's career. Never forgetting the hardships she faced while attempting to participate in sports at the collegiate level, she was a major advocate for the passage of Title IX. She served as a consultant to the the U.S. Senate for the Amateur Sports Act, which aimed to increase access to training facilities and find funding for female and minority athletes, and co-founded the Women's Sports Foundation in 1974. In 1999 she served as chairman of the Women's World Cup Soccer Tournament Organizing Committee, serving the most popular women's sporting event of its time.

JANET GUTHRIE

"No tits in the pits!" This was the taunt a throng of men chanted at race car driver Janet Guthrie when she came to compete in the NASCAR Cup race at Charlotte Motor Speedway. Unfortunately, it wasn't the first time she'd faced resistance in the male-dominated sport. At Darlington Raceway, she nearly missed the mandatory orientation meeting when track officials tried to bar her from the garage area. Despite having more than thirteen years of experience on road-racing circuits, building and maintaining her own race cars, she was repeatedly put in last place for NASCAR's technical inspection line, forced to wait while the male drivers utilized valuable pre-race practice time. At the Indianapolis Motor Speedway, a track guard shook a rubber chicken at her every time she drove past.

In 1977, Guthrie, a former aerospace engineer, became the first woman to qualify and compete in the prestigious Indy 500. Fans typically encouraged their favorite drivers to "Grab That Pole" (meaning to take the number one starting spot for the race) but signs mimicking that rallying cry were quickly drawn to heckle Guthrie, with the "pole" sketched as a penis. That was only the tip of the iceberg. Later she admitted that while mostly she could laugh at it, sometimes it made her mad. "The key," she said, "was that once [I was] out on the race track, I could make all the rest of it go away."

Despite these setbacks, Guthrie broke the gender barrier time and time again. In addition to being the first woman to race the Indy 500, she was also the first woman at the Daytona 500, where she finished in twelfth place and won "Top Rookie" honors. By the end of her five years at the top levels of the sport, she had won the respect of most of the men, who knew she was racing (and winning) in second-tier equipment. No one could ignore her talent and efficiency, especially when she beat them in multiple races. Over time, she began to win some opponents over. Even the track guard with the rubber chicken came around, leaving her the toy bird among the flower boxes and telegrams with a note tied to it that read "Who said she didn't have the guts and the will? I did, and my face is still red. Oscar is at your disposal. Good luck."

Guthrie was forced to leave auto racing in 1984, mainly because she could not get sponsorship in the male-dominated world. But still, she opened doors for the female drivers who came after her. Of her place in history, Guthrie said, "As a racer, I wish so badly that I had found the sponsorship to continue longer in the sport. But to think that I had a hand in changing people's opinions about the capability of women to compete at the top levels of the sport is truly an honor."

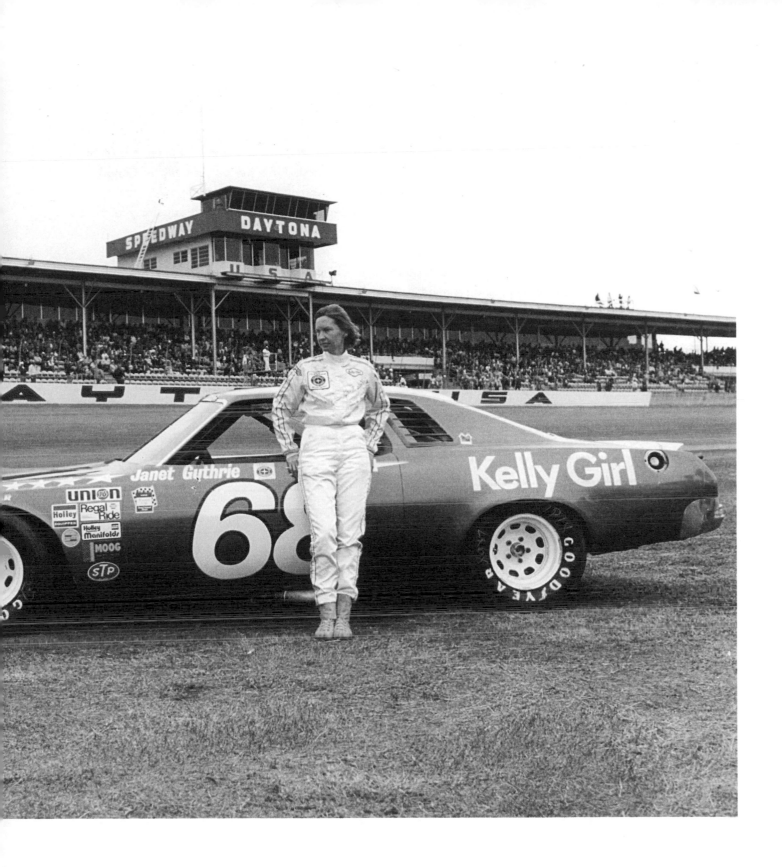

EDITH GREEN

Representative Edith Green, an outspoken Democrat from Oregon, will go down in history as the mother of Title IX, someone who may have done more for women in sports than anyone else. From her earliest days in Congress (she was elected in 1954), Green championed fair and equal treatment of women in the workplace. She was responsible for the passage of the Equal Pay Act of 1963, a groundbreaking federal law aimed at ensuring equal pay for men and women who did the same jobs.

By the 1970s, Green had the seniority, position, and power to introduce even more initiatives. In 1971, she held the first-ever hearings on the widespread sex discrimination in education against women and girls, which became the basis for Title IX. The act was passed in 1972 as part of the Education Amendments, making it possible for millions of women—and generations to come—to participate in sports and other federally funded programs. Republican Oregon Senator Mark Hatfield called her "the most powerful woman ever to serve in Congress."

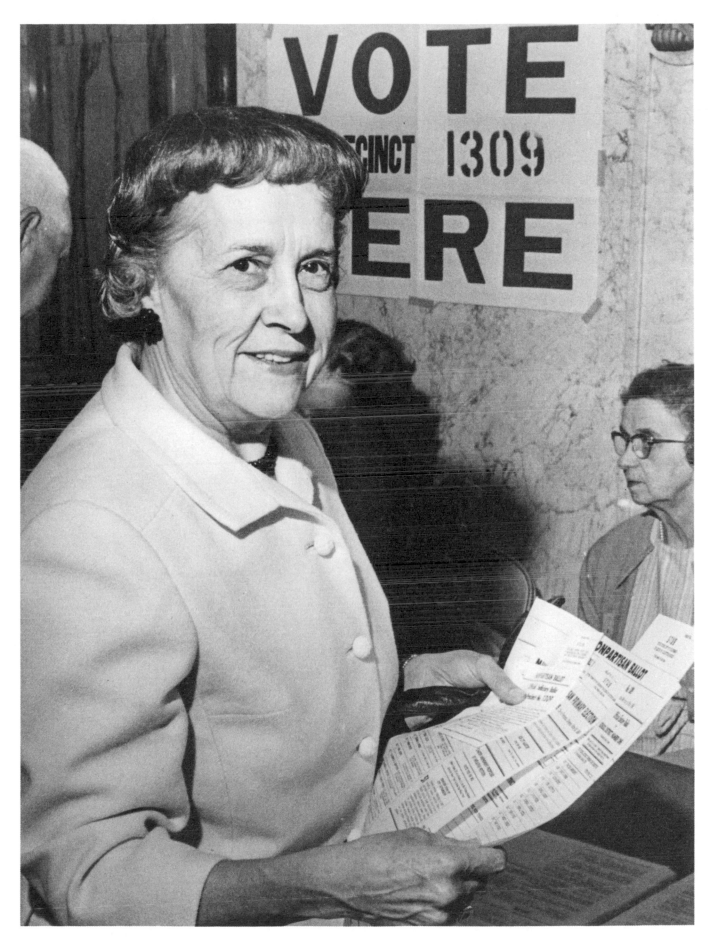

DOROTHY WISE

Dorothy Wise did not look like someone who should ever set foot into a pool hall, let alone be the self-appointed female Billiard World Champion for fifteen years. At a demure 5'2", 110 pounds, she didn't drink, smoke, or swear, but by the time she was in her fifties the outspoken, silver-haired Californian was at the height of her game. Her nickname in the world of billiards was "Cool Hand Dorothy," despite her wholesome nature and her goal of promoting the family image of the game. She won many local and state tournaments, and would have qualified for national competitions, but there was no U.S. Open pool championship for women. So Wise declared herself the Women's Title Winner for fifteen years, claiming, "No one would step up and challenge me." The first national tournament for women took place in 1967, which she entered, won, and kept winning for the next five years. In 1972, at the age of fifty-seven, she finally lost, to thirteen-year-old phenom Jean Balukas. In 1981, Wise became the first female member of the Billiard Congress of America Hall of Fame.

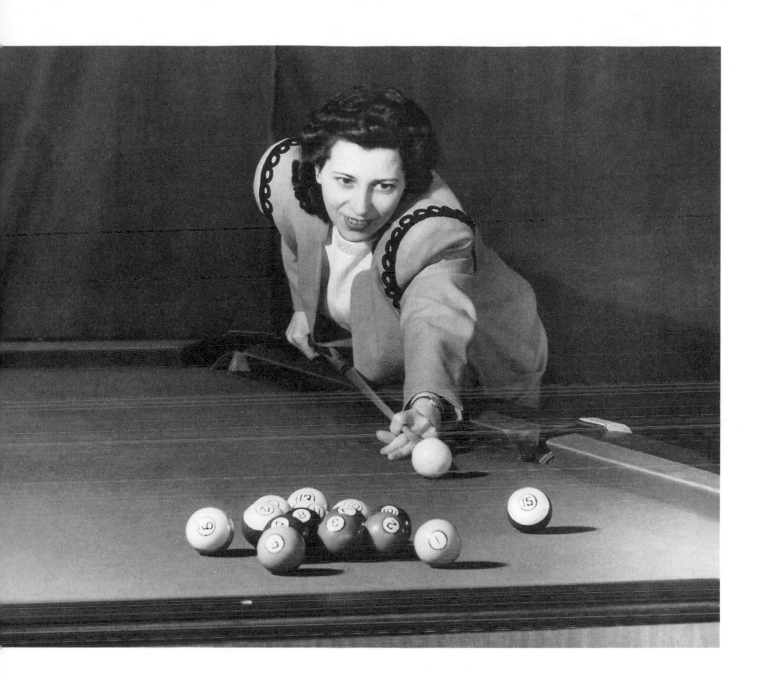

JOYCE WALKER

Joyce Walker became the third woman on the Harlem Globetrotters when she joined in 1986, shortly after Lynette Woodard and Jackie White. A two-time all-American and pioneering member of Sue Gunter's Louisiana State University Lady Tigers, she maintains the record as LSU's highest all-time scorer, as well as the NCAA career record for field goals, and is the fifth-highest scorer in NCAA history.

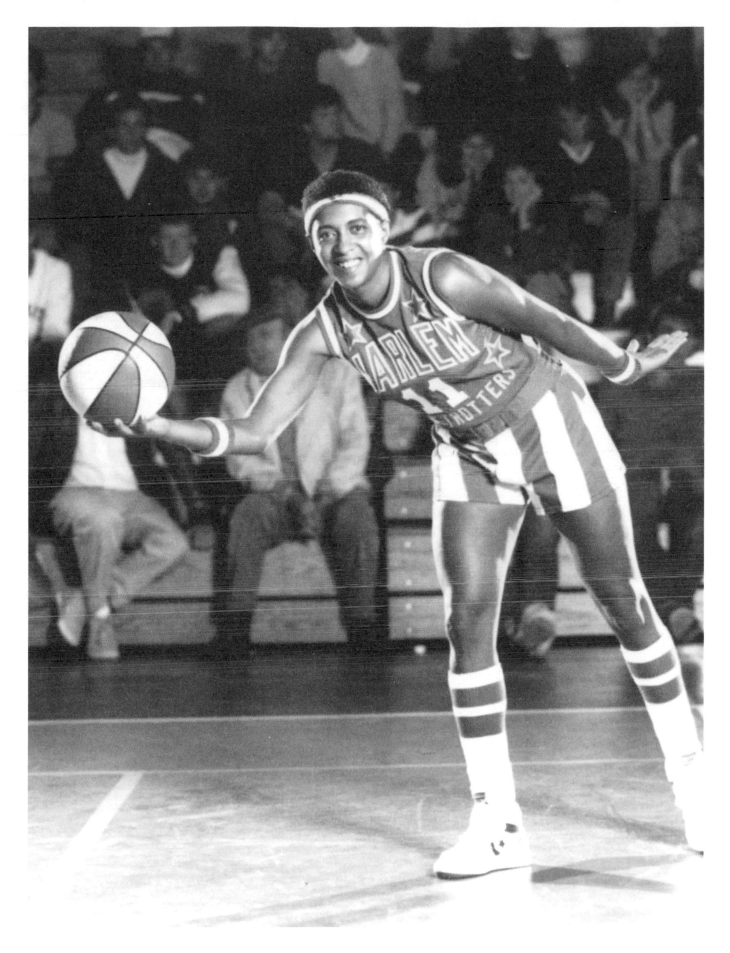

JUTTA KLEINSCHMIDT

Jutta Kleinschmidt acquired her first motorbike at eighteen, for an adventure trip across Europe. Originally an engineer at BMW, she quit her job in order to concentrate on motorsport racing, participating in four Paris–Dakar rallies, which were considered the most challenging off-road endurance race in the world. In 1995, she changed from motorbike to car racing. She dedicated herself to the development of the Mitsubishi Pajero Evolution rally car, and in 2001 she became the first (and only) woman and only German national driver to win the Paris–Dakar rally in the car category. Kleinschmidt continues to race regularly and advocate for the inclusion of women in motor sport racing.

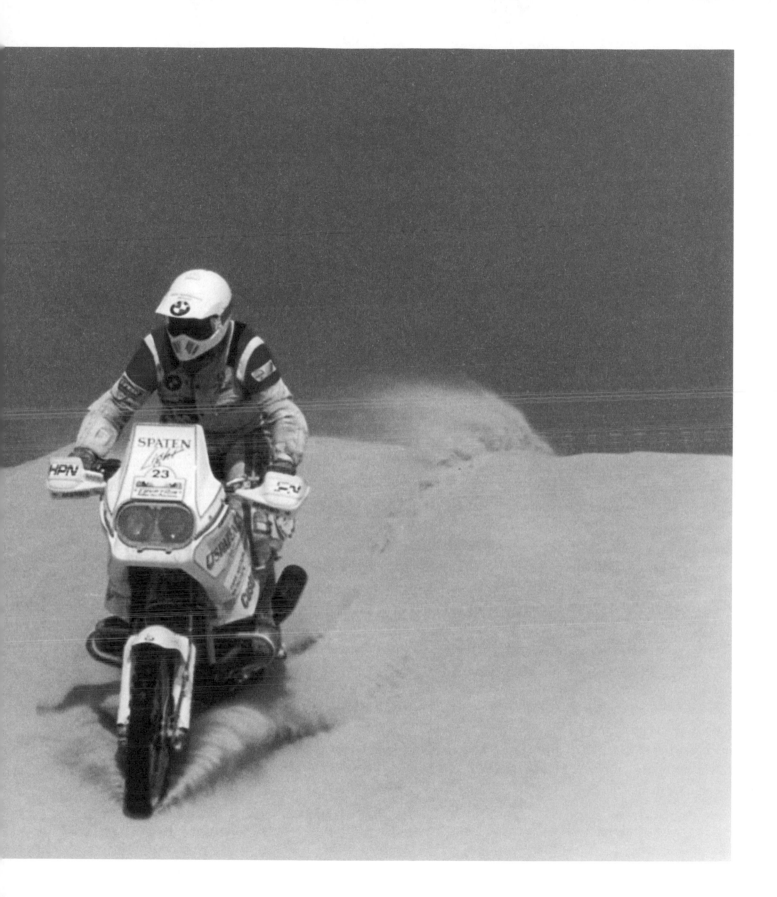

EMMA GATEWOOD

The packing list was simple: a shower curtain, a homemade denim bag, an army blanket, a raincoat, and Keds sneakers. With them, an ordinary woman completed an extraordinary task and became a legend. Emma Gatewood was sixty-seven years old when she became the first woman to hike all 2,050 miles of the Appalachian Trail in one season. She did it without a tent, map, sleeping bag, compass, or proper backpack. She also did it without anyone else. Instead, she relied on instinct to keep her safe and on course, and the kindness of strangers to provide her with occasional food and shelter.

Gatewood was a farmer, a mother of eleven, grandmother to twenty-four, and a survivor of a thirty-year, near-fatal abusive marriage. During the hard years, she would often find moments of solace in the woods behind her home, and perhaps for that reason, years later, at the age of sixty-two, after reading an article in *National Geographic* about the first men to through-hike the Appalachian Trail, she felt compelled to do the same thing herself. So she got a job as a practical nurse in order to qualify for Social Security, with a goal of doing the hike five years from then. She had no hiking experience and assumed that the trail would be a series of easy walks with fresh cabins at the end of each day. When she finally set out on the trail, she did so without fanfare. She simply told her children that she was going on a "walk." She left her native Ohio for Maine, and began by hiking up Mount Katadhin.

Her troubles started as quickly as she began. After almost getting lost during her first hours on the trail, she decided to bathe in a lake, accidentally stepping on her glasses and breaking them as she dried off. Unable to get her bearings, she started a small campfire to send out smoke signals for help that never came. She then ran out of food, and wandered for three days and two nights in hopes of finding her way back to where she had started. Fortunately, a couple of park rangers had taken note of Gatewood earlier on the trail. When they didn't see her come back down the mountain, they started looking for her, and found her soon after. Her feet were completely swollen and her hair tossed about by the surrounding brush and branches. Her broken glasses were precariously held together with tape. The rangers simply said, "Go home, Grandma."

The next year, she returned to through-hike the trail, only this time she started on the opposite end, at Mount Oglethorpe, Georgia. Local newspapers caught wind of "Grandma Gatewood" and by the time she had reached Maryland, the Associated Press had published an article about her journey. Five months after she began, on September 25, 1955, she reached the end of the trail. On her longest day she covered twenty-eight miles, eight on her shortest. Her feet were swollen two sizes and she had worn out seven pairs of Keds sneakers. The day before her final hike up Katadhin, she broke her glasses again, after a fall that also resulted in a sprained ankle. None of this stopped her and slowly but surely, she made it to the top. She later told *Sports Illustrated,* "I would never have started this trip if I had known how tough it was, but I couldn't, and wouldn't quit."

In 1957, Gatewood returned to the trail to hike it all over again, making her the first person to successfully through-hike the trail twice. She set yet another record in 1964, when she hiked the trail again in sections, making her the first person to tackle the whole thing three times.

KEIKO FUKUDA

Keiko Fukuda's family permitted her to participate in judo classes in the hopes that it would lead her to a suitable husband; little did they know that judo would become her life's true love, and that she would reject marriage completely in order to remain faithful to it. When she died in 2013, she was the highest-ranked female judoka in history.

Judo was in Fukuda's DNA. Her grandfather, samurai and jujitsu master Fukuda Hachino-suke, was a teacher to Kano Jigoro (aka Kano), the founder of judo. When she was twenty-one years old, Fukuda was invited to a class created specifically for women at Kano's revered training school, the Kodokan. Standing at 4'11", she had been trained in the feminine arts of calligraphy, flower arrangement, and tea ceremony: the aggressive martial arts were completely out of her comfort zone. The sight of women spreading their legs as they executed combative throws was shocking, yet she was completely captivated.

By her thirties, Fukuda was a revered judo instructor. In 1953 she was among the highest-ranked female judoka in the world. Following Kano's dying wish that his students travel the world to teach judo, Fukuda moved to the United States in 1966 to open the Soko Joshi Judo Club in San Francisco, where she taught for decades.

In November 1972, a letter campaign calling out the Kodokan's sexist practice of refusing to promote women higher than the fifth dan proved successful and Fukuda was the first of two women promoted to the sixth dan. She went up through the ranks and in 2011 was the first woman the Kodokan promoted to the ninth dan. The same year, she was awarded the rank of tenth dan by the board of USA Judo and she established the Keiko Fukuda Judo Scholarship to enable women to continue formal judo training. She taught judo three times a week until her death at the age of ninety-nine. Her legacy lives on through her school and in her personal motto, "Be strong, be gentle, be beautiful, in mind, body, and spirit."

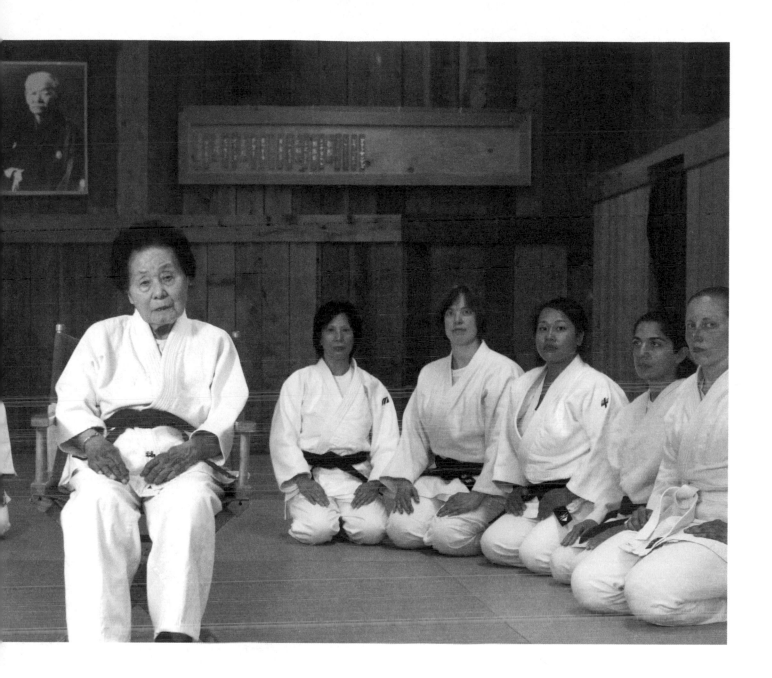

KIM GILBERT

Kim Gilbert began her table tennis career at fourteen, under the tutelage of Japan's former world table tennis champion Norikazu "Cannonball" Fujii. By seventeen, Gilbert was a junior champion and won the first of many gold medals at U.S. Olympic Festivals, living and training out of U.S. Olympic Training Centers. Along with her numerous state and national titles, Gilbert still holds the record for fastest-ever reflexes recorded at a U.S. Olympic Festival by any athlete in any sport. She is currently the CEO of Pongstarz, where she headlines and produces Ping-Pong themed corporate and celebrity events, and national fund-raisers for the American Cancer Society, Los Angeles Unified School District, NBA, MLB, and NHL. In 2015, she was named as an ambassador to the United States Association of Table Tennis and is considered the backbone of marketing and promotions for her sport.

ELSPETH BEARD

With six years of riding experience under her belt and a stable career on the horizon, twenty-three-year-old Elspeth Beard decided to take her BMW R 60/6 flat-twin bike on a two-and-a-half-year journey that would make her the first Englishwoman to ride a motorcycle around the world. In October 1982, after three years studying architecture and several months saving money while working at a Central London pub, Beard shipped her motorcycle across the ocean to New York, beginning the first leg of her trip. Five thousand miles later, she had covered New York to Canada, then Mexico and back to Los Angeles.

Success didn't come easy. On her way from Sydney to Perth, on the next part of her trip, Beard was involved in an accident that left her concussed and hospitalized for a week, but thankfully without any broken bones. In Singapore, her valuables were stolen, including her visas and passport, and she spent six weeks replacing lost documents. En route from northern Thailand to Penang, she was involved in her second major accident and a foot injury left her recuperating for a week in the home of the Thai family whose farm she had crashed near. Undeterred, she then shipped her bike from Penang to Madras and rode to Calcutta and then onto Kathmandu, Nepal, in the Himalayas.

As Beard traveled through changing geographical terrain, social landscapes shifted, too: on the trip from India through Pakistan, she arrived in postrevolution Iran and used her Bell helmet as a head covering, keeping it on even when off the bike. From there she went through Turkey and then on to Europe. One of the final roads of her journey was Yugoslavia's "Highway of Death," a narrow two-lane roadway flanked by crosses and flowers strewn about to commemorate fallen travelers.

By the time she arrived home in London, Beard had covered 48,000 miles in just under 1,000 days, a truly remarkable feat. Currently, she heads her own award-winning architectural practice. She continues to take long-haul trips around Europe and Morocco.

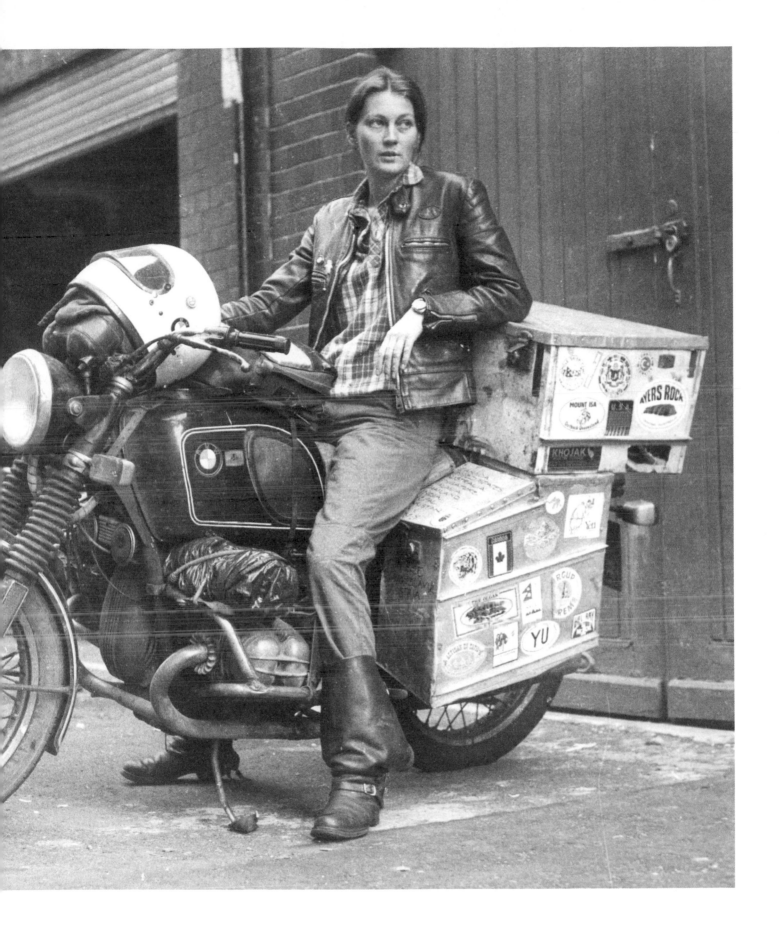

"For so long, it's like, give the girls a contest. Give us something. Give us something, but then it's 'Why don't we just make our own thing and then we don't have to ask'?"

LACEY BAKER, professional skateboarder, speaks with legend and Hall of Famer **LAURA THORNHILL** about femininity, financials, and finding a place to play.

LACEY BAKER: What was it like being a girl skateboarder in the seventies when the sport was new, with only a handful of women in the community?

LAURA THORNHILL: I was such a tomboy. I did every team sport imaginable. I was a die-hard roller skater. Every weekend, every holiday, I was at the roller rink. I just started riding because it was another athletic thing to do. I grew up in Dallas, and there were six boys who lived next door and had a beater skateboard they would leave on their front porch, and I would always steal it. I'd keep it for a day or two and I learned how to kick turn and go up and down my driveway. I'd go up the driveway and up the sidewalk to the house and back; I just loved it. It wasn't like I was seeing other girls do it. Then I moved to California in 1974 where they had begun putting urethane wheels on skateboards; that revolutionized the sport. *Skateboarder* magazine came out the next year, and there were a few pictures of girls in it. I saw that and thought, *I want to be in this magazine. I'm going to be the best.*

LB: What kind of board did you ride? What did it look like?

LT: It was called a Black Knight. It was a small wooden one with really archaic ball bearings and clay wheels. If you hit the littlest pebble, you were flying. You were going to eat the pavement.

LB: Did you have other girls that you skated with at that time?

LT: No, I really didn't. Not until my first contest when I was in middle school. I was in the seventh grade and it was just me and a bunch of guys, and I won.

LB: What did your life look like at that point in time?

LT: All my best friends were guys. Peggy Oki was the one girl on the Dogtown team and there were some girls in that, but I wasn't there yet. Steve's South Bay was my first contest. There were some teams formulating. There was the Sims team and Logan Earth Ski team and Gordon Smith and Bahne. I wanted to do good in that contest so that I could get asked to be on the Unity

Surf Shop team with Ty Page and some other really great skaters from the South Bay. I ended up winning that contest and was asked to be on the Logan Earth Ski team, which was one of the best teams to be on at that time. Two weeks later, I was down in San Diego and was asked to be the first woman to do a "Who's Hot" layout in *Skateboarder* magazine. Warren Bolster, who was the editor of the magazine and head photographer, totally took me under his wing and I became his favorite subject to photograph. My career just took off from there.

LB: That's really awesome. Do you feel like, going from not being sponsored to being sponsored, people made you be a certain way or change your image to suit them, and their companies, or do you feel like they were just backing you for who you were?

LT: At contests, we'd all be in a team shirt. A lot happened in the span of two to three years with the teams really coming together as units. There was a really distinctive difference between all those teams, but no one tried to change my image at all. Our team was just cool. Shortly after I joined Logan, the Dogtown team fell apart and all those guys ended up on our team. Jay Adams was on our team, Bob Biniak, Tony Alva.

LB: Nothing was really that corporate back then, right? That's probably where the fun is really coming from, because that company that will sponsor you, they want you to be you. It seems a lot more genuine.

LT: Yeah, it was the pioneering days. It was a new frontier.

LB: Did you feel like a pioneer at the time?

LT: Not at the time. I mean, yeah, we were breaking new ground and we were creating tricks, but at the time I was fourteen, fifteen, sixteen, seventeen. Those are really formative years and your head is not in that mode of "I'm a pioneer." It wasn't like that. You're out there riding because you have this burning desire to just skate.

LB: Did people make you feel "like a girl" when you were skateboarding, or was it just about respect?

LT: It was all about respect. I always rode more like a guy and was a tomboy, but I was fluid and graceful in ways the guys weren't. You had other girls who were really, really girly, like Ellen O'Neal and Ellen Berryman, who were doing more ballet-ish kind of stuff; that wasn't me. I was doing parks and pools and pipes. I just was doing my thing.

LB: Please tell me about the twenty-two foot pipes you skated [in Arizona in *Skateboarder* magazine]?

LT: There was the California Aqueduct pipeline project. We heard about these pipes and I was the one girl asked to go on the inaugural first trip of all the top skaters from California. It was with Warren Bolstor and twelve other guys. We flew into Arizona and had some idea of where we were going, but then we saw them in the distance, these scattered, huge, gigantic sections of pipe that were from that wall to this wall. Oh my God, the car was just rocking back and forth with excitement. We were freaking out. I got in there and just started rocking low. You go fakey back and forth and you start kick turning and at one point, you're getting so much momentum. I had to pull back because you would really get going. These were the most perfect pipes. Seamless.

LB: That trips me out because the way that it is now, you can just go online and look up a skate spot and go. There's no mystery. It's far less romantic. What do you think of girls skateboarding now, and girls being sponsored? How do you feel about it all?

LT: I know in corporate America, they want girls that look like girls. They want that model girl if they're going to put money behind her. I know one girl—she's beautiful, yeah, and she charges and she rips, but if she didn't look the way she does, would she be getting the same contracts? I don't know.

LB: I try to make that clear in my interviews because it's not about who's getting the attention. It's about where the attention is coming from and why the attention is being directed that way.

LT: It's being directed that way from the people that are up top.

LB: Yeah, the skating industry is pretty much all men and there's no room for us unless they create a little, tiny space for the prettiest one.

LT: Yeah, which is ridiculous.

LB: Did you ever feel competitive with anyone or was it just with yourself?

LT: Totally, yeah, we were competitive. You were competing and there was prize money, but at the same time, you were friends with everyone. But yeah, you wanted to win.

LB: Were there separate divisions or is everybody just competing? Were men and women separate?

LT: There was always a women's division, and the guys' prize money was always more. There was always inequity. There was never parity in prize money. Never.

If first-place money for the girls was $500, it was $1,500 for the guys. It made me mad, but it was what it was. It wasn't until a few decades later that the girls really stood up and put their feet down. We're working as hard as these guys and maybe some of us even skate better than some of those guys.

LB: Yeah, in my experience too, it's always been that guys get more than girls. The prize money in general has been raised. Like for X Games, when I first started, I think the top prize for girls was $15,000, but for guys it was $50,000. The Alliance started by Mimi Knoop and Cara-Beth Burnside has really done a lot. [The Alliance played an instrumental role in securing prize purse equality for men and women at all X Games events, both summer and winter. The Alliance has worked with various contest organizers, industry leaders, and sponsors to cultivate more opportunities for female action sports athletes so that they can better participate, compete, and become more successful professional athletes.] They boycotted the X Games. They're like, we're not skating it.

LT: How did you get your start?

LB: Well, I can't even remember how old I was, maybe three. I was in foster care and I got a skateboard for Easter as a present because my foster brothers skated a mini-ramp in the backyard. To me, I thought it was a huge vertical ramp, but now that I think about how tiny I was, it was probably four feet. I thought, *I want to do that.* I got a skateboard and then I was just pretty obsessed with it as a kid. I was always trying to learn tricks, ollie, roll down the driveway or do a 180. I kept trying to learn how to skate, and then I think by the time I was eight or so, I learned how to kickflip. I'd been trying that since I started. I remember running in and being like, Mom, I landed it! Then I got into California Amateur Skateboard League, which is a Southern California contest series. They have one contest a month at a skate park anywhere in Southern California. I was skating those and then that's how I got introduced to the skating competitions. I was the only girl. I was just skating with a bunch of dudes.

LT: How old were you at the time?

LB: I think I skated the first one when I was eleven. Then that went on for two years. I skated a contest in Torrance and that's where I was up against Lauren and Vanessa and Amy, all these girl skaters that I didn't even know existed. At the time, I thought I was the only girl skater. I won that contest and then that's how I got introduced to the World Cup contest, because the prize at that one was to travel to skate the Global Assault in Australia. I went there and then I started skating all the world cup contests, like Slam City Jam and West 49, those two Canada contests, and then X Games.

LT: Were you being sponsored and sent? Was your travel being paid for?

LB: Yeah, because I was sponsored by Billabong they actually paid for me and for my mom to go.

LT: Nice.

LB: It was pretty cool. A lot of that travel was for free and hotels were pretty much free. Billabong was paying for it, but I had to wear the logo and wear all this branded stuff. My mom was always like, put a sticker on your board, or you have to wear this shirt and match it with your pants. I was just like *Grrr, I don't want to.*

LT: How does your community support each other? Is it all women or are there men saying, "hey, this is how it needs to be and we need to help you guys"?

LB: Right now, I feel like it's women that are supporting one another in that respect. It's really just a small group of us. When we were in Norway, for example, after the X Games, my friend Kim pretty much organized and curated this whole event all on her own, just to reach out and get girl skaters to come together. We skated at the skate park on Friday and it was packed with little girl skaters and I was just in awe that we could actually bring them together just by coming together ourselves and making it happen. Otherwise, there would be no community. We are in this space right now where we can create so much visibility.

LT: I think there's a huge movement going on with women being recognized. I think the opportunities are definitely growing. Cindy Whitehead is doing amazing things with "Girl is NOT a 4 Letter Word" and with her line of boards. Kim and Mimi and Cara-Beth are definitely pioneers in that area, especially Cara-Beth and Mimi, and Amelia now. There's a continuation of women that are really trying to create this uprising of female empowerment and it's great. There are so many girls skating all over the globe right now, so many more than ever before. Female skateboarding is huge. My friend Barb Odanaka has a thing called the Sisters of Shred and there's this thing every Mother's Day called the Mighty Mama Skate-o-rama.

LB: It's so crazy, Laura. Every other girl skater you just mentioned just now, I've never heard of. I wouldn't know how to find out about them.

LT: There were girls. There were girls in the seventies and there were girls that continued on into the eighties and the nineties. How much notoriety they got or how many times they were in the magazine, probably some of them have maybe placed in a contest here or there.

Chances are they could never have been in a magazine. It was always a very small group of people who were even aware of their names.

LB: I think social media is changing how we find out about one another.

LT: Oh, absolutely.

LB: I have people almost everyday reaching out through Instagram, just being like "Hey, you're great. You inspire me to skate." I'm just like, holy hell, because it inspires me too, to keep skating.

LT: Do you think there is a pressure on you to look a certain way from other skaters?

LB: In the community I'm in now, no. Not at all. When we're all together, we're usually all together around contest times. We're just all hanging out. The way we look does not matter. We're all friends outside of skating and that's just something that really brings us together. I've met a couple of younger girls in the last two years and I feel like we're going to be friends for life and it's not just about skating with them, but it's connecting through skating. There is a huge solidarity. It's really cool to be a part of it.

LT: Same. I never felt that. The girls weren't being disrespected. The girls were being encouraged back when I was riding. The guys dug it. They weren't like, you can't ride this bowl. The girls were always given equal skating ground.

LT: How do you think the unfair prize money and sponsorship will change?

LB: I don't know. Build our own industry and make it fair. That's the idea I have. I feel like we're all . . . For so long, it's like, give the girls a contest. Give us something. Give us something, but then it's "Why don't we just make our own thing and then we don't have to ask"? When it comes down to just skating, if I was to skate with any of these guys who skate in the contest, sure, it'd be fun and awesome but it's the industry that's creating that.

LT: A divide.

LB: The divide, yeah. It's a shame because it's not what it's supposed to be like, I feel like. That's where I've become disheartened over the past couple years, in trying to be in a space that doesn't exist. I moved out of my mom's house when I was nineteen and then I was realizing skating is my only source of income and I cannot pay rent and live as an adult off the money that I'm making. I'm trying to reach out and skate and get photos, do anything I can, what any other guy would be able to do in the industry and I just don't have those opportunities. I was just like, this isn't going to work and it just made me really depressed about skating, because A) that's not why I started in the first place, and B) even if I did want to do it that way, there're no opportunities. Maybe if I didn't cut all my hair off, but that's not who I am.

Now that we're all coming together and creating our own community, it's lighting the fire up again to just feel really good about skating and what I'm doing. Reaching out to younger girls, creating a space in a community for younger girls, stuff that I didn't have going in.

LB: Laura, what was your worst injury?

LT: Mine was a fully dislocated elbow. That was the beginning of the end of my career. It was pro day at the Montebello Skatepark and it was some pretty slick concrete. I'd borrowed Stacy Peralta's board and went and did the snake run and then came back up to give it to him and I just went to do a kick turn to stop to give him back the board. It was not polished concrete, but close to it, and the board slid out and I went back and I just caught myself like you naturally would with your arm and it flew up and out. It hurt like a mother.

LB: What are your biggest triumphs?

LT: I think for me, looking back on it, it's that I get to be considered a pioneer. Having a lot of firsts. I hold those with great pride. Having the first "Who's Hot" in *Skateboarder* magazine. I had the first interview in *Skateboarder* magazine. I had the very first female signature model board of the Seventies. Shortly

thereafter, Robin Logan came out with the next female signature model. I had two contents pages in Skateboarder magazine, which was huge back then. Then to have the very first centerfold in a skateboarding magazine of a girl from the twenty-two-foot pipes out in Arizona. That was really big too. Winning the skateboarder poll, the first year they did the skateboarder poll, I won it for the girls. Tony Alva won it for the guys. Then getting inducted into the Skateboarding Hall of Fame.

LB: That's so cool. I love that.

LT: There was a poster I was on that I found out about from watching an after school special on TV. I'm sitting there in front of the TV and I see this shot of this girl in her bedroom and there's a poster behind her of a girl skating. Oh my God, that's my poster. What the hell? I didn't even know that Warren Bolster had sold the photo for them to do a poster. I'm proud of those moments and being in that decade. To look back and to know that we were doing all this stuff all those decades ago and that we were breaking new ground, that's something I'm really proud of. I'm proud of all you girls that are out there kicking ass and just showing how it's done. I see girls riding that are so much better than so many guys. Such a huge talent pool of female riders today.

LB: Yeah, it's just growing constantly. Constantly.

LT: I just saw two girls on skateboards on my way here, getting off the train. Two girls carrying their boards. They put them down and off they rode. It was their next mode of transportation.

LB: Right, yeah. I love that.

LT: What about you? What's your biggest triumph so far?

LB: If we're going to go all the way back, it was probably when I landed the kickflip. I was just so proud because it had been like eight years of trying.

LT: I know the first time I landed a kickflip after wrenching my ankle so many times, it was like, yes. For me, that moment was when I finally was able to do the handstand and not flip over, to roll down the street and hold that handstand on the board and ride down straight.

LB: When you feel it click and you're just like, finally, because you've been trying for so long. I guess winning the X Games too.

The other thing I'm the most proud of though, right now, is just being a part of something that's really important, like the community aspect and creating that and being able to send the message and people reaching out to do interviews and just always being able to say yes to that. I get a lot of younger girls reaching out and younger queer kids that are reaching out. It means a lot to me and I don't want to take it for granted.

LT: Yeah, being present's so great. Waking up and feeling good and wanting to go out and be active and do something that just kicks your ass and helps you sleep that much better at night is the best. It really is the best.

LB: If there's anything driving me to skate, it's the younger kids looking up to me that keep the fire alive.

LT: Are you sponsored now?

LB: Yeah, I'm pro for Meow Skateboards and Vans. They send me shoes. They actually paid for my flight to X Games, which never happens. I was pretty stoked about that. Then Indie sends me truck, and Bones sends me wheels. Okay, one last question. Describe the emotion that you felt when you skated.

LT: It just felt like I was connected to what I was meant to do at that time. It was all I cared about, being on that board and learning something new and mastering a new trick. The satisfaction of trying something and failing and failing, then finally getting it right was unlike any other feeling. It's just the best. •

EVONNE GOOLAGONG CAWLEY

When she was a child, Evonne Goolagong was more easily quieted by an old tennis ball than a security blanket. Her father had found the worn-out, hairless ball under the seat of his used car and at not even twelve months, Goolagong would squeeze it to calm herself during long drives. That preoccupation was a startling indicator of her fate: Evonne Goolagong was born to be one of tennis's greats.

Despite the fact that neither her father, an itinerant sheep shearer, nor her homemaker mother played tennis, at the age of three, Goolagong was given her first "tennis racket," a small board made from an apple crate that looked more like a tiny cricket bat. She tirelessly practiced hitting a ball against any flat surface she could find. At the age of nine, she read a cartoon about a little girl who dreamed of playing tennis at a magical place called "Wimbledon," and from then on, her waking and sleeping thoughts were filled with dreams of playing at the famed British tournament.

Such aspirations are big for anyone, but they seemed nearly impossible for a poor, Aboriginal girl from a tiny rural town. Tennis was a sport played by wealthy whites, and in the 1960s racism in Australia was rampant. The Australian government supported a welfare program that stole Aboriginal children from their families in order to be given a life away from poverty and an education in white Australian society. It was not uncommon for Goolagong's mother to tell her and her seven siblings to hide when she saw a car coming down the road, fearing it was someone coming from the welfare agency to take them away. It was legal to deny Aboriginals entry to bars, restaurants, and public places.

Things changed when a local tennis player named Bill Kurtzman invited Goolagong to play with him after he saw her looking at the courts through a hole in a fence. That led to her "discovery" at the age of ten by famed tennis coach Vic Edwards. At fourteen, she arrived at his home in Sydney with a handmade tennis dress her mother had fashioned out of sheets, and began training full-time. Five years later, in 1974, she found herself on the court of her dreams where she defeated fellow Australian Margaret Court at Wimbledon. Goolagong emerged a champion, and went on to win fourteen Grand Slam titles. The support from the people of her small hometown of Barellan inspired her to start the Goolagong National Development Camp, which helps encourage and facilitate Aboriginal children playing competitive tennis.

KIM AND SYLVIA GREEN

One simple sentence made Sylvia Green an unexpected activist and her nine-year-old daughter, Kim, a pioneer: "I'm sorry, little girls can't play baseball."

The infuriating words were born from a misunderstanding. Sylvia had brought Kim to sign up for the Midway Little League in their hometown of Newark, Delaware, because she had heard girls were now allowed to play Little League baseball in New Jersey, and she had assumed the ruling was nationwide. However, New Jersey was an exception to the rule: Little League regulations explicitly stated that girls were not allowed to participate. Kim, the daughter of a Major League Baseball player and an avid stickball player and bat girl for her brother's Little League team, was not permitted to sign up or try out. Sylvia had no intention of defying the rules in the moment, but the rejection compelled her to make sure that they were rewritten.

Sylvia learned that the edict had changed in New Jersey thanks to to a groundbreaking lawsuit filed by the National Organization for Women (NOW) in 1972 after a young girl named Maria Pepe was forced off her Little League team. NOW asserted that banning girls from play was unconstitutional gender discrimination. Despite the active protests of Little League's executive vice president, who testified to the "physiological differences" between boys and girls, and even dared to go as far to say that playing baseball could cause cancer in the latter group, the judgment was made in Pepe's favor.

The ruling in New Jersey set off a domino effect of matching lawsuits throughout the nation. By the time one of Kim's teachers, an active member of NOW, asked Sylvia if she could sue Little League in Delaware on behalf of Kim and four other excluded friends, there were twenty similar pending lawsuits. TV talk show host Mike Douglas got wind of the case and asked Kim to be a guest on his show alongside actress Marlo Thomas and Miami Dolphins fullback Larry Csonka. During the taping, Kim hit balls pitched by Csonka on a baseball diamond built in the studio. Csonka challenged the "no girls" rule on air and the crowd roared in awe of Kim's abilities and in agreement with Csonka's public declaration that she be allowed to play. Bending to the pressure of the impending lawsuits, on June 12, 1974, Little League announced that girls were now officially allowed to play. When Sylvia and Kim went to sign up, they were told that the teams had already been selected; Kim would have to wait until next year to play.

Unwilling to back down, Sylvia took matters into her own hands. She decided that she would start her own all-girls Little League team, posting signs all over town urging any girl ages eight to nine who wanted to play to come to tryouts. More than one hundred girls showed up, and the resulting team was christened "the Angels." The girls' collective talent and experience won them the first eight games of the season, finishing second in the league against all-boys teams.

The next year, Kim and girls across the country were all permitted to try out and participate in Little League. That first gender integrated year, it was estimated that more than thirty thousand girls played. Since 1974 the league estimates that hundreds of thousands of girls have joined Little League teams across the United States.

KITTY O'NEIL

As a child in Corpus Christi, Texas, Kitty O'Neil suffered from measles, mumps, and chicken pox, which rendered her deaf by the time she was four months old. Her mother, wanting her daughter to live as normal a life as possible, refused to let her learn sign language and instead taught her to speak by reading lips and holding a hand to her throat so that she could feel vocal vibrations. In high school O'Neil became a championship diver, but her Olympic aspirations were brought to a halt with the onset of spinal meningitis and a statement from doctors that she might never walk again. Triumphantly, she was on her feet in two weeks.

Undeterred by such obstacles in her life, O'Neil went on to race boats, cars, and motorcycles competitively. In 1976, she embarked on what would become a very successful career as a Hollywood stuntwoman, featured in hits like *Smokey and the Bandit*, *The Blues Brothers*, and *The Bionic Woman*.

That same year, she broke the women's land speed record by driving a 48,000-horsepower rocket-fueled vehicle named "the Motivator" across a dry lakebed in Oregon at 512 mph. She nearly broke the men's record as well, but was stopped by representatives of Hal Needham, a film director who had paid $25,000 for a chance to break the world record behind the wheel of the Motivator. He insisted she be pulled from the car, telling reporters that it would be "degrading" for a woman to break a man's record.

Nonetheless, O'Neil persevered, as she had from infancy. She retired in 1982 with twenty-two speed records on both land and water.

N59539

ELEANOR HOLM JARRETT

In July 1936, Olympic swimmer Eleanor Holm Jarrett boarded the SS *Manhattan* with dreams of clinching gold in the Berlin 1936 Olympic Games, just as she had in Los Angeles four years before. A world record holder at the height of her career, she had taken first place in every major race she competed in over the previous seven years. But when the ship arrived at its port in Hamburg, Jarrett was no longer a part of the American Olympic team. The events leading to her expulsion created a publicity firestorm and set the athlete's life on a path she never expected.

Two days after the *Manhattan* departed, Jarrett was invited onto the first-class deck to an all-night party for sportswriters. When nine o'clock struck, her female chaperone approached her and told her it was time for bed. "God, it was about nine o'clock, and who wanted to go down in that basement to sleep anyway?" Jarrett later recalled. "So I said to her: 'Oh, is it really bedtime? Did you make the Olympic team or did I?' I had had a few glasses of champagne. So she went to U.S. Olympic President Avery Brundage and complained that I was setting a bad example for the team, and they got together and told me the next morning that I was fired. I was heartbroken." Two hundred teammates came to her defense and petitioned Brundage to reverse the ban, but he wouldn't budge.

Despite her inability to compete, Jarrett still made headlines—and money. She stayed in Berlin and was hired by a news agency to report on the Games. Shortly after that, she secured the leading lady role in the feature film *Tarzan's Revenge,* and by 1937 was earning $700 a week as a vaudeville star. Her romantic life, unbelievably, was even more dramatic than her showbiz life. In 1939 she divorced her husband, singer Art Jarrett, with whom she had often performed "I'm an Old Cowhead" while wearing a white bathing suit, white cowboy hat, and high heels. She then married Billy Rose and became the star of his Aquacade musical and water show, doing thirty-nine performances per week. They lived in a five-story, fourteen-room house in Manhattan, until their vicious divorce in 1954, which the press coined "the War of the Roses." Jarrett accused Rose of being a "tightwad," a charge Rose refuted by pointing to her seven servants, collection of 113 pairs of shoes, 41 sweaters, and 11 fur coats, as well as her recent Christmas gift of coal wrapped in $10,000 in government bonds.

In 1966, Jarrett was inducted into the International Swimming Hall of Fame. She died in 2004, at the age of ninety.

FLORENCE ARTHAUD

Florence Arthaud survived a coma and overcame paralysis following a car crash at age seventeen to become the first to cross the Atlantic as an offshore racer. In 1990, she set the record for single-handed transatlantic crossing (with a broken radio), the first woman to win La Route du Rhum. A winner of many single-handed and team races, including the 1997 Transpacific with teammate Bruno Peyron (whose record she beat to win La Route du Rhum and set the new transatlantic record), Arthaud attempted to return to La Route du Rhum on the twentieth anniversary of her record-setting win, but was unable to secure sponsorship. At the time of her death, in a tragic helicopter accident alongside French Olympic gold medal swimmer Camille Muffat, she was planning an all-female offshore racing event out of her home port of Marseilles, France.

MELISSA LUDTKE

In 1973, Melissa Ludtke graduated from Wellesley College, a school that prided itself on matriculating "women who will make a difference in the world." Five years later, when she was twenty-six, Ludtke lived up to her alma mater's mission when she opened the doors to women's equality in the world of sports journalism.

In September 1974, Ludtke was hired as a researcher/reporter at *Sports Illustrated*, beginning her journalism career in the overwhelmingly male world of reporting. Being one of the only female reporters covering baseball brought with it a sense of isolation, and because she was a woman, many of her male colleagues assumed that she was ill-equipped to properly do the job. In a 2015 interview, she remembered:

> What I learned, was that I better know damn well what I'm talking about when I open my mouth, because there are going to be a lot of people watching me, a lot of people ready to say that I don't know what I'm talking about, a lot of people running to the assumption that I have to be there for some other reason than that I actually think I can do this job. That's kind of my memory of that time—putting pressure on myself to be as absolutely prepared as I could possibly be whenever I opened my mouth to speak or ask a question.

Three years after she was hired, the higher standard Ludtke had held herself to paid off when she was assigned coverage of the 1977 World Series between the New York Yankees and the Los Angeles Dodgers. There she hit an unexpected roadblock: Major League Baseball commissioner Bowie Kuhn said that because of her gender, she would not be permitted into the teams' locker rooms for essential postgame interviews. Kuhn's decision denied her the same access that male colleagues had. When negotiations between *Sports Illustrated* and the commissioner failed to secure equal access for its reporter, Time Inc. filed a lawsuit in federal court with Ludtke as the plaintiff. Inspired by the progress made by fellow sportswriters Robin Herman and Jane Gross—who had successfully broken the locker room gender barrier in the NHL and the NBA, respectively—she channeled their determination as proceedings began. In September 1978, district court judge Constance Baker Motley ruled in Ludtke's favor, ordering that women be allowed access equal to what their male colleagues had.

In January 1979, Ludtke left *Sports Illustrated.* Though she wrote the feature story, "The Despot and the Diplomat," about the strategic relationship of the catcher and home plate umpire for the 1978 spring baseball issue, along with many other stories, she had not been promoted since her arrival. She worked at CBS News, then *Time* magazine. In 1997, her book *On Our Own: Unmarried Motherhood in America* was published. The next year, she was named editor of *Nieman Reports* at Harvard University's Nieman Foundation for Journalism. She now produces and writes the multimedia project *Touching Home in China: In Search of Missing Girlhoods.*

FANNY BULLOCK WORKMAN

The only thing "feminine" about Fanny Bullock Workman's record-breaking ascent of Pinnacle Peak in the Himalayas in 1906 was that she did it wearing full skirts. Born to a wealthy family in Massachusetts in 1859, Bullock spent her life railing against the traditional role of a Victorian woman. She married William Workman when she was twenty-two and together they used their inheritances to move to Europe, where they began a life of exploration and adventure. She gave birth to a daughter, Rachel, in 1884 and left her at home with a nurse while they climbed the peaks of the Matterhorn and Mont Blanc. In 1898, they took their first trip to the Himalayas and discovered their mutual passion for climbing and mountain exploration. By the time their daughter turned eighteen, the Workmans had taken eight trips to the Himalayas and three epic bike rides across Spain, North Africa, and India. They coauthored books about each trip, though Fanny handled most of the writing duties. Their books were not only climbing accounts, but social commentaries as well, often denouncing the treatment of the women in the countries they visited.

Seemingly immune to altitude sickness, Workman had an advantage over many of her fellow explorers. In 1911, she and William went on a two-month exploration of the forty-five-mile Siachen Glacier, mapping the region and naming several of the peaks. Though she was an outspoken supporter of the suffrage movement and spent her life battling the male-dominated climbing community, Workman maintained a bitter rivalry with fellow female trailblazer Annie Peck Smith for many years. When Peck announced that she had broken a record, climbing 23,000 feet in Peru, Workman spent a large sum of money sending researchers to the mountain to measure for accuracy. When they discovered that that mountain was one thousand feet lower than Peck had estimated, Workman had the findings published in *Scientific American.*

Workman earned medals of honor from ten European geographical societies and was one of the founders of the American Alpine Club. She was the second woman to address the Royal Geographical Society and the first American woman to lecture at the Sorbonne.

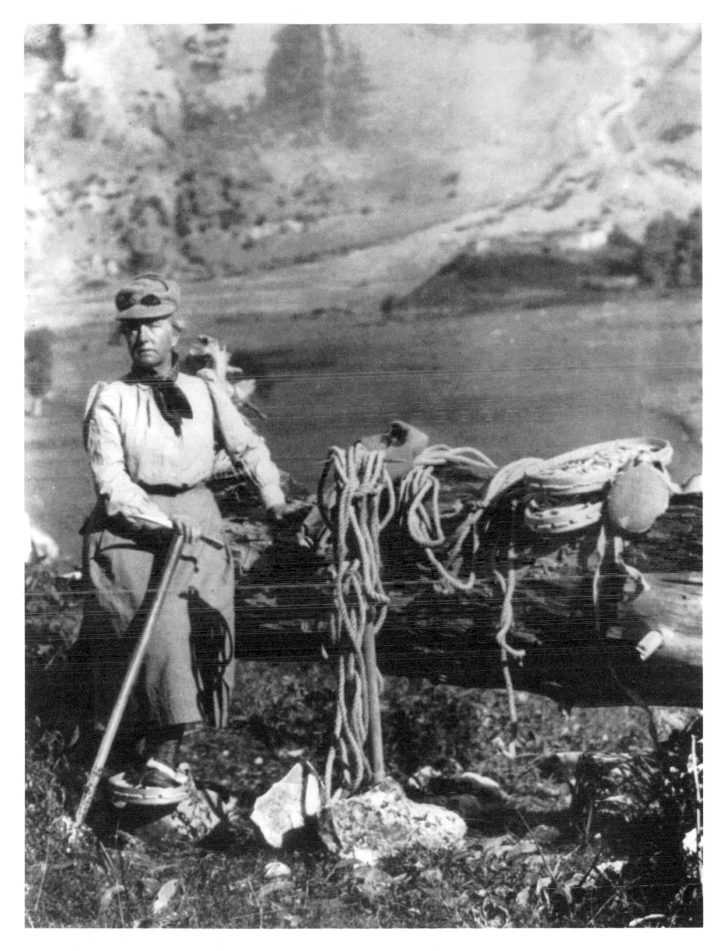

145

MARGARET MCGREGOR

In the midst of a heated argument, Margaret McGregor's first husband punched her. After that, she left him and vowed, "No man will ever do that to me again unless I let him." She made good on her promise by becoming one of the top-ranked female boxers in the country and on October 9, 1999, after going undefeated in her first first three professional bouts, stepped into the ring at Seattle's Mercer Arena—against a man.

The historic coed match was initially suggested to McGregor's manager, Vern Miller, as a joke by Bob Jarvis, the manager of a fighter in the main event of the October 9 card. Vern couldn't find another woman to fight against Margaret, and Bob felt that additional press for the undercard could boost ticket sales for his player's fight. After it was discovered that the Washington State Licensing Department didn't have any rules against mixed gender match-ups, the fight was on. The National Association of Boxing Commissions, expecting the worst, was staunchly against the idea, but nothing could be done. Even officials with the International Female Boxers Association denounced the match, saying that it would make a circus out of a female boxer, and had the potential to undo the small strides being made by the sport of women's boxing at the time.

McGregor was initially matched up against a fighter named Hector Morales, but he withdrew, uncomfortable with the idea of fighting against a woman. Soon, a thirty-three-year-old part-time jockey named Loi Chow stepped in. The traditional insults were thrown back and forth in the days leading up to the fight. In an interview with the *New York Times*, McGregor said, "If he thinks he's getting a cream puff, he's in for a real jolt. . . . I'm going to rock his world." She declared at another time, "This ain't no party, this ain't no disco. . . . Loi Chow's going down." Chow responded, "If she can get past my first punch, I'd be surprised." The state licensing department sanctioned the McGregor versus Chow match largely because they felt that the fighters were evenly matched. They could not have been more wrong. Standing at 5'5", McGregor towered above her opponent's 5'2" frame. In addition to her undefeated professional record, she also had an 8-0-1 record as a professional kickboxer. Chow had barely any experience as a boxer and was 0-2 in his fights against men.

In front of a packed stadium of 2,768 fans, McGregor danced around the ring, tirelessly throwing well-aimed punches for the entire match. Chow was largely on the defensive, his lack of training and experience as a boxer becoming more apparent with each passing moment. McGregor's punches weren't knocking him down, but they were racking up points. In the final moments of the fight, the entire arena chanted, "Margaret! Margaret! Margaret!" as she threw a combination that sealed her victory over Loi, 40 to 36. Both contestants excited the ring with minimal injuries.

After the fight, both fighters were asked what they thought the bout proved. Chow responded, "It proves a woman cannot hurt a man." McGregor replied, "Just that I'm a winner." Despite huge publicity and viewership, the contentious nature of the fight (especially considering the horrible domestic violence statistics in the country and that McGregor was a survivor of abuse herself) never sat well with television programmers, who publicly declared that they would never air or condone a boxing match between a man and woman. The McGregor versus Chow fight was the first and last of its kind.

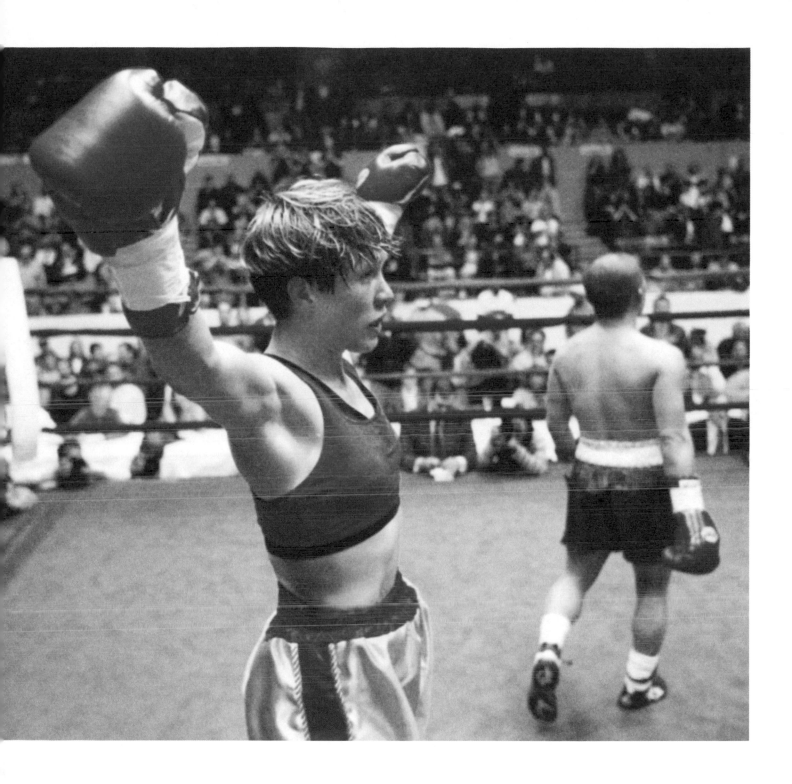

HELME SUUK

Helme Suuk became the first Estonian woman to ascend a peak above 23,000 feet when she summited the Pik Lenin, the second-highest mountain in the former Soviet Union. In 1991, she became the first woman from a Baltic country to be designated a Snow Leopard, an honor bestowed by the Russian government upon mountaineers who successfully summit all five peaks above 23,000 feet in the former USSR. The designation remains recognized today by the Commonwealth of Independent States. Over her decades-long career, Suuk has climbed more than one hundred of the highest mountains in the region and beyond, including Carstensz Pyramid, the highest mountain in Australasia, and participated in an expedition of Cho Oyu, the sixth-highest mountain in the world.

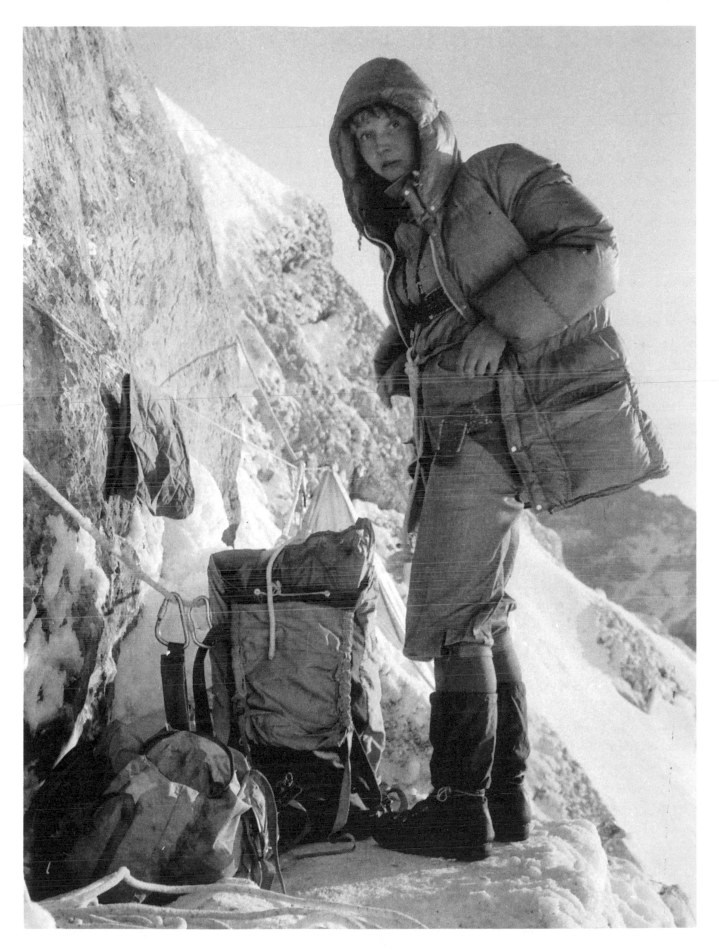

FLORENCE LEONTINE "PANCHO" BARNES

When the blue-blooded Californian Florence Leontine Lowe left her first husband, the Reverend C. Rankin Barnes, she fled south of the border and stowed away on a banana boat headed into the wilds of Mexico. Unbeknownst to her, the vessel was loaded with another kind of cargo: guns intended for a pack of revolutionaries. Lowe escaped with the help of a fellow American named Roger Chute, who had gone to Mexico seeking adventure. She stayed with him for seven months, where she protected herself by living in disguise as a man. When she finally crossed the border back into America, she had christened herself "Pancho." Florence Leontine Lowe was officially gone and "Pancho Barnes" emerged in her place.

Barnes had once been expected to follow in the footsteps of her debutante mother, but she was a pants-wearing rebel who followed in the footsteps of her paternal grandfather, Professor Thaddeus Lowe, a strong personality with a great interest in aviation. In 1928, she met a World War I veteran pilot and convinced him to teach her to fly that very afternoon. She quickly earned her membership into the National Aeronautic Association, with an official signature by Orville Wright, the founding father of flying, on her certificate. Barnes became addicted to flying. Her style could be characterized as devil-may-care when it came to safety, with speed and flashy style held above all else. She partici-pated in the first cross-country all-female air race, known as the "Powder Puff Derby," competing against the great Amelia Earhart in 1929. Though she failed to win that race, she made a memorably dangerous finish when her plane crashed into a moving automobile on the runway as she landed, nearly killing her. In 1930, she officially became the fastest woman on earth when she pushed her flying speed to a record 195 mph, besting Amelia Earhart's previous record of 185 mph.

Soon enough, Barnes found her place in stunt piloting for Hollywood films. Her performances appeared in Howard Hawks and Howard Hughes films, and eventually she became the founder, organizer, and only female member of the Association of Motion Picture Pilots, a union for stunt fliers. After losing much of her inheritance during the Great Depression, she bought 180 acres in the Mojave Desert, upon which she built the "Happy Bottom Riding Club." Part dude ranch, part restaurant, it catered to airmen from the nearby airfield and friends of hers from the film world in Hol-lywood. As the club became known for wild parties and high living (in addition to free steak dinners given to any pilots who broke the sound barrier), Barnes entered into a brutal battle with the United States Air Force over her property. When she refused to sell it to the air force to make way for a superlong runway, lawsuits ensued and when she pushed back, the ranch suddenly burned down in a mysterious fire, the cause of which was never discovered.

Eventually, the government bought her out and Barnes moved to Cantil, California, in hopes of starting anew. The Happy Bottom Riding Club was never rebuilt, but when Barnes passed away in 1975, her son received permission from the government to spread her ashes over the land upon which the club had stood. Flying a small Cessna airplane, he dropped the ashes over the site, only to have them get caught in a crosswind and blown back into the plane as if Barnes were performing one final stunt.

LYNN HILL

On the southern face of the monolith vertical rock formation in the Yosemite Valley known as El Capitan juts a massive prow that is home to a treacherous climbing route called "the Nose." Ascending the Nose's 2,900-foot sheer rock face without equipment was long considered impossible. That is, until 1993, when mountain climber Lynn Hill became the first person in history to "free-climb" it, using only her hands and feet in addition to fall protection. She did the seemingly impossible in four days. The following year, she returned and did it again in twenty-three hours.

The ascent up "El Cap" was something of a homecoming for Hill, who became a professional indoor climber in 1988. In a six-year span, she won more than thirty international titles, five of which were from the sport's most venerated competition, the Arco "Rock Master." She was considered the best climber in the world, male or female. Despite her success on the competitive circuit, she yearned to return to her roots and go back to climbing outdoors. In an interview with Andy McCue for *Climber* magazine, she said:

> [Climbing] the Nose was much bigger than me, it wasn't about me, it wasn't about my ego, my gratification. . . . I felt like I had a chance and that if I could do that it would be a really big statement to people to think about. . . . People tried to do that route and they failed on it and so if a lot of good climbers have come and tried to do it and failed and a woman comes and does it first it's really meaningful. That was my underlying motivation.

After she retired from competition, Hill continued to climb rock formations, often in remote and exotic places like Kyrgyzstan, Vietnam, Thailand, Scotland, Australia, Japan, South America, Italy, and Morocco. In 1999, she led a small, all-female team that successfully summited the 17,500-foot granite wall of the Tsaranoro Massif on the island of Madagascar. This route turned out to be the most difficult first-ascent, multi-pitch rock climb ever done by a team of women.

To this day, Hill remains true to the spirit of her early climbing days, when the sport was something reserved for societal outcasts and nonconformists. She is an outspoken proponent of women's equality in the climbing world, proving over and over again through her accomplishments that the sport is an objective medium that doesn't discriminate by size or gender. She currently resides and continues to climb in Boulder, Colorado.

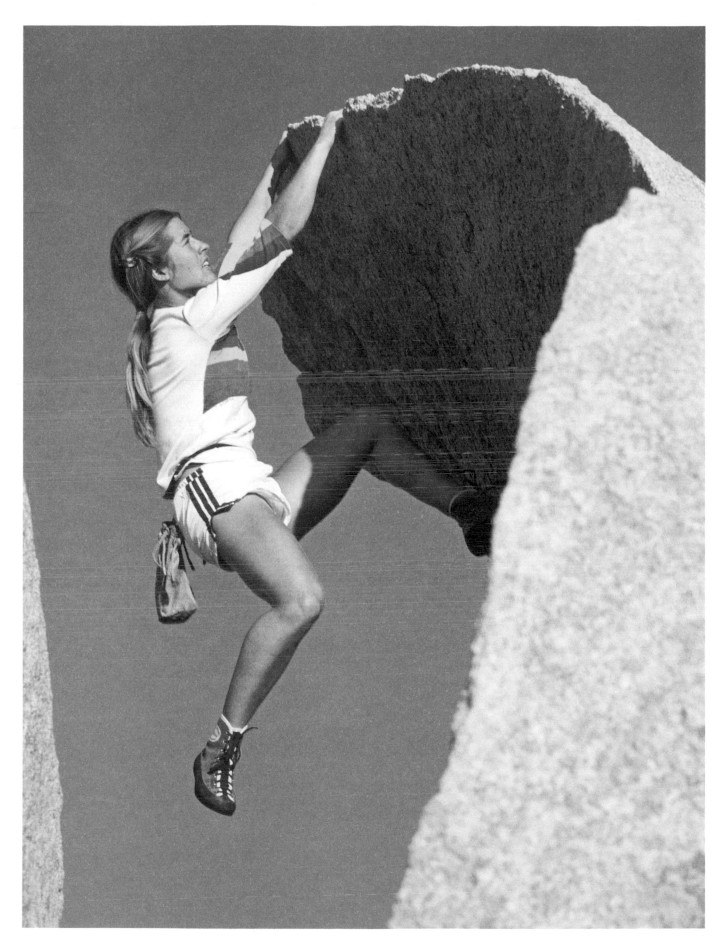

JOAN WHITNEY PAYSON

At most New York Mets games in the twentieth century, you could spot Joan Whitney Payson seated in the stands, enjoying a hot dog or Cracker Jacks, her portable radio tuned into the game, with her fingers visibly crossed during crucial plays. She seemed like any other devoted fan, but she had a much more important role to play: she was the majority owner of the team.

Payson, an heiress, philanthropist, and member of the prominent Whitney family, decided to mount a campaign toward creating a new National League franchise after she could do nothing to stop the New York Giants (in which she had a 10 percent stake) from moving to San Francisco. And so the New York Mets were founded in 1962, with Payson serving as the team's president from 1968 until her death. She was the first woman in history to own a Major League Baseball team in North America without inheriting it.

Known for her down-to-earth demeanor (despite a $100 million inheritance she received while just in her twenties), Payson was the mother of the Mets, as well as its patron and biggest fan. Dedicated to many civic and philanthropic causes, she was a frequent sight at charitable functions with her transistor radio, so she could follow whatever game was playing at the same time. She kept score of every game in a personalized code, averted her eyes during high-stakes plays in fear for "her boys," and had the Mets insignia stitched on nearly everything in sight. Her enthusiasm for her team was crucial for morale, especially during the 1962 season when the Mets accumulated a devastating 120 losses. In 1969 her faith (and investment) was finally rewarded when the team, despite being 100-to-1 long shots, miraculously went from ninth place in the league to World Series champs.

In 1972, after a decade's worth of attempts, Payson successfully negotiated the New York homecoming of former Brooklyn Giants star and baseball legend Willie Mays. The following year, the Mets made it to the World Series finals for the second time. It was as if the years of her good faith finally began materializing on the playing field; no longer known as the "lovable losers," the win made them known as the "Miracle Mets." During the 1973 season, the team's rallying cry became "You gotta believe!" (now officially trademarked by the team), proving that the fans had come to occupy the same place of loyalty and enthusiasm carried by Payson. She passed away in 1975 at the age of seventy-one and was posthumously inducted into the New York Mets Hall of Fame in 1981.

JACKIE TONAWANDA

Jackie Tonawanda, aka "the Female Ali," was the first woman to box in Madison Square Garden. Her history-making fight also happened to be against a man named Larry Rodania, whom she knocked out in the second round. She was 5'11", 175 pounds, and could pack a punch that would send her opponents into next week. In 1975 Tonawanda, along with two other female boxers, filed suit against the New York State Athletic Commission, seeking a license to box. She later became Muhammad Ali's bodyguard at his training camp in Deer Lake, Pennsylvania, and was the first woman boxer to become a member of Ring 8, a nonprofit organization based in New York City to help former boxers in need of financial assistance, including housing, medical care, and funeral-related expenses.

KOREAN DEEP SEA DIVERS

The Haenyeo or "Sea Women" of the Korean island of Jeju are known for repeatedly crossing the fine line between life and death. For more than three centuries, they have tempted fate for a living as they free-dive in frigid ocean water without the aid of diving equipment or a breathing apparatus. Sparsely armed with goggles, flippers, and lead belts (to promote a more rapid descent), the women go as deep as forty feet, spending up to two minutes underwater at a time, with five to six hours of diving a day, as they harvest conch, octopus, and abalone by hand. Before the introduction of wet suits, the Haenyeo dove in cotton suits, primarily to maintain modesty and allow women to dive when pregnant.

Recognizing the ever-present danger of their daily duties, the Hae-nyeo pray for protection from the Sea Goddess and sing traditional songs whose lyrics mention "diving with a coffin on the head" and "toiling in the netherworld so our family can live in this one." The diving tradition itself dates back to 434 CE and was a job for men until the seventeenth century. Due to the high mortality rate of men in war, combined with deep-sea fishing accidents, the responsibility of free diving and harvesting was eventually taken over by women. By the eighteenth century, the number of female divers outnumbered the male. This occupational reversal turned the Haenyeo into the primary earners for the island, resulting in a dramatic social conversion: 60 percent of the island's fishing revenue was now brought in by women, and so Jeju became a semi-matriarchal society. Though the rest of Korea remained unwaveringly patriarchal, the people of Jeju celebrated the birth of baby girls over men, and grooms paid a dowry to the family of their brides.

The Haenyeo are sometimes referred to as the "Amazons of Asia." In the 1960s there were more than 20,000 of them active; today there are approximately 2,500 divers, with the majority over the age of sixty. This rapid decline prompted South Korea to apply for the Haenyeo's inclusion on UNESCO's Intangible Cultural Heritage list. It is very likely that the current generation of Haenyeo will be the last.

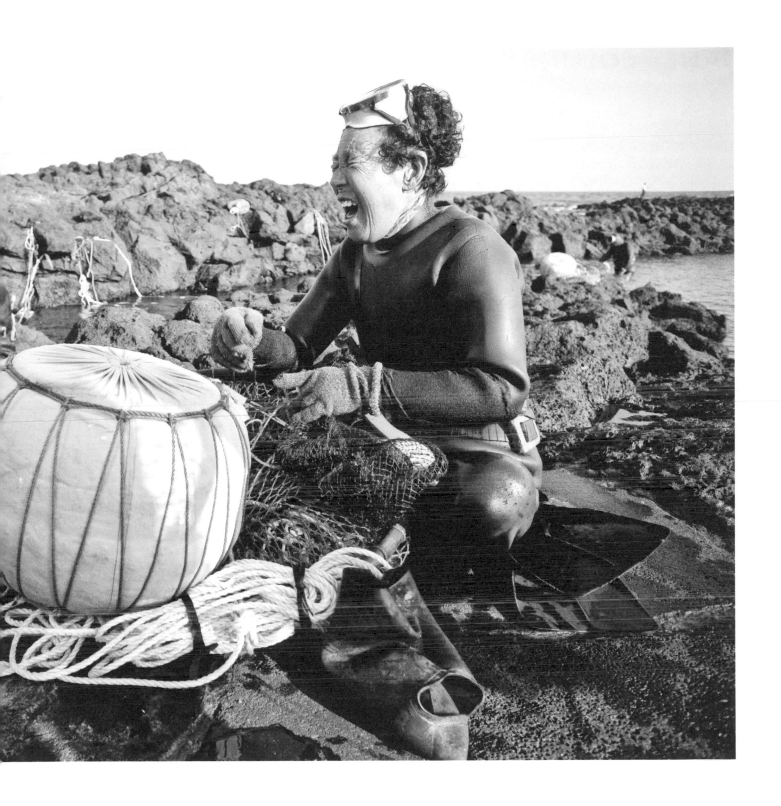

JANET COLLINS

On November 13, 1951, as the curtain came up on the Metropolitan Opera's season premiere of *Aida*, Janet Collins, one of the newest members of the company's *corps de ballet*, stepped out onto the stage, breaking the sixty-eight-year-long color barrier that had existed since the opera company's inception. She made history as the first black artist to ever be under regular contract at the Metropolitan. One year later she made history again, as the first African-American prima ballerina in the company.

Collins was born in New Orleans in 1917, but her parents relocated their family west to Los Angeles in pursuit of a life free from the oppression and discrimination that permeated every inch of life in the South. She studied classical ballet, along with modern and ethnic dance, at the Los Angeles Art Center School from the age of ten. Though California provided some wonderful opportunities, the world of ballet was still rooted in a prejudiced, narrow mind-set. At the age of fifteen Collins was offered a spot in the prestigious Ballet Russe de Monte Carlo, but was told by troupe director Léonide Massine that she would have to begin in the corps—and be painted white. She refused.

In Los Angeles, she danced in two major film musicals (*Stormy Weather, The Thrill of Brazil*), but it was a live performance at the Las Palmas Theater that resulted in a trip across the country to New York, where she danced her original choreography at the 92nd Street Y and captivated the New York critics. A *New York Herald Tribune* reviewer wrote, "It took no more (and probably less) than eight measures of movement in the opening dance to establish her claim to dance distinction. . . . She could, and probably would stop a Broadway show in its tracks as easily as she could and will cause a concert-going audience to shout for encores." In 1949, *Dance* magazine named her "Most Outstanding Debutante of the Season."

The next year Collins was on Broadway, dancing a solo created for her by Hanya Holm in the Cole Porter musical *Out of This World*. It was in this role that she caught the attention of Zachary Solov, the ballet master at the Met. In a later interview with the *Los Angeles Times*, Solov recalled the moment he first saw her perform: "She walked across the stage pulling a chiffon curtain, and it was electric. The body just spoke." Less than one year later, she was onstage in *Aida*. During her tenure with the Metropolitan Opera, she performed lead roles in *Carmen, La Gioconda*, and *Samson and Delilah*. She enjoyed success in New York but was not immune to racism, especially while on tour in the segregated South. She was often barred from dancing and forced to give up her performances to her white understudy.

Collins stayed with the Metropolitan Opera until 1954. Later she began teaching modern dance, which evolved into a career in choreography. In 1974, the Alvin Ailey Dance Company held a tribute to her groundbreaking career, which included her final piece to premiere in New York City, "Canticle of Elements."

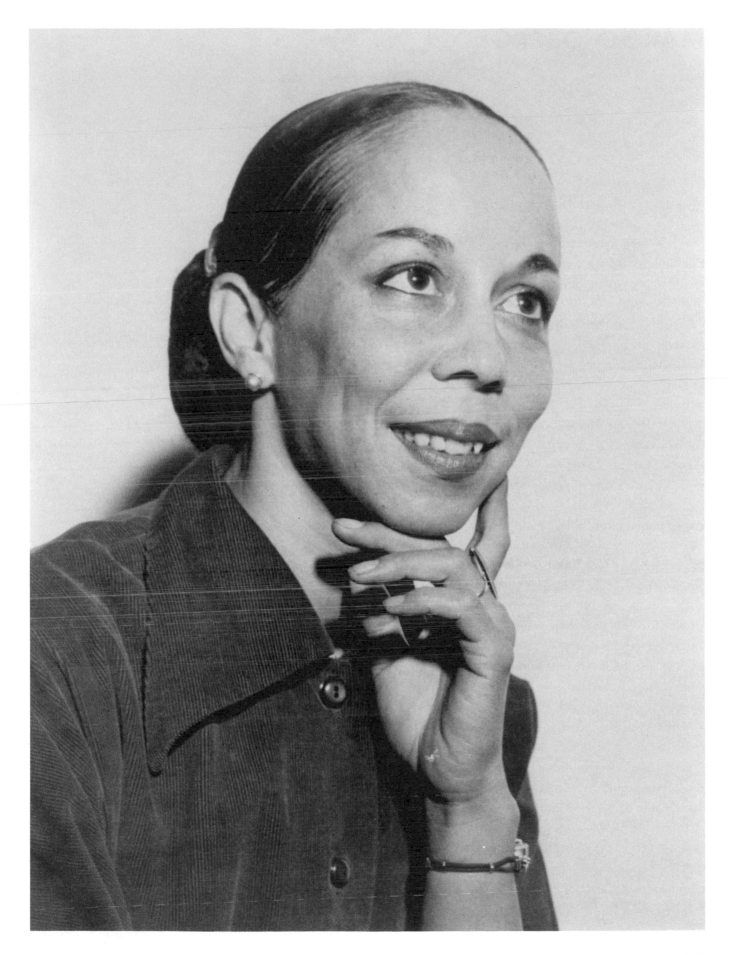

MARGO OBERG

*There are ten really famous male surfers in the world,
and one really famous female surfer. That's me.*

—Margo Oberg to People *magazine*

Margo Oberg (née Godfrey) started surfing off the coast of La Jolla, California, when she was ten years old. In 1968, she stunned the world by defeating twenty-one-year-old reigning surf queen, Joyce Hoffman, at the World Contest in Puerto Rico. Oberg was only fifteen, intensely competitive, and had a smile full of braces. The same year, she won the Makaha International, the East Coast Championship, and the Surfer Poll. After winning the Santa Cruz Pro-Am, she became the first woman to earn a paycheck ($150) through surfing.

When Oberg lost the 1970 World Contest, she was so devastated that she officially retired from the sport, two years before she finished high school. Five years later, she came out of retirement when she was offered a lucrative contract by the surf brand Lightning Bolt. In 1977, the International Pro Surfing tour added a women's category. Oberg seized the first title, but a year later she lost by a hair to a surfer by the name of Lynne Boyer. Her extreme distaste for losing came through again when she took a hiatus in 1979, later saying with a smirk, "Don't you love how I lose? I quit then I pout."

Upon her return to surfing in 1980, Oberg clinched another world title and reignited her rivalry with Boyer. It was a spectacular battle of athleticism and egos between surfing's two most accomplished women. When Oberg was asked in an interview who her favorite surfer was, she famously replied "myself." She left professional surfing for the third and final time after winning her fourth world title in 1983.

Oberg was inducted into the International Surfing Hall of Fame in 1991, the Huntington Beach Surfing Walk of Fame in 1995, and the Hawaii Sports Hall of Fame in 2001. She opened the Margo Oberg surfing school in Poipu Beach, Kauai, in 1977, where she continues to teach and shape the sport.

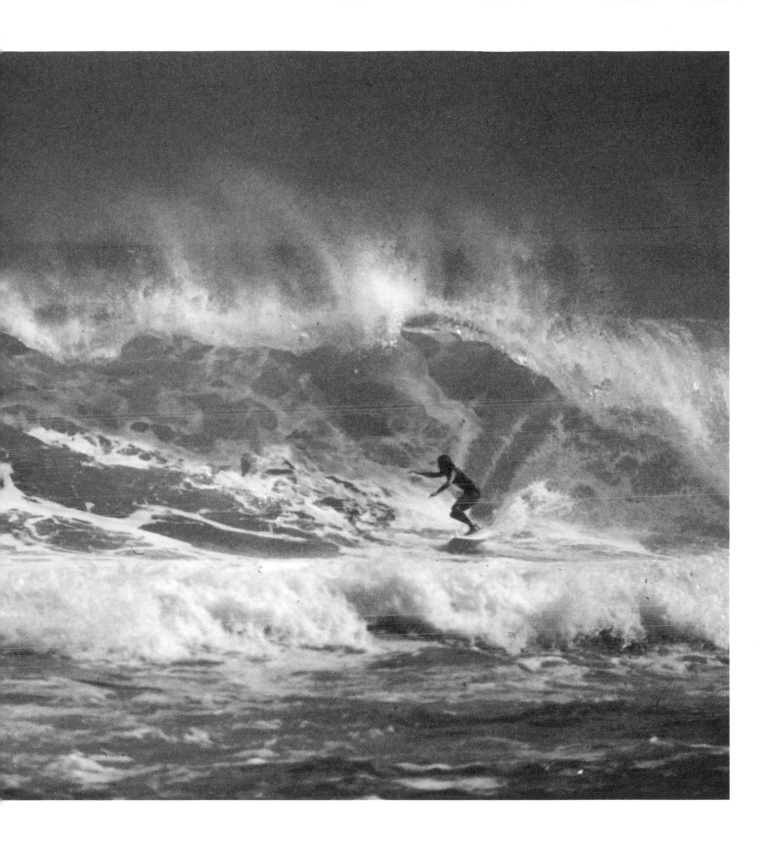

GRETCHEN FRASER

At the opening ceremonies of the 1948 Winter Olympics in St. Moritz, Switzerland, most people did not know who Gretchen Fraser was. Those who did dismissed her; one member of the press called her a "pretty Western housewife." That reporter, along with the rest of the world, never expected that the twenty-eight-year-old Washington State native with a penchant for wearing her hair in pigtails would become the first American, man or woman, to medal in an alpine ski event.

That year, fans had placed their bets on a fifteen-year-old phenom named Andrea Mead, a Vermonter born into a family of skiers who owned and operated a local ski resort. While Mead was practically born in skis, Fraser came late to the game, having only started skiing at thirteen and taking lessons at seventeen. She improved at a remarkably fast pace, claiming her first big victory one quick year later at the 1937 Northwest Championships. The outbreak of World War II and cancellation of the 1940 Winter Games dashed any hopes of making the Olympic team, so with the country in upheaval and her athletic career on an unforeseeable hold, she spent the duration of the war in Sun Valley, Idaho, volunteering on a ski resort that had been repurposed as a U.S. Navy facility for wounded soldiers. Skiing was reduced to a rare indulgence, though on occasion Fraser worked on instructional ski films for the military. The war years coincided with the years of what most would have considered her athletic prime, but nothing could be done about it.

When peace was declared in 1945, Fraser was in no rush to make up for the time that the war took away. She didn't return to competitive skiing until 1947, but for the second time in her life, she proved that she was an athlete who defied convention. In an astonishing turn that mirrored her earlier trajectory, she made the 1948 Olympic team after only having been back in the game for a year.

In St. Moritz, she shocked the world when she took the silver medal in the women's combined race. Suddenly, Fraser had made history as the first American to medal in the sport. That victory alone would have sufficed, but it turned out to be only a prelude to the main event. In the slalom, she had the fastest time to beat on her first run out the gate. Then, despite a delay with the timing system the kept her waiting at the top of a mountain in a bitter-cold starting gate for seventeen minutes (which could easily wear out spirit, mind, and body), she had the second-fastest run for her second run: the gold medal for slalom was officially hers. The late-blooming athlete finally found herself ahead of the pack when it mattered most.

Fraser returned home to a shower of ticker tape in a parade attended by crowds of loving, admiring Americans. She promptly retired from competition, focusing her life's goal on working with the handicapped in Sun Valley as a founder of the Flying Outriggers club for amputee skiers. She also became a mentor to younger athletes, including future Olympians Picabo Street and Susan Corrock. When she passed away at age seventy-five in 1994, her ashes were scattered over her namesake ski run in Sun Valley: "Gretchen's Gold."

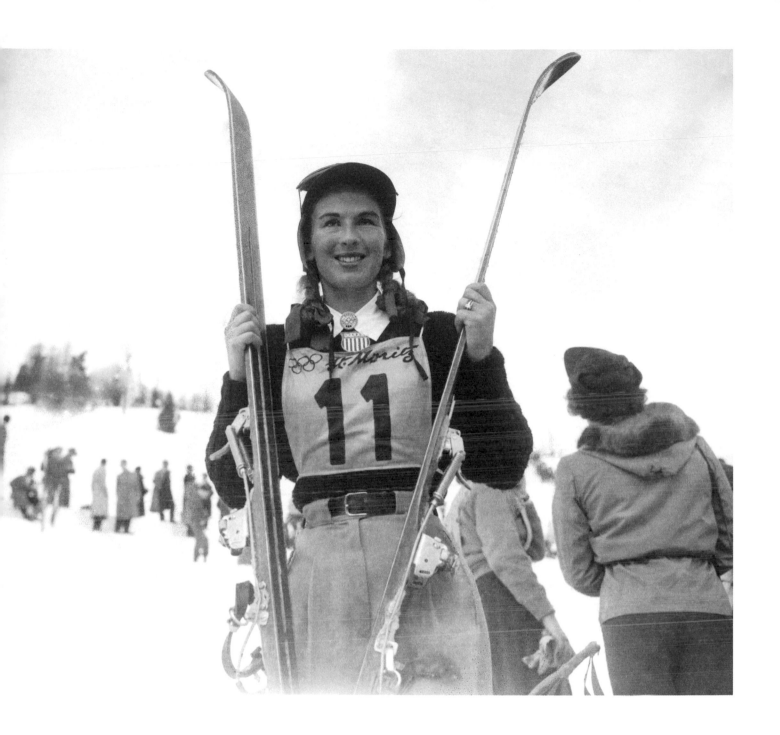

MIRIAM "LADY TYGER" TRIMIAR

Fed up with failed attempts to bring legitimacy to the sport of women's boxing, boxer Miriam "Lady Tyger" Trimiar stopped eating completely. For one month, the former world women's lightweight champ refused food, losing thirty pounds in just as many days. As she explained to a reporter from the *Chicago Tribune*, "We've tried being nice, but nice doesn't work."

Joined by boxers Joanne Metallo and Del Pettis, the trio aimed to improve opportunities for the estimated three hundred licensed professional female boxers worldwide using the extreme measure. They stated to the media:

> *Professional women boxers are exposing the myth of their nonexistence and proclaiming the facts of years of devoted training, the sacrifices they have made for boxing careers and the daily economic hardships they must face despite boasting world championship trophies. . . . Unless women get more recognition, we will be fighting just as a novelty for the rest of our lives. There will be no future.*

Inspired as a child by the fights and professional trajectory of Muhammad Ali, Trimiar, a native of Harlem, took up boxing in hopes that it would be her "vehicle out of the ghetto." Though it did do that, the venues it brought her to were nowhere near the ones she saw Ali fight in on TV. Poor promotion, low prize money, and an absence of coverage made it impossible for the sport to catch on.

Trimiar stopped fighting professionally in 1985 and never enjoyed the fruits of her efforts, though years later her legacy lived on when famed boxing promoter Don King signed female boxer Christy Martin to appear on his pay-per-view promotions.

In a 1995 interview with the *New York Times*, Trimiar gave advice to aspiring boxers, the harshness of her history reverberating through her message: "I'd tell women boxers the same I'd tell the men. Go to school. Don't give boxing everything. But I'd tell them, watch out. You don't realize the prejudice out there. Of all the isms, and I know them all, sexism is the worst."

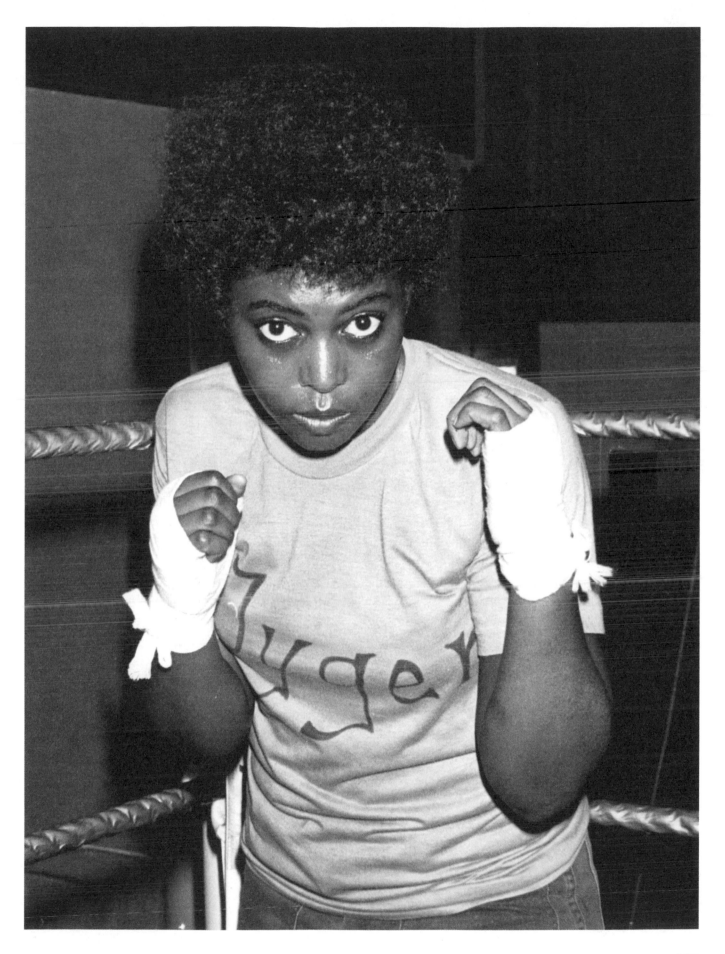

JOAN WESTON

Off the roller derby track, Joan Weston's favorite things were dogs, Disneyland, and the movie *Babe*. On the track, at 5'10'' and 165 pounds, she was known as the Blonde Bomber, with a mouth full of false teeth to prove her ferocity. Weston was the star player of the San Francisco Bay Bombers in the 1950s, a time when roller derby was a national fascination.

When Weston was twelve, she saw roller derby on TV and went straight to the Los Angeles track to ask if she could join the team. They laughed at her request and told her to come back when she was older. She did, and after four days of training she was picked up by the Brooklyn Red Devils. Having lived a sheltered life, Weston was shocked by the language and lifestyles she encountered at the derby and nearly quit. She called her mother, a truck stop waitress, and asked for advice. "Joanie," her mother replied, "Derby people aren't any different from any other people in this world. People and sex are like franks and beans. They go together."

Weston skated full-time for eighteen years and then part-time for another twenty-four. She was voted Roller Derby Queen four times, and continued to be thrilled by her success. Of her stardom, she once exclaimed, "Do you know what it's like to be able to bring twenty thousand people to their feet? To make them hate or love you? That's where it's at. Power!"

Though roller derby struggled to break from the taboo of spectacle to the respectability of sport, there is no doubt that Weston was an incredible athlete on the track and beyond. She excelled at every sport she tried. While playing softball at St. Mary's College in Los Angeles, she once hit eight home runs in a single game before the nuns forced her to ease up on the other team. She surfed the Pacific Ocean sans wetsuit and, while in Hawaii, threw herself off a waterfall on a boyfriend's dare. She later learned that human sacrifices had historically been hurled off the very same cliff.

Weston died at age sixty-two of a rare brain disease, but her legacy as the Blond Bomber lives on.

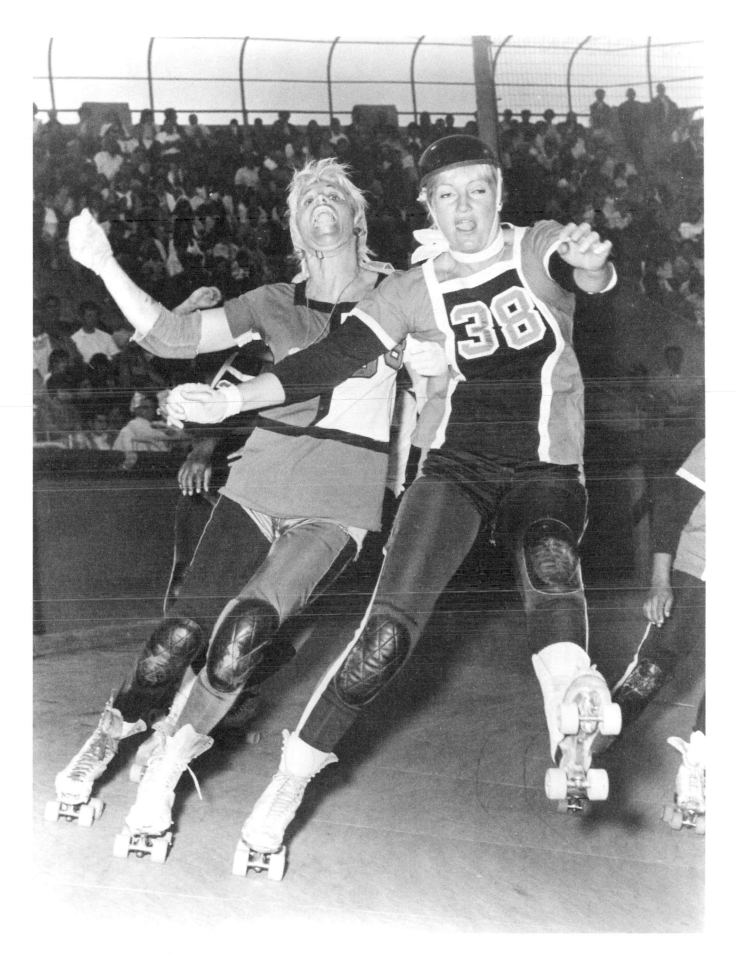

LISA OLSON

Though *Sports Illustrated* reporter Melissa Ludtke won equal access for female reporters to team locker rooms in 1978, change was slow to come. Harassment and humiliation by male athletes became a matter of course, reaching a very public climax in 1990, with *Boston Herald* reporter Lisa Olson at its center.

Olson had been covering the New England Patriots for a few months, and on September 17, she entered the Patriots' locker room to interview a player about an injury. Suddenly, she found herself surrounded by three players: Robert Perryman, Michael Timpson, and Zeke Mowatt. Mowatt allegedly stood in front of her, an arm's length away, fondled his genitals, and taunted, "Is this what you want? Do you want to take a bite out of this?" The other two crowded around her, naked and making lewd gestures, while other the players yelled, "Give her what she wants! Give her what she wants!" She fled the room, shaken and furious, later telling *People* magazine in an interview, "I didn't know whether to scream or break down and cry. It was a premeditated mind rape. After a few minutes, I gave up trying to interview Maurice, thanked him and walked away. I felt total, blind rage." Then-owner of the Patriots Victor Kiam II responded to the accusations by saying, "I can't disagree with the players' actions." He blamed the incident on the *Herald*, claiming they had "asked for trouble" when they assigned a female reporter to the beat. Kiam didn't spare the press his feelings about Olson, either, reportedly calling her a "classic bitch."

An investigation was launched into the incident and as a result, Olson was subjected to an avalanche of obscene phone calls and hate mail from Patriots fans. Her tires were slashed and her home was burglarized. She was even left a note that said, "Leave Boston or die." Fearing for her safety, she fled to Australia, where she remained for six years, writing for the *Sydney Daily Telegraph Mirror*. After returning to the United States, Olson continued to receive hate mail, but refused to back down from the job she loved. She went on to work for the New York *Daily News* and then AOL's *Sporting News*. In 2013, Olson was awarded the Mary Garber Pioneer Award, the highest honor from the Association for Women in Sports Media.

ROBYN SMITH, BARBARA ADER, AND BRENDA WILSON

Jockeys Robyn Smith, Barbara Ader, and Brenda Wilson in 1969 after competing in the first all-female, pari-mutuel race in the United States, the six-furlong Lady Godiva handicap at Boston's Suffolk Downs. Penny Ann Early, who had become the first licensed female jockey in America the year before and attempted to ride at Churchill Downs shortly thereafter (resulting in a unanimous boycott by the male jockeys and cancellation of the race), took home the $10,000 Lady Godiva purse.

JEAN BALUKAS

"I won, I beat her!"

That proud shout was rarely heard in Jean Balukas's Bay Ridge, Brooklyn, home, as her four older brothers lived with the one thing that traditionally makes little boys insane: losing to a girl. But losing to a boy—and eventually, to men—proved to be just as infuriating a concept to Balukas, who saw every defeat as an aberration of what she was truly capable of. In 1969, at the age of nine, her self-taught gifts soon became recognized beyond her basement table and her father's pool hall as she competed in her first Billiard Congress of America U.S. Open Straight Pool Championship. In 1972, at the age of thirteen, she won the first of what would become seven straight titles at the U.S. Open. She later claimed the world championship title six times, and later jumped to the men's tour, seeking more of a challenge, as she handily outplayed her female opponents.

Balukas's career only lasted nineteen years. Though some people might consider that a lengthy run, she was at her athletic prime at the time of her retirement. Twenty-eight years old, she had decided enough was enough. She had been competing in women's and men's tournament for some time, but resistance from all sides of the sport soon built up to a distracting degree. Many men refused to play her, and others demanded she abide by the strict wardrobe guidelines of "formal attire" set solely for female pool players, which she actively fought. In 1987, she dropped out of the women's side of the BC Open tournament in protest of the dress code. When she realized that opposition was futile, she attempted to rejoin the women's tourney, only to be refused entry. A year later, Balukas blurted out a rallying taunt to herself and her opponent at the Brunswick Invitational to "win with skill, not luck." Calling out during the competition was against the rules, and when microphones caught the words, her opponent filed a complaint, challenging her win and ordering that she be fined $200 for unsportsmanlike conduct. Balukas refused to pay the fine, out of principle.

To this day, Balukas is the youngest player and the second woman inducted into the BCA Hall of Fame. She now lives a quiet life running her family's wholesome smoke- and alcohol-free pool hall.

JOE CARSTAIRS

One of the least remarkable facts of the fascinating life of Marion Barbara "Joe" Carstairs would be considered a crowning achievement in anyone else's: she was a championship motorboat racer who spent millions of dollars building and racing customized boats, winning the prestigious Duke of York's Trophy in 1926.

The other details that make up Carstairs's eccentric existence read more like fiction than fact. She was the cigar-smoking, tattooed heiress to the Standard Oil fortune. She preferred wearing men's clothing. Her love life consisted of torrid affairs with Hollywood starlets like Marlene Dietrich and Tallulah Bankhead, but despite her many lovers, the only lasting object of her affection was a foot-tall leather doll named Lord Tod Wadley, which had been given to her by a girlfriend in 1925 and whom she called "her dearest friend," dressing him in expensive tailored suits and ordering him tiny leather shoes from Italy.

After facing tax problems in Britain and the United States, Carstairs left public life at the age of thirty-four and lived on a Bahamian island called Whale Cay, which she then purchased for forty thousand dollars. She outfitted it with her own Spanish villa, schoolhouse, power plant, radio station, and museum dedicated to her own personal accomplishments. She appointed herself the island's official ruler, making laws (alcohol and adultery were banned, though not for her), officiating marriages and births, naming all of the children born on Whale Cay, creating youth camps for the local residents, and protecting the island with the help of a private machete-bearing militia. From the comfort of her villa, Carstairs continued to entertain a parade of gorgeous women and socialite friends well into her seventies. She kept a photograph of each woman she slept with, amassing around 120 pictures, but the women never stayed for long, as they were forbidden from spending the night in Carstairs's bed.

In 1975, disenchanted with island life, Carstairs sold the island for $1 million and moved to Miami, where she spent the rest of her life tending to Lord Wadley and watching boxing shows on TV. She died in 1993 and was cremated and buried with Wadley by her side.

EUNICE KENNEDY SHRIVER

As the middle of nine children in the famed Kennedy dynasty, Eunice Kennedy Shriver was, like most of her siblings, ambitious. Though she was inspired by the public work of her brothers, political icons John, Robert, and Edward, her lifelong efforts on behalf of those with intellectual disabilities were dedicated to her older sister, Rosie. Rosie had, as it was called at the time, "a mild form of mental retardation," and spent most of her life institutionalized in Wisconsin after a failed lobotomy. Kennedy hated the way an entire population of society was pushed aside, hidden in an attic of shame, and vowed to help change the situation in any way she could.

One day in 1962, married to Sargent Shriver and with children of her own, she received a phone call from the desperate mother of a mentally handicapped child. No summer camp would accept her child, and she didn't know what to do. Thinking of her sister, Shriver replied, "You come here a month from today. I'll start my own camp. No charge to go into the camp, but you have to get your kid here, and you have to come and pick your kid up." That was the beginning of Camp Shriver, a summer day camp for disabled children that she hosted at her farm in Maryland. There was swimming, horseback riding, soccer games, and an obstacle course to entertain the attendees.

From the camp, the idea for an Olympic-style event was born, and in 1968, the first International Special Olympic Games were held in Chicago's Soldier Field, just weeks after the assassination of Shriver's brother Robert. One thousand athletes from twenty-six states and Canada participated. Anyone who had below-average intellectual functioning was allowed to take part, regardless of age. Today, more than three million Special Olympic athletes train year-round, spanning 181 countries.

Shriver received the U.S. Presidential Medal of Freedom, the World Sports Humanitarian Hall of Fame's Founder's Award, and nine honorary degrees. In 1995, the U.S. Mint created a commemorative coin with her portrait, making her the first living woman to be depicted on American currency. Three years before her death, she stood at a podium before a group of Kennedy Fellows and proclaimed:

> We've got to be so proud of what our special friends do and of their future. Their possibility of really bringing to the world something that really resembles peace and hope and faith and love, that's what they can do. And we're so proud of them. And we want to keep going all the time, the next twenty years. I'm going. You coming with me?

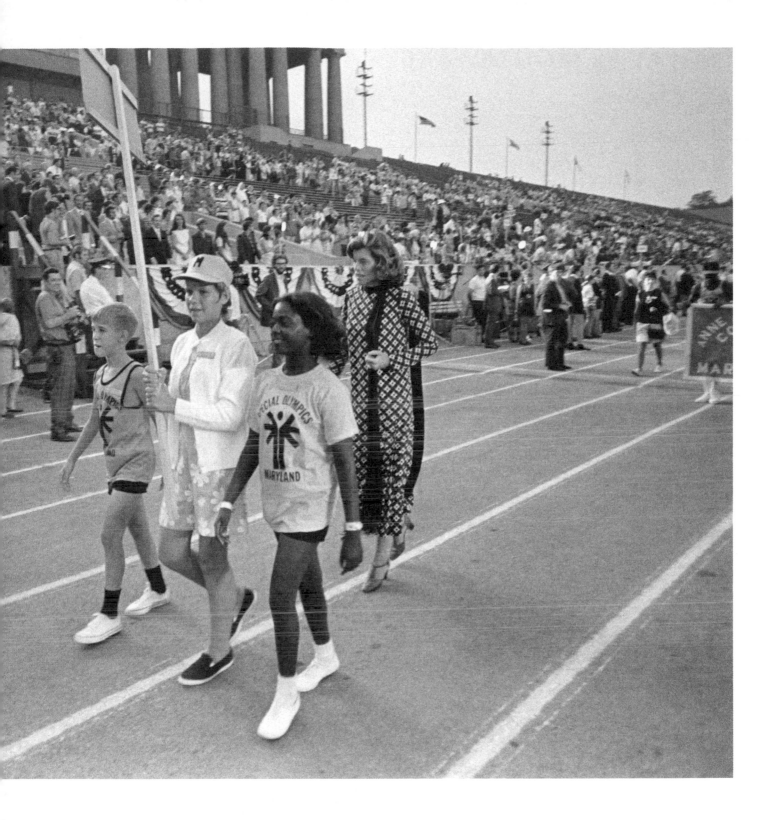

NAWAL EL MOUTAWAKEL

When Nawal El Moutawakel won gold at the 1964 Olympics in the 400m hurdles, her country's monarch, King Hassan II, passed an extraordinary decree: all Moroccan girls born on that day would be named after her. El Moutawakel's gold medal victory was a first in more ways than one. She was the first Moroccan, the first female Muslim born on the continent of Africa, and the first woman from a Muslim-majority country to take the prize. It was also the first time the Olympics had allowed women to compete in the event. To top it all off, her finishing time set a new world record. All this was a reality that mirrored dreams she barely felt confident enough to imagine.

When El Moutawakel arrived in the Olympic stadium, she expected to place in the top eight but never believed she would win. Taking home a gold medal was a nearly unattainable dream for a young woman from Morocco, where tradition and custom often prevented women from participating in sports. Yet she felt a strong urge to compete, and her family—most notably her father—stood behind her commitment. He accompanied her to the track every day and gave her words of ambition and optimism. Tragically, he did not see his daughter's historic success; he passed away in a tragic car accident months before the Summer Games. Still, his belief in her lived on in El Moutawakel's countrymen and her coaches from Iowa State University, where she was a student. They encouraged her to visualize herself as a winner day in and day out. It was a task that became routine, but she had not truly believed it could happen until it did.

El Moutawakel would later say that even as she approached the finish line, she couldn't see any of her competitors in her peripheral vision:

> I thought, "Where are the other ones? How come I'm the only one running? Maybe it's another false start." But in fact, I was so much in the front. . . . And I started looking. . . . Before the finish line, I turned my head left and right to make sure I wasn't the only one running from start to finish . . . but they were there, all the other competitors. . . . And then I kind of slowed down, because they were my friends, and I didn't feel well to just leave them way behind. . . .

In those final moments of the race, she was the complete embodiment of the magic of the Olympic dream and the humility and virtue that embody the spirit of the Games.

El Moutawakel is now a member of the International Olympic Committee. She was one of the eight bearers of the Olympic flag in the 2006 Winter Olympics in Turin, Italy, and helped carry the Olympic torch in the 2012 London Olympics. Her achievements opened doors for the multitude of Muslim and Arab women who have competed and won medals in the Olympics after her, showing them that not only could they attend the Olympics, they could win.

LAVONNE "PEPPER" PAIRE-DAVIS

Philip K. Wrigley wasn't a feminist, but he was a businessman. So when the chewing gum magnate and Chicago Cubs owner feared that World War II would be the end of men's baseball, he put up $100,000 to start the All-American Girls Professional Baseball League (AAGPBL) to ensure his own success. Wrigley was fixated on the idea that, despite their athleticism, the women in the league should embody what he considered "the highest ideals of womanhood." Terrified that his female players would come off as "short-haired, mannishly dressed toughies," they were required to wear lipstick while they played, and short skirts that left their legs bloody, bruised, and scratched up whenever they slid into bases. Off the field, Wrigley required all players to attend Helena Rubenstein's evening charm school classes, where proper etiquette for every situation under the sun was taught, along with personal hygiene, mannerisms, and instructions on how to dress. They were given beauty kits and forbidden from having short hair, drinking in public, or smoking. More than six hundred women ended up playing during the league's eleven-year existence, but none reached the level of notoriety bestowed upon Lavonne "Pepper" Paire-Davis.

As a child of the Depression, Paire-Davis had used playing softball as a way to pick up extra money for gas and food. As she developed her skills, the sport cemented a place in her heart and became a defining part of her identity. When she was nineteen years old, she quit her job as a welder and part-time college student in Los Angeles to join the AAGPBL. Over the course of her ten seasons, she became a star shortstop and catcher, helping her team win five championships. She played for the Minneapolis Millerettes, Racine Belles, the Grand Rapids Chicks, and the Fort Wayne Daisies. The schedule was grueling: games every day and doubleheaders on Sundays and holidays, but at the league's peak in 1948, one million spectators flocked to the stands.

When the league folded in 1954, Paire-Davis returned to Los Angeles to wait tables and regale customers with her tales of glory. Decades later, she was asked to serve as a consultant for director Penny Marshall on the film *A League of Their Own*, which was based on the AAGPBL, and became the inspiration for the character of Dottie Hinson, played by Geena Davis. When *A League of Their Own* hit theaters in 1992, featuring the "Victory Song" she had helped to write back in the 1940s, Paire-Davis, then sixty-seven, started making public appearances and promoting baseball again. "Beat the heck out of slinging hash," she told reporters. Once again, she was a star.

"I know what it's like for your dream to come true, mine did," she said in 1995. "Baseball was the thing I had the most fun doing. It was like breathing." She passed away in 2013, at the age of eighty-eight.

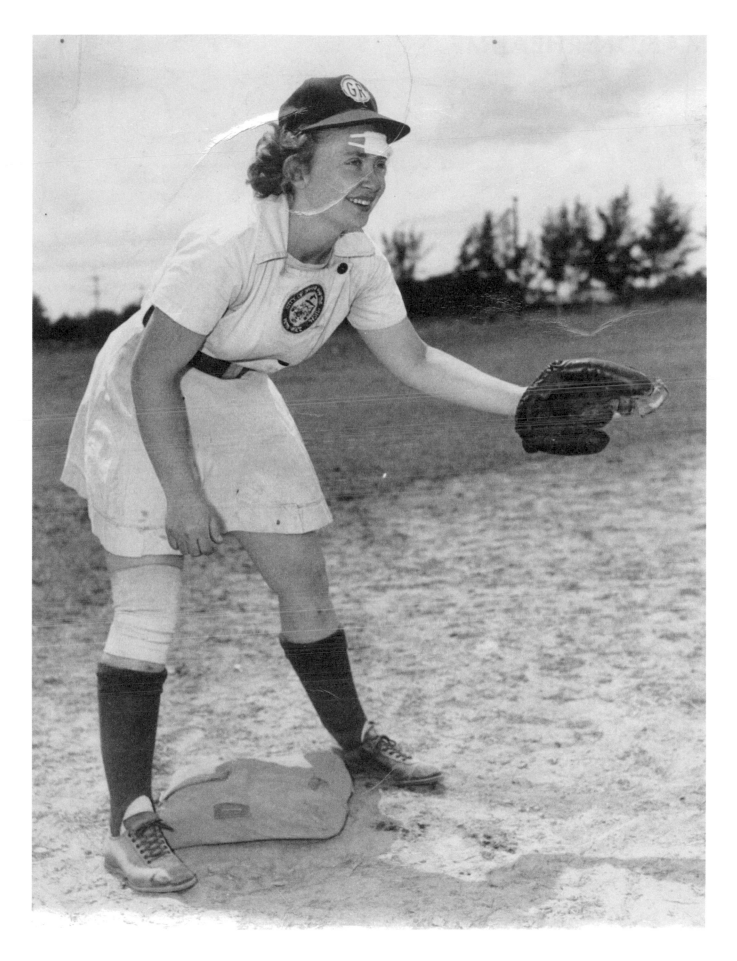

MANON RHÉAUME

The No. 1 comment I get from someone when they find out I play hockey: "You don't look like a hockey player." So my response is, "What should a hockey player look like?"

—Manon Rhéaume

Canadian ice hockey player Manon Rhéaume never looked like most hockey players, largely because she was often the lone woman in the rink in leagues completely populated by men. Raised in the French Canadian province of Quebec, she'd grown up in a hotbed of ice hockey, and in a family filled with male players. Her father, Pierre, coached her brothers' ice hockey team in addition to running the town's outdoor rink. She learned to skate at three years old, but never played herself until one fateful day when Pierre found his team short one goalie as they were about to enter into an important tournament. Rhéaume asked if she could be the team's newest goalkeeper, and without any other clear and immediate options, her father allowed it.

At the age of five, despite her father's initial reluctance, Rhéaume began her pioneering streak, playing goalie on her first all-male team. In 1991, at the age of nineteen, she became the first woman to play in a regularly scheduled Quebec major junior hockey game, for the Trois-Rivières Draveurs. In that game, she took a shot to the head, which left her bleeding, but she famously chose to stick it out until she was pulled from the game. Her determination and tenacity garnered international attention. Two years later she became the first woman to play for a minor-league professional hockey team, as well as the first woman to ever be invited to an NHL training camp (for the Tampa Bay Lightning). During her first day at camp, she stunned everyone by being the only goalkeeper to stop every single shot directed at her. In 1992, she became the first woman to sign a contract with an NHL team. She spent the next five years playing on major- and minor-league teams, as the only female in both leagues.

Rhéaume played on the Canada women's national ice hockey team, winning gold medals in the 1992 and 1994 IIHF Women's World Championship and nabbing a silver medal at the 1998 Winter Olympics. Since retiring from professional hockey, she has worked as a goaltending coach for the Minnesota Duluth Bulldogs women's ice hockey program and helped develop women's hockey gear for Mission Hockey in Irvine, California. She came out of retirement briefly to play in 2008–2009 for the professional women's ice hockey teams the Minnesota Whitecaps and Port Huron Ice Hawks.

KINUE HITOMI

Kinue Hitomi became the first Japanese woman (the only female athlete representing her country) to win an Olympic medal at the 1928 Summer Olympics in Amsterdam, which were the first to allow women to compete in track and field events. She took home the silver in the 800m, which would not be included in the women's Olympic program again until 1960, and set four world records at the Games. Two years before, as the sole Japanese participant in the Women's World Games, she had set the world record for the long jump, which she would then beat again during Japan's 1928 national games, a venue where she eventually established fifteen career and national records.

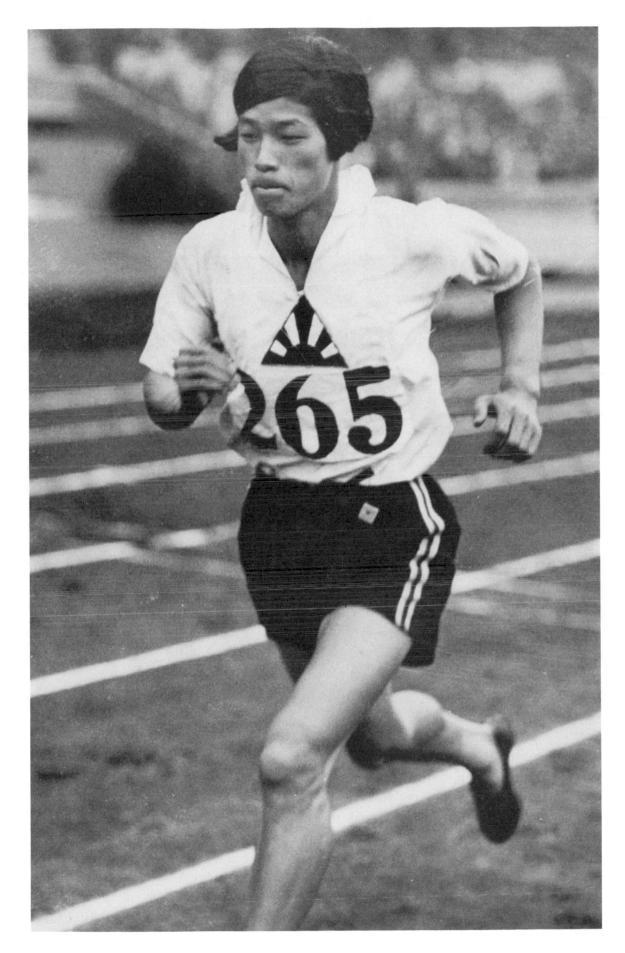

"You have to be ten times better than the person working next to you who works in the capacity and could be doing a really bad job."

ESPN *SportsCenter* Anchor **CARI CHAMPION** speaks to NBA and NFL Sportscaster **PAM OLIVER** about race and gender onscreen and on the sidelines.

CARI CHAMPION: Pam, let me just have my Pam moment. I am way too excited to interview you. You know that, right? I'm losing my mind right now. Jemele Hill and I often have these conversations about how when we all get together one day we're gonna be like best friends in our heads, and we'll have wine, and we'll talk about the business off the record, and have a good time. That's our conversation we're having with you.

PAM OLIVER: There you go. We got to make that happen.

CC: The only reason why so many of us brown girls are doing what we're doing is because of you. I don't know if you realize that. When I was on [ESPN's] *First Take*, Chuck Salituro told a story about you are such a boss, how you always have the best information, and how you would make the boys look bad, and then the

boys at the end of the day would be like, "Oh, we knew that," and I just loved it. In our minds this is how we imagine you, just bossing everybody up on the sidelines.

PO: Yes, and then they called me hard to get along with!

CC: That will always be the case because we're women. Anyway, Pam, how did you decide to get into the business?

PO: We were a military family. I lived in Dallas until I was eight years old, so that's the place that I claim as my home. We moved around maybe one, two, three, four, five times before high school. I remember sort of falling in love with sports because of my mom. She insisted and loved it so much, and we watched the NFL every Sunday as a family. That was our family center. It seems weird, but I knew coming out of the womb, practically, that I wanted to be a reporter. I was born in 1961, so it was a time of so much turbulence and change, and really important events happening in this country and in the world. I don't know how it was. It must have been through osmosis. I just knew that was an important decade, so by the time we left Texas I had a very clear image of being a reporter. I didn't care what kind, news or sport. I'd play pretend, and I'd walk around with a hairbrush as if it were a mic. I just dreamt of that, and I just couldn't believe all these years later that it came true.

CC: I love the idea of knowing. You felt destined for this position. It was yours to have. Tell me about some of your early experiences trying to become what eventually would be one of the best sideline reporters we've seen.

PO: It started when I was still in college. I got an opportunity to contribute to WFSU TV's public affairs station. They just let you go. I didn't have to really wait to get assigned. I remember one of my first stories that I came across and researched, we had to execute it. I had a photographer, and we went out and shot it. It was about poverty in Gretna, Florida. I only came across that story because we were driving somewhere, and I

saw the shacks with people living in them. I just remember being so moved, and sort of shattered inside. It was just so gut-wrenching that I went back to my bosses and asked if I could do something on that, and I ended up focusing on this eighty-year-old woman. She had no running water, no electricity, and I couldn't stop thinking about her. I couldn't take my eyes off her, and I just wondered what kind of life that was. She couldn't read. I just remember sort of wrapping my mind and my heart around this woman. I knew at that point that's what I was meant to do, kind of showing people what's really happening out there. I remember going back, and I edited that story, and did it myself. I didn't quite know what I was doing, but I figured it out as I went because I'd watched so much news and so many television programs. I sat there, and I tried to figure out how to blend this and blend that. It was a very important story that I wish I still had. It showed, I hope, the audience that this is still going on, and there's so much poverty that we're turning our eyes against. I just felt like that that was one of the things that solidified that this is what I'm supposed to do. My second gig was in Albany, Georgia, where I covered agriculture. Did I know anything about agriculture?

CC: Yeah, that sounds rough right there.

PO: It was rough, and you talk about adversity. I followed a very popular reporter. That had been her beat. You're assigned eight counties that you are responsible for making your beat calls in the morning, and seeing what kind of news happened overnight. She was really popular, and here I come, this black woman into a situation where there wasn't a whole lot of progressive thinking. I remember my colleague not really wanting to have lunch with me because of how it looked to the other people in small towns. We turned out to be great friends, but at the time it was just like "What?" I'd bring my lunch and eat in the car. That was how it was.

My first story I had to go cover a house fire, long after it was out. It happened the night before, and nobody was going to help me. I didn't know where to start, so I went trudging through this burnt-out house in my suit. I'm looking for somebody to talk to. I don't know who to ask questions about this, so I just charge in. I said to

myself, "Okay. You don't want to help me, I'll figure it out. If you don't want to have lunch with me, I'll bring my own food, and wait in the car." That was just one of many things. It just went on and on from market to market to market.

CC: Honestly, you're a great storyteller, but what's so interesting is that's how your story is. You have to say, "I got it." You have to say, "I don't need you to help me. I'm gonna figure it out. I have this. I'll figure it out." That is very much how it is, though, for a lot of minorities. That's how our career *has* to be. Not only are we women, we're black. I got my first job in 1999, and I was called *colored*, so I'm still dealing with it. You have to know that that always comes into play. Do you find that throughout your career, being a minority has helped you, or has it hurt you, or has it done both?

PO: Here's how I treat that. I don't even entertain the topic in my head. Obviously, I'm a woman, and obviously, I'm a black woman, but the way I looked at it first and foremost, I was there as a reporter. I wasn't there to bat my eyes, and play the role of "honey-pie, sweetie-lamb," or anything like that. I was there to work, but, of course I knew those were factors. There was nothing I ever used. It was nothing I ever felt would make this easier. Now players would say things like, "I'll talk to her. I'm not talking to that jerk. I'll talk to her." Guys knew that I obviously had put some work into my job, so maybe it went from the players saying in their head, "I'm gonna take care of the sister," but then it became, "I'm gonna take care of her because she does her homework, and she knows what she's talking about." Yeah, I think that maybe the gender factor, and the race factor, eventually, may have opened a couple of doors, but unless I'm being naive about it, I always charged in with the idea that I'm there as a reporter. I'm there to gather the facts, gather the news, do what I have to do from the standpoint of showing you that I know what I'm talking about, and it's my job to know what I'm talking about.

And just to be honest, straight up, I'm sure I was the minority hire in my first two jobs, maybe three. They were trying to make the newsroom diverse, and it was always people saying, "We needed to add a minority. Oh, hey, and why not add a female who's black, and

then we kill two birds with one stone." I wasn't tripping on that. I said, "That's your dumb fault that you haven't done things the way they should have been done, but I'm not here to be your token. I'm here to learn my craft, do what needs to be done, so I can be a better reporter, and learn this business." I walked into situations knowing that this was probably why I'm here, but that doesn't keep you there, and that doesn't help you earn the respect of your colleagues.

I just went about my business, knowing that they can think what they want to think, but I'm not gonna be the one who takes a position and feel like, "Okay, I got this because I don't have to work. I don't have to prove myself because I got this job to satisfy some quota." Girl, I went at it mainly for myself because I wanted to be the best I could be. I wanted to be good at my job, so all those other things were just factors that I had no control over, but what I did have control over, that's just what I worked on the hardest.

CC: I agree with you. We work for ourselves at the end of the day. Being the minority is just what it is, but I also feel like as a woman and as a minority there is little room for error, and that we always have to be the best at what we are. We have to be excellent to be accepted. Do you feel that way?

PO: Oh, of course, but I never really put that extra pressure on myself. I just feel like I am representing me. Ultimately, at the end of the day it's your work, it's your career, it's your reputation, and then it just dovetails into all of these other things that I'm completely aware of, but we've always felt that extra. . . . I don't want to say it's a burden, but that extra pressure that you have to be better. You have to be ten times better than the person working next to you who works in the same capacity and could be doing a really bad job.

That's just what our heritage has taught us, and our grandmothers and grandfathers and great-grandmothers and great-grandfathers. I think we understand we are standing on the shoulders of previous generations. Society says we always have to be better. But what happens is that makes you good at your job. I don't put that pressure on myself, but I do kind of understand that idea. You know when you go about your job, and you got your

own dramas, and you got your own hang-ups, and problems, and all that stuff that didn't go well, that's gonna bother me, but you also understand that there are people who are watching you. Young girls who are watching you. People in your field, athletes, coaches, they're watching you, and they're encouraging you, and they're pulling for you. That helps on a bad day.

I've had plenty of bad days, so I'm always honored when someone like you, Cari, will express your appreciation for the things that I've done. That matters to me, and I look at you with so much pride. But I always wonder where's the next generation? Where are they? Where's the next generation of black women doing this?

CC: We never see ourselves the way others see us. When you come on the TV, my colleagues and friends turn it up, and everybody has to be quiet. When you come on we're like *shhh*, because we're about to get an education on how it's done, and we need to watch how you do it with elegance and class. You know what it takes to get to the highest level, to sustain it, and you have done it better than anybody. Even the analysts say, "Pam was the best. She used to walk in the locker room, and we all worshipped her."

PO: Thank you, Cari.

CC: When you got your first "big gig" and "big story," did you say to yourself, "I made it, I just arrived," or have you ever *really* thought you made it and arrived?

PO: If I ever felt that way, then I would say I should probably find a new line of work. It's just like any field—you're always looking to stretch and grow and get better at things, and to satisfy this curiosity. That's sort of been my staple. I'm always curious about things. I never really looked at it and said, "I made it!" I've obviously reached a certain level, and gained a certain respect. This whole thing has given me a great life, and great opportunities, and I've been able to build some really great friendships. I'm trying to be humble, and to keep at it. I think it's important that you keep at it. You keep pushing yourself. You keep figuring things out, writing clearer sentences, and reading books. I just feel I still

have a thirst for it, and I'm a lifer. People want to put you on a shelf at a certain age, and a certain point in your career. You can do that. You can put me on some shelf, but I'm gonna jump right off it, and look for a different avenue.

That's where I am in my career now. I'm pretty sure the sideline thing is about to be over for me, but I just feel like there are so many other gears that I have. I guess I'm always looking to grow, and that may sound corny and cliché, but if you're not growing, what are you doing this for? I don't come from a position of fear when I say that. I just come from a position of wanting all aspects of my life, and all dimensions of myself to kind of get the attention and the nurturing that I think it deserves.

Again, it goes back to that curiosity of mine. I'm fascinated by so many things that I don't want to just sit and read trashy magazines. Nothing against trashy magazines, but I just want to know what's happening in the world. I'm a citizen of the world, not a citizen of sports only, so there's a whole thing going on out there that I want to be a part of, and I want to know about, so I just keep at it from that standpoint.

CC: At this next phase of your career where do you see yourself?

PO: I see myself moving maybe back into a news capacity, only because that still is the thing that floats my boat. Going down different avenues, and on different adventures, and getting back to my roots. I did eight years of news when I started my career, but I think there's a cap, and I've lasted longer than, I think, a lot of people thought I would, or probably thought I should. It's probably time to sort of reinvent, but not necessarily like Madonna, where you change *everything* about yourself. Just showing that you're versatile, and that you can do a number of things, and it's not just in that one capacity as a sideline reporter. I need to determine what is best for me, but I do think it's kind of forced on me at this point. I'm right outside that coveted demographic, whatever that is.

CC: You said it's forced. It's unfair that men can stay on-air until they die, right? Then we have to check out

at a certain time, we get the tap on the shoulder. Are you just at the point in your life where you're like, "I want to reinvent myself, not Madonna-style, but I want to do things that I love"?

PO: Yes, exactly, I just feel like this is a business that I don't want to be shoved out of because I think women are definitely held to a different standard, and I think it's sad when you see women who aren't dressing age appropriate, or trying to look like a young girl, and you're a grown woman. Why would you want to look like a young girl? You're a grown woman. Even if it's a news/sports combination, but I do feel that the news part, the telling of stories is really important to me, so I'm looking for whatever kind of combination that is. If I'm going to be off the sideline I'll look back, and say, "That was a blast." But there's also another gear, and there's just another place that I feel like I can go. Why should I take my toys and go home?

CC: You don't have to.

PO: I'm over here trying to continue to satisfy this unquenchable urge of mine to be . . . *better*, and to live these dreams, and to be a journalist. I'm not saying being a brand. Now it's all about the brand. I feel for you guys with this brand thing, I do.

CC: That's true.

PO: I don't speak that language, and I just think you should be Cari. You should be allowed to be Cari. "I'm Cari, not the brand. I'm Cari Champion, the journalist. I'm a reporter. I talk to people every day," and you're an interviewer. You have all of these things now like Twitter, and Instagram, and Facebook. There's so much depth to who you are, as Cari. I understand that that's where this thing goes for you guys now, but I just wish you could just be who you are from the standpoint of—I'm trained, I'm getting better every day, I'm an excellent interviewer, I'm good on television, I can write my butt off, I'm skilled at this, and I have so many other levels to me, and my personality. I wish you guys had that first and foremost. You can be all of those things, but you also have to satisfy that social media thing nowadays,

and I'm *not* a brand. I'm just plain old Pam, and I'm fine with that. I signed up for Twitter and have used it twice. I don't have anything to say. I don't have anything to add. I don't have public commentary on everything I see and every event that happens, and who does what, and says what, and what I did. It just doesn't resonate with me, that whole . . . It's just such a racket.

CC: That's a perfect word. It is a racket. We feel the pressure to tweet, and be the first to tweet. Is social media the biggest way journalism has changed for you in terms of when you were coming up?

PO: Yes. Those things didn't exist. We didn't even have the Internet when I came up. We relied on building our sources, and getting out our information the old-fashioned way, just gathering the news, then presenting it. It would trickle out slower, but it would trickle out. People would get the information. It might take a couple of minutes longer, but this immediacy for everything, I think it leads to errors. I think it leads to a false sense of how important you really are, or some people tweet and get their information out to show, "Look how fast I am, look how well connected I am."

I mean come on. If you're having a general conversation with a player, and he mentions something, do you turn away once the conversation is over and immediately go and tweet something? I don't understand. Can't it marinate? Can't you give it a second to kind of decide that was part of a personal conversation? Why do you feel the need to tweet that? Is it because of self-importance? Are you trying to demonstrate how well connected you are? You should be well connected.

CC: That's your job.

PO: You're supposed to have your sources. It doesn't make a hill of beans of difference if so-and-so tweeted this, and that becomes news. To me it's cheating in a lot of ways. It's just like, you haven't done the actual reporting. I think a lot of people respect you better if they can have a conversation with you, and it isn't on Twitter five seconds later. I think that builds better relationships when they know *I can just talk to her*, and it's not a matter of getting the word out. I don't feel like everything is

for public consumption, and that's where we are today. *Everything* is for public consumption, and that's the difference between where you guys are and where I came from. It's news-gathering, it's not just Twitter-gathering.

CC: Everything you just said immediately felt as if I needed to tweet, "Not everything is for public consumption." There you go! I look at all the sports that we cover, and I think of just the makeup of our newsroom, especially at ESPN. No matter how hard we try to push diversity, including to the forefront, it's just sorely lacking in 2016. How does that change, or will it ever?

PO: That's really the million-dollar question, and it's a matter of the people doing the hiring actually hiring the most talented person, and not necessarily "the Glamazon." The television world is overcome by "the Glamazon." There's nothing wrong, I'm saying, with being beautiful, and all of that, but I just think there should be a place in the business where sports, in particular, where everybody doesn't have to look like everybody else.

Right now the way people look doesn't vary. I don't know one person from the other person from the other person. It seems that there's a certain look that news directors, sports directors, or the people in the position of hiring are after right now, and it's a similar look. It is to a point, I think, where young women who have a different look, meaning not "Glamazons," saying, "Well, where am I gonna fit in, 'cause I don't look like that?"

I did a talk at Northwestern and I brought up that there are a plethora of blond women who are very prevalent on the airwaves on almost every sports and television network. There's nothing wrong with that. I'm so not hating on blondes, but I question, is that just an accident? That's the look. I spoke to some young women about this and said, "You want everything so fast, but why don't you go to a teeny-tiny little market, work your way up, and learn your craft, and then go from there. You don't have to fit into, or follow this certain pattern, and think that's the only way."

The only way of doing things in any avenue is to be who you are, and be the best at what you're trying to do without plotting to fit into a mold that is well taken care of. You don't have to kind of be like everybody else. I hate to say it, but everything blends in. This will probably get me in trouble, but that's okay.

We were talking about diversity and with true diversity, not everybody looks the same. You don't have to try hard to find people who are different. Until you get somebody in these higher-up positions who [is] not so narrow-minded and singularly focused, then there's nothing that can be changed.

It's very frustrating. I think at Fox there is a formula that they are looking for, and who they present on-air. I'm not breaking code here—all you have to do is turn on your television. The people doing the hiring there have a very specific look. I just feel like you can't do anything about it. You have to hope and pray that they're doing things for the *right* reasons instead of satisfying a demographic. This demographic thing, I think, that's total bullshit. See, I've aged out. I'm fifty-five, I'll be fifty-five next month, and I aged out four years ago, so I might as well not even get out of bed in the morning. I'm not even desirable to "the demographic." You can't do anything about people who are doing the hiring. You can only hope that it comes from the right place, and that the best-qualified person is chosen, but to be honest I don't think that's necessarily the case.

CC: I think a lot of it is cultural, Pam. I think if people are not familiar with the "other," If they don't understand, they become afraid, or they're confused by it, so they hire what's comfortable to them, and what's nearby, and so sometimes that determines the makeup of the newsroom. But is there a way to change the position of power, or is it the same thing we've been discussing? Should companies be mandated to say, "Hey look, you guys need to change"?

PO: I think it's common sense that people want to see people who look like them on television. Now people of power, they will say, "We always look for the best candidate," but they know what they want, and whether it's a gender or ethnicity, they know what they want, and they go in, I think, a lot of times very attached to what's the flavor of the month. I mean, Cari, I only see a couple of you.

CC: There's not too many. It's like five of us, it's a running joke. We have a running joke about it.

PO: We always joke, the couple of black people on my crew, if we end up in the same vicinity talking, we go, "Oh-oh, we got to break it up," so I'm not crazy.

CC: Break it up, yeah. The same jokes apply here, we always do it. When you were coming up, who did you look up to?

PO: I looked up to Carole Simpson, Max Robinson, Lynn Sherr. I bring in Lynn Sherr because she was always the one on the scene. She would have the greatest reports, and I was always like, "Wow, that's what I want to do. I want to go to where Lynn's going. I want to be out there like Carole Simpson." What I admired about Carole Simpson is how cool, calm, and collected she was. Her voice and diction were impeccable.

CC: Impeccable!

PO: Impeccable, and I was like, "Wow." I just felt like at that point things were opening up slowly, but surely. And Iola Johnson in Dallas, Texas. She was an anchor there. I'd look at her, and be like, "Oh, my, Iola Johnson, maybe I should come up with a stage name, like Iola Johnson." And she was glamorous. I just mean *glamorous* from the standpoint of she was on point, but fabulous in what she was doing.

CC: It's okay to be both, right? It's almost rare to be so good at both.

PO: There are enough hours in a day, too, because we both know. We can go on TV thinking this is out of place today, and you will hear about it. *Oh yes*, you will hear about it.

CC: There's no room for error on the TV.

PO: Don't you wish that it was more important that people heard what you said, as opposed to one of your eyelashes happened to be coming off? My earring fell, I have no idea where it is, and they don't hear a word you say.

CC: That's the charge with being a woman because our male coanchors can be completely disheveled, and not put together, and they're listening intently. Why is that?

PO: I always say because people are stupid.

CC: At the end of the day . . .

PO: You're looking for something with women, you're looking for something.

CC: We watch with a closer eye, more critical eye. I always think we have little room for error. I don't ever think there will be a time where there will be more women in positions of power in covering sports.

PO: But how about a guy can wear the same navy blue jacket like every other week?

CC: Every day, and no one cares.

PO: Oh my God, and with women, it's like, "Is that the only coat she has?" Come on. It's crazy; it's funny, though.

CC: Pam, I was told once on Twitter, "You wore that dress six months ago." I was like, "Okay." You know what, sometimes I reply and get snarky back. I'm all like, "Do you have enough wardrobe to last six months?" I'm like, "Excuse me." This is the advice that I want from you, Pam, I definitely want your word of advice for women who want to be in this business, but how to survive in this business is more key. How do you do it?

PO: What I want to know really from these young women today about just being in this business, whether it's news or sports is, What are your motivations? How pure are they? Are you wanting to be a journalist? A reporter? Or are you just wanting to be on television? I always question what drives somebody, and I think you have to really search deep in your heart to find out what

it is you actually are doing, what you hope you're doing, what you're pursuing, and why you're pursing it. If you just want to be on TV, I think your career is just going to be short-lived, if you are able to get it off the ground.

I know a lot of people who are graduating, have graduated, have nothing to show for it, other than the degree. You don't have any work samples to show anybody. What does that say? I always question, Where's your ambition? Where's your wherewithal to have some sort of example, to say, "This is me now, but I can grow so far from this"? Are you in it to win it, or are you in it to really be good as a journalist? I'm old-school when it comes to journalism. It's the who, what, where, when, and why. I just feel like you should read the *AP Style Book* as much as you're reading *Us Weekly*. I think you're obvious when you're wanting to just be on TV to have some pseudo-fame.

There's a whole lot of that going on, as we know, but I think the cream always rises. I don't understand why people would waste their time if they don't truly love it. That bug has to bite you at some point. Otherwise, you're just going from thing to thing to thing, reading the same articles we all read, you know, spouting out all of this information that's not really truly your own. Are you willing to stay up all night to study a topic, and go beyond what's on the same old website that we all read? Are you willing to be a citizen of the world? Do you know what's happening in Syria? Do you know what's happening with the German economy? I ask these questions because I just feel like you should be deep. Of course, we all know the same old stuff about football, baseball, because it's all right there, and it's on every website day after day after day, but are you able to have a conversation about other things whether it's going to be put to use or not? To me that just shows you're willing to have some depth, and you're willing to have a conversation. What if you go into an interview, and they ask you about current events, you're not gonna know. It's just like, expand your interests.

I go back to the citizen-of-the-world thing. I just think that matters. I think you should be able to have at least a general conversation about events around the world, current events to some degree, [more] than just the basic, what we all know about sports. We all know the same thing. If you went on a talk radio show, it's the same thing.

CC: How do you, Pam Oliver, survive?

PO: You survive by knowing your stuff, and you survive by, I think, a certain amount of politics you have to play into. I think you survive by having a plan. Plan A, B, and C. Plan A is, obviously, having the career that you want to have. Plan B, it's going to take longer for you to establish the kind of career that you want to establish. Plan C is go do what you got to do, but keep one foot in the business [in] some sort of way. I only got twenty hours a week of pay at a public affairs station, and I made up the other twenty hours a week at the JCPenney makeup counter, and was glad to do it. I did more than twenty hours, of course, at the public affairs television station, but to me all that mattered at that point was working on my craft, figuring things out, making a ton of mistakes, doing things incorrectly, and then I learned, "Okay, I can do this better on the interview. Now why did I ask that, and how could I have asked that better?" So that A, B, C, and D. I don't have a Plan D. I scooped out at Plan C, but if, say, you want to do it, there are more ways than one to be able to be in this business, survive in this business, and get a foothold of some sort in this business, but the road is littered with people with journalism degrees who cannot find work.

CC: Pam, you're a preacher on the side because I'm sitting here Amen-ing all the time. I'm just shaking my head, and Amen-ing the whole time. Thank you so much. It means the world to me, and it's been nothing but a pleasure. I'm going to save the nuggets you gave me, and I won't tweet them. •

MARY MCGEE

Mary McGee bought her first motorcycle, a Triumph Tiger, in 1957. By 1960, she was road-racing her Honda CB92 as the first woman in the United States with a Fédération Internationale de Motocyclisme license obtained by audition. After fellow FIM licensee Steve McQueen encouraged her to go off-road and into the desert, she joined him at the 1963 enduro at Jawbone Canyon in the Mojave Desert. In 1967 she was an inaugural participant, by invitation, in the Baja 1000. An accomplished auto racer, McGee continued to switch between the motorcycle and auto racing circuits and in 1975 completed the Baja 500 on a Husqvarna 250 while riding solo, passing seventeen two-man teams along the way. She also raced in the Mexican 1000 in a Toyota pickup with co-driver Janet Guthrie, the first woman to compete in the Indianapolis 500 and Daytona 500. At seventy-five, McGee obtained her state motorcycle driver's license.

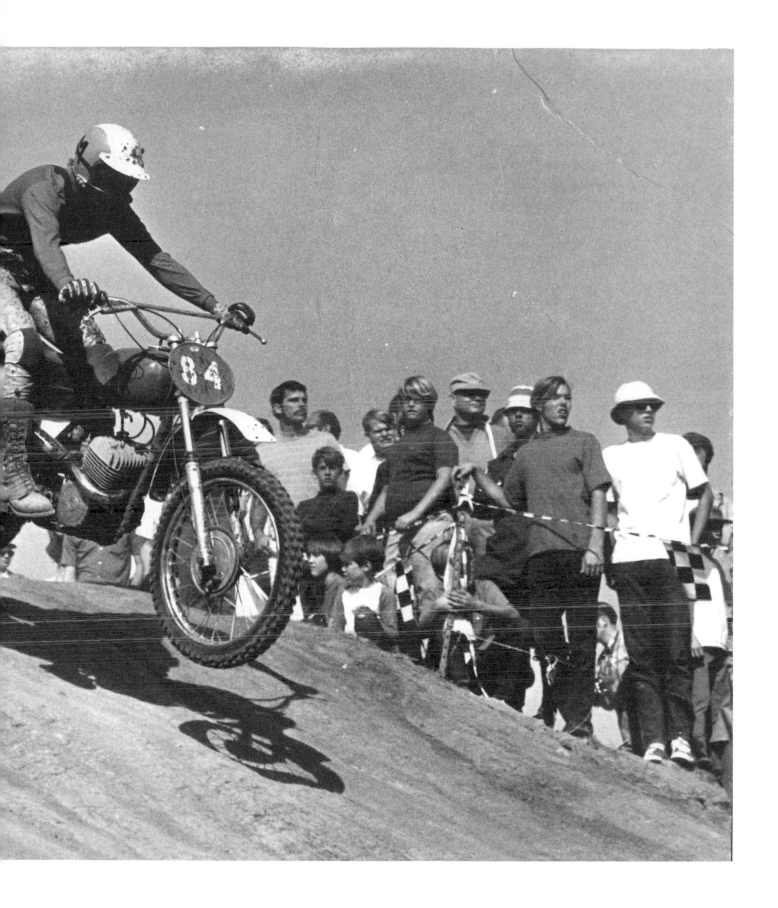

SURYA BONALY

Bold, athletic, rebellious, and unafraid of breaking the rules, Surya Bonaly brought an energy and personality to the world of figure skating that it had never seen before. An illegal backflip performed during warm-ups at the 1992 Olympics in Albertville, France, marred her international debut in a flurry of controversy that would follow her throughout her amateur skating career. The move was banned from Olympic competition due to its high risk factor, and though she executed it legally during warm-ups, the press accused her of doing it to intimidate gold medal favorite Midori Ito. In a sport where fitting in and following the rules are de rigueur, Bonaly became an instant outsider.

There were additional characteristics that distanced Bonaly from the other skaters: she had a background in gymnastics (she was a junior world champion as a child), which heavily influenced her skating style, and she was the only black figure skater in Olympic competition at the time. Her athleticism was seen as a strike against her by critics who favored grace and artistry. She was constantly referred to as a "gymnast," never the coveted "ice princess." The "athleticism versus artistry" debate came to a very heated point at the 1992 World Championships, where she placed second to Japan's Yuka Sato. Bonaly skated an excellent program, showcasing her explosive, powerful jumping style, while Sato's performance highlighted dynamic footwork and classic precision. It was an extremely close competition: five judges named Sato first, while four placed Bonaly in the lead position. When it came time for the medal ceremony, Bonaly shocked the judges by refusing to stand on the second-place podium. Once the silver medal was placed around her neck, she burst into tears and promptly took it off. The media labeled it a "tantrum," though she explained to the press that she was merely "fed up." The *Los Angeles Times* quoted her as saying, "This is a championship, not [a place] to do just like everybody else. It's not right. . . . When I change to just normal skating, that's not good, too. I don't know what I have to do. It's crazy." Her astounding acrobatic ability eventually earned her nine French national champion titles, five European champion titles, and three world silver medals.

After having surgery on her Achilles' tendon, Bonaly went on to the 1998 Olympics in Nagano, Japan, where she brought her career full circle. She knew that her recovery would not allow her to medal, but she wanted one last time in the Olympics before she retired. And so she decided, at the last minute, to replace a jump in her free skate program with the same illegal backflip that had introduced her to the world. In a sport rife with rules and preset ideas of what a skater should be, Surya Bonaly stood out above the crowd, embracing her differences and individuality. She currently lives in Minnesota, where she works as a coach.

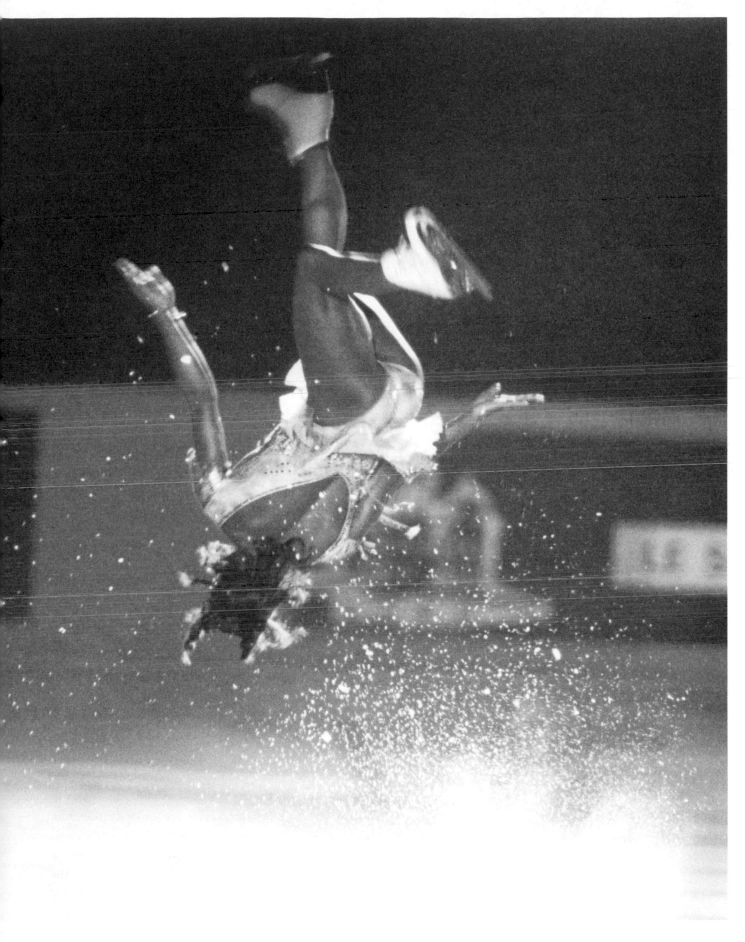

LORRAINE WILLIAMS

Lorraine Williams on a Philadelphia court in 1953, the year she became the first black woman to win a national tennis title by placing first in the junior division, four years before Althea Gibson won the U.S. Open. Growing up across the street from the clay-court Chicago Prairie Tennis Club, the oldest black tennis facility in the country, her first exhibition match was against Grand Slam record-setter Maureen Connolly.

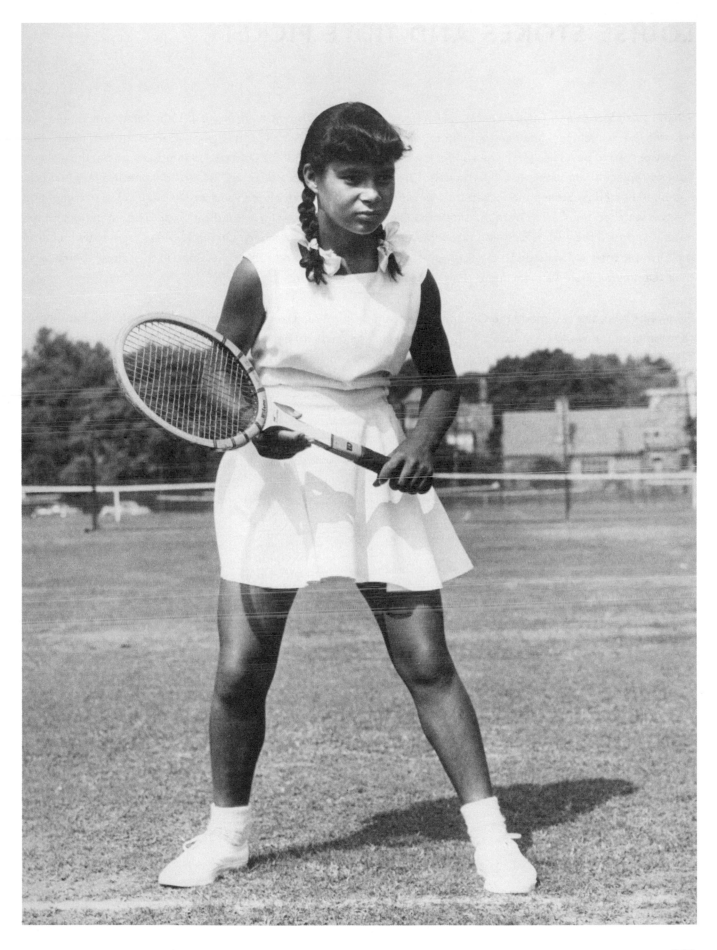

LOUISE STOKES AND TIDYE PICKETT

When Louise Stokes and Tidye Pickett qualified for the 1932 U.S. Olympic team in the 4x100m relay, they should have become the first African-American women to represent the United States in an Olympic Games. Unfortunately, their victory proved to be a false start when under the pretense of "fairness," the Olympic Committee voted at the eleventh hour to replace them with two white runners. The new additions were deemed "faster," despite the fact that both had been bested by Stokes and Pickett only weeks before during the trials in Evanston, Illinois. Instead of competing, the two watched the Games from the sidelines. The lack of public outrage was indicative of the time period: no one vocally opposed the switch, or made the women feel like true team members. On the two-day journey by train from the Olympic trials in Evanston to the Games in Los Angeles, Stokes and Pickett ate alone in their hotel rooms, while their teammates shared a meal in the "For Whites Only" dining room.

Four years later, the two made the Olympic track team for the 1936 Games in Berlin. Though Adolf Hitler attempted to mesmerize the world with disturbingly false images of a dazzling, peaceful Nazi regime, African-American runner Jesse Owens destroyed the myth of Aryan supremacy by winning four gold medals, and Pickett quietly competed in the 80m hurdles. Though she was disqualified in the semifinal heat, her presence on that track made her the first African-American woman to ever compete in the Olympics.

Meanwhile, it was quietly decided that Stokes, again, would not run. Her qualifying times in the 1936 Olympic trials had been low against track star Helen Stephens, whose quick-footed performance had made her the star of all events. She watched again from the sidelines, and retired from running soon after, moving on to a career as a professional bowler. She helped found the Colored Women's Bowling Association in 1941 and won a wealth of titles over a successful thirty years in the sport.

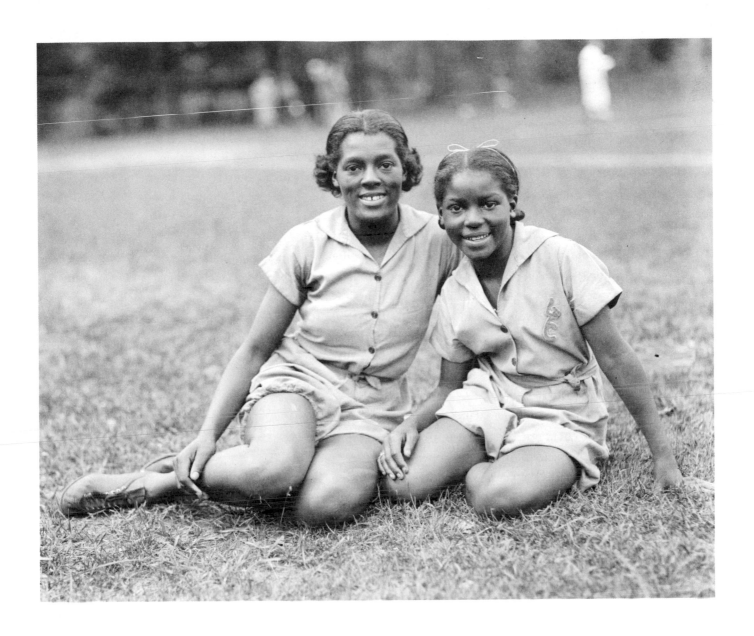

MOLLY BOLIN KAZMER

As a reporter from the *Washington Post* sat courtside watching Women's Basketball League (WBL) player Molly Bolin sink shot after shot after shot, he decided to call her Molly "Machine Gun" Bolin in his article. From 1978 to 1981, years before the WNBA, America had the WBL, and Bolin was one of its undisputed shining stars. The first player to sign a contract in the league (to the Iowa Coronets), she scored 50, 54, and 55 points in single games. Over a 36-game season, she totaled 1,179 points.

Off the court, Bolin's steadfast promotion of the publicity-hungry league made her its unofficial face. She appeared in press photos holding a gun (in reference to her nickname), scored multiple endorsement deals, and costarred with Larry Bird in a commercial for Spalding. Despite all the fanfare, women's basketball was an extremely marginalized sport and even its star players were treated negligently. Playing for the WBL meant struggling to survive on nominal paychecks (which often bounced), only one meal a day while on the road, and subpar housing. Not to mention being subjected to the harassment from male "admirers," who were often on the coaching staff.

When the WLB folded in 1981 due to financial struggles and a lack of corporate sponsors, Bolin's career took a serious hit. Embroiled in a nasty custody battle with her ex-husband, Dennie, she had to remain in the United States to appear in court, and so could not accept any opportunities to play overseas. Dennie's lawyers used Bolin's basketball career and glamorous publicity photos as evidence that she was unfit to raise a child. She lost the custody battle in a small Iowa court, but made a successful appeal to the Supreme Court, where the decision was unanimously overturned. It was a precedent-setting case. Without any other avenues to pursue a professional basketball career, Bolin began earning a living renovating homes in Southern California, eventually making a permanent career transition to real estate.

Throughout the 1990s, Bolin tirelessly advocated for a pro league as a quasi-commissioner, but as women's professional baseball gained traction in the same decade and other stars began to rise, her legacy faded into the shadows. A pioneer who perhaps came a few years too early, she still has not been inducted into the Women's Basketball Hall of Fame, and her 50-plus point games aren't recognized as women's pro basketball records. In a 1981 *Sports Illustrated* article, Roy Johnson wrote that Bolin "was right ahead of the trailblazers, she was ahead of the people who were recognized as the architects of the women's game."

MOLLY BOLLIN

IOWA CORNETS

NEROLI FAIRHALL

At the end of a four-day archery event at the 1982 Commonwealth Games in Brisbane, Australia, New Zealander Neroli Fairhall squeaked by Janet Yates of Northern Ireland; the two were tied at 2,373 and after a nail-biting recount, it was determined that Neroli's 60 gold hits defeated Janet's 57. The gold medal was a first-ever gold for a paraplegic in the history of the Commonwealth Games. As with many close finishes in the history of competitive sport, Fairhall's upset victory over odds-favorite Yates caused a media firestorm. A British journalist voiced a common concern: did shooting from a seated position give her an unfair advantage over Yates? Fairhall replied, "I don't know. I've never shot standing up."

In 1969, an ill-fated motorcycle ride had left Fairhall paralyzed from the waist down. After failing to make a turn at the top of Port Hills in Christchurch, the nineteen-year-old was thrown off her bike, lying on the side of the road for twenty-one hours before a car finally passed by and the driver got her help. Before that day, Fairhall had been a competitive equestrian; her athleticism remained, despite her accident. By 1974, she was competing in the Commonwealth Paraplegic Games as a shot put and discus thrower. She had the determination to succeed but felt she lacked the physical build and strength to properly compete, and so she switched to archery. The transition was grueling, but Fairhall persevered. She began swimming four times a week to strengthen and build the arm and stomach muscles, which archery left tired and fatigued. Her archery skills improved and she qualified for the Moscow Olympics in 1980. Unfortunately, New Zealand's participation in a large-scale boycott of the Games in protest of Russia's Afghanistan invasion prevented her from attending. Four years later, she made the Olympic team again, and when she competed in Los Angeles, she did so as the first paraplegic to compete in the Olympic Games.

Fairhall continued to have a successful career as an archer, officially retiring in 2001. She retained many national titles throughout her time competing, and worked as a coach as well as volunteering in archery schools, until she passed away in 2006.

MARILYN NEUFVILLE

Marilyn Neufville with her gold medal after winning the 400m event at the 1970 Commonwealth Games in Edinburgh. She broke the world record while representing Jamaica (her country of birth) over Great Britain (her country of residence), making her the first and only Jamaican woman to break an outdoor world record. Within a year, she also won gold at the European Athletics Indoor Championships—where she broke the world indoor record—the Pan-American Games, and the Central American and Caribbean Championships, all as a 400m competitor.

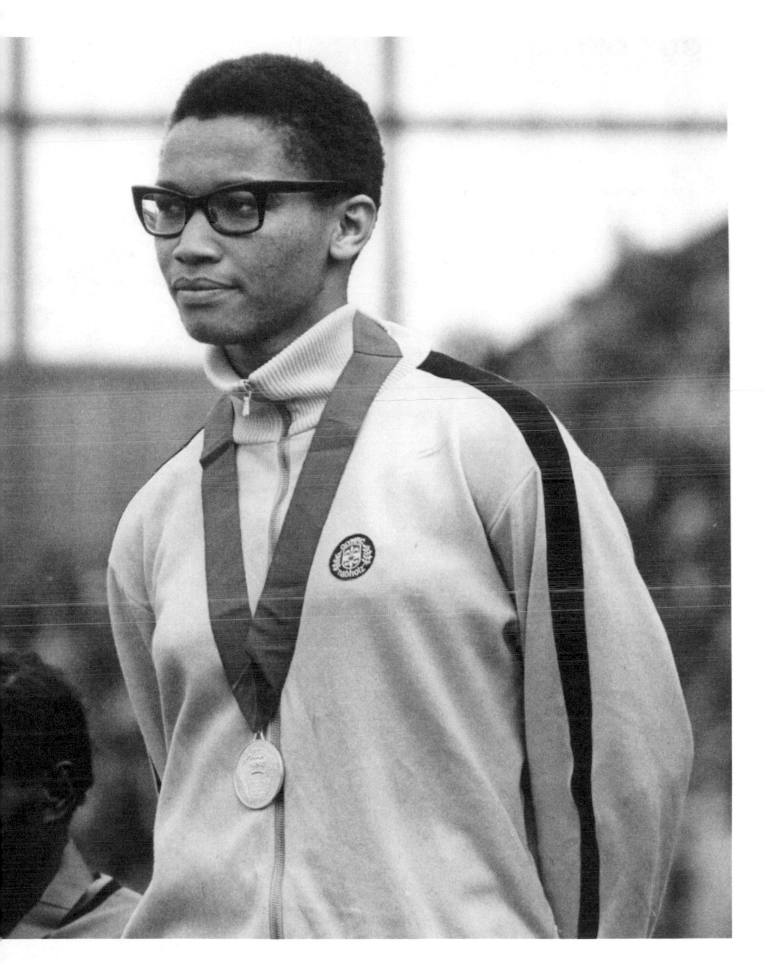

PEGGY OKI

Peggy Oki's skate style was something that the world of skateboarding had never seen before: knees deep, body low, riding aggressively with hands dragging on concrete. Along with the other members of the infamous original Zephyr skate team, including Jay Adams, Tony Alva, and Stacy Peralta, Oki changed the world of skateboarding forever, a tomboy whose status as the only "Z-girl" in a pack of "Z-boys" had no effect on how she was treated.

When the Zephyr team made their legendary debut at the Del Mar Nationals in March 1975, Oki carved on concrete like she was surfing an ocean wave, adding a gutsy creativity to the sport and setting a new style precedent that continues to define skating today. The Zephyr team came up in 1970s California, where a severe drought was forcing homeowners to keep their pools drained. Fans of skating on the sloping asphalt banks on school playgrounds, the girls brought their skate style to the empty pools, where they developed a new kind of aerial and slide skating. The Zephyr team blew away spectators and achieved cult status in the skateboarding world, further immortalized in the 2001 documentary *Dogtown and Z-Boys.*

After skating with the Z-Boys, Oki went on to the University of California, Santa Barbara, where she studied environmental biology and received her BA in painting at the College of Creative Studies. She continues to be an avid surfer, and works as an environmental and animal activist with the Origami Whales Project and the Whales and Dolphins Ambassador Program. She is also a visual artist and public speaker.

NAN ASPINWALL

When the western half of America was still wild, cowboys with shotguns ran the land, and mail was delivered by the Pony Express, a woman named Nan Aspinwall made history. A multifaceted entertainer who worked as an Oriental dancer, lariat expert, sharpshooter, and horsewoman, Aspinwall performed alongside her husband, Frank Gable, in Buffalo Bill's Wild West Show and Pawnee Bill's Far East Troupe. One day, Buffalo Bill himself challenged her to ride across the country on horseback, and on July 8, 1911, Aspinwall rode into New York City on her horse, Lady Ellen, completing a three-thousand-mile journey that had begun the year before in San Francisco.

Aspinwall completed her journey by covering approximately twenty-five to thirty miles a day, and staying overnight in stables. According to a *New York Times* article about her arrival at City Hall, she wasted no time telling the crowd about the most difficult parts of her journey:

> *Talk about Western chivalry . . . There's no such thing. Why, in one place I felt so bad that I rode through the town shooting off my revolver just for deviltry. At another place I had to send several bullets into a door before they would come out and take care of me.*

With that, she handed over a letter from the mayor of San Francisco to the mayor of New York City. When the ceremony ended, the *Times* reported, "the crowd cheered, Miss Aspinwall flicked her quirt, doffed her sombrero and galloped off in a most approved Western fashion, with a horde of urchins at the heels of her steed."

After her trip, Aspinwall returned to her husband and the two continued to perform in various Wild West shows (she under the nickname "Two-Gun Nan"), until Gable's death in 1929, when she retired. She passed away in 1964 in San Bernardino, California, after living for decades in obscurity.

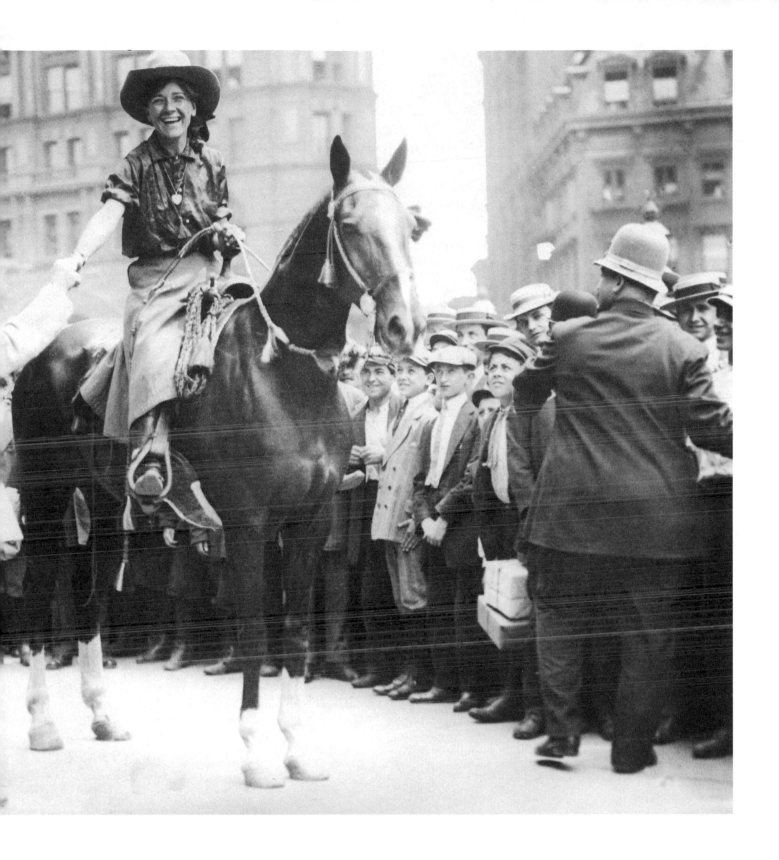

MARILYN BELL

From the moment sixteen-year-old Marilyn Bell plunged into the 65-degree waters of Lake Ontario from the shores of Queens Beach in Niagara-on-the-Lake, Ontario, it took only 20 hours and 59 minutes for all of Canada to know her name. No one was expecting her to become the first person to swim across the expansive thirty-two-mile-wide lake; in fact, not many people knew that she was making the attempt at all.

At the same time Bell was planning her swim, the world-famous American long-distance swimmer Florence Chadwick declared her intention to do it as well. The Canadian National Exhibition in Toronto offered Chadwick ten thousand dollars to swim the lake as publicity for their annual exhibit. Many Canadians, including Bell and Winnie Roach Leuszla, thought it unfair that a Canadian wasn't being offered the history-making opportunity and cash prize, and so they decided to make an unofficial race out of it. The competition began in the evening, with the swimmers covering most of their distance in the dark. None of the women knew where the others were, and the cold, choppy waters created five-foot-tall swells. Sea lampreys, bloodsucking, eel-like creatures, infested the waters of the lake; one sank its teeth into Bell as she swam, breaking through her bathing suit, trying to attach its mouth to her skin. With one forceful blow she was able to knock it off her.

After several hours, Chadwick succumbed to stomach pains that led to vomiting, forcing her to drop out. Soon after, the grueling conditions overpowered Leuszla as well. By dawn, Bell had covered nearly fourteen miles. Her major hurdles were nature and exhaustion. Her coach, Gus Ryder, traveled alongside her by boat, shouting encouragement and keeping her energized by feeding her Pablum (corn syrup and lemon juice with water). News of her progress spread every hour via radio reports and extra editions of newspapers published throughout the day. By the time she reached the breakwater by Toronto's Boulevard Club (just west of the Canadian National Exhibition grounds), she was greeted by an onslaught of media and a crowd of fans totaling over 250,000 waiting for her on the shore. It was 8:05 p.m. In the end, Bell had swum forty miles, eight more than she expected (wind, the current, and subpar navigation equipment caused her to veer off course). She became a national hero and was unexpectedly gifted with more than $50,000 in prizes. That included the $10,000 meant for Florence Chadwick, from the Canadian National Exhibition.

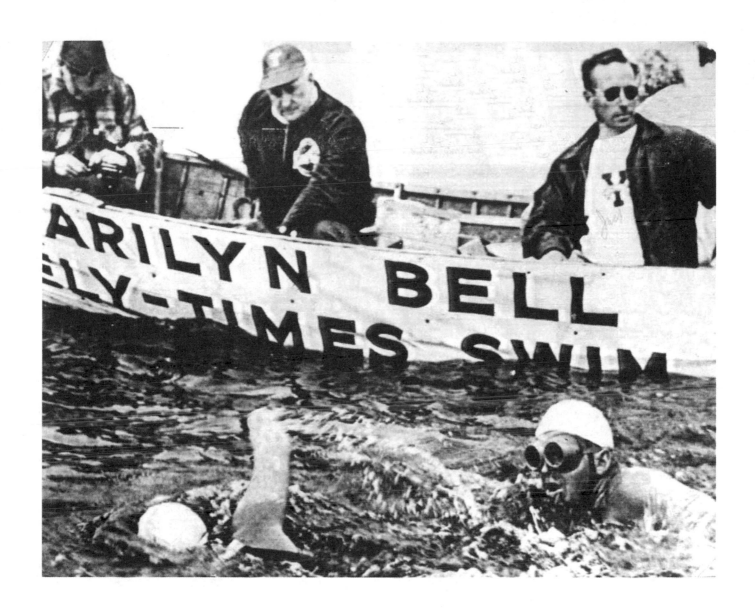

SUSAN BUTCHER

Racing the Iditarod means facing subzero temperatures, constant threat of frostbite, snow blindness, illness, lack of sleep so extreme it can bring on hallucinations, and a multitude of other unexpected and unavoidable hazards. It is a treacherous competition that demands unparalleled mental and physical endurance from both the mushers and sled dogs who participate, spanning eight days and 1,151 miles. Susan Butcher was the second woman to win the Iditarod, and went on to win it four more times in five years, one of the most incredible runs the competition has ever seen. Her husband and fellow dog musher David Monson recalled, "She was the first woman ever to dominate and be the best in the world at a sport where men and women compete equally, and the men did not like that."

Butcher's unlikely rise to the top mirrored the career of her beloved lead dog, Granite. Born the runt of his litter, Granite was a sickly dog unlikely to survive, but Butcher ignored the advice of others to give him away and kept him, sensing his desire to race. She worked year-round with all of her dogs—a practice that she started as the exception and thanks to her success is now the standard—and concentrated on building Granite's confidence. He soon became her lead dog, guiding the pack to Iditarod victories in 1986 and 1987. When he collapsed on a run in 1987 from a mixture of kidney infection and heatstroke, the vet delivered twofold bad news: Granite's racing days over, and he didn't have very long to live. Remarkably, the faith and care that Butcher gave him in the beginning of his life coaxed him into recovery, and he led her pack to a third consecutive Iditarod win in 1988.

Butcher passed away in 2006 after a year-long battle with leukemia. She is survived by her husband and two daughters. In honor of this truly remarkable athlete, the first Saturday in March has been designated "Susan Butcher Day" in Alaska.

RENÉE RICHARDS

Transgender pioneer Renée Richards began her athletic career as Richard Raskin, a successful ophthalmologist in New York City who played recreational tennis on the amateur circuit. After going through sexual reassignment surgery, Richards relocated to California to begin life anew, restarting her practice and, against the advice of friends, playing in amateur women's tennis tournaments. When the 6'2" Richards won the La Jolla Championships in 1976, a curious reporter did some digging that led to national headlines that read: "Women's Winner Was A Man."

In response to the story, the United States Tennis Association (USTA) released a statement declaring that Richards would not be welcome to participate in the U.S. Open, which prompted a boycott of the South Orange Open by Richards and twenty other female players. "I'm not a full-time major league tennis player," she said in a public statement. "I'm here to make a point. It's a human rights issue. I want to show that someone who has a different lifestyle or medical condition has a right to stand up for what they are."

Prior to the USTA's decision, Richards had had no desire to compete at the professional level, but the ruling so angered her that playing in the tournament became her primary focus. She applied to play in the U.S. Open, but because she refused to take the mandatory chromosome gender verification test, she was denied entry into the competition. She sued the USTA for gender discrimination and the case was taken to trial. The USTA provided a long line of witnesses who all testified that Richards shouldn't be able to play, but her lawyers had one surprise witness for her side: the most famous and highly regarded women's tennis player of the day, Billie Jean King. It was all that they needed. In an interview with the BBC, Richards recalled, "My lawyer handed over an affidavit from Billie Jean King that said she had met me, that I was a woman, that I was entitled to play, and that I couldn't be denied. And that was it. We won."

In 1977, Richards made history as the first transgender woman to play in a professional tennis tournament. In her first year of competition, she and Betty Ann Grubb reached the doubles final, losing to Martina Navratilova and Betty Stove. She made up for that loss, however, by winning the 35-and-over women's singles title. In later years she reached the mixed doubles semifinals two more times and won the 35-and-over singles competition again in 1979. She retired from playing in 1981, going on to become Navratilova's personal coach.

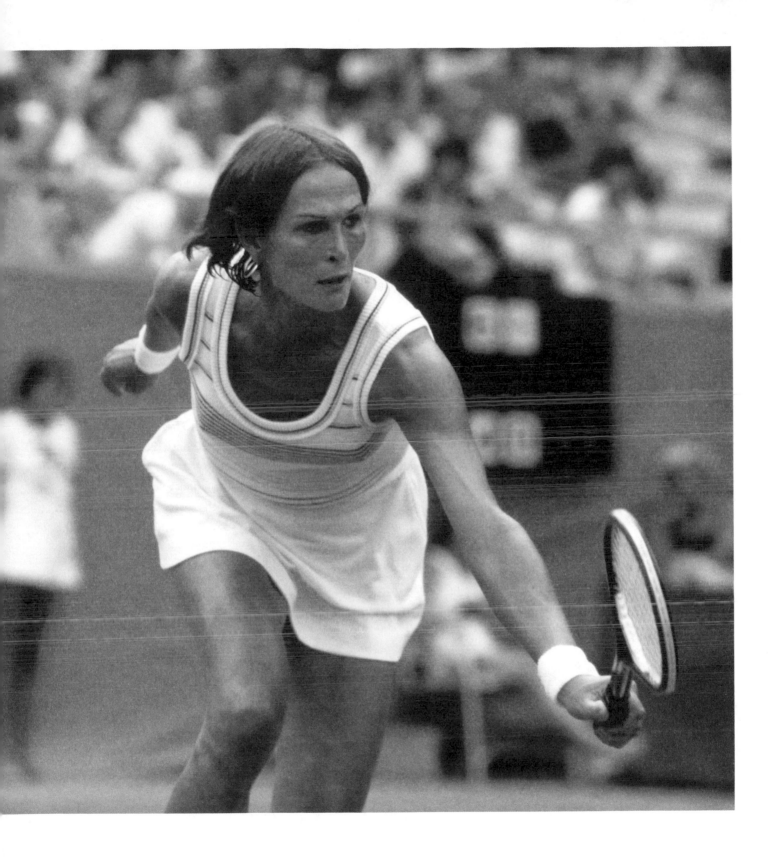

LIBBY RIDDLES

In March 1985, a blizzard swept across the Norton Sound in Alaska, causing competitors in that year's Iditarod to pause their race and seek safety in the tiny Eskimo village of Shaktoolik. It was there that twenty-nine-year-old Libby Riddles took fate into her own hands and made a shocking, high-risk, high-reward gamble. While her rivals took shelter, she plunged into the whiteout, mushing across the Norton Sound with her thirteen dogs in the darkness of the early morning. After gaining a favorable lead, she set up camp in the middle of the menacing ground storm. Unable to see much of the trail, Riddles later said, "I kept kicking myself and saying it was the stupidest thing I'd ever done, but I didn't think about ever turning back." By morning, it was evident that her plan had paid off. The storm had almost entirely dissipated, along with the chance that other mushers would be able to catch up to her.

Eighteen days, twenty minutes, and seventeen seconds after she started the 1,100-mile race in Anchorage, having passed over two mountain ranges, the Yukon River, and twenty-seven checkpoints, Riddles arrived in Nome, becoming the first woman to win the Iditarod. The second-place winner trailed her by about three hours.

A native of the Lower 48, Riddles didn't arrive in Alaska until the age of sixteen. Her love of animals pushed her toward sledding and training her own dogs, and five years after her move north, she entered into her first dogsled race, coming in first place. She eventually reached the skill level necessary to enter into the 1980 and 1981 Iditarods, but her inadequate performance in competition left her without sponsorship. She lived in a trailer without plumbing or electricity, feeding herself by living off the land. In order to earn money to feed her dogs, she sold souvenir hats to passing tourists. Riddles's great victory in 1985 changed everything for her, along with the perception of women in the Iditarod. She proved the impossible possible, confirming that gender has nothing to do with who can become the winner of "the Last Great Race on Earth."

SHIRLEY MULDOWNEY

Shirley Muldowney, the "First Lady of Drag Racing," boasted a career-long habit of standing out on the drag strip. She wasn't just a woman playing a man's game—she was one who systematically defeated the majority of her competition.

Muldowney began street racing at the age of sixteen in her native Schenectady, New York. "School had no appeal to me," she once said. "All I wanted was to race up and down the streets in a hot rod." At eighteen, she made her official debut on the Fonda Speedway. In the early part of her career, she faced massive opposition from everyone within her sport, later recalling that:

> A lot of competitors were ugly to me. What they didn't realize was they were making it worse for themselves. The angrier they made me, the more pissed I was, the better I was in the car. Driving came naturally for me. I was not afraid or unready to deal with the unexpected. That's where I think I had an edge on some other drivers. . . . Nobody held my hand.

No one wanted a woman in the races. That is, except for the fans. The burly men who made up the fan base of the drag racing world filled up the stands to see Muldowney tear up the strip, and went wild when her trademark pink parachute deployed. Despite the pushback from the higher-ups, no one could argue the fact that her presence meant ticket sales. She was a crowd favorite, and she was good for business.

Her record-breaking career spanned four decades, during which she became the first woman licensed by the National Hot Rod Association (NHRA), the first woman to race an NHRA top-fuel dragster, to win a top-fuel world championship, to break the six-minute barrier, and the first person in general to take the world championship title more than once (she won a total of three times). She collected eighteen national victories in NHRA competition, in addition to the others she had won in international and American Hot Rod Association sanctions. She was the first woman to claim the Winston World Championship, drag racing's most prestigious title.

In 1984, at the age of forty-four, Muldowney narrowly escaped death when a front tire failure caused her to veer off course. Her twenty-six foot car was thrown into a ditch at 250 mph and went on to tumble six hundred feet at a horrifically high speed, with her still strapped inside. She shattered her legs, pelvis, and hands and broke three fingers. It took six hours for doctors to clean her wounds before they were able to operate. For the next seven and a half weeks, they worked tirelessly to put her back together, doing everything in their power to avoid amputation. After eighteen months of skin grafts, bone grafts, thumb reattachment surgery, and a left ankle fusion (resulting in one leg being three-fourth of an inch shorter) Muldowney miraculously got back into a car, winning "Comeback Driver of the Year."

The NHRA has ranked Muldowney number five on its permanent list of drag racing's fifty all-time greatest drivers. She was inducted into the International Motorsports Hall of Fame in 2004, one year after she officially retired from the sport.

LINDA JEFFERSON

When Linda Jefferson first started out on the football field, long before she led the Toledo Troopers in a five-year undefeated streak in the National Women's Football League, her biggest defensive obstacle was sneaking out of her house, past her mother's watchful eye, so she could make it to the first few games. Fortunately, the need for secrecy disappeared once Jefferson's mother saw her daughter play and recognized her incredible gifts on the gridiron. She became her daughter's biggest fan, but she wasn't the only one who felt that way. In 1975, the running back was named *womenSports* Athlete of the Year, after leading the Troopers to an unprecedented 28-0 record for the first five seasons.

Along with her teammates, a ragtag mash-up of housewives, beauticians, and businesswomen, Jefferson played for a meager sum of twenty-five dollars a week, but clearly she wasn't in it for the money: "On the field we're football players," she said. "Off the field we're women. We like to win. To me, winning—winning with the whole team—that's the joy of it for me."

Over the course of six seasons with the Troopers, Jefferson amassed 140 touchdowns and 8,207 yards for a 12-yards-per-carry average. When she retired, she had scored more touchdowns than Jim Brown, O. J. Simpson, and Walter Payton. She made appearances on the *Today* show, *The Dinah Shore Show*, and the game show *To Tell the Truth*. In 1976 she appeared on ABC's hit show *Women Superstars* and placed fourth.

Jefferson is one of only four women inducted into the American Association Football Hall of Fame. She went on to teach and became a behavioral specialist, working for many years in Detroit with autistic children.

NURSES SOFTBALL TEAM

A women's softball team composed of army nurses stationed at an Allied hospital in North Africa during World War II on September 20, 1943. From left to right: Lieutenants Lydia Duewell, Eleanor Kelly, Helen Maag, Ann Kelly, Barbara Jerome, Marcella Whitlock, Ann Skorupa, Marie Edson, Berry Versaci, Kathryn Protz, and Red Cross worker Wenonah Wahler.

NADIA COMANECI

Nadia Comaneci in multiple exposure on the balance beam as she goes on to win her second gold medal of the night and her third of the 1976 Summer Olympics in Montreal, where she set the record for youngest-ever Olympic gymnastics all-around champion. The record stands to this day. Until the 1976 Games, the gymnastics scoreboard displayed only three digits, as a perfect score of 10 was presumed impossible. Comaneci scored seven perfect 10s total during the 1976 Games, and changed the sport forever.

ORA WASHINGTON

At the age of twenty-five, Ora Washington was encouraged to take up a sport to help her cope with the devastating sadness she felt after the death of her beloved sister. She opted to try tennis at her local YWCA branch in Philadelphia, where she had moved at a young age with her family, seeking a change from the Virginia landscape. The athleticism of her youth seemed to reawaken, and within a year she had won her first national women's title from the American Tennis Association (ATA), an organization created to provide opportunities for black tennis players banned from the exclusively white tournaments of the U.S. Lawn Tennis Association (USLTA).

She went on to win seven consecutive ATA national titles, eight overall, as well as twelve consecutive doubles titles and three mixed doubles titles. She would collect more than two hundred trophies throughout her nearly twenty-year tennis career, a record that established her as one of the country's best female tennis players.

Many successful athletes try to test their physical prowess in other sports, though the focus needed to dominate one sport is often too hard to replicate, or too time-consuming. Washington was the exception to this rule. In 1931 she joined and quickly became a star and leading scorer of arguably the most successful women's basketball team in the country, the Philadelphia Tribunes—right in the middle of her tennis reign. She even coached the team at times. She and her squad would travel the country playing any team that would accept the challenge, regardless of gender or race. They competed throughout the 1930s, and until the team's disbanding a decade later, lost only six times. During their road trips, the Tribunes would host free basketball clinics for girls in each town, sharing their tips for success with future generations of female athletes.

Although she knew it was a long shot, Washington wished more than anything to compete against Helen Wills Moody, the top-ranked tennis player of the all-white USLTA. Moody refused to play against her, and the segregated policies of the country at the time left Washington unable to do anything about it. She retired from singles competition in 1937, with a lingering feeling of disappointment that would never go away. She continued to play doubles until the mid-1940s, when she retired completely.

Despite her great athletic accomplishments, racial bias left Washington historically anonymous. Though she continued to help younger generations play tennis in her hometown of Germantown, Pennsylvania, she had to support herself as a housekeeper until she died in 1971. Her legacy on the court set the stage for the greats like Althea Gibson and the Williams sisters. Four years after her death, she was inducted into the Black Athletes Hall of Fame.

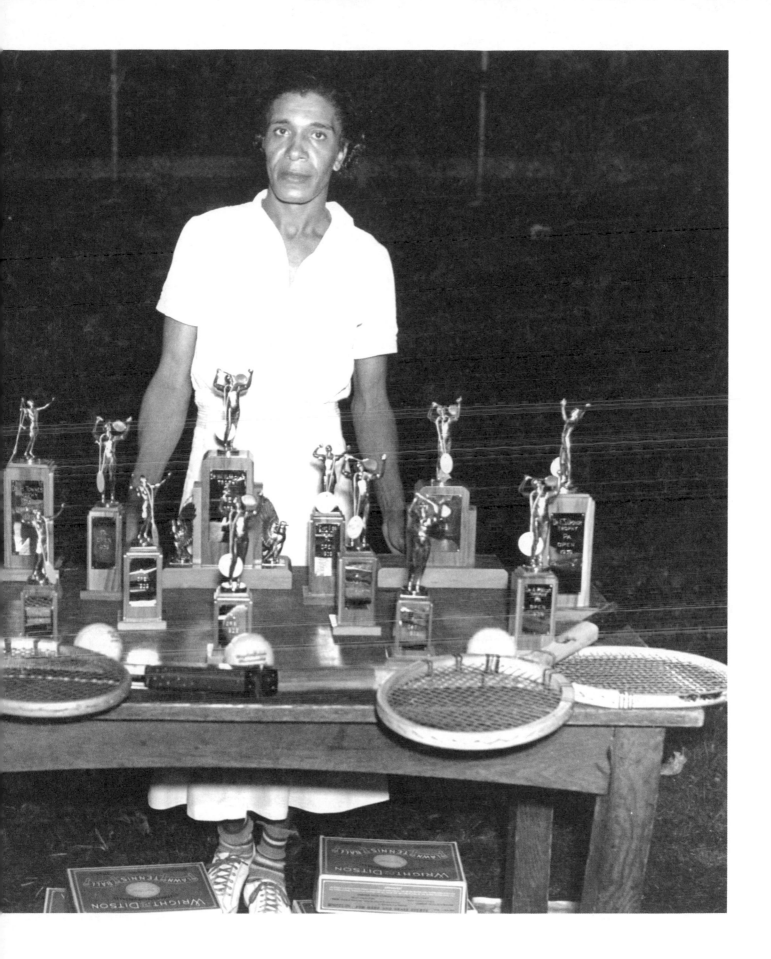

SHERYL SWOOPES /
NIKE AIR SWOOPES

For years, a female athlete's search for a basketball sneaker meant scouring stores for men's shoes in diminutive sizes, lest they fall victim to the "shrink it and pink it" marketing strategy, which counted women's basketball shoes among its casualties. In 1996, that all changed with the birth of the Nike Air Swoopes.

The Air Swoopes were named for Sheryl Swoopes, the first player to be signed by the WNBA. The shoe came out during her rookie season and was Nike's first signature basketball sneaker named for a female player. The shoe's lead designer, Marni Gerber, based it on Swoopes's personality, even going to Lubbock, Texas, to observe her among family and friends for inspiration. The resulting shoe was made not for a "girly girl," but a strong and capable athlete. The sneaker became so popular that for the first time in history, men desperately hunted for it in a larger size.

Over the years, Nike Air Swoopes went on to have seven signature models. Nike went on to create signature sneakers for Lisa Leslie, Dawn Staley, Cynthia Cooper, and Chamique Holdsclaw, with FILA and Reebok joining suit by putting out signature sneakers for Nikki McCray and Rebecca Lobo, respectively. Swoopes was named the 1993 Sportswoman of the Year, in the team category, by the Women's Sports Foundation.

PAT LAURSEN

Pat Laursen learned to shoot a rifle at the age of eight (a 16-gauge shotgun came later), and became a national champion at sixteen. Three years later, she shot a near-perfect 199 out of 200, almost winning the men's national championship. By the age of twenty, she was a three-time national women's skeet champion—the first woman ever to retain the title—and the national overall champ for having shot more targets than any other competitor that year, as both captain of the women's all-American team and member of the men's all-American team.

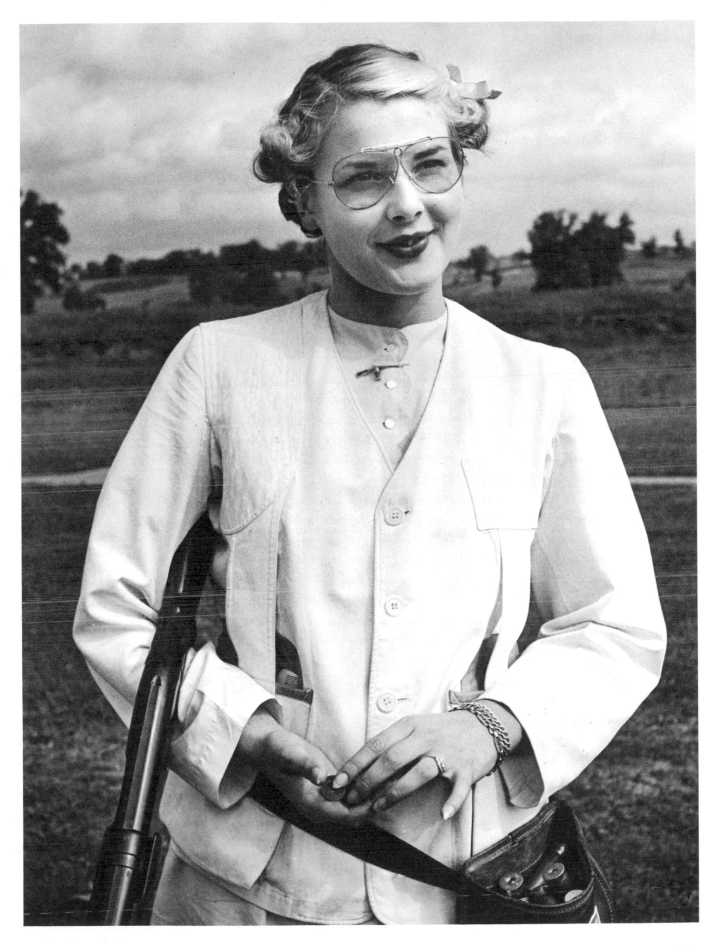

OLGA KORBUT

When measuring the history of gymnastics, there are certain athletes and performances that are considered milestones in the evolution of the sport. One of these moments was the 1972 Olympics in Munich, where a young girl changed the game forever. From that moment on, modern gymnastics could be divided into two eras: before and after Olga Korbut.

Before Korbut, gymnastics was regarded as an athletic derivation of ballet, dominated by adults. The sport's biggest star before 1972 was six-time gold medalist Larisa Latynina, a twenty-nine-year-old Soviet mother of two. She was traditional and precise, standing at just over five feet and weighing just over 100 pounds. Belarusian newcomer Korbut was a stark contrast. Standing at a diminutive 4'11" and weighing in at 85 pounds of pure athleticism, the seventeen-year-old captured the hearts of millions with her performances, and created a national obsession that had young American girls everywhere clamoring to become gymnasts.

During her first routine on the balance beam at the Munich Games, Korbut pulled off a back handspring to swing down to cross-straddle sit, a move never before seen in Olympic competition. In one pass, she seamlessly blended poise and grace with innovation and a daring attitude that made all take notice. The world fell further under her spell when she moved on to the uneven bars: after slipping and making multiple mistakes during her first pass, the pigtailed youngster broke down into tears, weeping in front of the cameras. The unexpected public display of emotion erased long-held stereotypes of steel-faced, unfeeling Russians. When Korbut wept, the world wept with her. With audiences already on her side, she produced a move on the uneven bars that would become known as the "Korbut flip." Standing on the top bar, she dove backward, catching the bar with her hands. Typically mild-mannered television announcers erupted with enthusiasm, shock, and awe. Never before had any of them seen anything like it—or anyone like her. The move was banned almost a year later; some said because it was deemed too dangerous, while others believed it to be an effort to rein in her uncontrollable influence. Korbut went home with two gold medals and one silver.

After the Olympics, she toured the world, meeting the queen of England and the Shah in Iran before arriving in the United States, where she met Mickey Mouse in Disneyland and President Richard Nixon at the White House. When the president remarked, "You're so tiny," Korbut charmingly replied, "You're so big!" The Soviet foreign minister later remarked that in a few weeks, the teen had improved Soviet-American relations more than he could in five years. Ironically, her success and influence led to the end of her career. She had inspired so many girls to compete during her 1972 Olympic performance that by the time the next Games came around, there was a major influx of young competitors, dramatically decreasing the age of the talent pool. Korbut was too old compared to the new wave of gymnasts at the forefront of the sport, and took a step back.

In 1994, Korbut was named one of *Sports Illustrated*'s "40 Greatest Athletes," and was the first person inducted into the International Gymnastics Hall of Fame. She now lives in the United States, where she teaches gymnastics.

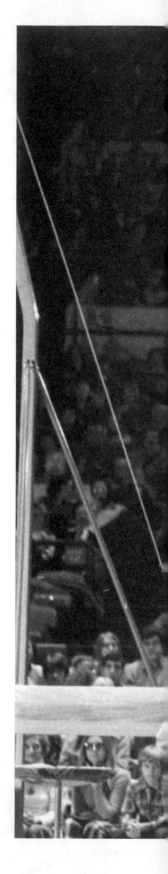

237

PAT SUMMITT

To players and fans of women's NCAA basketball, one name evokes feelings of admiration, love, and respect: Pat Summitt. One of the most iconic coaches in the history of the sport, she led the University of Tennessee's women's basketball team to a record 1,098 victories—more than any NCAA team, male or female—from 1974 to 2012. She also won 8 national titles and 32 combined Southeast Conference titles.

Summitt's love of basketball was born on a court built in a hayloft by her father, Richard Head, on their farm in Tennessee. When Summitt couldn't play basketball in high school because they didn't have a girls' team, her father's response was simple: "We'll just move." He made good on his word, and the 5'11" teenager was able to pursue her love of the game through to the 1976 Olympic Games, where she was a member of the first women's basketball team to represent the United States at the event.

Two years before, at the exceptionally young age of twenty-two, Summitt was hired to coach the Lady Vols at the University of Tennessee. Though Title IX had been enacted, women's college basketball was still in its infancy. That meant a low salary ($250 a month) and barely any funding, so she conducted doughnut sales to raise money for team uniforms, which she would wash herself. When the team had away games, it was she who drove the van, and on one occasion, the Lady Vols slept on the floor of the opposing team's locker room in sleeping bags laid atop thin rolled-out mats because a hotel would have been too expensive. For Summitt, lack of resources was not a surprise. While playing in college for the University of Tennessee, Martin, she had played in a dirty uniform for two out of three straight games, simply because the team only had one set of uniforms, and no time to wash them.

As her career progressed, Summitt's coaching style became as notorious as her record. Her father's authoritarian attitude came through from time to time; she often exploded onto the court, yelling and ripping into her players. She later admitted that her tone mellowed over the years, to keep players from quitting and keep herself from burning out—so, instead of yelling at underperforming players, she fixed them with icy stares. But she was still prone to outbursts, and in the 1990s she was caught grabbing and twisting point guard Michelle Marciniak's jersey. In an excerpt from her memoir, *Sum It Up*, she wrote, "It looked like the Wicked Witch talking to Spinderella." Summit kept her physical hands off from that moment on, but her outsize personality remained. She used a combination of passion, fury, love, and manipulation to get what she wanted out of her players, and was unconditionally honest, refusing to walk on eggshells or avoid embarrassing players. She called her treatment "brutal but not cruel," believing that honesty was her most powerful tool to create solutions that led to wins. "Sometimes I almost wanted to say to a kid, 'I'm going to save you from yourself, and you don't even realize you need it,'" she said. "'I'm going to show you how to live.'"

In August 2011, Summitt announced that, at the age of fifty-nine, she had been diagnosed with early onset dementia, and that the upcoming season would be her last. At every game she was met with stadium-wide standing ovations and throngs of fans wearing "We Back Pat" T-shirts (the proceeds went to Alzheimer's research). In November 2011, she created the Pat Summitt Foundation Fund to raise money for cutting-edge research, and a few months later, President Barack Obama announced that she would receive the Presidential Medal of Freedom. It was the last in a collection of hundreds of awards and accolades from over the years. In 1999, she was inducted into the National Basketball Hall of Fame. She passed away in 2016.

PATTI MCGEE

Patti McGee, aka "the Original Betty" or "OG Betty," was the first female professional skateboarder in history. Like the boys who helped grow the sport of skateboarding alongside her, the San Diego native was originally a surfer who used skateboarding as a way to occupy herself when the wind blew out. She built her first board using an old roller skate and a piece of plywood when she was only nine years old. The picture of clean-cut, effortless California cool, McGee became a spokesperson for Hobie skateboards, traveling all over the country giving demonstrations, as on *The Tonight Show*, appearing in commercials, and teaching Americans about the newest athletic craze. By the time she was nineteen, McGee was an iconic figure in the sport, appearing on the cover of *Life* magazine in 1965 doing a handstand on a moving skateboard. She called upon her experience as a diver to execute her skate moves with ballet-like grace, creating a strong, impressive style that was also distinctly feminine.

WOMENSPORTS MAGAZINE

At great financial risk and against the advice of some financial experts, Mrs. King has started a magazine, womenSports, to give women athletes national exposure and a forum for exchanging ideas. She has other business interests, but none is so close to her heart, none so perilous. If the magazine fails, it could wipe her out financially.

—*Jay Searcy,* New York Times, *September 8, 1974*

Determined to normalize the image of athletic women and nurture their dreams of competing on a professional stage, Billie Jean King followed her heart instead of her financial advisors when she launched *womenSports*, the first magazine to exclusively cover women in sports.

Copublished by King and her then-husband Larry, the magazine was headed by an all-female editorial staff and written by both men and women, making it just as revolutionary in content and execution as it was in print. Unlike the existing publications of the day, *womenSports* was staunchly against sexist text or imagery. The *New Yorker* covered the new venture's 1974 launch, and during its research found a conversation between King and *Newsweek*'s sports editor, Pete Axthelm, about *Newsweek*'s cover story on women athletes. King had liked the story but wasn't so sure about the pictures. "I got the feeling the women in the pictures were chosen mostly because they're pretty," she said. "Now, male athletes don't have to be pretty." *womenSports*'s founding editor, Rosalie Wright, felt the same way, and summed up the magazine's feminist slant clearly when she said, "No centerfolds, thank you."

The inaugural issue of *womenSports* appeared on newsstands in May 1974, with King on the cover. Articles included a piece by King titled "How to Win," along with profiles of race car driver Glenna Sacks and tennis champion Eleonora Sacks. Golfer Jane Blalock, Olympic gold medalist Donna de Varona (swimming), and Olga Fikotová Connolly (discus) served as consultants. Within the first year, the magazine gained 200,000 female readers—twice that of *Sports Illustrated*—and 70,000 subscribers. It appealed to athletes as well as those involved in the women's movement.

womenSports underwent many editorial and ownership changes until 1984, when it was acquired by Condé Nast. It was subsequently renamed and was absorbed into another of their publications (*Self*) in 2000, but it remains an integral part of the childhoods of a generation of female athletes and sports fans.

The drug epidemic in big-time athletics
Wheelchair World Games

Alone across the Atlantic
Claudia Starr. Jockey

WomenSports

November 1974

$1.00

PRO FOOTBALL
Women Take the Field

Skiing in Davos

Hunting in Maine

Burro racing
in the Rockies

Micki King
teaches flyers to dive

How
to buy skis
to throw a football
to mate a king

RUBERTA MITCHELL

In 1952, Ruberta Mitchell was a rookie with the San Francisco Bay Bombers, the National Roller League's premier franchise. She emerged as a star on other racially integrated, mixed-gender teams, including the Los Angeles T-Birds, the Detroit Devils, the New York Bombers, and the Eastern (Philadelphia) Warriors, with whom she appeared on the track opposite Raquel Welch in the 1972 film *Kansas City Bomber*. Mitchell, who captained the Baltimore-Washington Cats, was inducted into the Roller Derby Hall of Fame in 2014.

ZOLA BUDD

As a young girl in Bloemfontein, South Africa, Zola Budd slept with a poster of America's track sweetheart, Mary Decker, taped above her bed. Little did she know that in just a few short years, Decker's name would become indelibly linked to hers, and that for years to come she would be wrongfully held responsible for her hero's dashed Olympic medal dreams.

Budd grew up running barefoot through the hills of her hometown with her beloved older sister, Jenny. When Jenny died of melanoma at twenty-five, fourteen-year-old Zola dealt with her deep grief by running harder and faster than she ever had before. Years later, running a race in Stellenbosch, South Africa, she set a new women's world record in the 5000m, breaking Decker's record by six seconds. This unexpected achievement made Budd the talk of the running world, which was awed by the tiny seventeen-year-old girl who had shattered a world record while running in what would become her trademark bare feet. But South Africa's apartheid policies excluded it from international competition, and so her time was not recorded or ratified.

As the 1984 Olympics approached, the British tabloid the *Daily Mail* sensed a potentially interesting story line in Budd, and in exchange for money and a British passport (which would allow her to compete), she gave the paper exclusive rights to her story. Her arrival in England was met with controversy and disdain. Many were outraged at what they perceived as a white, privileged, opportunistic girl from a racist nation getting preferential treatment, "a remorseless symbol of South Africa's segregationist policies," according to a *New York Times* reporter. Almost immediately, they positioned her against the universally adored Decker, not realizing—or caring—that the real Zola Budd was a shy, introverted teenager who had experienced deep loss and just loved to run.

When the time finally came for Budd and Decker to race one another in the highly anticipated 3000m Olympic final, the media-spurred rivalry was at its apex. The women were neck and neck, and ran into each other three times during the race. The third time Decker fell, ripping Budd's number off her back as she went. Budd kept running. It wasn't until she heard the crowd booing that she realized they all thought she was the reason for her opponent's fall. Frightened, she dropped back from the lead and finished the race in seventh place. Though she tried to apologize after the race, Decker was furious and blamed her for the whole affair. Budd was briefly disqualified, but reinstated an hour later after officials reviewed the tape and saw that she could not have been responsible for Decker's fall. Still, the quiet teenager was an easy target and was met with hatred, insults, and even death threats from spectators and fans.

After the Games, Budd continued to compete in the United Kingdom, winning international cross-country titles and breaking the 5000m record yet again. She hoped to compete in the Olympics in Seoul in 1988, but she was banned for having attended—not even competing in—two races in South Africa. Now married with two children, she continues to run to this day, though not for the medals, she has said. Just for the love of the sport.

SHAWNA ROBINSON

Shawna Robinson began racing diesel trucks with her amateur racer father at eighteen, and within a year was voted the Great American Truck Racing (GATR) Rookie of the Year, after becoming the first woman to win a GATR major super-speedway race. Four years later she graduated to stock cars and within the year became the first woman to win a major NASCAR Touring Series event, and subsequently, the first woman to win a NASCAR pole position in a Grand National NASCAR race. She advanced to the Grand National Division not long after, competing in eight NASCAR Cup races and sixty-one Nationwide Series races during her decades-long career.

STELLA WALSH

The story of Stella Walsh is a tale of two people—how she saw herself and how the world and history saw her were sadly at odds. Born in Poland in 1911 with the name Stanislaw Walasiewicz, her family emigrated to Cleveland, Ohio, when she was an infant. From then on, she went by "Stella Walsh" to minimize her ethnic difference from her peers.

Throughout her life, Walsh's prowess on the track balanced out the cruel treatment she received for having what were widely seen as "less than feminine features." Eventually, her dominance of regional track meets made her a Cleveland celebrity and wiped away the taunts and references to "Bull Montana" (a widely popular actor famous for playing henchmen), and she burst onto America's radar when she set a world record for the 100-yard dash in 1930. The press descended upon her parents' home, and though they were unable to speak English, Julian and Victoria Walasiewicz/ Walsh sat proudly on their front porch, brandishing all of their daughter's trophies and medals for a throng of photographers. Almost overnight, she became America's gold medal favorite for the upcoming 1932 Olympics in Los Angeles.

Though she was a formidable athlete, Walsh was also a regular employee of the New York Central Railroad. When the Great Depression hit, she lost her job, and a way to pay for a trip to the Olympic Games (something required of all American athletes at the time). Her dreams suddenly felt as if they were fading away before her. One week later, on the very morning she was to become a naturalized American citizen, a messenger from the Polish consulate arrived at her home with the offer of a job and money for her education—with the caveat that she represent Poland at the Games. The decision lay before her: compete for Poland or don't compete at all. She chose to compete. She announced her decision to the press, noticeably torn over having to leave Cleveland. The move was the first of two great controversies that would divide public opinion of her. Some blamed the U.S. Olympic Committee's lack of support for female athletes, while others saw her move as a total betrayal of the United States.

In 1932, Walsh captured a gold medal for Poland at the Los Angeles Summer Games. She then moved to Poland to train and study. While in Europe, she was a six-time medalist (four gold, two silver) at the Women's World Games, won a silver medal at the 1936 Olympics in Berlin, and added two Olympic medals for Poland and eight European records to her more than one hundred career records. But cultural differences placed unexpected emotional stress upon her. Her American upbringing made her a stranger in her own home country. She soon moved back to the United States, and was finally naturalized in 1947.

Walsh spent the rest of her years in her beloved Cleveland, immersed in the Polish-American community, where she supported the growth of young athletes until her tragic death during an armed robbery in 1980. This led to the second controversy that would affix itself to her legacy: an autopsy revealed that Walsh had had a chromosomal disorder known as mosaicism (also known as "intersex"), which gave her ambiguous genitalia. A media firestorm ensued. Papers cruelly proclaimed her "Stella the Fella," questioning the legitimacy of her medals and records if she was actually a man. The Polish-American community and the city of Cleveland stood by her. In 1981, a reporter refuted the accusations, declaring that despite the presence of the XY chromosome, "[s]ocially, culturally and legally, Stella Walsh was accepted as a female for sixty-nine years. She lived and died a female."

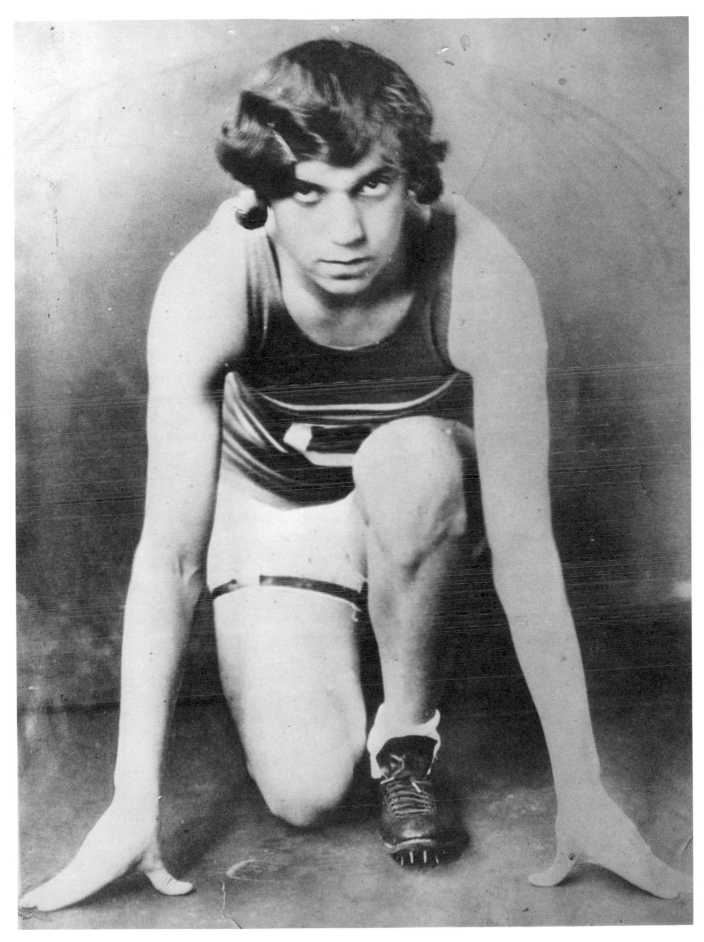

WILMA RUDOLPH

Before she became the first American woman to win three gold medals at a single Olympics, before she was known as "the Tornado, the fastest woman in the world," before she made her mark as one of the most famous athletes in American history, Wilma Rudolph was a young girl who spent much of her childhood struggling to stand up on one foot. When her first Olympic medal was placed around her neck, the sixteen-year-old sprinter had only been running for five years, and hadn't been walking for much longer.

Born premature, the next-to-last of twenty-two children in St. Bethlehem, Tennessee, Rudolph started her life defying the odds. Though she would one day tower over her competition at nearly six feet tall, she came into the world weighing only four and half pounds, and was struck by scarlet fever and double pneumonia simultaneously during her infancy. Because the local hospital was for whites only, she had to be cared for at home and nearly died. She contracted infantile paralysis caused by polio at age four, and though she eventually recovered, she had to wear a metal brace on her twisted left leg. Once a week, on her day off, Rudolph's mother would take her on the ninety-mile bus ride to the closest hospital that would allow a black child in for rehabilitation. On other days, her siblings took turns caring for her and massaging her leg. Eventually an orthopedic shoe replaced the brace, and when she was eleven her family woke up to a miracle: she was playing basketball in the backyard in nothing but her bare feet.

From that moment on, Rudolph's life would be defined by her athleticism and grace. By age thirteen, she was on her high school basketball team, making all-state twice. Soon after she was scouted by Tennessee State University track coach Ed Temple and recruited to practice with the institution's esteemed track team, the Tigerbelles. By 1956, she was the youngest person on the American Olympic team, competing in Melbourne. In 1960 she returned to the Olympic stage—this time in Rome—stronger and more experienced. This time the entire world took notice. She won three gold medals, and set two world records, one with three of her Tigerbelle teammates in the 4x100m relay. The newspapers called her "the Black Pearl" and "the Gazelle" for her graceful, regal demeanor and powerful running style. When the U.S. team toured Europe, fans clamored to get a glimpse of her. In Berlin, admirers stole her shoes, then surrounded her bus and beat on it until she waved. *Sports Illustrated* reported that mounted police had to keep back fans in Cologne.

Upon her return home, Rudolph continued to create history. When Tennessee's governor, Buford Ellington, made plans for a segregated homecoming celebration, she refused to attend. Eventually she won out, and her victory parade and banquet were Clarksville, Tennessee's first integrated event. Rudolph retired from amateur track at the age of twenty-two, becoming a teacher, track coach, and sports commentator. She spent the later years of her life mentoring many African-American female athletes, including future champions Florence Griffith Joyner and Jackie Joyner-Kersee, until her death in 1994. Her legacy continues to inspire and fortify the dreams of minority athletes and women all over the United States and the world.

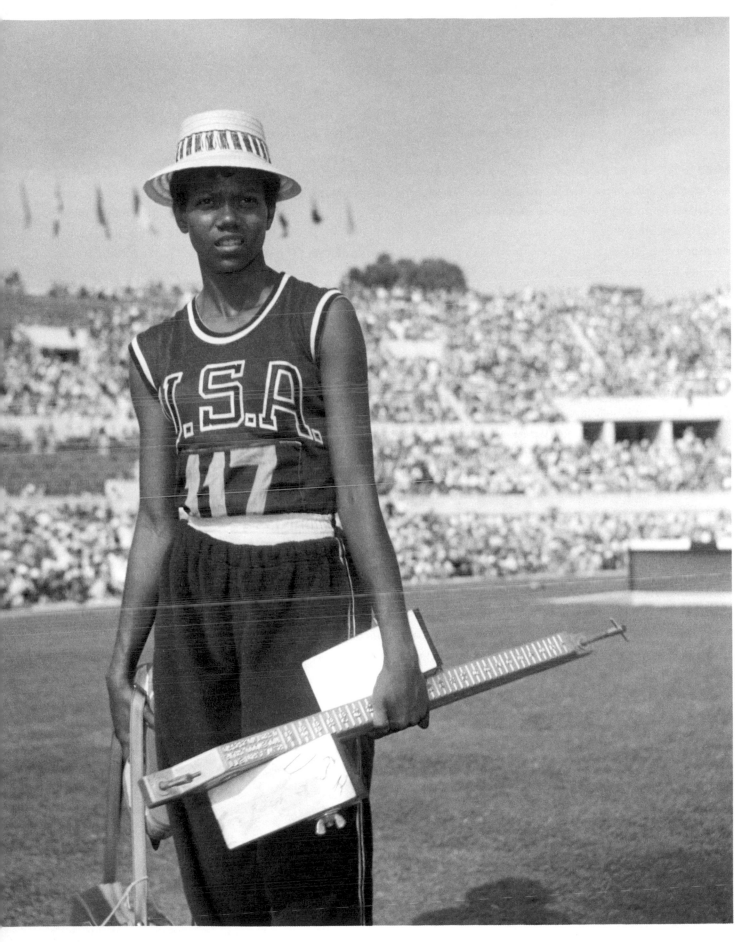

TONI STONE

When Marcenia Lyle, aka "Toni Stone," was hired in 1953 as the first woman to play in the Negro Leagues, she hoped it would bring her one step closer to her dream of becoming the female Jackie Robinson.

Hired to fill the space created when Hank Aaron left the Indianapolis Clowns for the major leagues, Stone's selection was treated with near-circus-like exploitation. The Negro Leagues made her their spectacular main attraction, trying to bolster attendance (which had dramatically decreased after Jackie Robinson broke the color barrier in the majors) with the unconventional idea of a woman playing amongst men. The Clowns' owner, Syd Pollack, threw all the focus on promoting Stone's gender. An interview that year in *Our World* stated, "The second baseman of the triple-pennant winning Indianapolis Clowns of the Negro American League wears a size 16 dress. That is, when she is not playing baseball. On the playing field she wears an oversize 42 shirt (to accommodate her 36 bust) and thinks, talks, and plays like a man."

Stone's presence reinvigorated the league's fan base, yet she was often heckled from the stands and on the field. At one point she said her teammates treated her as if "I wasn't supposed to be there. They'd tell me to go home and fix my husband some biscuits, or any damn thing. Just get the hell away from here." After she complained about a teammate who sexually harassed her, the team's manager told her she'd have to handle things herself—she took their advice by going after the guilty party with a baseball bat. When she rode on the team bus from game to game, it was assumed that she was the team's prostitute, a supposition teammates neglected to correct. In a twisted act of defiance, Stone occasionally sought room and board in brothels while on the road, where she was provided shelter, a meal, and somewhere to wash her clothes, creating unlikely fans out of the prostitutes she met; many of them even kept up with her progress by reading the sports section of the newspaper.

While her gender may have made her controversial, Stone's athletic prowess was undeniable. In what would be her first and last year playing for the Clowns, she appeared in fifty games, batting an average of .240, which included a hit off legendary pitcher Satchel Paige. In the off-season, she was traded to the Kansas City Monarchs. With her age catching up to her (she had lied about her age early in her career, pretending to be ten years younger to increase her appeal) and resentment from her new teammates proving difficult to adjust to, Stone retired from the Negro League at the end of the season. Sports historians often refer to her as "the best baseball player you've never heard of." In 1993 she was inducted into the Women's Sports Hall of Fame.

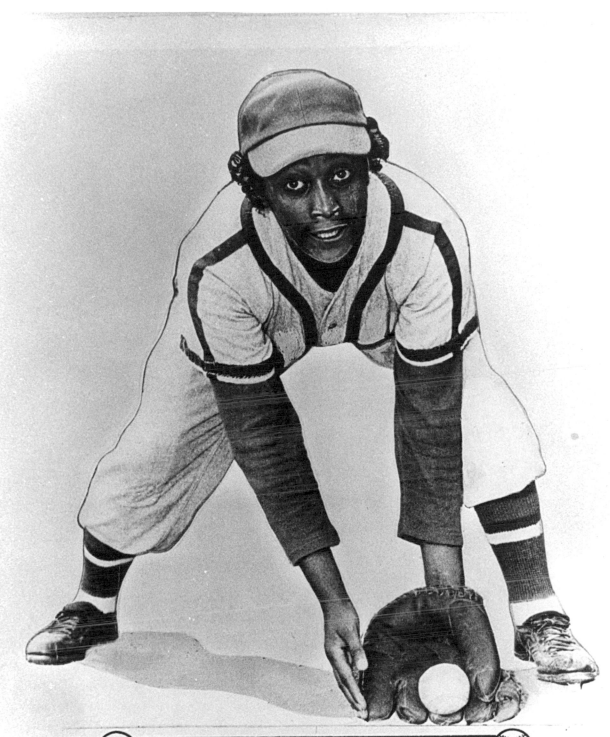

Toni STONE
Female 2nd Baseman of
Negro American League
CLOWNS

TRUDY BECK

Trudy Beck, one of the fastest desert racers of the 1970s and a member of the American Motorcycle Association's premier desert racing body, District 37, began racing with her father at twelve years old. By sixteen, she was the top-ranked women's desert racer in the United States. In 1975, the name of the Powder Puff National Championship was changed to the Women's Motocross Championship, signaling a heightened regard for women in the sport by virtue of the accomplishments and tenacity of trailblazing riders such as Beck.

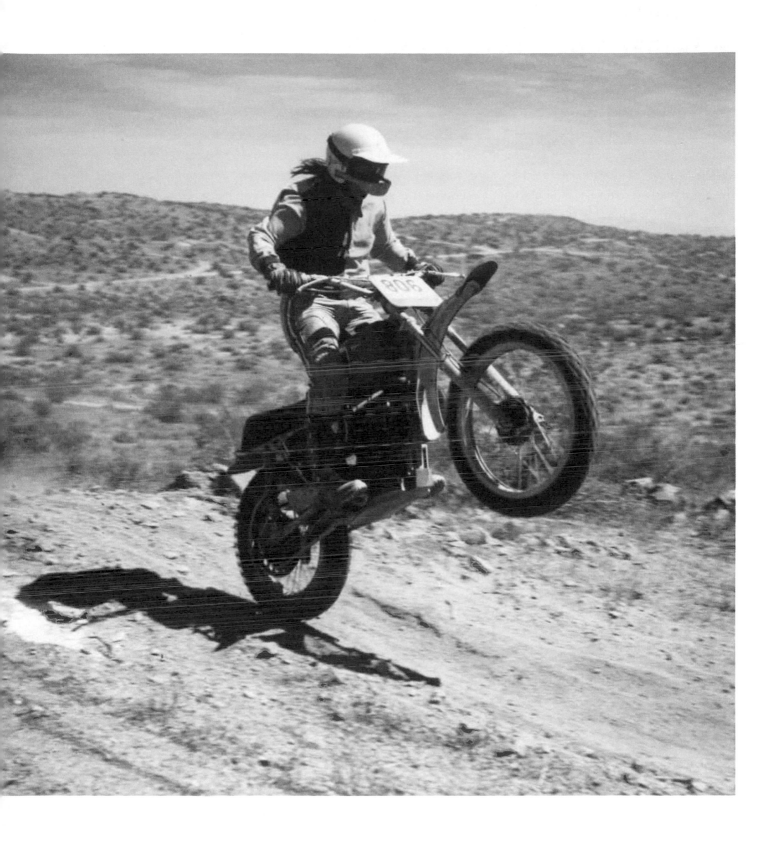

MARIBEL OWEN, LAURENCE OWEN, MARIBEL VINSON-OWEN

When the American figure skating team boarded Sabena flight 548 on February 15, 1961, bound for the World Championships in Prague, along with sixteen of their friends, coaches, and family members, hope and excitement were in the air. Years of hard work had led them here, and they were ready to make headlines. Unfortunately, they did, when the flight crashed during a landing attempt in Brussels the same night. All seventy-two passengers were killed, thirty-four of them from the U.S. skating delegation. Esteemed coach Maribel Vinson-Owen and her two rising star athlete daughters, Laurence Owen and Maribel Owen (aka Maribel Jr.), were among the lives that were lost, robbing future generations of two talented and passionate athletic role models.

The Owen family had just become instant celebrities that year when, for the first time in history, the skating national championships were broadcast on live television by CBS. Laurence and Maribel Jr. stuck out almost immediately. The former, a senior at Boston University, won the pairs competition with her partner, Dudley Richards, and her sixteen-year-old sibling took first place as a single skater. America was enraptured. Laurence went on to win the North American Championships less than a month later, on February 12, just two days before the crash that took her life. She was particularly captivating, with a fresh, hip bob haircut and a joyful, graceful demeanor on the ice. The day before the flight, on February 14, she appeared on the cover of *Sports Illustrated*, the headline proclaiming her "America's first exciting girl skater."

Though her daughters were successful, Maribel Vinson-Owen was a legend in her own right, a nine-time U.S. national figure skating champion, an Olympic bronze medalist who competed on three U.S. Olympic teams, and a two-time world championship medal winner. As a pairs skater, she was a six-time national champion. The daughter of two figure skaters herself and the wife of figure skater Guy Owen, one of her professional pairs partners, Vinson-Owen began coaching when her career on ice slowed down, and she left an indelible legacy on American figure skating. She authored three books on the sport (*Primer of Figure Skating*, *Advanced Figure Skating*, and *The Fun of Figure Skating*), and her style of coaching was passed down through her students, who kept with her methods when they became coaches themselves. Of the twelve members of the 1960 Olympic figure skating team, six had been coached by her.

Vinson-Owen was a three-time inductee of the U.S. Figure Skating Hall of Fame, most recently in 2011, when she, her daughters, and the rest of the 1961 U.S. Figure Skating Team were honored. The U.S. Figure Skating Memorial Fund was established soon after the crash, and still exists today to provide funding for thousands of American figure skaters. Olympic medalists Peggy Fleming, Kristi Yamaguchi, and Scott Hamilton were among those helped by the fund in their earlier years.

PENNY PITOU

As has often been the case for determined female athletes at the onset of their careers in the years before Title IX, Penny Pitou had to disguise herself as a boy in order to compete on the Laconia, New Hampshire, high school "boys-only" ski team. She had her friends call her Tommy and hid her long hair under her winter ski hat. Despite winning several races, she was kicked off the team in 1953 when she caught an edge of her ski and crashed into a gate, knocking her hat off and revealing her hair—and secret.

Born in 1938, Pitou learned to ski at the Gilford Outing Club in New Hampshire when she was seven years old, and continued to practice her sport on New England mountains. She qualified for the 1956 Olympics in Cortina d'Ampezzo, Italy, but failed to perform to the standards she set for herself, and so she spent the next few years training intensely, to ensure she was the gold medal favorite for the 1960 Winter Olympics in Squaw Valley, California. While the gold eluded her, again, Pitou managed to earn silver in both the downhill and giant slalom events, becoming the first U.S. athlete to win an Olympic medal in downhill, and establishing a new era of ski racing in the United States.

After the Games, she solidified her legacy on the local stage by starting the Penny Pitou Ski School at the Gunstock Ski Area in Gilford, New Hampshire. She bought a travel agency in 1974 and after a few years began to organize skiing and hiking trips to the Alps. Pitou was selected to the New England Women's Sports Hall of Fame in 2001, and continues to run one of the largest travel agencies in New England.

SHIRLEY AND SHARON FIRTH

Twin sisters Shirley and Sharon Fifth grew up on the freezing tundra of Canada's Northwest Territories, on the scenic Mackenzie River in the tiny village of Inuvik. Members of the Gwich'in First Nation, the Firths were a traditional native family who lived off the land. The father, Stephen, was a trapper, who followed the large, wild caribou herds of the Mackenzie Delta and taught his daughters how to trap small game. Their mother, Fanny Rose, taught them how to fish and sew animal hides, and their daily chores included cutting and packing wood and retreiving water from the river. What they did as children had been done by generations before them, but what they accomplished as young adults had not.

Cross-country skiing was unheard-of in Inuvik until 1965. That year, a Roman Catholic priest and avid cross-country skier named Father Jean-Marie Mouchet was stationed in the local church. Observing the naturally athletic way of life in the rugged tundra, he thought that the kids would do well with the sport and made plans to introduce it to the community. The first day the children tried out skiing, Father Mouchet invited a friend, Bjorger Pettersen, a Norwegian coach working with the Canadian Ski Association, to observe. Shirley Firth was one of the first children to receive a pair of skis. Her mother allowed her to participate on one condition: she bring her sister Sharon.

Soon the Canadian government found out about Mouchet's burgeoning ski program and gave him money to support and continue. The program was officially called the Territorial Experimental Ski Training program (TEST) and it was decided that the best skiers in the Mackenzie Delta would train formally with Pettersen and a Norwegian coach named Anders Lenes. Lenes single-handedly coached and trained the Canadian National Ski Team from 1975 to 1984, and brought them to the 1976, 1980, and 1984 Winter Olympics, as well as the 1978 and 1982 World Nordic Ski Championships. His focus was technical skills, and he immediately recognized the Firth sisters' potential. They made their national debut at the Canadian Junior Cross-Country Championships in 1968, and took silver (Shirley) and bronze (Sharon). In 1970, they became members of the very first women's Canadian Olympic cross-country ski team, and the first female indigenous athletes to represent their country. They went on to compete in the 1972, 1976, 1980, and 1984 Winter Games, and their combined wins totaled 79 medals from national championships, including 48 national titles. The two dominated the world of Canadian cross-country for the large part of their unprecedented seventeen-year tenure on the national team.

In 2015, Sharon and Shirley Firth became the first inductees from their territory to the Canada Sports Hall of Fame. Sharon accepted the honor on behalf of herself and her sister, who had passed away two years earlier. In an interview with CBC News North, she said: "It is the highest honor you can get in sports in Canada. I'm sharing it with all the communities in the territories and dedicating my award to all the young people. All thirty-three communities, and Nunavut, and the Yukon."

WYOMIA TYUS

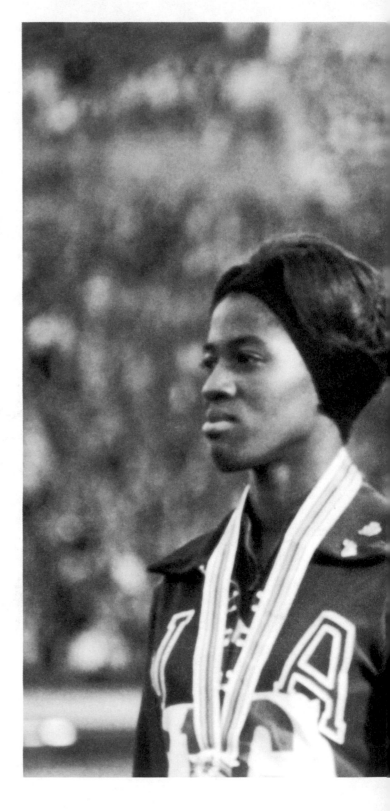

Wyomia Tyus is awarded the gold medal for the 100m at the 1964 Summer Olympics in Tokyo, establishing herself as the fastest woman in the world. Four years later, she would become the first defending Olympic champion in the event, winning a second consecutive gold medal at the 1968 Mexico City Games, where she also set a world record during her leg of her team's gold medal-winning 4x100m relay. She announced to the press shortly after that her team was dedicating their win to fellow American Olympians Tommie Smith and John Carlos, who had been expelled from the Games and stripped of their gold and bronze medals, respectively, for a silent, peaceful act of protest during their national anthem against the human rights abuses of black Americans.

RICA REINISCH

As she competed at an elite East German sports school, twelve-year-old swimming prodigy Rica Reinisch's body was changing, but not in the ways that most do. Some of the physical shifts, like increased weight and muscle mass, were expected for a young athlete who had been intensely training for seven to eight hours a day since the age of ten, but other changes, like the deeper tenor of her voice, seemed less normal. Her coach, Uwe Neumann, assured her it was nothing to worry about, and gave her cups full of vitamins to take after a workout, saying that they would "help [her] body regenerate more quickly." Because she was so young and trusted him like a father, Reinisch took them without question. Mixed in with the pills was a little blue tablet, administered to her and the hundreds of other athletes in the communist country's Olympic training program. Though the pill disappeared from her regimen just before the 1980 Olympics in Moscow, she barely noticed; she was busy setting three new backstroke world records and winning three of the East German women's swim team's eleven gold medals. When the Olympics were over, the vitamins came back, and she set three European world records.

Then, in 1982, while at a training camp in the Ukraine, Reinisch suddenly collapsed. She was flown back by helicopter to Dresden, East Germany, where her examining doctor gave her a distressing diagnosis: her ovaries had become so greatly inflamed that she needed to give up competitive sport. Reinisch and her parents were shocked and furious. She later shared that her mother immediately went to the pool in a fit of anger and screamed at Uwe Neumann, "From your clutches . . . I will rescue my daughter from your clutches." That was Reinisch's last day of swimming. She was only sixteen.

At the time she was devastated, but nearly a decade later she discovered that early retirement had probably saved her life. When the Berlin Wall collapsed in 1989, so did the highly classified, state-sponsored East German doping program known as "State Planning Theme 14.25." In an effort to prove communism's supremacy through exceptional athletes, the government had subsidized the production of Oral-Turinabol, or O-T, an anabolic steroid derived from testosterone, through its state-run pharmaceutical company, Jenapharm. Hundreds of coaches were responsible for doling out the drug to East German athletes beginning in the mid-1970s.

While many were, like Reinisch, completely unaware of the drugs, others revealed that they had had suspicions, or knew but felt they could not stand up to the ruling body administering the drugs. Regardless, every athlete felt the physical consequences of the program for years to come. Reinisch suffered from ovarian cysts and an irregular heart condition that prevented her from serious physical exercise and in part caused two stillbirths. She is considered a mild case. Other female athletes suffered from cardiovascular diseases, liver failure, cancer, and in the extreme case of shot-putter Heidi Kreiger, an irreversibly masculine form that led to a sex change in 1997.

From the program's inception until its end, the total medal count of East German participants at the Winter and Summer Olympics from 1956 to 1988 amounted to 203 gold, 192 silver, and 177 bronze. Reinisch's sentiments on the matter echo those of so many of the hardworking athletes deceived by the government they unwittingly gave their lives for: "The worst thing is they took away from me the opportunity to ever know if I could have won the gold medals without the steroids. That's the greatest betrayal of all."

ROBIN HERMAN

Breaking the gender barrier in any social or professional sphere is usually an isolated incident reserved for a fortunate few. Yet for Robin Herman, it was an impressive recurrence. It began on her first day of college at Princeton University in 1969, when she was counted among the first forty female freshmen to have been admitted to the institution in its two-hundred-year history. That same year, she became the first woman staff member of the school newspaper, the *Daily Princetonian*. She got her start covering men's rugby, was quickly promoted to first female sports editor at the paper and eventually became managing editor. After graduation, she made history again when she became the *New York Times'* first female sports reporter in 1973.

While covering the NHL for the *Times*, Herman noticed a great disadvantage to female sportswriters. Unlike their male counterparts, they were not permitted into the professional locker rooms, which excluded them from access to crucial postgame coverage. She fought for more than a year to gain entry and thus, equal opportunity. Finally, in 1975, while covering the NHL All-Star Game in Montreal, she and Canadian journalist Marcelle St. Cyr became the first women ever allowed in a men's professional locker room in any North American sport. The milestone occurred unexpectedly when, without solicitation, both teams' coaches invited the women to conduct postgame interviews along with the men. The groundbreaking decision suddenly turned the spotlight away from the athletes and onto Herman and St. Cyr. In an interview with the *New York Times*, she recalled, "I kept saying, 'I'm not the story; the game is the story But of course that wasn't the case. The game was boring. A girl in the locker room was a story."

Not everyone approved. The decision sent shock waves through the professional sports world, resulting most notably in a vote by the New York Rangers to ban female reporters from the locker room, despite the fact that none of the players had ever interacted with a female reporter. Herman later wrote of the experience:

> I wanted to voice a warning that they need to pay attention. I thought my experience as the "girl in the locker room" was shorthand for the barriers we had to break and the case we had to make that we deserved equal opportunity and treatment in the spheres of employment and other rights.

Later, she became the first female member of the Professional Hockey Writer's Association and was the seventh winner of the Mary Garber Pioneer Award, the Association of Women in Sports Media's highest honor. In 1978, Herman transitioned from sports to politics for the *New York Times*. In 1999, she moved again, this time to academia, when she was appointed assistant dean of Harvard University's School of Public Health.

TENNESSEE TIGERBELLES

The Tennessee State University Tigerbelles sightsee in Rome during the 1960 Summer Olympics, during which Wilma Rudolph (second from right) broke three world records and became the first American woman to win three gold medals in a single Olympic Games, for the 100m, 200m, and (with her fellow Tigerbelles) the 4x100m relay. The Tigerbelles made their Olympic debut in 1956, when six Tennessee State University female athletes, under coach Ed Temple, qualified for the team. Twenty-three Tigerbelles won Olympic medals, thirteen of which were gold, and thirty-four won national championships during Coach Temple's forty-four-year tenure, making them the most internationally accomplished athletic team in the state's history.

WAYLAND BAPTIST FLYING QUEENS

No reasonable explanation can be given to describe how Wayland Baptist University, a tiny West Texan school known for matriculating "teachers and preachers," became home to a pioneering women's basketball team that boasted a five-season undefeated streak that has yet to be surpassed to this day.

From 1953 to 1958, nearly two decades before the passage of Title IX and thirty years before the NCAA began sponsoring women's basketball, at a school so conservative that women were forbidden from wearing shorts outside the gym (even on the walk back to their dorm rooms) the Wayland Baptist Flying Queens were beloved more than any men's sports team. The school went through uncharacteristically progressive changes during the tenure of president J.W. Marshall (who held the position from 1947 to 1953). His presidency was defined by accomplished hopes of landmark social reform (Wayland was the first four-year liberal arts school in the states of the former Confederacy to be voluntarily integrated, giving students of color the same rights and privileges as all other students), and a desire to improve the school's music and athletic programs.

History was made in the early 1950s when Marshall asked local businessman Claude Hutcherson, a rancher and owner of a flying service, if he could provide transportation for the women's team to a series of games in Mexico. Hutcherson agreed and the encounter blossomed into a full-fledged sponsorship, with Hutcherson spending copious amounts of money on the team. The generous sponsorship was astonishingly luxurious. Beechcraft Bonanzas became the signature mode of transportation for the 9,000 miles a year the Flying Queens traveled to get to games. They were provided three sets of uniforms, traveling attire, and stayed in upscale hotels. On the court, the Flying Queens were just as spectacular. After a fortuitous encounter with the Harlem Globetrotters, the Flying Queens began incorporating some of the team's theatrical moves into their pregame warm-up. The school was so enthralled with the Flying Queens that when the team ended its 131 consecutive game winning streak, all classes were canceled to allow for a collective day of mourning. Despite the team's historical winning streak and unparalleled popularity, the Wayland board of trustees voted unanimously to eliminate the women's basketball program in 1961, just three years after the team was at its peak. It seemed that change could only go so far: none of the men's scholarships or teams were eliminated. The town proved their loyalty to the team when independent business owners, organized by Claude Hutcherson, rallied together to fund one year's worth of scholarships. The community's opposition caused the board to call a revote and the decision was reversed.

1976 YALE CREW TEAM

On March 3, 1976, nineteen members of the Yale women's crew team met in their basement locker room to begin a solemn, controversial mission that would become the stuff of legend at the university. They wrote "Title IX" in large lettering on each other's backs and sternums, then dressed in navy sweats. Moving together as a unit on land with the same efficiency that made them champions on the water, they made their way across campus to the office of Joni Barnett, Yale's director of women's athletics and physical education. Once inside the office, the nineteen women took off their sweatsuits, exposing their bare bodies and message. Teammate Chris Ernst read the team's statement, which said in part:

> These are the bodies Yale is exploiting. We have come here today to make clear how unprotected we are, to show graphically what we are being exposed to. . . . On a day like today, the rain freezes on our skin. Then we sit on a bus for half an hour as the ice melts into our sweats to meet the sweat that has soaked our clothes underneath. . . . No effective action has been taken and no matter what we wear, it doesn't make these bodies warmer, or dryer, or less prone to sickness. . . . We are not just healthy young things in blue and white uniforms who perform feats of strength for Yale in the nice spring weather; we are not just statistics on your win column. We're human and [are] being treated as less than such.

During frigid Connecticut winters, the Yale women's crew team trained in the off-season, and led by rowing in near-freezing temperatures, focused and emboldened by their winning record, as well as two members who had become world championship medalists the year before. On the water, the women reigned supreme over the men, whose only "success" had been a record-breaking slump that had failed to produce an Olympic athlete in more than a decade. And yet, off the water, gender alone gave an infinitely favorable position to the men's team: glaring inequality was the law of the land. Though Title IX had been in effect for nearly four years, Yale University's athletic policies were of another era, one rife with disparity. The men had state-of-the-art new boats, while the women were left with archaic, wooden shells. After every practice, the men would go into the showers, while the women got on the bus in the cold, exhausted and wearing wet clothes while they waited for their male counterparts to finish. The school provided a small trailer on campus with four showerheads for the women that produced ice-cold blasts of water.

This all served as a reminder of the gender bias the women were unable to overcome despite various entreaties to the university. The protest in Barnett's office was a well-thought-out, impassioned effort to get the equality the law deemed was their right. A reporter for the Yale newspaper who doubled as a stringer for the New York Times was present in the room with Barnett and the team, and so the next day, a story titled "Yale Women Strip to Protest a Lack of Crew's Showers" appeared in national papers. The women saw the immediate effects of their actions when the four showers in the trailer were brought back to working order. One year later, a permanent women's locker room was added to the boathouse, and the university hired Louise O'Neal to overhaul women's athletics at the school.

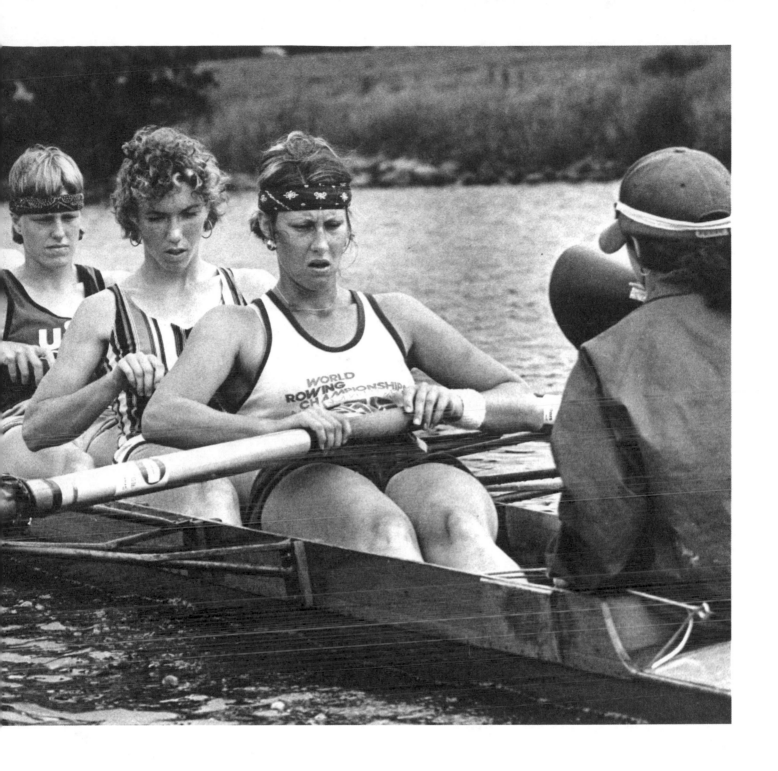

RUSTY KANOKOGI

Rena "Rusty" Kanokogi spent most of her childhood wandering the streets of Brooklyn, New York's Coney Island with a bayonet strapped to her leg, looking for trouble. Nicknamed after a stray dog, she was largely ignored by her parents, so she found companionship elsewhere, leading a girl gang named the Apaches, and befriending the local freak show performers. In 1955, a friend showed her how to lift and throw a person to the ground in a judo throw. She was hooked.

Though Kanokogi immediately fell in love with the sport, she was told that she could not compete in local judo club competitions because she was a woman. Never one to take *no* for an answer, and already with cropped short hair, she taped down her breasts with a bandage and entered the 1959 YMCA judo championships as a man. When she won the competition, the organizers asked her if she was in fact a woman. She told the truth, and they stripped her of her medal. The incident prompted her to move to judo's historical home, the famed Kodokan in Tokyo, Japan, in 1962, where women had been allowed to train (in separate groups from the men) for nearly forty years. After outfighting all the women in her training group, Kanokogi became the first woman to break the gender barrier by training with the men, also becoming the first woman to earn a seventh-degree black belt. During that time, she met her future husband, black belt Ryohei, and together they traveled back to the United States and began her decades-long fight for public recognition of women's judo. She wrote letters, spent tireless nights on the phone raising money, stormed offices, filed various injunctions in order to stop continuous discriminatory events, and rowed to sue the Olympic Committee if women's judo wasn't treated equally to men's. She even mortgaged her house to help pay for the first women's judo world championship, held at Madison Square Garden in 1980.

In 1988, twenty-four years after men's judo became an Olympic sport, Kanokogi brought a U.S. women's team to the Summer Games in Seoul. After she was awarded the Order of the Rising Sun, one of Japan's highest civilian honors, she received the YMCA gold medal that she had rightfully won in 1959. She died in 2009 and is buried in the Kanokogi clan's tomb with the epitaph "American Samurai."

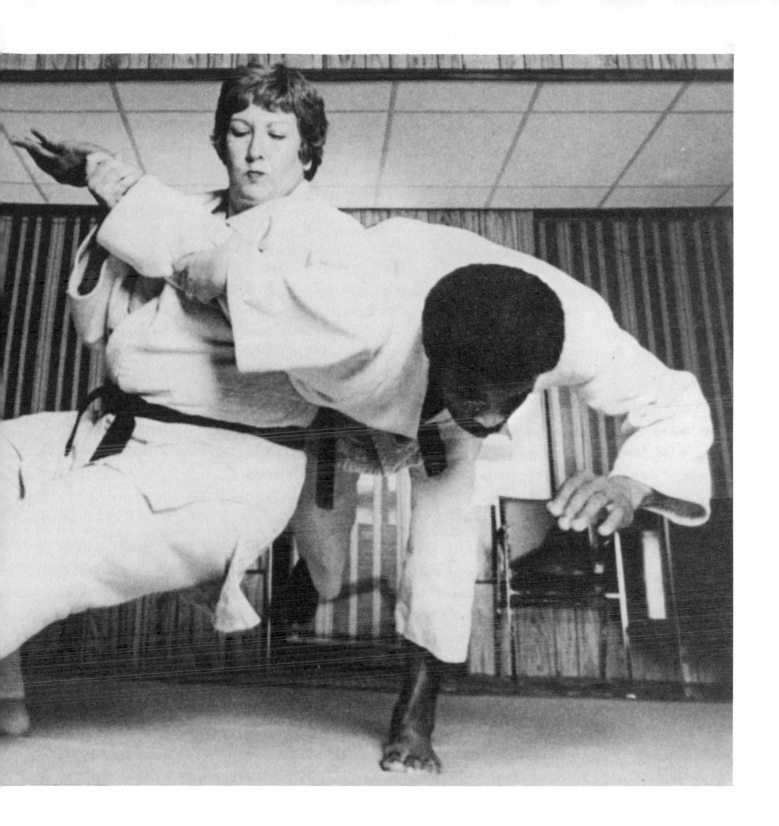

VIOLET PALMER

Violet Palmer, the first female referee in the NBA, can still remember how she felt stepping onto the court to officiate her first game: "I was scared out of my wits. . . . Because I just knew the entire world was *waiting* for me to fall on my face." Just two years earlier, she had received a surprise call from the NBA, recruiting her for their referee training program. She thought it was a prank. It was 1989 and she had been refereeing for nearly a decade, beginning as a ref for high school games before moving up to Division I collegiate women's basketball. Palmer had no idea that the NBA had even been observing her. The idea, in fact, seemed impossible: the league had never had a female referee.

Palmer started her basketball career in Southern California as a star point guard for the Compton High School women's team. Fortunate enough to benefit from the establishment of Title IX, she was able to garner an athletic scholarship to California Polytechnic State University, where she helped carry their NCAA Division II team to back-to-back championships in 1985 and 1986. During the summer, she took part-time jobs as a scorekeeper for the men's basketball games. Fate intervened when, on a few occasions, the referees didn't show up and Palmer had no choice but to fill in.

By the time she was scouted for the NBA, she was the third-ranked women's basketball referee in the world. Satisfied and at the top of her field, she had never harbored NBA ambitions; she viewed that particular goal as "unrealistic." Yet, once the challenge was put on the table, she went through a major gear shift, deciding to make the unimaginable a reality. No matter what, she would become the first woman to referee for the NBA.

In October 1997, both Palmer and another female official, Dee Kantner, were among the five new additions to the NBA's fifty-eight member referee roster. Palmer refereed the season opener between the Vancouver Grizzlies and the Dallas Mavericks, making her the first woman to referee any major-league, all-male sport. She was thrilled, but others were not. Male referees lamented they'd have to treat her—and work—differently. Upon hearing of her hiring, Charles Barkley announced that basketball was a man's game and should stay that way. Later in the season, when Celtics broadcaster Cedric "Cornbread" Maxwell disagreed with one of her calls, he said that Palmer should "get back in the kitchen and cook me some bacon and eggs." Luckily, the opposition only fueled her determination to succeed. By the end of her first season, Barkley had withdrawn his earlier statements, admitting that she had done a better job than some of the veteran referees. In 2007, Maxwell made an on-air apology for the comments he had made a decade before.

In 2006, Palmer became the first woman to officiate an NBA playoff game, and in 2009 officiated in the NBA Finals. She is the only woman to officiate the playoffs in any major American professional sport. On February 16, 2014, she became the first female to officiate an all-star game in any of the four major U.S. sports. Through most of her career, she has been the only female referee (Dee Kantner left the NBA in 2002), but the door that she kicked open now has other women slowly following in her footsteps. In 2014, Lauren Holtkamp became the NBA's third female referee, while other women are getting trained for the job.

Violet Palmer (second from right) with her teammates

WAKE-ROBIN GOLF CLUB

Wake-Robin Golf Club (WRGC), the oldest registered African-American women's golf club in the United States, was created in large part because a group of wives grew tired of being left at home on the weekends while their husbands were out on the course. Many of the first thirteen members of the group were married to men who were members of Washington, D.C.'s all-black, all-male Royal Golf Club and on April 22, 1937, they gathered in the home of founder Helen Webb Harris for their first official meeting.

The club was politically active from its inception; in order for them to have a course to play on, they had to petition for the desegregation of public golf courses in the Washington area. In 1938, the group began pressuring Harold Ickes, the secretary of the interior to do so. Golf courses would not be desegregated until 1941, but to appease members of the WRGC in 1939, Ickes approved the construction of the Langston Golf Course in the northeast corner of the city. Built on the site of an abandoned trash dump, the course retained many of the vestiges of its earlier life; rusted tin cans and old tires littered the corners of the property, often proving tricky obstacles around which players had to retrieve balls. Despite its less than desirable attributes, the Langston Golf Course was valued as a place that African-American golfers could finally call their own.

Next, the women of the Wake-Robin Golf Club joined up with other minority clubs to force the Professional Golfers Association to drop its "whites only" rule for for eligibility. They succeeded in doing so in 1961. The club also played an integral role in the creation of the United Golf Association, which put on tournaments around the country for the best black professionals. The club remains active today as a nonprofit organization that continues to foster the interest and growth of women in golf.

KIM CESPEDES

Fearless and only eighteen years of age, Kim Cespedes rips up the side of the Escondido reservoir in April 1977. Cespedes was a Hobie team rider born in San Diego, whose style was described as "aggressive" and "superfluid." She was known to skate anything cement: pools, banks, and reservoirs. She is now an avid surfer and has been for years.

RHYTHM IN ORANGE

Clad in orange leotards and tights, women of all ages and abilities give a display of eurhythmics at a gymnastic festival in Stuttgart.

NOTES

1964 JAPANESE VOLLEYBALL TEAM (6)

Robert Whiting, "'Witches of the Orient' Symbolized Japan's Fortitude," *Japan Times*, October 21, 2014.

1976 YALE CREW TEAM (274)

Steve Wulf, "Title Waves," ESPN, June 14, 2012.

Kevin Paul Dupont, "Former Yale Rower Chris Ernst to Be Honored for Forcing Changes in Women's Athletics," *Boston Globe*, June 17, 2012.

Tim Bennett, "Christ Ernst '76 Receives Special Achievement Award at the Tradition," YaleBulldogs.com, June 28, 2012.

1984 CUBAN NATIONAL WOMEN'S BASKETBALL TEAM (64)

"Fidel Castro and Cuban Women's Basketball Team, 1984 Los Angeles Olympic Games Preview," Neil Leifer, Getty Images, http://www.getty images.com/license/165349518.

Associated Press, "Cuba Withdraws from Olympics," *New York Times*, May 24, 1984, http://www.nytimes.com/1984/05/24/world/cuba-with draws-from-olympic.html.

ABBY HOFFMAN (16)

"Honoured Member Stories," Canada's Sports Hall of Fame, www.sportshall.ca/stories.html?proID=461.

"Abigail 'Abby' Hoffman," AbigailHoffman.blogspot.com, January 2009.

"Abby Hoffman," Library and Archives Canada, https://www.collectionscanada.gc.ca/women/030001-1509-e.html.

"Legends of Hockey—Non-NHL Trophies—Abby Hoffman Trophy," Hockey Hall of Fame, www.hhof.com/htmlSilverware/silver_splashabby hoffman.shtml.

"Abby Hoffman," Sports-Reference.com, www.sports-reference.com/olympics/athletes/ho/abby-hoffman-1.html.

"Convocation 2015: Legendary Athlete Abby Hoffman Receives Honorary Degree from U of T," University of Toronto, June 9, 2015, https://www .utoronto.ca/news/convocation-2015-legendary-athlete-abby-hoffman-receives-honorary-degree-u-t.

"Abby Hoffman," JewsInSports.org, www.jewsinsports.org/Olympics.asp?sport=olympics&ID=633.

ALFREDA JACKSON, RUTH HARRIS, CLEMENTINE REDMOND, LILLIAN HARDY (ATA) (24)

"Alfreda Jackson, Ruth Harris," Afro Newspaper/Gado, Getty Images, http://www.gettyimages.com/license/513430001.

American Tennis Association, http://www.americantennisassociation.org/ata-history/.

ALICE COACHMAN (4)

"Coachman Olympic Hall," The Associated Press, http://www.apimages.com/metadata/Index/Associated-Press-Sports-Iowa-United-States -Trac-/d93e43c591e4da11af9f0014c2589dfb/9/0.

Richard Goldstein, "Alice Coachman, 90, Dies: First Black Woman to Win Olympic Gold," *New York Times*, July 14, 2014, http://www.nytimes .com/2014/07/15/sports/alice-coachman-90-dies-groundbreaking-medalist.html?_r=0.

ALICE MARBLE (2)

Eliza Berman, "Meet the Women's Wimbledon Champion Who Was Also a Spy," *Time*, June 29, 2015.

"Alice Marble," *Wikipedia*, accessed March 13, 2016.

"Alice Marble Biography: Spy, Tennis Player, Athlete (1913–1990)," Biography.com, www.biography.com/people/alice-marble-40332.

Lorri Ungaretti, "A Remarkable Life: Alice Marble," *Guidelines: Newsletter for San Francisco City Guides and Sponsors*, www.sfcityguides.org/public_guidelines.html?article=1206.

ALISON JANE HARGREAVES (10)

Steve Boggan, "'Summit Fever' Killed Hargreaves," *The Independent*, August 22, 2015, http://www.independent.co.uk/news/summit-fever-killed -hargreaves-1597490.html.

Josie Bernard, "I loved her because she wanted to climb the highest peak. That's who she was," *Guardian*, August 28, 2002, https://www.theguardian .com/world/2002/aug/28/gender.familyandrelationships.

ALL AMERICAN RED HEADS (14)

"All American Red Heads Team," *Wikipedia*, accessed January 9, 2016.

Howard Beck, "Photo in an Attic Leads to a Forgotten Team's Place in the Hall of Fame," *New York Times*, September 8, 2012.

ALTHEA GIBSON (12)

Larry Schwartz, "Althea Gibson Broke Barriers," ESPN, https://espn.go.com/sportscentury/features/00014035.html.

"Althea Gibson," International Tennis Hall of Fame, https://www.tennisfame.com/hall-of-famers/inductees/althea-gibson.

Sarah Palfrey, "Althea Gibson, a Shy and Awkward Girl Who Had to Fight Herself as Often as a Hostile World, This Week Will Try for Her First National Singles Title at Forest Hills. Here Is a Warm Glimpse of Her by an Old Friend," *Sports Illustrated*, September 2, 1957.

"Althea Gibson by Richard Evans (Black History Month)," 10sballs.com, February 4, 2016, www.10sballs.com/2016/02/04/althea-gibson-by-richard- evans-black-history-month.

The Learning Network, "July 6, 1957: Althea Gibson Becomes First Black Player to Win Wimbledon," NYtimes.com, July 6, 2011, http://learning .blogs.nytimes.com/2011/07/06/july-6-1957-althea-gibson-becomes-first-black-player-to-win-wimbleldon.

"Althea Gibson," History.com, 2009, www.history.com/topics/black-history/althea-gibson.

ANDREA JAEGER (39)

Peter Alfano, "Struggling Jaeger Is Beaten by Jordan," *New York Times*, August 29, 1985.

Neil Amdur, "Billie Jean King Defeats Andrea Jaeger," *New York Times*, March 24, 1983.

"Jaeger Honored for Charity Work," *New York Times*, March 9, 1994.

Robert Lipsyte, "A Short Career, a Lifetime Commitment," *New York Times*, August 27, 2000.

Patrick Saunders, "Jaeger Finds Joy in Serving Others," *Denver Post*, January 31, 2008.

Douglas Robson, "Jaeger Now In Service to Next Calling," *USA Today*, March 18, 2011.

ANITA DEFRANTZ (8)

Randy Harvey, "Is She the Most Powerful Woman in Sports?" *Los Angeles Times*, June 30, 1996.

Candace LaBalle, "DeFrantz, Anita 1952– ," 2003, Encyclopedia.com, www.encyclopedia.com/topic/Anita_L._DeFrantz.aspx.

Ronald D. White, "How I Made It: Anita L. DeFrantz, President of the LA84 Foundation," *Los Angeles Times*, April 27, 2014.

"Penn Biographies: Anita Lucette DeFrantz (Born 1952)," University of Pennsylvania, www.archives.upenn.edu/people/1900s/defrantz_anita_l.html.

ANKE-EVE GOLDMANN (18)

"Anke Eve Goldmann: Amelia Earhart on Two Wheels," *Motorcycle Race Mag*, April 22, 2014.

Paul D'Orleans, "Anke-Eve Goldmann," *The Vintagent*, February 18, 2009, http://thevintagent.blogspot.com/2009/02/anka-eve-goldmann.html.

Paul D'Orleans, "Have You Seen This Woman?" *The Vintagent*, February 16, 2009, http://thevintagent.blogspot.com/2009/02/have-you-seen
-this-woman.html.

Rob Sherwood, *Granite Beemer: The Newsletter of the Granite State BMW Riders*, August 2011, http://ns2.webmasters.com/*gsbmwr
.org/httpdocs/Archives/GSBMWRnewsletter1108.pdf.

Poppy Gall, "Anke-Eve Goldmann: Motorcycle Racer and Designer," Poppy Gall Design Studio blog, October 17, 2011, http://poppygall.com
/blog/2011/10/17/anke-eve-goldmann-motorcycle-racer-designer.

Cy Linder, "Piston Poppin'," *American Cyclist*, November 1959, 17.

ANN KOGER (42)

Information provided by Ann Koger.

ANNIE SMITH PECK (20)

Milbry C. Polk, "Peck, Annie Smith," *American National Biography Online*, April 2014, www.anb.org/articles/20/20-91931.html.

Hannah S. Kimberley, "Peck's Bio," Annie Smith Peck: A Woman's Place Is at the Top, 2012, https://anniesmithpeck.org/pecks-bio-4.

"Annie Smith Peck," *Living on Earth*, August 10, 2012, www.loe.org/series/story.html?seriesID=13&blogID=2.

"Annie Smith Peck," *Wikipedia*, accessed February 18, 2016.

ANNMARIA DE MARS (36)

Eugene S. Robinson, "AnnMaria De Mars, Ronda Rousey and the Art of the Armbar," OZY, February 12, 2014, www.ozy.com/rising-stars
/annmaria-de-mars-ronda-rousey-the-art-of-the-armbar/6415.

"AnnMaria Rousey DeMars," World Wide Dojo, 2010, www.worldwidedojo.com/traditional-based/annmaria-rousey-demars.

Pedro Olavarria, "Seven Questions for Ronda Rousey's Mom," *Fightland* blog, Vice.com, November 20, 2014, http://fightland.vice.com/blog
/seven-questions-for-ronda-rouseys-mom.

"Dr. AnnMaria De Mars," 7 Generation Games, www.7generationgames.com/about/our-team-2/annmaria-de-mars.

ARLENE BLUM (30)

Dashka Slater, "How Dangerous Is Your Couch?" *New York Times*, September 6, 2012.

Marc Lifsher, "How I Made It: Arlene Blum," *Los Angeles Times*, December 7, 2014.

BABE DIDRIKSON ZAHARIAS (28)

Don Van Natta, "Babe Didrikson Zaharias's Legacy Fades," *New York Times*, June 25, 2011.

Larry Schwartz, "Didrikson Was a Woman Ahead of Her Time," ESPN Sports Century, https://espn.go.com/sportscentury/features/00014147.html.

"Babe Didrikson Zaharias," *Wikipedia*, accessed March 20, 2016.

BAKERSFIELD JUNIOR COLLEGE WOMEN'S SWIM TEAM (26)

"Bakersfield Junior College," Ralph Crane, Getty Images, http://www.gettyimages.com/license/573875097.

BARBARA POLK WASHBURN (40)

Michael J. Bailey, "Barbara Polk Washburn, 99; 'Accidental Adventurer' Was First Woman to Ascend Mount McKinley," *Boston Globe*, September 25, 2014.

"The 10th Annual Washburn Challenge," Museum of Science (Boston), http://legacy.mos.org/washburnchallenge/barbara.php.

Mike Dunham, "Barbara Washburn, First Woman to Climb Denali, Dead at 99," *Alaska Dispatch News*, October 7, 2014.

Brendan Leonard, " 'Accidental Adventurer' Barbara Washburn," *Adventure Journal*, October 15, 2014, https://adventure-journal.com/2014/10
/historical-badass-accidental-adventurer-barbara-washburn.

BERNICE GERA (32)

"Bernice Gera Biography: Women's Rights Activist, Baseball Player, Athlete," Biography.com, www.biography.com/people/bernice-gera-215063#synopsis.

Craig Davis, "Called Out: Major League Baseball Kept Her Out, but Bernice Gera Knew Her Calling," *South Florida Sun Sentinel*, September 15, 1989.

BERNICE SANDLER (48)

"Bernice Resnick Sandler," National Women's Hall of Fame, https://www.womenofthehall.org/inductee/bernice-resnick-sandler.

"The Real Story Behind the Passage of Title IX 35 Years Ago," Women in Higher Education, http://wihe.com/the-real-story-behind-the-passage-of-title-ix-35-years-ago/#.

Jeahlisa Bridgeman, "Profile of Bernice Sandler," in A. Rutherford, ed., *Psychology's Feminist Voices Multimedia Internet Archive*, 2014, www.feministvoices.com/bernice-resnick-sandler.

Kelly Kline, "Forty Years Later: The Impact of Bernice Sandler on Title IX," Full Court, June 20, 2012, www.fullcourt.com/kelly-kline-fullcourtwbball/21402/forty-years-later-impact-bernice-sandler-title-ix.

Bernice Sandler, testimony before the Special Subcommittee on Education of the Committee on Education and Labor, House of Representatives, 91st Congress, 2d session, June 19, 1970, part 1, p. 302.

BerniceSandler.com, accessed March 21, 2016.

"Bernice R. Sandler," Maryland Women's Hall of Fame, Maryland State Archives, 2010, http://msa.maryland.gov/msa/educ/exhibits/womenshall/html/sandler.html.

BETTY COOK (22)

Bill Bruns, "That World Champion in the Cockpit, Captain Cook, Is a Grandma Named Betty," *People*, July 17, 1978.

Lily Dizon, "Powerboat Racer Betty Cook Dead at 70," *Los Angeles Times*, January 9, 1991.

"Betty Cook," HistoricRaceboats.com, www.historicraceboats.com/bettycook.htm.

Bob Ottum, "Any More Questions, Fellas?" *Sports Illustrated*, August 4, 1980.

BETTY ROBINSON (44)

Frank Litsky, "Betty Robinson, a Pathfinder in Women's Track, Dies at 87," *New York Times*, May 20, 1999.

Karen Rosen, "Betty Robinson: The Olympic Gold Medalist Who 'Came Back from the Dead,'" Team USA, April 28, 2015, www.teamusa.org/News/2015/April/28/Betty-Robinson-The-Gold-Medalist-Who-Came-Back-From-the-Dead.

Tom McGowan, "Golden Girl: The First Olympic Speed Queen," CNN, August 3, 2012.

"Speedy Starlet Robinson Makes Dramatic Bow," Olympic.org, www.olympic.org/news/betty-robinson-athletics/179776.

BILLIE JEAN KING AND THE BATTLE OF THE SEXES (34)

Dave Hirshley, "Billie Jean King Beats Bobby Riggs in 'Battle of the Sexes,'" New York *Daily News*, September 21, 1973.

Jesse Greenspan, "Billie Jean King Wins the 'Battle of the Sexes,' 40 Years Ago," History.com, September 20, 2013, www.history.com/news/billie-jean-king-wins-the-battle-of-the-sexes-40-years-ago.

BRIANA SCURRY (46)

http://briscurry.com/.

CAROL ROSE AND THERESA SAMS (56)

"Women's Football Match," Authenticated News, Getty Images, http://www.gettyimages.com/license/110169140

UNFC, http://www.uncf.org/our-mission.

CATHY RUSH/IMMACULATA COLLEGE (94)

Amy Farnum, "The One That Started It All," NCAA, October 14, 2011, www.ncaa.com/news/basketball-women/article/2011-10-01/one-started-it-all.

Greg Garber, "Where Did It All Begin? Just Ask Immaculata's Mighty Macs," ESPN, April 1, 2008.

Brendan Quinn, "She's Simply Remarkable," Nooga.com, April 19, 2012, http://nooga.com/154907/shes-simply-remarkable.

"Cathy Rush," *Wikipedia*, accessed December 11, 2015.

CHICAGO DAILY DEFENDER 17TH ANNUAL
HANDICAP BOWLING TOURNAMENT OF 1965 (70)

"Chicago Daily Defender Bowling Tourney," Robert Abbott Sengstacke, Getty Images, http://www.gettyimages.com/license/117637337.

"The Chicago Defender," Wikipedia, https://en.wikipedia.org/wiki/The_Chicago_Defender.

CHRIS VON SALTZA (60)

"Chris Von Saltza (USA)," International Swimming Hall of Fame, http://www.ishof.org/chris-von-saltza-(usa).html.

"Chris Von Saltza," A. Y. Owen, Getty Images, http://www.gettyimages.com/license/50564039.

Tom Slear, "Chris Von Saltza Olmstead: A Swimming Rock Star," USA Swimming, November 3, 2014, http://www.usaswimming.org/ViewNews Article.aspx?TabId=0&itemid=6462&mid=14491.

CHRISTY MARTIN (58)

Joyce Wadler, "Christy Martin, Boxer, Takes Another Shot," *New York Times*, January 22, 2011.

Associated Press, "Martin Back in Ring," *New York Times*, June 4, 2011.

Timothy W. Smith, "Martin Deflects Jabs Aimed at Her Fame," *New York Times*, August 20, 1997.

Evelyn Nieves, "A Boxer in a Hurry," *New York Times*, November 2, 1996.

Richard Hoffer, "Gritty Woman Christy Martin Is Knocking Down Stereotypes Even as She Refuses to Champion the Cause of Women in the Ring," *Sports Illustrated*, April 15, 1996.

Chris Mannix, "Fighting Response," *Sports Illustrated*, January 31, 2011.

Aimee Berg, "Million Dollar Maybe," *Sports Illustrated*, April 25, 2005.

Jane Ann Morrison, "Boxer Tells of Her Attack to Draw Attention to Domestic Violence," *Las Vegas Review-Journal*, May 28, 2011.

Associated Press, "Christy Martin First Woman to Fight for $1M Purse," *USA Today*, July 21, 2005.

Michael Belfiore, "Martin, Christy," Encyclopedia.com, 2004, www.encyclopedia.com/doc/1G2-3407900365.html.

"Christy Martin," Womens Boxing Archive Network, www.wban.org/biog/cmartin.htm.

CONCHITA CINTRÓN (62)

Bruce Weber, "Conchita Cintrón, 'Goddess' of Bullring, Dies at 86," *New York Times*, February 21, 2009.

Barnaby Conrad, "Conchita Cintron," *Encyclopaedia Britannica*, www.britannica.com/biography/Conchita-Cintron.

"Conchita Cintrón," *The Economist*, March 5, 2009.

CONSTANCE APPLEBEE (76)

"Constance Applebee," *New York Times*, January 27, 1981.

"Women Take Up Hockey," *New York Times*, November 9, 1901.

"Field Hockey Today: Four-Day U.S. Championship to Be Held in Malverne," *New York Times*, November 23, 1961.

"Field Hockey Popular," *New York Times*, October 6, 1902.

Liz Farquhar, "Rise of U.S. Field Hockey," NCAA, May 15, 2013, www.ncaa.com/news/fieldhockey/article/2013-04-08/rise-us-field-hockey.

DEBI THOMAS (84)

http://www.arthurashe.org/blog/a-look-back-figure-skater-debi-thomas.

DENISE MCCLUGGAGE (72)

John Pearley Huffman, "Denise McCluggage, Legendary Writer, Racer, and Adventurer, Has Passed Away," *Car and Driver*, May 7, 2015.

Matt Stone, "The Fastest Woman on Four Wheels," *Road and Travel*, www.roadandtravel.com%2Fcelebrities%2Fdenise_mccluggage .html.

Sam Roberts, "Denise McCluggage, Auto Racing Pacesetter, Dies at 88," *New York Times*, May 9, 2015.

DIANA NYAD (86)

Elizabeth Weil, "Marathon Swimmer Diana Nyad Takes on the Demons of the Sea," *New York Times*, December 1, 2011.

Lizette Alvarez, "Sharks Absent, Swimmer, 64, Strokes from Cuba to Florida," *New York Times*, September 2, 2013.

Associated Press, "Diana Nyad Finishes Historic Swim," ESPN, September 4, 2013.

Patrick Oppmann, "5th Time a Charm? Diana Nyad Tries Cuba to Florida Swim Again," CNN, September 1, 2013.

DIANE CRUMP (66)

Sheena McKenzie, "Jockey Who Refused to Stay in the Kitchen," CNN, October 2, 2012.

"Diane Crump Biography: Athlete (1948–)," Biography.com, www.biography.com/people/diane-crump-214143.

DICK, KERR'S LADIES FC (88)

Will Buckley, "The Forgotten Story of the Dick, Kerr's Ladies Football Team," *The Guardian*, September 9, 2009.

"Dick, Kerr's Ladies F.C.," *Wikipedia*, accessed March 11, 2016.

DONNA DE VARONA (106)

"Donna De Varona: Olympic Champion and Sportscaster," Makers.com, www.makers.com/donna-de-varona.

"Donna de Varona," *Wikipedia*, accessed February 15, 2016.

Jane Summer, "De Varona, Donna," Encyclopedia.com, 2004, www.encyclopedia.com/topic/Donna_De_Varona.aspx.

Rachel Siegal, "Pioneer Donna de Varona Shares Title IX, Broadcasting and Soccer Thoughts," ESPN Front Row, 2012.

Bruce Schoenfeld, "Touch of Gold," *Sports Business Daily*, March 2, 2015.

DOROTHY WISE (112)

Charles Hillinger, "'Cool Hand' Dorothy Is Women's Champion," *Sarasota Herald-Tribune*, October 27, 1971.

EARLENE BROWN (100)

"Brown, Earlene Dennis," Encyclopedia.com, www.encyclopedia.com/article-1G2-2591301466/brown-earlene-dennis-1935.html.

"Earlene Brown Bio, Stats, and Results," Sports-Reference.com, www.sports-reference.com/olympics/athletes/br/earlene-brown-1 .html.

"Earlene Brown," USATF Hall of Fame, www.usatf.org/halloffame/TF/showBio.asp?HOFIDs=209.

"Interview with Earlene Brown," November 21, 1967, San Francisco Bay Television Archive, posted October 14, 2011, https://diva.sfsu.edu /collections/sfbatv/bundles/190890.

Martha Ward Plowden, *Olympic Black Women* (Gretna, LA: Pelican, 1996).

EDITH GREEN (110)

"Title IX—The Nine," American Civil Liberties Union, https://www.aclu.org/title-ix-nine.

"Green, Edith Starrett," History, Art & Archives, U.S. House of Representatives, http://history.house.gov/People/Detail/14080.

Scott Crass, "Edith Green Mother of Title IX and Abundance of Higher Ed Firsts," *The Moderate Voice*, July 6, 2013, http://themoderatevoice .com/edith-green-mother-of-title-ix-and-abundance-of-higher-ed-firsts.

EDITH HOUGHTON (96)

Paul Vitello, "Edith Houghton, Rare Woman Among Baseball Scouts, Dies at 100," *New York Times*, February 15, 2013.

Doug Fernandes, "First Female Baseball Scout Edith Houghton Celebrates Her 100th Birthday in Sarasota," *Herald Tribune*, February 10, 2012.

"Edith Houghton," *Wikipedia*, accessed August 28, 2014.

ELEANOR HOLM JARRETT (138)

Richard Goldstein, "Eleanor Holm Whalen, 30's Swimming Champion, Dies," *New York Times*, February 2, 2004.

Myrna Oliver, "Eleanor Holm Whalen, 90; Olympic Star Lost Swim Team Spot for Carousing," *Los Angeles Times*, February 4, 2004.

"Eleanor Holm," *The Telegraph*, February 4, 2004.

"Eleanor Holm Bio, Stats, and Results," Sports-Reference.com, www.sports-reference.com/olympics/athletes/ho/eleanor-holm-1.html.

"Eleanor Holm," in John S. Bowman, ed., *The Cambridge Dictionary of American Biography* (New York: Cambridge University Press, 1995).

ELSPETH BEARD (124)

"Elspeth Beard—One of the Early Globetrotters," *Motorcyclist*, February 23, 2009, www.motorcyclistonline.com/elspeth-beard-one-early-globetrotters.

Kenric Hickson, "Typical Biker: Elspeth Beard," *The Telegraph*, February 20, 2001.

Jon Patrick, "Air-Head Around the World: Elspeth Beard on Her BMW R 60/6," *The Selvedge Yard*, January 30, 2011, https://selvedgeyard .com/2011/01/30/air-head-around-the-world-elspeth-beard-on-her-bmw-r-606.

EMMA GATEWOOD (118)

David Maraniss and Robert Samuels, "Grandma Gatewood Survived Domestic Violence to Walk the Appalachian Trail Alone at 67," *Washington Post*, January 5, 2015.

"Grandma Gatewood," *Wikipedia*, accessed February 14, 2016.

Larry Luxenberg, *Walking the Appalachian Trail* (Mechanicsburg, PA: Stackpole, 1994).

"Mrs. Emma Gatewood," *Sports Illustrated*, August 15, 1955.

ENRIQUETA BASILIO (102)

"Enriqueta Basilio—Olympic Torch—Athletics," Olympic.org, October 9, 2013.

"Enriqueta Basilio," *Wikipedia*, accessed March 15, 2016.

EUNICE KENNEDY SHRIVER (178)

"Eunice Kennedy Shriver," Eunice Kennedy Shriver: One Woman's Vision, www.eunicekennedyshriver.org/bios/eks.

"Eunice Kennedy Shriver," John F. Kennedy Presidential Library and Museum, www.jfklibrary.org/JFK/The-Kennedy-Family/Eunice-Kennedy -Shriver.aspx.

Joseph Shapiro, "Eunice Kennedy Shriver's Olympic Legacy," National Public Radio, July 17, 2011.

EVONNE GOOLAGONG CAWLEY (132)

Harry Gordon, "How the Daughter of an Ancient Race Made It Out of the Australian Outback," *New York Times*, August 25, 2013.

Matt Majendie, "Evonne Goolagong: Defying Prejudice to Become a Star," CNN, January 30, 2015.

Pallen, "Living Legend Coming to Grafton," *Grafton Daily Examiner*, May 22, 2012.

"Evonne Goolagong Cawley on *Where Are They Now* Australia," posted by Tapesalvage, YouTube, January 8, 2011, https://youtu.be/G_Lx4JGOijY.

FANNY BULLOCK WORKMAN (144)

Thomas H. Pauly, "Vita: Fanny Bullock Workman," March–April 2012.

http://harvardmagazine.com/2012/03/vita-fanny-bullock-workman.

Brendan Leonard, "Climber and Explorer Fanny Bullock Workman," *Adventure Journal*, November 14, 2012, https://adventure-journal .com/2012/11/historical-badass-climber-and-explorer-fanny-bullock-workman.

"Fanny Bullock Workman," American Alpine Club, http://library.americanalpineclub.org/exhibits/show/womenclimbing/fannybullockworkman.

Matt Hickman, "8 Trailblazing Female Explorers," Mother Nature Network, November 11, 2014, www.mnn.com/lifestyle/arts-culture/photos/8 -trailblazing-female-explorers/ahead-of-their-time.

Elizabeth Cody Kimmel, *Ladies First: 40 Daring American Women Who Were Second to None* (Washington, DC: National Geographic, 2005).

FLORENCE ARTHAUD (140)

Chris Museler, "Florence Arthaud, Celebrated Solo Sailor, Dies at 57 in Helicopter Crash," *New York Times*, March 10, 2015, http://www.nytimes .com/2015/03/11/sports/international/florence-arthaud-celebrated-solo-sailor-dies-at-57.html.

FLORENCE LEONTINE "PANCHO" BARNES (150)

"Pancho Barnes," *Wikipedia*, accessed March 10, 2016.

Nick Spark, "The Story of Pancho Barnes . . . and Her Happy Bottom Riding Club," Legend Of Pancho Barnes (Originally appearing in *Airpower* magazine), January 31, 2010. Retrieved: August 3, 2013.

Ana Japenga, "Pancho Barnes: An Affair with the Air Force: Ex-Socialite, Stunt Pilot, Club Owner Had the Right Stuff," *Los Angeles Times*, November 17, 1985.

"The Legend of Pancho Barnes," PBS SoCal, www.pbssocal.org/tv/programs/legend-of-pancho-barnes.

GABRIELA ANDERSEN-SCHIESS (68)

Jerry Crowe, "Spirit of Competition Continues to Drive Her," *Los Angeles Times*, July 16, 2007.

Earl Gustkey, "With the End in Sight: Andersen's Staggering Finish in 1984 Women's Marathon a Haunting Image," *Los Angeles Times*, September 12, 1988.

"An Unforgettable Marathon Finish—Gabriela Andersen-Schiess | Moments in Time," posted by Olympic, YouTube, December 6, 2014, https://youtu.be/1BasZWjd92k.

GERTRUDE EDERLE (80)

"Gertrude Ederle Becomes First Woman to Swim English Channel," History.com, 2009, www.history.com/this-day-in-history/gertrude-ederle -becomes-first-woman-to-swim-english-channel.

Richard Severo, "Gertrude Ederle, the First Woman to Swim Across the English Channel, Dies at 98," *New York Times*, December 1, 2003.

Elliott Denman, "Gertrude Ederle, Pioneer Swimmer, Looks Back on Her Unforgettable Feat," *New York Times*, April 30, 2001.

"Gertrude Ederle," *Wikipedia*, accessed March 25, 2016.

GLADYS HELDMAN (82)

"Gladys Heldman," International Tennis Hall of Fame, https://www.tennisfame.com/hall-of-famers/inductees/gladys-heldman.

Lisa Dillman, "Gladys Heldman, 81; Recognized for Her Pivotal Role in Boosting Women's Tennis," *Los Angeles Times*, January 26, 2003.

Lena Williams, "Gladys Heldman, 81, a Leader In Promoting Women's Tennis," *New York Times*, June 25, 2003.

Bill Dwyre, "Julie Heldman Helped Open Up Women's Tennis," *Los Angeles Times*, August 23, 2014.

GRETCHEN FRASER (164)

"Gretchen Fraser," *Wikipedia*, accessed March 23, 2016.

"Gretchen Fraser Goes Gold," Legacy.com, 2012, www.legacy.com/news/explore-history/article/gretchen-fraser-goes-gold.

espnW, "Gretchen Fraser Skis to History," ESPN, February 5, 2014.

HELME SUUK (148)

Brief (unofficial) History of Mountaineering and Climbing Sport in Estonia, History of "Firn" Included, http://www.firn.ee/history.html.

BNS, "First Estonian Woman Reaches 8,000-meter Peak," *Estonian News*, May 13, 2013, http://news.postimees.ee/1234010/first-estonian-woman-reaches-8-000-meter-peak.

ISABEL LETHEM (98)

"Letham, Isabel," *Encyclopedia of Surfing*, http://encyclopediaofsurfing.com/entries/letham-isabel.

"Letham, Isabel (1899–1995)," Trove, National Library of Australia, 2009, http://nla.gov.au/nla.party-714079.

Shane Maloney and Chris Grosz, "Isabel Letham and Duke Kahanamoku," *The Monthly* (Australia), August 5, 2008.

Joanna Gilmour, "Australia's First Lady of the Surf," *Australian Geographic*, June 8, 2012.

Fred Pawle, "Legend and Fib Combine as Isabel Letham Surfs into History on Wave of Fancy," *The Australian*, December 27, 2014.

JACKIE TONAWANDA (156)

Lena Williams, "Boxing; Knowing the Ropes, And She Shows It," *New York Times*, December 16, 2010, http://www.nytimes.com/2000/12/16/sports/boxing-knowing-the-ropes-and-she-shows-it.html.

Bill Gallo, "Jackie Tonawanda, known as 'Lady Ali' and boxing pioneer, dies at 75," *Daily News*, June 9, 2009, http://www.nydailynews.com/sports/more-sports/jackie-tonawanda-lady-ali-boxing-pioneer-dies-75-article-1.374118.

JANET COLLINS (160)

PrimaJanetCollins.com, accessed March 24, 2016.

Jennifer Dunning, "Janet Collins, 86; Ballerina Was First Black Artist at Met Opera," *New York Times*, May 30, 2003.

Arlene Yu, "Celebrating the Life of Janet Collins, an African-American Pioneer in Dance," New York Public Library, February 14, 2012, https://www.nypl.org/blog/2012/02/14/celebrating-janet-collins-dance.

Taylor Gordon, "After Six Decades, Janet Collins Still the First and Only Black Prima Ballerina at the Metropolitan Opera," *Atlanta Black Star*, April 20, 2015.

Anna Kisselgoff, "Judith Jamison Offers a Structured Solo," *New York Times*, May 24, 1974.

Jon Thurber, "Janet Collins, 86; Broke Ballet Color Line," *Los Angeles Times*, June 2, 2003.

Anna Kisselgoff, "Collins and Primus in Ailey Spotlight; Social Protest Supported," *New York Times*, May 15, 1974.

JANET GUTHRIE (108)

Ryan McGee, "Janet Guthrie Outraced Insults to Make History," ESPN, February 20, 2013.

"Janet Guthrie, First Female Indy 500 Driver, Born," History.com, 2009, www.history.com/this-day-in-history/janet-guthrie-first-female-indy-500-driver-born.

"Biography," JanetGuthrie.com, www.janetguthrie.com/biography.htm, accessed March 21, 2016.

JEAN BALUKAS (112)

Will Yakowicz, "The Greatest! Jean Balukas—Pool Legend—Speaks!" *New York Post*, November 23, 2009.

Roger Starr, "The Best Woman in the Hall," *New York Times*, October 18, 1987.

Douglas Martin, "Billiard Master Reposes in Self-Exile," *New York Times*, August 22, 1992.

JOAN WESTON (168)

Roller Derby Highlights, http://www.stealthskater.com/Documents/RollerDerby.pdf.

Jean H. Lee, "Roller Derby Star Was Fierce Competitor," Associated Press, July 13, 1997, http://community.seattletimes.nwsource.com/archive/?date=19970713&slug=2549244.

Frank Deford, "Joan Weston—The Blonde Bomber," Derby Memoirs, http://derbymemoirs.bankedtrack.info/mem_Weston_Joan.html.

Robert McG. Thomas Jr, "Joanie Weston, 62, a Big Star In the World of Roller Derbies," *New York Times*, May 18, 1997, http://www.nytimes.com/1997/05/18/us/joanie-weston-62-a-big-star-in-the-world-of-roller-derbies.html.

JOAN WHITNEY PAYSON (154)

Joan M. Thomas, "Joan Payson," Society for American Baseball Research, http://sabr.org/bioproj/person/88dc3fa9.

Joseph Durso, "Joan Whitney Payson, 72, Mets Owner, Dies," *New York Times*, October 5, 1975.

Harold Friend, "Willee Mays Returns to New York to Help the New York Mets," *Bleacher Report*, May 21, 2009.

JOE CARSTAIRS (176)

Carolyn T. Hughes, "No Ordinary Joe," *New York Times*, May 17, 1998.

Terry Castle, "If Everybody Had a Wadley," review of *The Queen of Whale Cay: The Eccentric Story of "Joe" Carstairs, Fastest Woman on Water*, by Kate Summerscale, *London Review of Books* 20, no. 5 (1998): 10–12.

Alice La Plante, "No Ordinary Joe," *Stanford Magazine*, September–October 1998.

JOYCE WALKER (114)

"A Look Back: Figure Skater Debi Thomas," Arthur Ashe Learning Center, http://archive.usab.com/womens/wjcup_1981.html.

JUNKO TABEI (104)

Robert Horn, "No Mountain Too High for Her," *Sports Illustrated*, April 29, 1996.

Tomoko Otake, "Junko Tabei: The First Woman atop the World," *Japan Times*, May 27, 2012.

Japanese Women's Everest Expedition website, www.jwee1975.com/about_jwee.

JUTTA KLEINSCHMIDT (116)

Information gathered by an interview with Jutta Kleinschmidt.

KATHRINE SWITZER (74)

"Kathrine Switzer: First Woman to Enter the Boston Marathon," Makers.com, www.makers.com/kathrine-switzer.

"1967 Boston Marathon: The Real Story—Kathrine Switzer—Marathon Woman," KathrineSwitzer.com, http://kathrineswitzer.com/about-kathrine/1967-boston-marathon-the-real-sto.

KATHRYN "KATHY" KUSNER (78)

"Kathryn Kusner," *Wikipedia*, accessed March 19, 2016.

"Kathy Kusner," Sports-Reference.com, www.sports-reference.com/olympics/athletes/ku/kathy-kusner-1.html.

"Horse Expert Witness," www.kathykusner.com, accessed March 22, 2016.

"Kathy Kusner: First Licensed Female Jockey," Makers.com, www.makers.com/kathy-kusner.

KAY YOW (90)

Richard Goldstein, "Kay Yow, Hall of Fame Women's Basketball Coach, Dies at 66," *New York Times*, January 24, 2009.

"Kay's Story," Kay Yow Cancer Fund, http://kayyow.com/the-mission/kays-story.

KEIKO FUKUDA (120)

William Yardley, "Keiko Fukuda, a Trailblazer in Judo, Dies at 99, *New York Times*, February 16, 2013.

"Keiko Fukuda," *Wikipedia*, accessed February 5, 2016.

KIM CESPEDES (282)

Information gathered by an interview with Kim Cespedes.

KIM GILBERT (122)

Information gathered by an interview with Kim Gilbert.

KIM AND SYLVIA GREEN (134)

Mark Kram, "Dallas Green's Daughter Pioneered Title IX Spirit," *Philadelphia Daily News*, June 20, 2012.

Chelsea Janes, "The Girls Who Fought for the Right to Play in Little League Look Back, 40 Years Later," *Washington Post*, August 13, 2014.

"Current Directors," Camp Blaze, http://campblaze.com/current-directors, accessed March 24, 2016.

KINUE HITOMI (186)

Ian Buchanan, "Asia's First Female Olympian," *Journal of Olympic History*, September 2000, http://library.la84.org/SportsLibrary/JOH /JOHv8n3/johv8n3l.pdf.

KITTY O'NEIL (136)

Sue Ellen Jares, "The Renaissance Woman of Danger—That's Tiny Kitty O'Neil," *People*, January 24, 1977.

"Deaf Stuntwoman Kitty O'Neil Sets Women's Land-Speed Record," History.com, www.history.com/this-day-in-history/deaf-stuntwoman-kitty -oneil-sets-womens-land-speed-record.

Kate Kelly, "Kitty O'Neil (1947–)," America Comes Alive, March 7, 2011, http://americacomesalive.com/2011/03/07/kitty-oneil-1947/#.V46HLqLw6y8.

Elizabeth Bryant, "Kitty O'Neil: The Fastest Woman on Earth," 2000, http://historytrendsanddeafeducation.pbworks.com/w/page/18570620 /Kitty%20O'Neil%3A%20The%20Fastest%20Woman%20on%20Earth.

KOREAN DEEP SEA DIVERS (158)

Andrea Denhoed, "The Sea Women of South Korea," *New Yorker*, March 29, 2015.

Choe Sang-hun, "Hardy Divers in Korea Strait, 'Sea Women' Are Dwindling," *New York Times*, March 29, 2014.

Jordan G. Teicher, "These Korean Women Dive Deep Underwater Without Any Breathing Equipment," *Slate*, May 13, 2015.

"Jeju Haenyeo Mulot and Diving Tools," Google Arts and Culture, https://www.google.com/culturalinstitute/beta/exhibit/QQj-M39D.

LAURA THORNHILL AND LACEY BAKER (126)

In conversation for *Game Changers*.

LAVONNE "PEPPER" PAIRE-DAVIS (182)

Aly Semigran, "'A League Of Their Own' Inspiration Lavonne 'Pepper' Paire-Davis Has Died," KRRO.com, February 6, 2013, http://krro.com /news/articles/2013/feb/07/a-league-of-their-own-inspiration-lavonne-pepper-p.

William Yardley, "Lavonne Paire Davis, Baseball Pioneer, Dies at 88," *New York Times*, February 4, 2013.

Associated Press, "Lavonne 'Pepper' Paire-Davis Dies," ESPN, February 3, 2013.

David Whitley, "Lavonne 'Pepper' Paire-Davis Was in a League of Her Own," *Sporting News*, February 7, 2013.

Jeff Merron, "Reel Life: 'A League of Their Own,'" ESPN, February 5, 2011.

LIBBY RIDDLES (220)

"Woman, for First Time, Wins Alaska Sled Race," *New York Times*, March 20, 1985.

"About Libby," www.libbyriddles.com/about-libby.html, accessed March 24, 2016.

"Meet Libby Riddles, First Woman to Win the Alaskan Iditarod Race," NASA Quest, January 28, 1999, http://quest.arc.nasa.gov/space/frontiers /riddles.html.

Paul D. Buchanan, *The American Women's Rights Movement: A Chronology of Events and of Opportunities from 1600 to 2008* (Boston: Branden, 2009).

B. Myint, "Libby Riddles: The First Lady of the Iditarod," Biography.com, March 18, 2015, www.biography.com/news/libby-riddles-facts-biography -iditarod.

LINDA JEFFERSON (224)

Amanda Berg, "Real Troopers," *Fayetteville Observer*, November 1, 2014.

"What Does a Football Player Look Like?" Toledo.com, October 10, 2014, www.toledo.com/news/2014/10/10/frogtown-features/what-does-a -football-player-look-like.

"Pro Football Glass Ceiling Broken," Pro Football Hall of Fame, January 21, 2016, www.profootballhof.com/news/women-shaping-the-game.

Tom Henry, "Remembering Toledo's Troopers," *Toledo Blade*, June 16, 2013.

Dick Berry, "Toledo Troopers Football Team Set Women's Sports on Right Path," WTOL, August 31, 2013, www.wtol.com/story/23310116/toledo -troopers-football-team-set-womens-sports-on-right-path.

LISA OLSON (170)

Sherry Ricchiardi, "Offensive Interference," *American Journalism Review*, December 2004/January 2005.

Thomas George, "Patriots and 3 Players Fined in Olson Incident," *New York Times*, November 28, 1990.

Barbra J. Smerz, "Olson, Lisa," Encyclopedia.com, 2004, www.encyclopedia.com/doc/1G2-3407900415.html.

Allie Kessel, "An AWSM Experience for Merrill Students," Association for Women in Sports Media, July 8, 2013, http://awsmonline.org/an-awsm -experience-for-merrill-students.

Kelsey Nelson, "Breaking into the 'Big Leagues' in an AWSM Way," Association for Women in Sports Media, July 8, 2013, http://awsmonline.org /breaking-into-the-big-leagues-in-an-awsm-style.

Kelly Erickson, "Lisa Olson Receives AWSM's 2013 Pioneer Award," Association for Women in Sports Media, June 22, 2013, http://awsmonline.org /lisa-olson-receives-awsms-2013-pioneer-award.

Meri-Jo Borzilleri, "Olson Named Mary Garber Pioneer Award Winner," Association for Women in Sports Media, November 20, 2012, http://awsmonline.org/olson-named-mary-garber-pioneer-award-winner.

James S. Kunen and S. Avery Brown, "Sportswriter Lisa Olson Calls the New England Patriots Out of Bounds for Sexual Harassment," *People*, October 15, 1990.

LORRAINE WILLIAMS (200)

"Lorraine Williams, Chicago Wonder Girl, Is Following in Tennis Footsteps of Prodigies Maureen Connolly," *Sarasota Herald-Tribune*, May 21, 1952, https://news.google.com/newspapers?nid=1755&dat=19520521&id=qoEcAAAAIBAJ&sjid=vWQEAAAAIBAJ&pg=4149,327599 0&hl=en.

LOUISE STOKES AND TIDYE PICKETT (202)

Paula Edelson, "Pickett, Tidye, and Louise Stokes," *A to Z of American Women in Sports* (New York: Facts on File, 2002).

"The Nazi Olympics Berlin 1936," United States Holocaust Memorial Museum, https://www.ushmm.org/wlc/en/article.php?ModuleId=10005680.

Kenan Heise, "Tidye Ann Phillips, Olympian and Principal," *Chicago Tribune*, November 23, 1986.

LYNN HILL (152)

"Biography," Lynn Hill Climbing, http://lynnhillclimbing.com/?page_id=5.

"Lynn Hill Biography—Chronology, Awards, and Accomplishment, Further Information," http://sports.jrank.org/pages/2064/Hill-Lynn.html.

"Lynn Hill," *Wikipedia*, accessed March 11, 2016.

MANON RHÉAUME (184)

Associated Press, "A Woman on the Ice," *New York Times*, November 27, 1991.

Associated Press, "Rheaume: Another Shot?" *New York Times*, April 12, 1993.

Arpon Basu, "Rhéaume Arrives at Lightning Training Camp," NHL.com, September 23, 2012, https://www.nhl.com/news/part-2-rheaume-arrives-at-lightning-training-camp/c-642006.

A. Petruso, "Rheaume, Manon," Encyclopedia.com, 2004, www.encyclopedia.com/doc/1G2-3407900452.html.

William Plummer, "The Puck Stops Here," *People*, September 28, 1992.

Mark Kearney and Randy Ray, *Whatever Happened To . . . ?: Catching Up with Canadian Icons* (Toronton: Dundurn, 2006).

MARGARET DUNKLE AND ABBY WAMBACH (50)

In conversation for *Game Changers*.

MARGARET MCGREGOR (146)

Associated Press, "McGregor Easily Wins by Decision," ESPN Boxing, October 9, 1999, http://a.espncdn.com/boxing/news/1999/1009/106430.html.

Michael Hirsley, "Just a Very Dumb Idea," *Chicago Tribune*, October 24, 1999.

"Women in the Ring," CBS News, October 11, 1999.

Chuck Stark, "McGregor Toughened by Rough Past," ESPN Boxing, October 8, 1999, http://a.espncdn.com/boxing/news/1999/1008/103644.html.

Sam Howe Verhovek, "When a Man Meets a Woman (in the Ring)," *New York Times*, October 3, 1999.

MARGARET MURPHY (92)

Information gathered by an interview with Margaret Murphy.

MARGO OBERG (162)

"Margo Godfrey-Oberg," History of Women's Surfing, www.historyofwomensurfing.com/margo-godfrey-oberg.

"Margo Oberg," Hawai'i Sports Hall of Fame, www.hawaiisportshalloffame.com/cms/index.php?page=oberg-margo.

Greg MacGillivray, Jim Freeman, Larry Lindberg, Jeff Divine, Ron Stoner, and *Surfer Magazine*, "Oberg, Margo," *Encyclopedia of Surfing*, http://encyclopediaofsurfing.com/entries/oberg-margo.

Reid Levin, "Margo Oberg Becomes First Woman to Earn Paycheck for Surfing," *The Inertia*, July 31, 2014, www.theinertia.com/surf/margo-oberg-becomes-first-woman-to-earn-paycheck-for-surfing.

MARIBEL OWEN, LAURENCE OWEN, MARIBEL VINSON-OWEN (258)

Flip Bondy, "End Zone: Remembering Crash That Rocked U.S. Skating," New York *Daily News*, January 29, 2011.

"February 15, 1961: U.S. Figure Skating Team Killed in Plane Crash," History.com, 2011, www.history.com/this-day-in-history/u-s-figure-skating-team-killed-in-plane-crash.

Bonnie D. Ford, "OTL: An Enduring Legacy for Ice Skating," ESPN, March 23, 2016.

http://espn.go.com/espn/eticket/story?page=110215/skatingcrash.

MARILYN BELL (214)

"Marilyn's Big Surprise," *Sports Illustrated*, September 20, 1954.

James Marsh, "Marilyn Bell Swims Lake Ontario," Toronto in Time, http://citiesintime.ca/toronto/story/marilyn-bell.

"Marilyn Bell," Library and Archives Canada, https://www.collectionscanada.gc.ca/women/030001-1502-e.html.

MARILYN NEUFVILLE (208)

"Marilyn Neufville at Commonwealth Games," Getty Images, http://www.gettyimages.com/detail/news-photo/jamaican-athlete-marilyn-neufville-stands-on-the-podium-news-photo/545285937#jamaican-athlete-marilyn-neufville-stands-on-the-podium-wearing-her-picture-id545285937.

"Marilyn Neufville," Wikipedia, https://en.wikipedia.org/wiki/Marilyn_Neufville.

MARY MCGEE (196)

"AMA Honors Racing Pioneer Mary McGee," America Motorcyclist Association, MotoUSA.com, http://www.motorcycle-usa.com/2012/05/article/ama-honors-racing-pioneer-mary-mcgee/.

Additional information gathered by an interview with Mary McGee.

MELISSA LUDTKE (142)

Melissa Ludtke and Time, Inc., Plaintiffs, v. Bowie Kuhn, Commissioner of Baseball, U.S. District Court, Southern District of New York, 461 F. Supp. 86, September 25, 1978, http://law2.umkc.edu/faculty/projects/ftrials/communications/ludtke.html.

"Melissa Ludtke," interviewed by Ashley Oerman, Journalism and Women Symposium, www.jaws.org/work-we-do/interviews-with-members/women-journalists-in-the-21st-century-melissa-ludtke.

"Melissa Ludtke," *Wikipedia*, accessed September 27, 2014.

Maxwell Strachan, "37 Years Ago, a Female Journalist Won the Right to Do Her Job," *Huffington Post*, September 25, 2015.

Lynn Zinser, "In 1975, 2 Women Crossed a Barrier," *New York Times*, January 23, 2010.

MIRIAM "LADY TYGER" TRIMIAR (166)

Lee Harris, "Boxing League Given Bout Against Gangs," *Los Angeles Times*, January 1, 1987.

Alissa and L.A., "Feminist Friday: Tyger Trimiar," *Total Knockout*, February 2016, www.totalknockout.style/2016/02/feminist-friday-tyger-trimiar.html.

Leigh Behrens, "Boxer Hungry for Recognition," *Chicago Tribune*, April 19, 1987.

Sue T. L. Fox, "Historical Events in Women's Boxing," ESPN, February 6, 2016, http://assets.espn.go.com/boxing/s/2003/0206/1504885.html.

Robert Lipsyte, "For These Women, a Heavy Right Is More Powerful than Sisterhood," *New York Times*, April 21, 1995.

MOLLY BOLIN KAZMER (204)

Joanne Lannin, "Finding Molly Bolin," *Finding a Way to Play*, December 27, 2013, https://findingawaytoplay.com/2013/12/27/finding-molly-bolin.

"Molly Machine Gun Bolin," All American Red Heads, http://www.allamericanredheads.com/index.html.

Matt Caputo, "The Forgotten," *SLAM*, May 28, 2013, www.slamonline.com/other-ballers/womens/molly-bolin-the-forgotten/#9pxFrcUPStDlQGfH.97.

NADIA COMANECI (228)

Biography.com Editors, "Nadia Comaneci," Biography.com, http://www.biography.com/people/nadia-comaneci-9254240.

NAN ASPINWALL (212)

"Nan J. Aspinwall, Western Entertainer," Nebraska State Historical Society, www.nebraskahistory.org/publish/publicat/timeline/nan_aspinwall.htm.

"From Sea to Sea Rode Nan in Saddle," *New York Times*, July 9, 1911.

NAWAL EL MOUTAWAKEL (180)

"Nawal El Moutawakel," *Wikipedia*, accessed January 23, 2016.

"Biography of Nawal El Moutawakel," Laureus.com, https://www.laureus.com/academy/members/nawal-el-moutawakel.

"16 Days of Glory—Nawal El Moutawakel," posted by Ynotlleb, YouTube, April 25, 2008, https://youtu.be/xvd6Jcvaw6M.

"A History Making Victory from Nawal El Moutawakel | Moments in Time," posted by Olympic, YouTube, October 18, 2014, https://youtu.be/GIwWfMS3axg.

NEROLI FAIRHALL (206)

"Neroli Fairhall: New Zealand Olympian," Olympic.org, http://olympic.org.nz/athletes/neroli-fairhall.

Phoebe Falconer, "Obituary: Neroli Fairhall," *NZ Herald*, June 16, 2006.

NURSES SOFTBALL TEAM (226)

"Army Nurses Softball Team," Bettmann, Getty Images, http://www.gettyimages.com/license/514686904.

OLGA KORBUT (236)

Brigid McCarthy, "40 Years Ago, Soviet Gymnast Olga Korbut Dazzled the World," Public Radio International, July 24, 2012.

Jeré Longman, "30 Years of Hard Falls for Olga Korbut, After the Gold and Glory," *New York Times*, February 9, 2002.

Roslyn Sulcas, "Artistry Fades as Gymnasts Push Boundaries," *London 2012* blog, *New York Times*, August 7, 2012.

Leigh Montville, "Olga Korbut," *Sports Illustrated*, September 19, 1994.

"Korbut Flip," *Wikipedia*, accessed May 28, 2015.

Paul Doyle, "50 Stunning Olympic Moments No. 47: Olga Korbut Redefines Gymnastics," *The Guardian*, July 6, 2012.

Gerald Eskenazi, "Olga: Overshadowed; 19,694 Don't Care; No Untoward Incidents," *New York Times*, March 24, 1973.

ORA WASHINGTON (230)

"Ora Mae Washington, 'Queen of Tennis,'" FIGAH: Filling in the Gaps in American History, http://figah.us/Washington__Ora_Mae_2.php.

"Ora Washington (1899–1971) Historical Marker," Explore PA History, http://explorepahistory.com/hmarker.php?markerId=1-A-35A.

Eve M. Hermann, "Washington, Ora," Encyclopedia.com, 2004, www.encyclopedia.com/doc/1G2-3407900605.html.

"Ora Mae Washington Showed Great Athletic Skills," African American Registry, www.aaregistry.org/historic_events/view/ora-mae-washington-showed-great-athletic-skills.

"All Hail the Philadelphia Tribune Girls! (Happy Birthday Ora Mae Washington)," Black Fives Foundation, January 22, 2008, www.blackfives.org/all-hail-the-philadelpha-tribune-girls-happy-birthday-ora-mae-washington.

PAM OLIVER AND CARI CHAMPION (188)

In conversation for *Game Changers*.

PAT LAURSEN (234)

"Pat Laursen national women's skeet shooting champion," Getty Images, http://www.gettyimages.com/detail/news-photo/pat-laursen-national-womens-skeet-shooting-champion-wearing-news-photo/72399427.

"Beautiful Skeeter: Pat Laursen Is National Champion," *LIFE*, September 16, 1940, https://books.google.com/books?id=D0oEAAAAM-

BAJ&pg=PA54&lpg=PA54&dq=Pat+Laursen&source=bl&ots=RHwMmbsej-&sig=ZSTlOWb5Ancbl-oWOy6Bn-5CoLI&hl=en&sa=X&ved=0ahUKEwjanp_4vbjOAhVB2WMKHQZRAZAQ6AEIQjAL#v=onepage&q=Pat%20Laursen&f=false.

PAT SUMMITT (238)

Emily Bazelon, "Lady Vol," *New York Times*, May 31, 2013.

"The Pat Summitt Foundation," PatSummitt.org.

Mechelle Voepel, "Tracking the Ascension of Summit," ESPN, March 19, 2012.

PATTI MCGEE (240)

Sky Siljeg, "A Talk with Patti McGee," *Scholastic News*, http://teacher.scholastic.com/scholasticnews/indepth/skateboarding/articles/index.asp?article=patti.

Xavier Lannes, "Patti McGee 1965 Skateboard Champion," I Skate Therefore I Am, November 7, 2011, http://blog.istia.tv/2010/11/patti-mcgee-1965-skateboard-champion.html.

Fiona Zublin, "Skateboarding Queen Patti McGee," OZY, August 25, 2015, www.ozy.com/flashback/skateboarding-queen-patti-mcgee/60627.

PEGGY OKI (210)

Steve Olson, "Dogtown Chronicles: Peggy Oki," *Juice Magazine*, February 1, 2002.

Lee Nentwig and Theo Constantinou, "Propelled by Passion," *Paradigm Magazine*, October 1, 2014.

Jessica Hundley, "Life on the Edge of a Skateboard," *Los Angeles Times*, April 25, 2002.

Keith David Hamm, "The Z-Girl in the Skateboard History Books," *Los Angeles Times*, December 1, 2002.

"Z-Boys," *Wikipedia*, accessed November 20, 2015.

PENNY PITOU (260)

Joe Sullivan, "Penny Pitou," *New Hampshire Union Leader*, November 15, 2001.

"Penny Pitou," Sports-Reference.com, www.sports-reference.com/olympics/athletes/pi/penny-pitou-1.html.

Paula Tracy, "NH Woman Who Competed in 1960 Olympics Describes Advances in Equality," WMUR, January 26, 2014, www.wmur.com/escape-outside/nh-woman-who-competed-in-1960-olympics-describes-advances-in-equality/24099658.

RENÉE RICHARDS (218)

Robin Herman, "'No Exceptions,' and No Renee Richards," *New York Times*, August 27, 1976.

Sara Lentati, "Tennis's Reluctant Transgender Pioneer," BBC News, June 26, 2015.

Michael Weinreb, "Renée Richards Wants to Be Left Alone," *Grantland*, July 7, 2011.

Emily Bazelon, "Cross-Court Winner: Renée Richards (1934–)," *Jewish Jocks: An Unorthodox Hall of Fame* (New York: Twelve, 2012).

RHYTHM IN ORANGE (284)

"Rhythm in Orange," Ernst Haas, Getty Images, http://www.gettyimages.com/license/3435249.

RICA REINISCH (266)

Sarah Naimzadeh, "Wonder Girls and Steroids," Bryn Mawr College, 2000, http://serendip.brynmawr.edu/biology/bl03/f00/web2/index.html.

Alan Cowell, "In a Cold War Hangover, Germany Confronts a Legacy of Steroids," *New York Times*, April 4, 1998.

Craig Whitney, "Miss Reinisch Gets 3rd Gold, 4th World Mark," *New York Times*, July 28, 1980.

"Athletics: The Prodigy Whose Body Lasted Two Years," *The Guardian*, October 31, 2005.

Luke Harding, "Revenge of the Wunderkind," Associated Press, November 2, 2005.

ROBIN HERMAN (268)

Lynn Zinser, "In 1975, 2 Women Crossed a Barrier," *New York Times*, January 23, 2010.

"Jan. 21 Is 35th Anniversary of Women Breaking Locker-Room Barrier," Associated Press Sports Editors, January 21, 2010, http://apsports editors.org/in-the-news/jan-21-is-35th-anniversary-of-women-breaking-locker-room-barrier.

Rachel Lenzi, "Herman Named 2015 Mary Garber Pioneer Award Winner," Association for Women in Sports Media, December 26, 2014, http://awsmonline.org/robin-herman-named-2015-mary-garber-pioneer-award-winner.

Robin Herman, "Reporter's Notebook: A Look at Equal Rights and Hockey," *New York Times*, February 9, 1975.

ROBYN SMITH, BARBARA ADER, AND BRENDA WILSON (172)

"Women Jockeys After Lady Godiva Handicap Horesrace," Bettmann, Getty Images, http://www.gettyimages.com/license/514886846.

Thomas Rivera, "Jockey Penny Ann is 'Scratched' Again," *Chicago Tribune*, November 22, 1968, http://archives.chicagotribune.com/1968/11/22/page/73/article/jockey-penny-ann-is-scratched-again.

"Penny Ann Early," Wikipedia, https://en.wikipedia.org/wiki/Penny_Ann_Early.

RUBERTA MITCHELL (244)

Roller Derby Hall of Fame, http://www.rollerderbyhalloffame.com/.

David Block, "Acknowledging How Roller Derby Embraced African-Americans from Day One," blindfilmmaker.com, April 2014, http://www.blindfilmmaker.com/recent-articals/acknowledging-how-roller-derby-embraced-african-americans-from-day-one/.

RUSTY KANOKOGI (276)

Joshua Robinson, "Rusty Kanokogi, Fiery Advocate for Women's Judo, Dies at 74," *New York Times*, November 22, 2009.

Keith Thursby, "Rena 'Rusty' Kanokogi Dies at 74; U.S. Women's Judo Pioneer," *Los Angeles Times*, November 24, 2009.

Andi Zeisler, "Adventures in Feministory: Rena," Bitch Media, August 29, 2011, https://bitchmedia.org/post/adventures-in-feministory-rena-%E2%80%9Crusty%E2%80%9D-kanokogi-mother-of-judo.

Michele Kort, "Farewell to a Pioneer of Women's Sports," *Ms. Magazine* website, fall 2009, http://msmagazine.com/Fall2009/kanokogi.asp.

SHAWNA ROBINSON (248)

Marty Smith, "Robinson Fighting Cancer With a Smile," ESPN, May 1, 2014, http://www.espn.com/racing/nascar/cup/story/_/id/10869139/nascar-shawna-robinson-facing-cancer-fight-smile-door-door.

SHERYL SWOOPES/NIKE AIR SWOOPES (232)

"Nike Air Swoopes," Nike Inc., July 29, 2012, http://news.nike.com/news/nike-air-swoopes.

Russ Bengtson, "An Ode to the Nike Air Swoopes Zoom," Complex.com, March 25, 2014, www.complex.com/sneakers/2014/03/an-ode-to-sheryl-swoopes-signature-nike-sneakers.

"Sheryl Swoopes," *Wikipedia*, accessed January 9, 2016.

SHIRLEY AND SHARON FIRTH (262)

Tabitha Marshall, "Shirley and Sharon Firth," *The Canadian Encyclopedia* (Toronto: Historica Canada, 2013).

"Sharon and Shirley Firth Enter Canada's Sports Hall of Fame," CBC/Radio Canada, October 21, 2015.

"Shirley and Sharon Firth," Cross Country Canada, January 10, 2011, www.cccski.com/About/History/Our-Olympians/Shirley-and-Sharon-Firth-(1).aspx#.V455SaLw6y8.

SHIRLEY MULDOWNEY (222)

Shirley Muldowney, "Awards, Honors and Milestones," https://www.muldowney.com/milestones.html.

Mark Bechtel, "The Drag Queen Departs: A Woman Who Whipped the Good Ol' Boys Retires—for Her Husband," *Sports Illustrated,* November 3, 2003.

Sam Moses, "Fiery Return of a Leadfoot Lady," *Sports Illustrated,* February 10, 1986.

J. E. Vader, "Two Foes Bury the Hatchet, but Not the Competition," *Sports Illustrated,* September 4, 1989.

Bill McGuire, "Shirley Muldowney—The Queen of Drag Racing in Her Own Words," *Hot Rod,* April 25, 2009.

STELLA WALSH (250)

Matt Tullis, "Who Was Stella Walsh? The Story of the Intersex Olympian," *SB Nation,* June 27, 2013, www.sbnation.com/longform/2013/6/27 /4466724/stella-walsh-profile-intersex-olympian.

Paul Farhi, "The Runner's Secret," *Washington Post,* August 22, 2008.

"Stanislawa Walasiewicz: The Curious Story of Stella Walsh," *Encyclopaedia Britannica,* https://www.britannica.com/topic/1932-Olympic -Games-The-Curious-Story-of-Stella-Walsh-1367962.

"Stanisława Walasiewicz," *Wikipedia,* accessed January 13, 2016.

SURYA BONALY (198)

Stacia L. Brown, "The Rebellious, Back-Flipping Black Figure Skater Who Changed the Sport Forever," *New Republic,* August 18, 2015.

Christopher Clarey, "French Skater Decides to Stay Within Lines," *New York Times,* February 25, 1993.

Rebel on Ice, dir. Eva Longoria, ESPN, August 14, 2015.

SUSAN BUTCHER (216)

Viv Bernstein, "Susan Butcher, Pioneer in Sled-Dog Racing, Is Dead at 51," *New York Times,* August 7, 2006.

Sanka W. Dog, "Granite and Susan Butcher—Hero and Heroine," Iditarod.com, October 19, 2012, http://iditarod.com/zuma/granite-susan-butcher -hero-heroine-by-sanka-w-dog.

Jill Burke, "On the Iditarod Trail, Recalling a Mom Named Susan Butcher," *Alaska Dispatch News,* March 12, 2012.

TENNESSEE TIGERBELLES (270)

" Legendary Tigerbelles Coach Ed Temple Honored at USA Outdoors," USA Track & Field, June 28, 2014, http://www.usatf.org/News/Legendary -Tigerbelles-head-coach-Ed-Temple.aspx?feed=news.

Lucas Johnson, "Tennessee State University Has Rich Olympic History," Tennessee State University Newsroom, August 9, 2016, http://tnstatenews room.com/archives/tag/tigerbelles.

"Legendary Tigerbelles Featured In Parthenon Olympic Exhibit," TSU Men's Track & Field, August 16, 2004, http://www.tsutigers.com/mtrack /news/2004-05/1098/legendary-tigerbelles-featured-in-parthenon-olympic-exhibit/.

TONI STONE (254)

Deborah Blagg, "Curveball: Toni Stone's Challenge to Baseball and America," *Radcliffe Quarterly,* July 1, 2009.

"Toni Stone Biography: Baseball Player, Athlete (1921–1996)," Biography.com, www.biography.com/people/toni-stone-40319.

Stew Thornley, "Toni Stone," Society for American Baseball Research, http://sabr.org/bioproj/person/2f33485c.

Precious Sanders, "Toni Stone: The First Woman to Play in the Negro Leagues," *The Baseball Attic,* July 22, 2015, thebaseballattic.wordpress .com/2015/07/22/toni-stone-the-first-woman-to-play-in-the-negro-leagues.

Robert McG. Thomas Jr., "Toni Stone, 75, First Woman to Play Big-League Baseball," *New York Times,* November 9, 1996.

TRUDY BECK (256)

Information gathered by an interview with Orrie Beck.

VIOLET PALMER (278)

"Violet Palmer: First Female Referee, NBA," Makers.com, www.makers.com/violet-palmer.

Johnette Howard, "The Right Woman for the Job," ESPN, December 1, 2013.

Aaliyah Kellogg, "Violet Palmer: Still Breaking Barriers," *SI Kids*, September 29, 2015.

Michael McCann, "Cedric Maxwell's Sexist Comments about NBA Referee Violet Palmer," *Sports Law Blog*, February 28, 2007, http://sports-law.blogspot.com/2007_02_01_archive.html.

Alex Putterman, "NBA Referee Reveals He Is Gay after Rajon Rondo Calls Him a Slur," *The Comeback*, December 14, 2015, http://thecomeback.com/nba/rajon-rondo-bill-kennedy-gay-slur.html.

Associated Press, "Broadcaster Offers On-Air Apology for Sexist Remarks," ESPN, February 28, 2007.

Mark Heisler, "NBA Breaks New Ground by Hiring Female Referees," *Los Angeles Times*, October 29, 1997.

Vanessa Juarez, "Out of Bounds: As an NBA Ref, Violet Palmer Is the Only Woman in a Man's Game," *Newsweek*, March 8, 2004.

WAKE-ROBIN GOLF CLUB (280)

"History," Wake-Robin Golf Club, www.wake-robingolf.org/History.html.

"The Wake Robin Golf Club Founded," African American Registry, www.aaregistry.org/historic_events/view/wake-robin-golf-club-founded.

"Helen Webb Harris," *Wikipedia*, accessed March 21, 2015.

WAYLAND BAPTIST FLYING QUEENS (272)

Jeré Longman, "Before UConn, There Was Wayland," *New York Times*, December 18, 2010.

"Wayland Baptist University," *Wikipedia*, accessed January 14, 2016.

Tommy Magelssen, "West Texas Ties, Patient Sharp Made It Possible to Build Up Texas Tech's Women's Basketball Program," *Lubbock Avalanche-Journal*, February 14, 2013.

Kellie Mitchell, dir, *Flying Queens: A Basketball Dynasty*, flyingqueens.com.

"Pioneers with Minorities," Wayland Baptist University, www.wbu.edu/about_wayland/history_and_traditions/pioneer_with_women_and_minorities/pioneer_for_minority_educational_opportunities/default.htm.

Skip Hollandsworth, "Hoop Queens," *Texas Monthly*, April 2013.

"Odom Is an Elite Member of an Exclusive Club," Wayland Baptist University Athletics, www.wbuathletics.com/sports/2013/1/7/WBB_0107131815.aspx.

Rhane Jeffress, "Queens Experienced Record Win Streak in the 1950's," Wayland Baptist University, February 22, 2006, https://www.wbu.edu/news_and_events/2006/formerqueens.htm.

B. B. Branton, "Paula Westfall, the Flying Queens and 131 Straight Basketball Wins," *The Chattanoogan*, May 18, 2015.

Betsy Blaney, "The Walls Came Tumbling Down," *Lubbock Avalanche-Journal*, August 5, 2001.

Robert W. Ikard, *Just for Fun: The Story of AAU Women's Basketball* (Fayetteville: University of Arkansas Press, 2005).

WILMA RUDOLPH (252)

Rob Bagchi, "50 Stunning Olympic Moments No. 35: Wilma Rudolph's Triple Gold in 1960," *The Guardian*, June 1, 2012.

"Wilma Rudolph Biography: Track and Field Athlete (1940–1994)," Biography.com, www.biography.com/people/wilma-rudolph-9466552.

"Women in History: Wilma Rudolph Biography," Lakewood Public Library, Lakewood, OH, www.lkwdpl.org/wihohio/rudo-wil.htm, accessed March 20, 2016 (no longer online).

Frank Litsky, "Wilma Rudolph, Star of the 1960 Olympics, Dies at 54," *New York Times*, November 13, 1994.

M. B. Roberts, "Rudolph Ran and World Went Wild," ESPN, https://espn.go.com/sportscentury/features/00016444.html.

Barbara Heilman, "Like Nothing Else in Tennessee," *Sports Illustrated*, November 14, 1960.

Kate Kelly, "Wilma Rudolph (1940–1994)," America Comes Alive, March 8, 2011, americacomesalive.com/2011/03/08/wilma-rudolph-1940-1994.

WOMENSPORTS MAGAZINE (242)

Margaret Roach, "Sports Magazine Faces a Change in Ownership," *New York Times*, December 4, 1977.

Jay Searcy, "Magazine Venture Is a Risky Game for Mrs. King," *New York Times*, September 8, 1974.

"About Us," Women's Sports Foundation, www.womenssportsfoundation.org/home/about-us.

"WomenSports," *Wikipedia*, accessed December 19, 2015.

Philip H. Dougherty, "Advertising; Setting New Goals for *WomenSports*," *New York Times*, October 18, 1977.

Associated Press, "Billie Jean's *WomenSports* Due on Stands," *Rome News-Tribune*, May 8, 1974.

"New Mag Gets Sneaked," *New York*, May 4, 1974.

Cheryl Bentsen, "A High Hurdle for *WomenSports*," *Milwaukee Journal*, April 5, 1975.

WYOMIA TYUS (264)

"Winners of Women's 100-meter Run in Olympics," Bettmann, Getty Images, http://www.gettyimages.com/license/515492934.

"Wyomia Tyus," USA Track & Field, http://www.usatf.org/halloffame/TF/showBio.asp?HOFIDs=175.

Dave Zirin, "In the Spirit of Wyomia Tyus, Women Athletes Say #BlackLivesMatter," *The Nation*, December 15, 2014, https://www.thenation.com/article/spirit-wyomia-tyus-women-athletes-say-blacklivesmatter/.

ZOLA BUDD (246)

Steve Friedman, "After the Fall," *Runner's World*, May 7, 2013.

Simon Burnton, "50 Stunning Olympic Moments No. 30: Zola Budd in 1984," *The Guardian*, May 15, 2012.

PHOTO CREDITS

1964 JAPANESE
VOLLEYBALL TEAM
Photo courtesy of Sankei Archive/Getty

1976 YALE CREW TEAM
Boston Globe/Getty

1984 CUBAN NATIONAL WOMEN'S
BASKETBALL TEAM
Neil Leifer/Getty

ABBY HOFFMAN
City of Toronto Archives

ALFREDA JACKSON, RUTH HARRIS,
CLEMENTINE REDMOND,
LILLIAN HARDY (ATA)
Afro Newspaper/Gado/Getty

ALICE COACHMAN
Associated Press

ALICE MARBLE
New York Daily News Archive/Getty

ALISON JANE HARGREAVES
Courtesy of Tom Frost

ALL AMERICAN RED HEADS
Jacobsen/Getty

ALTHEA GIBSON
Hulton-Deutsch Collection/Corbis

ANDREA JAEGER
Focus On Sport/Getty

ANITA DEFRANTZ
Bettmann/Corbis

ANKE EVE GOLDMANN
Unknown

ANN KOGER
Photo courtesy of Ann Koger/
Photo by Tom Booker

ANNIE SMITH PECK
ullstein bild/Getty

ANNMARIA DE MARS
Courtesy of David Finch

ARLENE BLUM
Associated Press/*Fort Collins Coloradoan*,
Arlene Blum

BABE DIDRIKSON ZAHARIAS
New York Daily News Archive/Getty

BAKERSFIELD SWIM TEAM
Ralph Crane/Getty

BARBARA POLK WASHBURN
Museum of Science, Boston

BERNICE GERA
National Baseball Hall of Fame Library,
Cooperstown, New York

BERNICE SANDLER
National Advisory Council on Women's
Educational Programs, May 8, 1978,
photo courtesy of Bernice Sandler

BETTY COOK
Courtesy of Kaama Marine admin team

BETTY ROBINSON
Corbis

BILLIE JEAN KING
Neil Leifer/Getty

BRIANA SCURRY
Courtesy of Briana Scurry

CAROL ROSE AND THERESA SAMS
HultonArchive/Getty

CATHY RUSH/IMMACULATA
COLLEGE
John Iacono/Getty

CHICAGO DAILY DEFENDER
BOWLING TOURNAMENT
Robert Abbott Sengstacke /Getty

CHRIS VON SALTZA
A.Y. Owen /Getty

CHRISTY MARTIN
Bill Frakes/Getty

CONCHITA CINTRÓN
Getty

CONSTANCE APPLEBEE
Bryn Mawr College Special Collections

DEBI THOMAS
David Madison/Getty

DENISE MCCULGGAGE
Millard Smith/Getty

DIANA NYAD
Lynn Pelham/Getty

DIANE CRUMP
Jim Raftery

DICK, KERR'S LADIES FC
Nationaal Archief/Collection Spaarnestad
Photo/Het Leven

DONNA DE VARONA
Mondadori Portfolio/Getty

DOROTHY WISE
Courtesy of Billie Billing
and Moon Bothelho

EARLENE BROWN
Mondadori Portfolio/Getty

EDITH GREEN
Oregon Historical Society

EDITH HOUGHTON
National Baseball Hall of Fame Library,
Cooperstown, New York

ELEANOR HOLM JARRETT
Courtesy of the Boston Public Library,
Leslie Jones Collection

ELSPETH BEARD
Courtesy of Elspeth Beard

EMMA GATEWOOD
The Appalachian Trail Museum

ENRIQUETA BASILIO
Bride Lane Library/Popperfoto/Getty

EUNICE KENNEDY SHRIVER
Bettmann/Corbis

EVONNE GOOLAGONG CAWLEY
The AGE /Getty

FANNY BULLOCK WORKMAN
Getty

FLORENCE ARTHAUD
JARNOUX Patrick/Getty

FLORENCE LEONTINE
PACNCHO BARNES
Underwood & Underwood/Corbis

GABRIELA ANDERSEN-SCHIESS
David Madison/Getty

GERTRUDE EDERLE
New York Daily News Archive/Getty

GLADYS HELDMAN
Joseph Consentino/Getty

GRETCHEN FRASER
Bettmann/Corbis

HELME SUUK
Jaan Künnap

ISABEL LETHAM
Warringah Library Local Studies Collection

JACKIE TONAWANDA
Courtesy of the Frank Mt. Pleasant Library
of Special Collections, Chapman University

JANET COLLINS
Library of Congress Prints and Photo-
graphs Division, New York World-Telegram
and the Sun Newspaper Photograph
Collection

JANET GUTHRIE
RacingOne/Getty

JEAN BALUKAS
Library of Congress

JOAN WESTON
Phil Berrier, Director of Operations/
National Roller Derby Hall of Fame

JOAN WHITNEY PAYSON
Bettmann/Corbis

JOE CARSTAIRS
Slim Aarons/Getty

JOYCE WALKER
Courtesy of Joyce Walker
and the Harlem Globetrotters

JUNKO TABEI
Jaan Künnap

JUTTA KLEINSCHMIDT
Photo courtesy of Jutta Kleinschmidt

KATHRINE SWITZER
Walter Iooss Jr./Getty

KATHRYN "KATHY" KUSNER
Mark Kauffman/Getty

KAY YOW
John D. Hanlon/Getty

KEIKO FUKUDA
Lance Iversen/San Francisco Chronicle/
Polaris

KIM CESPEDES
Photo by Jim Goodrich

KIM GILBERT
Courtesy of Los Angeles Daily News

KIM AND SYLVIA GREEN
Courtesy of Kim Green

KINUE HITOMI
Wikipedia Commons (Source Unkown)

KITTY O'NEIL
tom nebbia/Getty

KOREAN DEEP SEA DIVERS
Douglas MacDonald/Getty

LAURA THORNHILL
Photo by James O'Mahoney, courtesy of
Laura Thornhill

LAVONNE PAIRE-DAVIS
Courtesy of The History Museum

LIBBY RIDDLES
Corbis

LINDA JEFFERSON
Courtesy of Corey Gray

LISA OLSON
Associated Press/Steve Senne

LORRAINE WILLIAMS
Getty

LOUISE STOKES AND
TIDYE PICKETT
Courtesy of the Boston Public Library,
Leslie Jones Collection

LYNN HILL
Courtesy of Lynn Hill, Photo by John
Bachar

MANON RHÉAUME
B Bennett/Getty

MARGARET DUNKLE
Courtesy of Margaret Dunkle

MARGARET MCGREGOR
Patrick Hagerty/Sygma/Corbis

MARGARET MURPHY
Photo provided by Margaret Murphy

MARGO OBERG
Matt Kane

MARIBEL OWEN, LAURENCE
OWEN, MARIBEL VINSON-OWEN
Bettmann/Corbis

MARILYN BELL
Canada's Sports Hall of Fame

MARILYN NEUFVILLE
Ed Lacey/Getty

MARY MCGEE
Courtesy of Mary McGee

MELISSA LUDTKE
Associated Press/Dave Pickoff

MIRIAM "LADY TYGER" TRIMIAR
Keystone Pictures USA/Alamy

MOLLY BOLIN KAZMER
Courtesy of Molly Bolin Kazmer
and Rich Cummins

NADIA COMANECI
Bettmann/Corbis

NAN ASPINWALL
ullstein bild/Getty

NAWAL El MOUTAWAKEL
Tony Duffy/Getty

NEROLI FAIRHALL
Bob Thomas/Getty

NURSES SOFTBALL TEAM
Bettmann/Corbis

OLGA KORBUT
Getty

ORA WASHINGTON
John W. Mosley Photograph Collection,
Charles L. Blockson Afro-American Collec-
tion, Temple University Libraries, Philadel-
phia, PA

PAM OLIVER
Mark Brettingen/Getty

PAT LAURSEN
Alfred Eisenstaedt/Getty

PAT SUMMITT
Lynn Johnson/Getty

PATTI MCGEE
Photo courtesy of Hailey Villa

PEGGY OKI
Photo courtesy of Pat Darrin

PENNY PITOU
George Silk/Getty

RENÉE RICHARDS
Manny Millan/Getty

RHYTHM IN ORANGE
Ernst Haas/Getty

RICA REINISCH
ullstein bild/Getty

ROBIN HERMAN
Bob Glass/Redux/*New York Times*

ROBYN SMITH, BARBARA ADER,
AND BRENDA WILSON
Bettmann/Getty

RUBERTA MITCHELL
Photo courtesy of Phil Berrier, Director of
Operations, National Roller Derby Hall of
Fame

RUSTY KANOKOGI
Photo courtesy of Peter Perazio

SHAWNA ROBINSON
RacingOne/Getty

SHERYL SWOOPES/NIKE AIR
SWOOPES
Nathaniel S. Butler/Getty

SHIRLEY AND SHARON FIRTH
Dick Darrell/Getty

SHIRLEY MULDOWNEY
Muldowney private collection

STELLA WALSH
Cleveland Public Library

SURYA BONALY
Jean-Yves Ruszniewski/
TempSport/Corbis

SUSAN BUTCHER
Paul A. Souders/Corbis

TENNESSEE TIGERBELLES
David Lees/Getty

TONI STONE
National Baseball Hall of Fame Library,
Cooperstown, New York

TRUDY BECK
Courtesy of Orrie Beck

VIOLET PALMER
Courtesy of Violet Palmer

WAKE-ROBIN GOLF CLUB
Afro Newspaper/Gado/Getty

WAYLAND BAPTIST COLLEGE
FLYING QUEENS
Courtesy of Betty Courtney Donaldson
and Wayland Baptist University

WILMA RUDOLPH
Rolls Press/Popperfoto/Getty

WOMENSPORTS
Joe Traver / Getty

WYOMIA TYUS
Bettmann/Corbis

ZOLA BUDD
Photo by Hiram Clawson, copyright 1984
by the *Los Angeles Times*

ACKNOWLEDGMENTS

First and foremost, thank you, Cass Bugge, who wrote all the entries in record speed. I am forever indebted to you for being my every kind of compass imaginable. We make The. Greatest. Team.

Thank you to my extraordinary editor, Julianna Haubner. You deserve the gold for your encouragement and vision. Your official offer letter is printed out and saved in a special wooden box alongside my social security card and other important documents. Thank you for being patient and kind and respecting my voice and process.

Thank you to the one and only, my agent, Erin Hosier, at Dunow, Carlson & Lerner. I appreciate you so much. Without you, I am not sure where I'd be. You are the best agent on planet Earth, a true feminist champion.

Thank you to all the women in the book who took the time to send me photos, share stories, and help get this book made, especially Abby Wambach, Margaret Dunkle, Pam Oliver, Cari Champion, Lacey Baker, and Laura Thornhill-Caswell. You donated your time, which I know is of great value to you.

Thanks also to: Dana Trocker, Maureen Cole, and everyone at Simon & Schuster, my family (including you, Oliva Bugge), Nina Gregory, Matt Bloomgarden, Mary Grill, Julia Kenny, School of Doodle, Michael Rapaport, Emily Spivack, Wayne Wilson and LA84, Lizzie Garrett Mettler, Leah Ruddick, Justine Jones, Julia Gilmore, Carolyn Strauss, Jenny Johnson, Rob Brady, and Tal Schori.

Thank you to all of my @theunsungheroines friends who have been with me from the start and who are with me now.

ABOUT THE AUTHOR

Molly Schiot is a Los Angeles–based filmmaker who parlayed her dedication to telling women's stories into the Instagram account @TheUnsungHeroines. She is the creator of the "Check You Out" series for *PAPER* magazine and recently directed an ESPN *30 for 30* short, "Our Tough Guy," about the life of one of the NHL's most fearsome players, John Wensink. *Game Changers* is her first book.